Bucking the
Artworld Tide

About the Author

Michelle Marder Kamhi is an independent scholar and critic. She is the author of *Who Says That's Art? A Commonsense View of the Visual Arts*, lauded by *Kirkus Reviews* as a "forceful and persuasive" defense of traditional art. She also co-authored *What Art Is: The Esthetic Theory of Ayn Rand*—praised by *Choice* magazine for its "well-documented . . . debunking of twentieth-century art . . . and art theory" and by *The Art Book* (the review journal of the British Association of Art Historians) as a "balanced critical assessment of Rand's idiosyncratic arguments."

Since 1992 Kamhi has co-edited the arts journal *Aristos*, having served as associate editor from 1984 to 1992. In its original incarnation as a print journal, *Aristos* was recommended by *Magazines for Libraries* as "a scholarly but gutsy little periodical" that "vigorously challenges modernist scholars and critics." Following the publication of *Who Says That's Art?*, Kamhi launched her blog, *For Piero's Sake*, at www.mmkamhi.com.

A graduate of Barnard College, Kamhi earned an M.A. in Art History at Hunter College of the City University of New York. Prior to her association with *Aristos*, she was an editor at Columbia University Press, where she worked on titles in its distinguished Records of Civilization series. She was also active as a freelance writer and editor. Among her independent projects was *Books Our Children Read*, a film documenting a constructive approach to resolving communal conflict over controversial literature in public school classrooms and libraries.

Kamhi is a member of the American Society for Aesthetics, the National Art Education Association, the National Association of Scholars, and AICA-USA (the American section of the International Association of Art Critics). Articles by her have appeared in the *Wall Street Journal*, *Art Education*, and *Arts Education Policy Review*, among other publications.

Bucking the Artworld Tide

Reflections on Art, Pseudo Art, Art Education & Theory

Michelle Marder Kamhi

PRO ARTE BOOKS
NEW YORK, NEW YORK

Pro Arte Books
147 West 94th Street
New York, NY 10025

E-mail: pab@mmkamhi.com

Publisher's Cataloging-in-Publication Data

Names: Kamhi, Michelle Marder, 1937-, author.
Title: Bucking the artworld tide : reflections on art , pseudo art , art education & theory / Michelle Marder Kamhi.
Description: Includes bibliographical references and index. | New York, NY: Pro Arte Books, 2020.
Identifiers: LCCN 2019956233 | ISBN 978-0-9906057-3-7 (pbk.) | 978-0-9906057-4-4 (Kindle) | 978-0-9906057-5-1 (epub)
Subjects: LCSH Art criticism--Philosophy. | Art--History. | Art--Philosophy. | Arts, Modern. | Art, Modern--20th century. | Art, Modern--21st century. | Arts--Study and teaching. | BISAC ART / Criticism & Theory | ART / History / Contemporary (1945-) | ART / Individual Artists / Essays | ART / Art & Politics
Classification: LCC N7445.2 .K36 2020 | DDC 701--dc23

In grateful memory
of the teachers
who believed in me

Contents

Illustrations

For links to online images of art cited in the text and notes see www.mmkamhi.com.

Preface

This book is both a prequel and a sequel to *Who Says That's Art? A Commonsense View of the Visual Arts*, published in 2014. It incorporates material predating that work, revealing some of the thinking that led up to it, as well as numerous subsequent articles, talks, and weblog posts that further developed its ideas. In all, it represents more than three decades of writing and speaking on the subject of visual art.

In that time, I have watched and commented with increasing dismay as standards regarding the visual arts have continued to decline in every cultural sphere, from academia and journalism to museum management and K–12 education. Moreover, the breakdown has been global in scope. With scarcely any exceptions, public institutions the world over have uncritically embraced every variety of "cutting-edge" contemporary work, however bizarre—heedless of the extent to which it not only deviates from traditional art (and therefore merits a different name) but also alienates many art lovers. It is as if humanity's cultural gatekeepers were afflicted with collective amnesia regarding what made visual art valuable in the first place.

I share the view aptly expressed by the critic and art historian John Canaday (1907–1985) that art is "the tangible expression of the intangible values men live by." Throughout my work, I have sought to show how works of genuine art fulfill that essential function, while the contemporary work that dominates today's artworld (I call it "pseudo art") largely fails to do so. In addition, I have aimed to explain why such expressions are important for both individuals and society. Perhaps most important, unlike traditional work the "con-

temporary art" that fills our museums and galleries does not speak for itself but depends on reams of verbiage to explain it. Much of my writing and speaking has therefore been devoted to debunking the artworld spin on such work.

Many of the pieces included in this volume were first published in *Aristos*, the arts journal I co-edit with my husband, Louis Torres. They are reprinted here with the permission of the Aristos Foundation. Four of them later appeared in somewhat revised form, with expanded endnotes, in the *Arts Education Policy Review*, which has kindly granted permission for those versions to be reprinted. The only changes I have made in any of the work are minor—to correct errors or stylistic infelicities, to clarify chronological references, or to insert an informative note or two. No substantive alterations have been made. In all cases, the publication history is indicated on the first page of each piece.

The contents are organized thematically, rather than strictly chronologically. Part I comprises material on art history and individual artists—some whose work I admire, as well as many whose elevated artworld status I question. Part II is devoted to a critique of "abstract (i.e., nonobjective) art." Art education is the subject of Part III. And Part IV presents articles dealing with theoretical considerations.

Countless friends, colleagues, and relatives, too numerous to list here, have offered interest and support over the years—which has encouraged me in no small measure to stick to my guns. To them, collectively, I extend my warmest gratitude. One person I must name here, however, without whom none of this work would ever have been undertaken. That is my husband, Louis Torres. He not only introduced me to the theory of art that validated and informed my intuitive sense that something was terribly amiss in the avant-garde work that had come to dominate the artworld. He also founded *Aristos*, the journal that first provided an outlet for my writing on art. My debt to him on that double score is incalculable.

M.M.K.
New York City
November 20, 2019

Part I

Art & Pseudo Art

Robert Payne
Uncommon Guide
to the World of Art

In these closing years of the twentieth century, when our culture is plagued by a fevered confusion over the question, What is art?, it is salutary to revisit, if only vicariously, some landmarks in the long tradition of painting and sculpture. For such a pilgrimage, one could find no more inspiring or illuminating guide than the prolific British-born writer Robert Payne, who died in 1983 at the age of seventy-one.

Biographer, novelist, historian, poet, journalist, librettist, and translator, with well over a hundred books to his credit, Payne was neither an art historian nor a critic by profession. But in his deeply felt survey *The World of Art* (1972), and in highly literate travel books such as *The Splendor of Greece* (1960), he offers consistently penetrating insights into the visual arts—insights not only informed by wide-ranging scholarship but also infused with the passionate enthusiasm of his own responses and communicated in a prose that is often breathtaking in its lucidity and grace.

Although Payne at times refers to art as a mystery that is "beyond the frontiers of reason," he in fact understands better than most twentieth-century historians and critics what art is and why it affects us so profoundly. He also understands the nature of artistic creation,

Aristos, December 1993.

and the role of the artist in relation to his culture. What the artist attempts, Payne explains in his Introduction to *The World of Art*, "is nothing less than a recreation of worlds, of universes, of people." The artist, like the shaman and the prophet, is a seer who holds us "within the concentrated circle of his own vision." While all art tends to reflect the physical circumstances and the cultural values of its time and place, each artist also imposes his individual stamp of value and feeling, albeit in varying degree from culture to culture and artist to artist.

Most important for an appreciation of the whole of art history, Payne is able to discern, through the veil of vast cultural differences, the transcendent, universal values relevant to humanity in any time or place. In his company, the products of millennia of art-making are seen as more than a dry succession of monuments and artifacts, pigeon-holed by period and linked mainly by notions of stylistic development. They come alive as an intensely palpable legacy of the entire human race.

The Earliest Artists

"When we look for the first artists," Payne begins his survey of world art,

> we see them standing on high scaffolding in the depths of lime-stone caves, . . . the darkness lit only by the feeble flames of oil lamps. They are painting the shapes of horses, wild bulls, bison, reindeer, mammoth, and rhinoceros on the craggy walls. . . . And there is nothing in the least tentative about their portrayal of these animals seen grazing quietly or racing across the prairies.

As Payne informs us in fascinating detail, the cave painter was a "sophisticated workman," whose technical means were much like those employed today. (In fact, the earliest extant paintings were probably the product of a tradition thousands of years in the making.)

Unlike most writers on the subject, who tend to focus on the supposed magic and ritual purposes of the cave paintings, Payne attempts to plumb the emotional depths of the Paleolithic artists by identifying the central values implicit in their work.

Their imaginative life was filled with the gleaming presences of the beasts who gave them fur and food and bone, sinew and hide and horn. So they painted them out of reverence and fellowship, with a deep compassion for them, knowing themselves to be sharers of the same kingdom. . . . They filled the walls with them because their minds were filled with them.

Ever conscious of the vital connection between all art, Payne adds:

Just as Fra Angelico painted the walls of the cells of the Convent of San Marco with illustrations from the life of Christ, so the painters in these caves drew the outlines of the great themes of life and death. The wounded bison, dying in agony, was a subject for profound meditation, for the death of a powerful animal was an illustration of death's magnitude; and the procession of living animals was an affirmation of life.

The analogy seems entirely valid when one considers especially sensitive prehistoric images such as the remarkable painting of *Two Reindeer* from the Font-de-Gaume cave in France, in which a male tenderly nuzzles a crouching, apparently wounded female.

The First Civilizations

Payne's emphasis on the universality of art does not blind him to significant differences between cultures, however. Identifying the core values of each culture, he then shows how those values are reflected in its art. And he never commits the error, now endemic among "politically correct" art historians and critics, of judging art from other times and places in terms of a narrowly framed modern perspective. Instead, he reconstructs the original cultural context, beginning with the physical environment, which in pre-industrial societies had an especially powerful influence on culture. Consider this passage in relation to the ancient Egyptian world:

In the calm light of Egypt, where the never failing sun rises every day like a glory and the Nile rises every year like a dependable blessing, the earth and the sky proclaim a sense of order. In that sheltered world ringed round and protected by mountain barriers, nature seems to have restrained herself in order to provide a gifted people with the fruits of the earth, an unhindered livelihood.

For the ancient Egyptian, Payne explains, heaven was earth. Thus the paintings and reliefs adorning the Old Kingdom tombs depict scenes from daily life with amazing vivacity and delight so that the deceased could "contemplate his life on earth, seeing himself hunting and fishing or attending the festivals of the seasons in the company of his wife and children." Those who think of Pharaonic Egypt as a harshly despotic realm, in which all but the king lived in wretched oppression and morbid fear, may be astonished at the values Payne discerns in its art.

> The Egyptian artists were the first to explore the world of human relationships. They learned very early to depict husband, wife, and children together and to suggest the devotion they had for one another. . . . They invested the ordinary lives of ordinary mortals with a grave dignity, [as] in no other ancient civilization. . . . In the long noonday of Egypt this was perhaps the greatest triumph of all.

Equally satisfying is Payne's discussion of individual works, such as the wondrous portrait bust of Nefertiti, wife and queen of the great reformer Akhenaton. In that work, Payne notes, the artist expressed not only "the self-consciousness inevitable in any-one so beautiful" but also "the changing, flickering pattern of her thoughts, so that we are aware of an intense inner life, of subtle and delicate meditations."

By striking contrast with the predominantly tranquil millennia of ancient Egyptian culture, Payne renders a forbidding picture of Mesopotamia. Explaining that, "unlike the Nile, the Tigris and Euphrates are unpredictable in their rise and fall," he continues:

> Harvests were uncertain, and wars were frequent, for those who lacked crops would fight those who brought in a good harvest. In these conditions of uncertainty, depending on the vagaries of nature, the Mesopotamians quite naturally came to possess an attitude toward life and the gods radically different from that of the Egyptians.

The result was, in Payne's words, "a pitiless empire [that] produced a pitiless art"—an epigram aptly characterizing Assyria, if not the earlier Sumerian civilization. But even in so brutal a culture as the Assyrian, in which "the faces of all men are alike," Payne finds a point of sympathy in its art—an affirmation of the value of life, amidst the

scenes of battle and carnage. So I, too, discovered a couple of years ago. Rushing through the ground-floor rooms at the British Museum on my way to see the Parthenon sculptures before closing time, I was stopped in my tracks by a series of reliefs from Assurbanipal's palace in Nineveh. As Payne observes, in these royal hunting scenes, the animals are far more compelling than the hunters. A poignant intensity quickens the depictions of

> wounded lions and lionesses as the blood pours out of them and they roar with pain, their muscles tense in the agony of dying, as they wearily attempt to lift their heads from the dust or turn to observe the heavy arrows in their flesh, snapping at them, for they would bite them off if they could. A wounded lioness with paralyzed hind legs tries to drag herself along by the forelegs, and every curve of the sagging back and belly, and every tendon of the forelegs suggests the awareness of death.

Through the agony of that creature's death, the artist reminds us of the wonder and power of life.

Ancient Greece and Italy

For lovers of Greek antiquity, Robert Payne offers particular delights, in an excellent chapter in *The World of Art*, as well as in *The Splendor of Greece*. "The traveler visiting Greece for the first time is shocked by the barrenness of the land," the latter volume begins. "The deserts of rock are everywhere." It was not from the land that the Greeks drew their special sustenance and inspiration, Payne continues, but rather from the

> naked light—a light unlike any other light on the surface of the earth. It is a light that can be drunk and tasted, full of ripeness; light that filters through flesh and marble; light that is almost palpable. . . . It is a living thing: so living that the Greeks gave it the physical presence of a god and called it Phoebus Apollo, the god of the divine radiance.

For the Greeks,

> The whole body of Apollo poured across the sky, intensely virile, flashing with a million points of light, healing everything it touched, germinating the seeds and defying the powers of darkness.

"The ancient Greeks had no illusions about the depth of darkness in the human soul," Payne hastens to add. "Yet they were essentially creatures of light, believing that the lucidity of the mind could put an end to the darkness of the soul."

Following the Greek victory over the Persians in 479 BCE, the triumph of light over darkness found its supreme expression in art. For the next fifty years, Payne writes,

> The Greeks lived, thought, built temples, sculpted and painted as though they were the natural children of the gods. . . . In the space of two generations, . . . they set out to conquer the furthermost regions of the human spirit, and they progressed so far that all the works of art and literature composed since that time are hardly more than footnotes to the vast page they wrote.

Such an encomium will not endear Payne to today's "multiculturalists," eager to discredit Western civilization. Yet years before their politicized viewpoint began to gain a stranglehold on thought, Payne himself was oddly ambivalent about certain aspects of Western culture. Regarding the great bronze figure of Poseidon, retrieved from the sea off Cape Artemision, he notes in *The Splendor of Greece*: "It seems to be one of the fatal flaws of Western consciousness that it can only represent power in terms of murderers and their victims"—a baffling indictment when one considers that the Poseidon figure celebrated a just victory over foreign invaders. In *The World of Art*, written a decade later, however, Payne more appropriately singles out the Poseidon figure as the epitome of the heroic spirit of the Golden Age.

> No more dramatic representation of human majesty has ever been conceived. . . . There is about that naked bearded figure, so calm in his divine savagery, an authority surpassing any surviving statue of this time, or of any time. Poseidon is at once a man of transcendent beauty and a divinity with human features and a human body, and we shall not see his like again until Michelangelo carved his *David* for the Florentines.

Also eloquent is Payne's account of the Parthenon sculptures— from the Panathenaic procession depicted on the frieze (a work that "preserves the character of an entire people in the years of their tri-

umph") to the monumental equine heads at the angles of the east pediment: the horse of the sun god Helios, "youthful and arrogant, rearing his arched neck"; the moon god's steed, "sink[ing] down in exhaustion and fatigue." Implicitly re-affirming the principle of the *selective* re-creation of reality involved in all art, Payne notes:

> These horses are not rendered naturalistically: the natural forms have been rethought and reshaped to present them in powerful well-defined masses, with gaping nostrils and bulging eyes; they are the huge elemental horses which gallop across the fields of heaven.

Payne remarks in *The Splendor of Greece* that the period commonly known as the "classical age" was, rather, a "fiercely romantic time," whose apparent calm, order, and self-restraint in fact contained intense passion and enormous energy. Passion and energy were more manifest in the later, Hellenistic period, of course, in work such as the splendidly animated *Victory of Samothrace*. In its original setting, on the prow of a stone ship surrounded by water, Payne informs us in *The World of Art*, the great wings would have reflected the rippling light of the water, thus increasing the illusion of movement. In this magnificent work, he sees "the purest image yet conceived of divine grace hurrying to earth to offer her protection and blessing to men."

When Payne shifts his attention from Greece to Italy; it is Etruscan rather than Roman culture that elicits his particular sympathy. Etruscan art gives him the sense "of having lived among a people who were content with life and in love with vigorous joys." Apparently intended to warm the dead with memories of life, the frescoed burial chambers simulated the form of an Etruscan house, Payne observes, each reflecting its owner's individuality, for "the Etruscans rejoiced in their differences and took their separate personalities with them to the grave." (Payne points out, in the sort of scholarly gloss that consistently illuminates his work, that our word *personality* itself derives from the Etruscan word *phersu*, meaning "mask.") Etruscan frescoes and life-size terra-cotta sarcophagal figures depicted husband and wife reclining together on their funerary couch, with evident "tenderness in [their] half-formed embrace and lingering smiles." No other culture, Payne notes, has so richly documented conjugal affection.

China and Japan

Early in life, Robert Payne was captivated by Asian culture. From the age of seven (when he wrote a story called "Adventures of Sylvia, Queen of China, Princess of Denmark") to the end of his life, the theme that occupied him was, he once said, "the marriage of East and West." And it was his books on China—beginning with his journal *Forever China* (1945) and the novel *Torrents of Spring* (1946)—that gained him his earliest and most lasting reputation. In *The World of Art*, he writes of the profound effect that "the misty gorges, the terraced fields, the tiger-headed rivers, and the haunted lakes" had upon Chinese art. Yet, the peculiar genius of that culture's landscape tradition is not captured nearly so well in his chapter on China as in the contrasts he draws with Japanese art.

Payne brilliantly conveys the essence of the Japanese artistic imagination—an imagination wrought in an unstable natural environment. "A secluded village in the heart of the mountains might vanish overnight in an earthquake," he explains, "or be torn to matchwood in a hurricane or be burnt to the ground if a thunderbolt fired the surrounding forests." Citing a characteristically Japanese sentiment—"the world is fleeting; it can never return"—Payne opposes it to the Chinese spirit: "The world is here, and endures forever."

But unlike other peoples obsessed with the impermanence of life, Payne suggests, the Japanese *rejoice* in it.

> Throughout their lives they have an awareness of the pathos of existence, that trembling quality of the mind which they call *mono no aware*. Life is forfeit; it has gone almost as soon as it occurs; and what remains is the memory of a sudden splendor. Instead of a monumental art the Japanese concentrated on producing an art that was fragile, restless, exquisitely refined, explosive.

Also illuminating is the contrast Payne draws between the worlds of Japan's greatest printmakers, Hiroshige and Hokusai: "one gentle and compassionate, the other strenuous and almost merciless in [his] judgment on mankind." Payne continues: "A famous print by Hokusai shows the Chinese poet Tu Fu departing into exile in the midst of a snowstorm. A tree laden with frost hangs over him, the narrow road is sharp with stones, and the snow falls like bullets." Hiroshige,

on the other hand, represented "a gentler and more indulgent tradition which sought to render landscape with luminous intensity and brooding affection." In his winter scenes, "the snow enfolds the earth like a garment," and the countryside is "transformed into a foretaste of paradise." In Hiroshige, Payne concludes, "it was as though it were given to a single man to express all the graces of Japanese feudal society and none of its violence."

The Italian Renaissance

Sensitive as Payne is to the influence of geography and climate on culture, he is no less keenly aware that a people can transcend the limitations of circumstance through ingenuity and industry. Setting the stage for the Florentine Renaissance, he writes:

> A visitor to Florence about A.D. 1260 would have found a small walled city living luxuriously but without visible means of support. The soil was stony, patched with scrub and occasional cypresses and clumps of pine. Some of the hill slopes supported vines and olives, but the grudging soil demanded almost more labor than it was worth. . . . Having no resources of their own, the Florentines made a virtue of necessity. They became entrepreneurs on a massive scale, traders in far countries, experts in rates of exchange, bankers to everyone. . . .

During the three centuries between the birth of Giotto and the death of Michelangelo, Payne observes, the Florentines were inspired by a passion to excel and by their sense of human freedom, illuminated and fed by the pure, clear, steady light of the Tuscan hills.

Regarding Giotto's incomparable fresco cycle for the Arena Chapel in Padua—a series of unprecedented compositions "alive with emotion"—Payne comments:

> For the first time in European painting we become aware of the weight of human bodies and the air in their lungs, and we almost hear their voices. . . . At the same time Giotto's sense of the dignity and monumentality of the human form permits him to endow his figures with such power that we do not question their divinity.
>
> A new element has entered painting—intelligence. In Giotto's work the mind and the body are in movement.

Giotto's fellow Florentine, Michelangelo, is the only artist to whom Payne devotes an entire chapter. This "elemental and titanic" sculptor, painter, architect, and poet was called by his contemporaries *divino*—a title that, Payne points out, had been previously reserved for emperors.

Even when Michelangelo borrowed a timeworn compositional convention of Flemish art—the *Pietà*—he thoroughly transformed it. In place of the tearful, bloody agony of the earlier treatments, Payne notes, he brought splendor and dignity to the subject. "The dead Christ resembles a Greek warrior fallen in battle and the Virgin might be Athena mourning for her lost son"—tenderly and with compassion.

Whereas Michelangelo's *Pietà* is an expression of "the ultimate blessedness, the certainty of divine Love," Payne observes, his *David* embodies "a pagan reliance on strength, cunning, and intelligence."

> He stands there like a god who has descended to earth in order to chastise the mighty and to tear kings from their thrones. His brows are knit, his eyes are watchful, the youthful body stands in absolute composure, conscious of its own strength, its own power to accomplish whatever the intelligence demands. Authority and self-reliance have become so habitual that he scarcely knows they exist, and he wears his flesh with the same divine negligence. . . . In his arrogance and splendor, superbly defiant, celebrating his own humanity, beauty, and magnificence [he] is more Apollo than David, and belongs more to Greece than to the Renaissance. Here Michelangelo stated once and for all, in a manner he would never surpass, the ideal inhabitant of the visionary earth.

While "the very air and atmosphere of Florence call for a sculptor to fill all the empty spaces," Payne aptly observes, Venice demands paintings. He likens the Venice of the Renaissance to "an open jewel box blazing with color. . . . Color is the sovereign lord of Venice, and the painters are her priests, her servants, and her worshipers."

As Payne makes clear, the Venetian school encompassed artists radically different from each other in temperament and output—from Giovanni Bellini, who for three generations painted Madonnas and Pietàs "with an enthralled tenderness" and an unfailing imagination, to Tintoretto, who depicted "the rush and fury of things, the brilliant revelation of sudden colors, the confrontation of God and man."

There was also the elusive Giorgione, who created "an enchanted golden age" and who moved painting into a secular realm "of luminous forms, imaginary mythologies and dreamlike images." In works such as his *Sleeping Venus*, "the flesh of a woman was an object of veneration, and the earth was bathed in the divine light of the sun."

Payne contrasts Giorgione's pagan innocence with the worldly sophistication of his pupil Titian. Unlike Giorgione, who created a visionary world, Titian remained at home in this world, Profound in his study of portraiture, he also "reveled in sumptuousness and splendor, and all his works convey his electric excitement in portraying the flesh and the lineaments of the human face."

"While the Florentines always resembled youths and were in love with youth," Payne concludes, "the Venetians were mature men in love with maturity," who "achieved an astonishing plenitude in their art."

Flanders and Holland

"The great periods of art nearly always come when peace is secure, when the barriers of trade are thrown down, and when there are great accumulations of wealth," Payne notes. "[Art] flourishes under gifted and wealthy patrons, and languishes under tyrants. It withers away if it cannot breathe the air of the outside world, and it is the first victim of wars."

So the golden age of Flemish art began in the fifteenth-century Duchy of Burgundy, ruled over by Philip the Good (1396–1467)—"a man of exquisite taste and formidable knowledge of the arts." Payne's evocation of the Flemish bourgeoisie clearly reflects the sumptuous paintings of the period.

> They enjoyed great processions and festivities, . . . but they especially enjoyed their own intimate daily lives. . . . In small rooms cramped with possessions, the narrow windows open to let in the sound of the cobbled streets, their families gathered round them, rich food on the table, and fine linen spread below the silver drinking vessels, these burghers seem to have known a contentment we can only envy. Their days were full and they died peacefully.

But, Payne emphasizes, these "eagerly acquisitive" burghers were also deeply religious. For them, earthly beauty and domestic comforts

were but a manifestation and reflection of the ultimate splendor of Heaven. Thus Payne likens the vision of the great early Netherlandish painter Jan van Eyck, in his masterwork the *Ghent Altarpiece*, to the vision that inspired the creation of the Gothic cathedrals: both were informed by the conviction that "the splendor and beauty of God could be conveyed through rich adornments, brilliant vestments, the fire of precious jewels." And van Eyck's image of a "plump and mild-eyed" Lamb of God is

> like an image in a dream, at once beyond belief and totally credible in that mysterious landscape of forests and rosebushes, churches and strangely shaped rocks. Toward this Lamb, as though propelled by some force greater than themselves, come the rich and the humble, the knights of Christ and the holy virgins; and in their movement, and in the way they hold themselves, there is a kind of quiet relish, as though they knew themselves to be blessed.

How removed from the pious serenity and innocence of Jan van Eyck's world is Payne's account of Peter Paul Rubens, who epitomized the mature phase of Flemish painting two centuries later. "Painter, art collector, secret agent, ambassador to the courts of the most powerful kings in Europe, scholar, linguist," Rubens "seemed to be living six lives at once." He was "robust, sensual, addicted to all the pleasures of life," and yet was "capable of fantastic powers of concentration, so that on one occasion he completed a huge altarpiece in six days." In Payne's view, Rubens was unrivaled in communicating "the excitement of the flesh." Even in his religious paintings his sensuality is ever-present—as in *The Fall of the Rebel Angels*, in which he shows us "a cascade of tumbling naked bodies plunging helter-skelter into the flaming pits of hell."

By way of introducing the art of Holland's golden age, which began with the Dutch liberation from Spanish rule in 1609, Payne roots its bourgeois sobriety in the character of the land and its people. "Holland was a land at the mercy of the sea, and every Dutchman knew that a man must live cautiously if he was to safeguard the land reclaimed from the sea." Unlike the Catholic Flemings—who reveled in festivals at which they "joyfully paraded the sins of the flesh under the watchful eyes of the priests"—the Dutch were sober Calvinists.

The influence of the more flamboyant Flemish art, especially that of Rubens, is apparent in the early work of Frans Hals, the first of the great Dutch painters, whose "slashing brushstroke . . . conveys a finger or the curve of a cheek in a single throw." At close range, Payne points out, his work seems to disintegrate into "meaningless ridges and troughs of color exactly like the paintings of the Impressionists, who admired and imitated him." But viewers who consider Hals shallow, Payne cautions, do not fully appreciate his ability to depict, with "staggering intensity" and "lusty warmheartedness," the broad gamut of the Dutch people—from burgomasters and preachers to fishwives, strolling players, and devout old women.

Born just a quarter-century after Hals, Rembrandt carried the study of character to far more profound depths, with an "unerring sense of nobility." By the age of fourteen, Payne reports, Rembrandt had resolved to be a painter, and within a few years the earmarks of his art were evident: "an insistence on character, a love of darkness and chiaroscuro, a delight in rich embroidered fabrics to offset the rich embroidery of the human face." Whereas Michelangelo "saw heroic form in the naked body," Payne observes, Rembrandt found it "in the wrinkles of an aging face." One sixth of Rembrandt's entire output consisted of portraits of family members and of himself. In the threescore self-portraits he produced, it was, Payne stresses, the image of his inner life that he sought.

Always attentive to the individual life behind the work of art, Payne often enriches *The World of Art* with biographical details about the artists that lend their work added poignancy. So we are reminded of Rembrandt's life, with its unremitting series of tragic losses—from the death of his first wife, Saskia, after only eight years of marriage and the loss of three of their four children in infancy; to the early death of his second wife, Hendrickje, leaving behind a daughter; and finally, the loss of his beloved son, Titus, at the age of twenty-seven. Rembrandt died a year later, "working to the very end," Payne adds. "An unfinished canvas stood on the easel: it was a picture of an old bearded man with a child in his arms."

The art of that other great Dutchman Vermeer was, like Rembrandt's, "intensely personal." It consisted mainly of paintings of his wife and daughters, with an occasional self-portrait. On the vex-

ing question of why Vermeer's recognition as a master was so long delayed, Payne suggests that "he was not so much an innovator as an artist who, coming at the end of a long tradition, concentrates all its energies in his own person." Vermeer, in truth,

> did not invent the silence and clarity we associate with his name. To a quite extraordinary degree he deepened the silence and gave to clarity a hitherto unknown brilliance.

The Eighteenth Century

Surprisingly, one of the most absorbing chapters in Payne's *World of Art* covers the Age of Enlightenment, a period far less distinguished for its painting and sculpture than for its philosophy and science. It was a troubled time, Payne explains. Traditional mores were breaking down as the industrial revolution advanced and the Church's influence waned. And tyranny was rampant, availing itself of the latest instruments of war. While philosophy, science, and technology had challenged the old order, a humane new order had not yet been forged. This tumultuous era gave rise to artistic personalities as different as Watteau, Chardin, Piranesi, and Goya.

Antoine Watteau, a master draftsman and brilliant technician, painted elaborate courtly *fêtes*, set in the pleasure gardens of the rich—portraying weary "masqueraders in an indifferent world, where everything is transient." His art is the fragile, poignant expression of a sensitive and vulnerable spirit.

Although similar to Watteau in temperament and in his mastery of painting, Payne tells us, Jean-Baptiste Siméon Chardin gave form to a very different vision of world.

> He painted only the things he knew, and he had not the slightest interest in the world of the court, or of fashion. . . . He would paint a kitchen and put his wife or a maidservant in it, and this was enough. Paradise was a pomegranate on an earthenware plate. . . . Jugs and roughhewn cups and all the bare necessities of life reigned in perfect silence, every object in harmony with every other object.

Chardin's work was highly valued only by other artists, Payne points out. Yet by his hand a loaf of bread or a jug of wine gained "more true dignity than anything that existed in the palace at Versailles."

The Venetian artist Giovanni Battista Piranesi, Chardin's close contemporary, seems, as contrasted by Payne, to belong to another world entirely, a world of "immense crumbling ruins, palaces and triumphal archways," which he envisioned in countless engravings of Roman antiquities and vast, empty prison scenes—all the product of the same desperate, intense vision.

Of Francisco Goya, who was active well into the nineteenth century, Payne relates that much of his work depicted "the night-mare of a world going mad." And yet, even when Goya was himself on the brink of insanity, he continued to paint, as Payne notes, superb portraits which are entirely sane—"sober, earthbound, filled with human character and affection." Payne thereby calls atten-tion to an essential aspect of this artist that is neglected by most twentieth-century interpreters, who are intent on viewing Goya's work as a seminal expression of the modern spirit of alienation and despair. That distorted view has been substantially corrected by Priscilla Muller's scholarly monograph *Goya's 'Black' Paintings: Truth and Reason in Light and Liberty* (1984) and by the exhibition and catalog *Goya and the Spirit of Enlightenment* (Metropolitan Museum of Art, 1989), both of which have amply documented Goya's humanist aspirations and the cautionary, constructive intent behind his most horrifying images.

Nineteenth and Twentieth Centuries

Though far from comprehensive, and at times uneven, Payne's account of successive upheavals in the world of art from the Impres-sionist movement in the second half of the nineteenth century to the brutish canvases of Jean Dubuffet in the mid-twentieth offers telling observations. For example, after praising the Impressionists for "re-awakening the eye" by their emphasis on the direct study of nature, Payne then remarks: "If they . . . failed to produce a single artist who could rank with Michelangelo or Rembrandt, this was because they were concerned with the appearance of things, not with the dark depths." (The pessimism implicit in that last phrase aside, Impressionist work, however appealing, often does lack psychological and philosophic depth.) In contrast with the Impressionists, Payne

observes, Gauguin attempted to plumb the "ancient springs" of man-kind's being. His exotic, visionary paintings exude "primitive wonder and a [profound] sense of the wholeness of the earth."

As for Cézanne, he strove to create, in Payne's words, a "sturdy, incontrovertible world of solid forms arranged in space in such a way that their solidity was maintained. . . . He was obsessed with the enduring and the eternal, and he had the Provençal peasant's passion for the land, the only enduring thing under the sun." Most of his paintings were landscapes or still lifes; and his occasional portraits treated the human face "as though it were a roughhewn rock quarry, full of sharp splintered planes."

Whereas Cézanne aimed to create "constructions after nature," Payne pointedly relates, Picasso wrote: "For me, a picture is a sum of destructions." *Cubism* was therefore a misleading term, Payne argues.

> The Cubists were not attempting to rearrange their figures into elementary forms; they were attempting a revolution which would drastically change the nature of painting itself by means of "a sum of destructions."

Nevertheless, Payne makes the mistake of echoing the conventional modernist claim that the destructive new forms, evident in music and literature as well as in painting and sculpture, were inevitable reflections of the "growing disorder of society." Such a claim is belied by the work of at least one prominent modernist—Matisse—whose work projected, over a long career (recently documented in a vast retrospective at the Museum of Modem Art), a sensuous, childlike joy of life. It is also belied by the output of countless painters and sculptors working in traditional forms throughout the twentieth century.

As Payne notes, Matisse detested Picasso's *Demoiselles d'Avignon* (the savagely cubistic rendering of five nudes in a brothel), which he foresaw would retard the development of painting. Yet Payne does not seem to recognize that the great gulf between Picasso and Matisse is not merely formal or stylistic but stems, more fundamentally, from their disparate attitudes toward life.

Acknowledging that Picasso's *Demoiselles d'Avignon* began a revolution in painting that has produced work "increasingly remote from ordinary human preoccupations," Payne nonetheless heartily

praises modernists such as Miró. Instead of faulting their abstract works for being divorced from human concerns, he admires their "new worlds . . . of non-representational forms."

To Payne's credit, however, he was extremely critical of the dominant trends in painting and sculpture following World War II. He excoriates Dubuffet for "pronouncing a sentence of death on all human values," and he ironically observes that "Jackson Pollock would simply pour paint on immense stretches of canvas . . . and the finished painting would solemnly be presented to collectors as a work of art." By thus suggesting that Pollock's work is not art, Payne separated himself from the vast majority of art historians and critics today. If he did not fully understand the kinship between the modernists he admired and Pollock, he nonetheless saw that something fundamentally human was lost in the "piling up of abstraction upon abstraction."

Equally important, Payne rejected the nihilism at the very root of modernism. "The visitor to museums of modern art," he lamented, "sees paintings and sculptures made in derision and hatred of men, gallery upon gallery filled with a fierce, intoxicated calligraphy designed to remind men of their helplessness." It is not at all surprising that such statements led one writer, reviewing *The World of Art* for the monthly *Art in America*, to call it a "dangerous commodity."

In concluding his survey, Robert Payne reminded readers that, contrary to the "all-encompassing doom" purveyed by modern art museums, art has long proclaimed "the beauty and divinity of man, the subtlety of his mind, the joy of his handiwork." The nihilism of modernism, Payne suggested, is but a temporary aberration, inimical to human nature. His conclusion, albeit entirely intuitive, is essentially correct, of course. Indeed, it is remarkable that, though Payne lacked a consistent philosophic perspective, his intuition and innate sensitivity so often led him straight to the fundamental truths about art.

Regrettably, most of Robert Payne's work is out of print. But perhaps this article will help to prompt a reprinting of *The World of Art* and

The Splendor of Greece. (*The World of Art,* in particular, might serve as an enriching supplementary text for any historical survey of art.) Meanwhile, readers may be lucky enough to find these titles through a library or used-book dealer.

Valentin Who?
A Neglected French Master

Valentin who? Valentin de Boulogne (1591–1632), that's who! But I must confess that I had never heard of this masterly painter before the landmark exhibition now at the Metropolitan Museum, though I've been studying art history for more than half a century.[1] Valentin achieved no small fame in his lifetime, however. Ranked high among the followers of Caravaggio (1571–1610), he also inspired notable nineteenth-century realists such as Courbet and Manet. Yet, astonishingly and inexplicably, *Valentin de Boulogne: Beyond Caravaggio* is the first monographic exhibition ever devoted to him. Co-curated by the Met's Keith Christiansen, John Pope-Hennessy Chairman of the Department of European Paintings, and Annick Lemoine, lecturer in art history at the University of Rennes, it at last gives Valentin his well-merited due.

The son of a painter and glazier, Valentin was born near Paris in 1591 and by 1614 had moved to Rome—then Europe's cultural capital—where he remained till the end of his short life. Like many of the ambitious painters who flocked to that city in the early seventeenth century, he emulated the style of Caravaggio. He not only adopted Caravaggio's earthy naturalism; he also employed his method of painting directly from live models posed in the studio, thus dispensing with the elaborate preparatory drawings used by Renaissance masters.[2]

For Piero's Sake, October 19, 2016.

Transcending Precedents

Valentin left his own distinctive stamp on Caravaggesque painting, however. His work is marked by psychological insight and subtlety rare in Caravaggio. His *Judith and Holofernes*, for example, is far more believable than Caravaggio's version of the same subject. Departing somewhat from the biblical narrative—which describes Judith as a "widow" (suggesting some maturity)—Valentin's Judith has an almost childlike face. In sharp contrast with Caravaggio's Judith, she does not recoil from the horrific deed, but proceeds with all the tight-lipped, cold-blooded determination that would have been required to carry it out. And the clandestine drama of the scene is heightened by a starker composition, subtly illuminated in front of a cavernous darkness—not diminished as in Caravaggio by a gratuitous swath of red drapery. It is one of the most compelling pictures in the Met's show.

So, too, Valentin's *Cardsharps*, cloaked in deep shadow, have a far more sinister aspect than those in Caravaggio's more famous treatment, which is colorful but superficial. Especially chilling in the Valentin image is the predatory gaze of the cheat eyeing his pathetic victim—who clutches his cards to himself, oblivious of the evildoer's cross-eyed partner in crime lurking behind him.

A distinctive aspect of Valentin's approach to religious subject matter was his tendency to focus on a rarely depicted moment in the narrative. For the story of Susannah and the Elders from the Book of Daniel, for example, he eschewed representing Susannah bathing alone in her garden, ogled by the hidden elders. That scene has served many an artist as a welcome pretext for depicting a sensuous female nude. But Valentin chose instead to represent, in *The Innocence of Susannah*, a later moment, in which the young Daniel points the finger of judgment at the guilty elders for bearing false witness. While one of them pulls at the garment of their fully clothed victim, he is apprehended by an officer, and she turns toward the viewer, arms folded across her bosom in a gesture of self-protecting modesty. To her left, in the lower right corner of the painting, stand two small children. One gazes out at the viewer with an anxious look, while the other tugs at her robe, as if to ask,

"Mommy, what are those men doing to you?" It is a poignant touch unlike anything I know of in Caravaggio.

Equally remarkable, Valentin's *Samson* (the poster image for the exhibition) shows the biblical hero neither in one of his prodigious feats of prowess nor in the act of being unmanned by Delilah— the narrative moments most often chosen by artists. He is instead depicted alone, at rest. He is leaning on the jawbone of an ass, the crudely improvised weapon with which he has slain a multitude of Philistines. Wide-eyed and agape, he seems to be reflecting, not on his victory but on the magnitude of the havoc he has wrought. Is it perhaps of further philosophic import that Valentin has rendered Samson in his own likeness?

Another remarkable painting is Valentin's *Christ and the Adulteress*, illustrating a well-known passage from the gospel of John. As Jesus is intent on writing a lesson on the ground for his disciples, he is interrupted by a group of scribes and Pharisees (Valentin represents them as figures of authority in seventeenth-century armor). Thrusting forward a woman guilty of adultery, for whom Mosaic law prescribed punishment by stoning, they demand to know what judgment Jesus would render. On reflection, he responds that whoever is without sin should cast the first stone. Valentin's intensely personal moral focus is clear. Electrifying highlights create a riveting connection between Christ's stern gaze (in the biblical account, he later instructs the adulteress to "sin no more") and the woman, who hangs her head in shame, her half-bared bosom tellingly contrasting with her accusers' armor.

In Valentin's hands, *The Last Supper*, too, becomes an extraordinarily intimate event—so very different from Leonardo's formal scene, which he would have known from engravings. Moreover, its ingenious composition seems to leave an open place at the table for the viewer. One could easily imagine taking a seat at it, flanked by the two disciples whose back is toward us. As Jesus appears to announce "one of you will betray me," Judas (on the left) guiltily turns away, clutching his bag of silver behind his back, the evidence of his betrayal, while the disciple on the right bends to pick something off the floor, apparently missing the moment of intense drama reflected on the other disciples' faces.

Valentin's ability to make the viewer feel more like a participant than a mere spectator was evident even in what was probably one of his early works, *The Return of the Prodigal Son*. The broad sweep of the venerable patriarch's compassionate embrace (which spans two thirds of the image) seems to encompass the viewer along with the prodigal, who kneels contritely before his father.

Such works are yet another reminder that even the most time-worn subjects can be infused with new life by a talented artist.

Like Caravaggio, Valentin knew the rowdy taverns and bawdy night life of Rome well, and depicted aspects of that life in his paintings. Rome in the seventeenth century scarcely lived up to its epithet of "holy city." It was instead a seething den of crime, violence, and debauchery, from which artists not only drew their secular subjects but also picked the live models for their sacred images. As Caravaggio's biography attests, artists often became embroiled in its turbulent events. Most of what we know about them is derived from police reports and court proceedings—as vividly documented in Andrew Graham-Dixon's *Caravaggio: A Life Sacred and Profane*, for example. And scholars have only begun to plumb the depths of such records to gain a fuller picture of the period. One fact that has emerged is the existence of a lively market of private art patrons—though art historians for-merly tended to regard Counter-Reformation painting as driven primarily by the church. The curators even cite paintings being used for money laundering by a notorious diamond thief who doubled as a dealer!

Valentin's numerous scenes of taverns and music-making are tinged with a profound sense of melancholy that transcends the crass vulgarity of Roman low life, however, and suggests, in the curators' words, "a meditation on life itself—its deceptions and its transient pleasures"—as well as its uncertainties, I might add. Especially haunting is *Concert with a Bas-Relief*. Notably, it features a sad-eyed young boy at its center, as does Valentin's equally melancholic *The Four Ages of Man*.

In this connection, the curators quote an apt passage from the sixteenth-century philosopher-essayist Michel de Montaigne, relat-ing the following experience:

I am not melancholic, though much given to daydreaming. . . .
Once, while gaming and in the company of ladies, I was suspected
[of] being preoccupied with some ill-digested jealousy or with my
player's luck. But in truth, I was meditating. . . . Only a few days
before, as [a friend] was returning from just such a party, his head
filled, like mine, with nonsense, women, and merriment, he had
been surprised by fever and death.

Montaigne unwittingly presaged Valentin's own death a few decades
later. In the summer of 1632, after a night of drunken carousing, the
painter fell into a fountain, subsequently developed a fever, and died,
at the age of only forty-one.

This exhibition was a once-in-a-lifetime chance to survey at first
hand and in depth this stellar painter's work, culled from diverse
public and private collections here and abroad. Some of the paint-
ings were never before loaned. What I have presented here are but a
few of the show's highlights. The exhibition numbered forty-five of
Valentin's sixty extant works, many of them on loan from the Louvre,
where it opened in February 2017. If you missed the exhibition, you
might want to console yourself with a copy of the comprehensive
catalogue, *Valentin de Boulogne: Beyond Caravaggio*.

Victorian Treasures
Paintings from the McCormick
Collection

The Victorian era, spanning the seven decades from 1837 (when Victoria ascended the throne) into the first decade of the twentieth century, was a period of enormous activity in the arts, as in commerce and industry. Artistic productivity was, in fact, fueled by the patronage and interest of the burgeoning middle class, whose disposable income enabled them to indulge a craving for beauty in everything from their simple household objects to their heavy machinery.

Encompassed in the prodigious output of Victorian art was an unprecedented diversity of genres, subject matter, and themes. To appreciate the extent of the diversity in painting, one need only glance at the contents of a survey such as Jeremy Maas's *Victorian Painters*—with its generously illustrated chapters devoted to historical painting, landscape, seascape, nude and still life, portrait, genre, animal, and fairy painting, among others. As for the specific subject matter of painting, it expanded, like the British Empire, to touch on much of the known world, with all its cultural riches. Subjects were drawn from every conceivable sphere—history, religion, mythology, literature, fantasy, and contemporary life. Not surprisingly, with the shift in patronage from the aristocracy to the growing middle class, representations of all aspects of daily life increased in popularity as the century wore on.

Aristos, May 1990.

Styles likewise covered a broad gamut: from J.M.W. Turner's freely painted epic visions of nature to the fastidious realism of the first "Pre-Raphaelites," who emulated Italian painters of the early fifteenth century; to the neoclassicism of Frederick Leighton and Edward John Poynter, inspired by the monumental style of the Italian High Renaissance; to the intimate, Dutch-inspired style of genre paintings produced by many artists of the day; to the aestheticism of Albert Moore, who achieved an extraordinary fusion of classicism with a delicacy of line and color learned from Japanese art.

The Modernist View

For much of the twentieth century, critics, scholars, and curators have tended to dismiss virtually the entire output of Victorian painting, in all its diversity, as unworthy of serious consideration. As the British scholar Quentin Bell noted in his *Victorian Artists* (published in 1967), it was, for many people, the "gloomiest and most unrewarding period in the history of British painting." In a 1979 *New York Times* article, Hilton Kramer (then chief art critic of the *Times*, later editor of *The New Criterion*) commented, with characteristic disdain, on a "new vogue for Victorian art." Noting that nineteenth-century British academic painting had been even more overlooked than the work of contemporary French academicians (which had at least been fleetingly studied, if only as evidence of what the avant-garde painters in France were viewed as pitted against), Kramer concluded, with no apparent regret, that because there had been no comparable avant-garde movement in England, "modern art historians have simply ignored the era." "It was so mired in the past," Kramer added, "that it hardly seemed to belong to the age of modernism, even as a negative force."

Thus we have had until very recently an astoundingly skewed history of nineteenth-century art, bypassing the painters who were best known and most popular in their day to focus on the artists now considered to have anticipated modernism by moving away from concrete subject matter toward formal abstraction. Further, the understanding of even these anticipatory artists has been less than complete. How many of the modernists who today praise Turner as

a precursor of the modern movement are aware, for example, that he was passionately promoted in his own day by none other than John Ruskin (the most influential critic of the Victorian age, and the frequent butt of the modernists' contempt)? —Or that Ruskin (whose five-volume study *Modern Painters* [1843–1860] was inspired by Turner), far from rejecting the free handling of form in Turner's late works, praised it for its profound and essential truth to Nature?

Finally, and perhaps most damaging, the twentieth-century modernist bias has conveyed the very false impression that innovation, originality, and seriousness of purpose were exclusive to the avant garde, and that "traditional" painters were a homogeneous group, all alike in their degree of conservatism and general lack of artistic depth, sincerity, and imagination. The fact is that artists faithful to Ruskin's prime dictum of "truth to Nature" sought and often found original modes of authentic expression, suited to their individual personalities and esthetic temperaments.

Criteria for Collecting

One of the problems confronting the would-be connoisseur of Victorian art—apart from the modernist bias that has cast a pall over the entire output—is the sheer volume of work that has survived. Inevitably, there is much inferior work (has any era managed to produce only great art?). Quality varies markedly, not only from artist to artist but, perhaps more strikingly, within the output of individual artists. Separating the dross from the true metal is no small challenge, requiring a fresh eye and an open mind, and the courage to value what others have dismissed as worthless.

When Suzanne and Edmund McCormick first encountered Victorian painting in the 1970s, they were on largely unfamiliar ground. Their first purchases were thus based solely on their immediate personal response to the works themselves. Later, after consultation with experienced collectors and dealers (Christopher Forbes, the principal private collector of Victorian art in the United States; Christopher Wood, the dealer who introduced the McCormicks to Victorian painting; and Jeremy Maas, the London dealer whose book on Victorian painters Edmund McCormick calls "superb"), a systematic plan

was devised for forming a truly representative collection—aiming to include at least one characteristic work by each of the well-known artists of the time. But the McCormicks' final criterion of selection has continued to be their own personal response to the work (as it must be for anyone who buys art primarily for pleasure, rather than for the social status or the investment potential motivating many collectors). Thus the collection they have assembled is not only an expression of its time and the many artistic personalities represented but a reflection of the McCormicks' own values and sensibilities as well. ("Good taste is essentially a moral quality," wrote Ruskin. "Tell me what you like and I'll tell you what you are.")

Highlights of the Collection

The McCormicks' first acquisition—*The Piano Tuner* by Frederick D. Hardy—clearly reveals some of the qualities which drew them to Victorian art. Richly painted (in warm reds and browns), it is the sort of charming genre scene, capturing the pleasures of domestic life, which middle-class Victorians were very fond of. It is handsomely conceived, focusing on the piano tuner's imposing figure: arched intently over the instrument, his form echoes the reverse curve of the raised piano lid and completes a sweeping central motif in the composition, which is anchored on the left by the woman intent on her sewing before a light-filled window and on the right by the two small children who observe the visitor in rapt curiosity. Through such formal elements of design and the quality of light suffusing the scene, *The Piano Tuner*, like the seventeenth-century Dutch interior scenes it recalls, conveys a sense of tranquil order and profound well-being, so that an ordinary event of everyday life assumes a dignity and importance beyond the moment.

Thomas Brooks's *Relenting* is an example of another very popular Victorian picture type—the narrative painting with a moral message. It skirts on the edge of melodrama, but is saved by the artist's restraint and fine feeling for gesture and facial expression. Just as the raw material of mere soap opera can be turned into absorbing and revealing drama in the hands of the best British actors and directors, the theme of mercy for an indigent widow is here raised above

the maudlin level of many lesser pictures of this type by the artist's sensitive handling. The widow is no abject beggar but a figure of quiet strength and some nobility. The landlord is no archvillain but a man capable of compassion. While his agent matter-of-factly inventories the apartment's modest contents, the landlord soberly reflects on the widow's silent plea. Though the captioned title (a line from Shakespeare's *The Winter's Tale*—such references to literary sources were common in Victorian art) was supplied by the painter, it is not essential to an appreciation of the painting.

For Edmund McCormick, as for the Victorian public that loved them, such narrative paintings are valued in part because they teach something of the life and morals of their time. Although modernist art has scorned all obvious "storytelling," there is no doubt that a genuine esthetic pleasure can be afforded by narrative painting. "To be learning something is the greatest of pleasures," wrote Aristotle in his *Poetics*, "not only to the philosopher but also to the rest of mankind"; thus part of the delight in looking at a painting can be that "one is at the same time learning—gathering the meaning of things." In any case, some of the greatest works in the entire history of painting have prominent narrative elements.

Ultimately, of course, the quality of any painting is determined not by the subject matter itself but by the way that material is interpreted and transformed by the artist. Frank Holl's *Convalescent* is a case in point. The illness—and often the death—of loved ones, especially children, was a preoccupation (some say an obsession) of nineteenth-century society. It is wholly understandable that artists of the time dwelt on such themes, given both the importance of the family (as historian Anthony Wohl has noted, "there were few aspects of their society the Victorians regarded with greater reverence than the home and family life within it") and the high rate of mortality, particularly in childhood. But through the boldness and simplicity of its conception, and the delicacy of its realization, Holl's *Convalescent* transcends the morbid aspect of the theme and avoids the cloying quality of many such paintings. Eliminating all external detail, save some scattered blossoms and an orange, and using a limited palette (the girl's chestnut hair and ivory skin are set against the subtly modulated white and grayish tints of her pillow and coverlet), Holl focused

in on the child, whose wide-eyed gaze and folded hands suggest she is patiently waiting for the return of health. It is a hauntingly tender image of fragile, innocent awareness.

Completely different in spirit is John Naish's brilliantly colored, delight-filled *Midsummer Fairies*. Though Naish was not on the McCormicks' list of artists targeted for acquisition, and the subject was not at all typical of his work, the McCormicks did well to acquire this rare but highly successful foray by Naish into the realm of fantasy. Fairy paintings were wildly popular in mid-nineteenth-century England, inspired not only by a widespread interest in spiritualism and the occult but by numerous literary sources. Coming "close to the centre of the Victorian subconscious," as Jeremy Maas suggests in a fascinating chapter on this distinctive genre, they afforded escape from mundane concerns and gave free play to the psyche's fantasies, including erotic impulses deemed unacceptable in other contexts.

Whereas some of the better-known fairy paintings have brooding, grotesque, ominous, and even sadistic aspects, Naish's fairy world is essentially luminous and playful, inhabited by lovely winged creatures who seem to have materialized out of a dazzling shaft of moonlight to cavort among geraniums and butterflies. Like many of the Victorian fantasy painters, Naish constructed his "unnatural" world out of elements derived from a meticulous, almost scientific, observation of nature. When such painting succeeds, as it does here, the imaginary realm of fantasy comes palpably, vibrantly, to life.

Naish's minutely observed realism reflects the wide influence the Pre-Raphaelite Brotherhood had on British artists just after mid-century. The early members of this movement sought in part to revitalize English painting by returning it to a closer imitation of nature. In contrast, the second, more intensely romanticizing phase of the Pre-Raphaelite movement is exemplified by Burne-Jones's breathtakingly ethereal *Head of an Angel*—which seems the perfect distillation of English beauty and typifies the rarefied style of this painter, who led the later Pre-Raphaelites. Burne-Jones's soft outlines and barely perceptible modeling, very different from the earlier Pre-Raphaelite style, are perfectly suited to the delicate features of his angel.

A special gem of this collection (and a particular favorite of the McCormicks') is Albert Moore's *An Embroidery*, a serenely elegant

image of timeless beauty. Epitomizing both the eclecticism and the idealism of late Victorian art, Moore succeeded—where many other artists failed—in integrating two essentially disparate stylistic traditions: those of Greek antiquity and Japanese art. His image of an ideal woman combines a Japanese subtlety of line and color (predominantly silvery tones with mauve-pink and brown accents) with a classical sense of form in her handsome head and her richly draped figure. Unlike similar works now in the Frick Collection (New York) by Moore's close friend and admirer J.M. Whistler, this panel by Moore is not of monumental dimensions, yet it achieves a monumental effect true to the Hellenistic spirit.

Enduring Qualities

Though it is impossible within the limited space available here to offer a detailed examination of each of the works owned by the McCormicks (the collection now totals forty-seven paintings and drawings), the few works discussed exemplify those qualities in Victorian art that—however different our mores and social attitudes—are still valid for our time. These are, significantly, the very qualities that modernist painters and critics have largely rejected: intelligibility; a sense of the order and beauty of the natural world; a concern for craftsmanship; and, above all, an interest in human experience and events, and in the emotions that surround them.*

* The Yale Center for British Art in New Haven, Connecticut, exhibited forty works from *The Edmund J. and Suzanne McCormick Collection* in 1984, and published an illustrated catalogue of the exhibition by Susan P. Casteras.

Anna Hyatt [Huntington]'s
Joan of Arc

An innovative program to restore New York City's deteriorating civic monuments has recently brought to public notice a number of works which ought never to have fallen into obscurity. Outstanding among them is a slightly larger-than-life equestrian statue of Joan of Arc, completed in 1915 by the American sculptor Anna Vaughn Hyatt (born in 1876, she married—and took the surname of—philanthropist Archer Milton Huntington in 1923; she died in 1973).

Inspired by the legend of the Maid of Orleans, Hyatt initiated a major figure of Joan on her own, independent of any commission or competition, in Paris in 1909—the year in which Joan was beatified, prior to her canonization in 1920. Hyatt was then a sculptor mainly of animal figures—for which she is still best known. In view of the social and artistic conventions of the day, it is remarkable that she undertook a full-scale equestrian statue, quite probably the first such monument of a woman by a woman; moreover, she resolved to do all the work herself, without male assistants—including the heavy preparatory work of building the sizable armature and covering it with more than a ton of clay. So it is not surprising that when the piece was exhibited at the Paris Salon of 1910, the jury, though very much impressed with the work—according to contemporary accounts—grudged it a mere honorable mention, apparently doubting that it could be the single-handed achievement of a woman.

Aristos, March 1987.

More fitting recognition followed, however. In 1914, Hyatt was chosen, from among numerous competitors, as the sculptor for a monument to be erected in New York City to commemorate the five-hundredth anniversary of Joan of Arc's birth. She reworked and refined her original conception, enlarged the scale somewhat, and had the work cast in bronze (the Paris version had been executed only in plaster). Architect John Y. Van Pelt—who was likewise selected in an open competition—designed an elegant, historically appropriate Gothic pedestal, nearly thirteen feet high, incorporating stones from the building where Joan had been held prisoner in Rouen and from Rheims Cathedral, which also figured prominently in her history.

Unveiled to great fanfare on December 6, 1915, the monument was praised by critics and enthusiastically received by the public. It swiftly established Hyatt's reputation, bringing her many honors—including (perhaps most fittingly, given the chivalric spirit of the work) knighthood in the French Legion of Honor. In addition to numerous smaller versions, several full-size replicas of Hyatt's *Joan* were made for other cities (see below). But the work eventually fell victim to the harsh urban environment of the later decades of this century: air pollution, vandalism, and neglect—together with the modernist distaste for figurative art—divested it of its former glory. And Anna Hyatt Huntington's reputation waned, as did that of many another fine figurative artist of her day.

Spiritual, Not Physical, Force

Hyatt's figure of Joan in armor, astride a powerful, wild-eyed steed, seems so natural and lifelike that the sculptor's achievement can easily be underestimated. One need only compare the work to some of the great bronze equestrian monuments of the past—Donatello's *Gattamelata* or Verrocchio's *Colleoni*, for example, to see how original and effective it is. Unlike those imposing Renaissance condottieri, Hyatt's *Joan of Arc* is a slight, girlish figure; she commands not so much by physical as by spiritual force. Hyatt wrote:

> I thought of her there before her first battle, speaking to her saints, holding up the ancient sword. Her wrist is sharply back to show

her soldiers the hilt, which is in the form of a cross. . . . It was
only her mental attitude, only her religious fervor, that could have
enabled her to endure so much physically, to march three or four
days with almost no sleep, to withstand cold and rain. That is how
I thought of her; that is how I have tried to model her.

From the inception of the Paris version to the completion of the
bronze in New York six years later, the work was shaped not only by
the sculptor's vision and imagination but by her meticulous concern
for historical and anatomical detail. In addition to studying various
texts of the life of Joan, for example, she consulted a curator at The
Metropolitan Museum of Art on early-fifteenth-century armor. And
though she was an experienced horsewoman, who probably knew
enough about equine anatomy and the close relationship between
horse and rider to do the figure from memory, she went to consid-
erable trouble to find suitable models for the sturdy mounts in both
the Paris and the New York version, and had a niece sit (albeit astride
a barrel) for the figure of Joan. All of that would be of little interest,
of course, were it not for the quality of the finished work. Happily,
that inspiring monument can again be seen much as it appeared on
the wintry day it was first unveiled, splendid in its simplicity, clarity,
and strength of form.*

* The original *Joan of Arc* monument stands at Riverside Drive and 93rd
Street in New York City. Full-size replicas of the bronze equestrian figure
can be seen in San Francisco, Gloucester (Massachusetts), Quebec, and
Blois, France. Smaller versions are located in Brookgreen Gardens (South
Carolina), the Cleveland (Ohio) Museum of Art; and the National Arts
Club in New York City, among other collections.

R. H. Ives Gammell

In an interview for *American Artist* shortly before his death in 1981, R. H. Ives Gammell wryly referred to himself as a "fossil." However humorously intended, it was a poignant remark. He had devoted a long and productive career to perpetuating the time-tested traditions of Western painting, while he had seen modernism gradually take possession of the contemporary cultural arena, in which artists like himself were increasingly regarded as mere anachronisms.

Born in 1893, the youngest son of a prominent Rhode Island family, Gammell was reared in the patrician New England society that was both patron and subject matter to the fashionable Boston painters of the turn of the century. That small group of artists, thoroughly trained in their profession, staunchly maintained the old standards of craftsmanship, at a time when the avant-garde forming in New York and Philadelphia had begun to reject such standards. Gammell received his most important training from the Boston painters. His principal mentor, William McGregor Paxton, had studied with the eminent French academic painter Gérôme, whose teacher, in turn, had been a pupil of the great Jacques Louis David.

Despite their close ties to the French academic tradition, the Boston painters, including Paxton, were essentially impressionists; that is, they painted scenes from daily life in a manner capturing effects of light and atmosphere and making subtle use of color. Unlike the French Impressionists, however, they did not repudiate academic technique, with its rigorous emphasis on sound draftsmanship and its more deliberate approach to execution.

Aristos, May 1990.

Gammell became fairly adept in the Boston style of painting. As the 1985 retrospective of his work at the Hammer Galleries in New York City demonstrated, he could competently, sometimes even sensitively, render an "impression" of a portrait, landscape, still life, or interior. But, as that exhibition also indicated, his real passion was for *imaginative painting*—the creation of complex allegorical, historical, or literary scenes, composed of dramatic figural groups in elaborate costume and architectural settings. The choice of this most demanding of all painting genres was an extraordinarily challenging one for Gammell, since he was by his own admission a painter of only average talent (taking as his standard the great works of Western art), and his teachers could offer little specific guidance on this approach to picture making.

Gammell spared no effort toward the creation of an ambitious body of imaginative paintings. He traveled extensively in Europe, North Africa, and the Near East, visiting museums to study the Old Masters, and tirelessly recording exotic details of costume, ornament, and architecture that he observed in various locales. More remarkable, when he was past thirty and had been painting professionally with a fair degree of success for a decade, he interrupted his career to spend two years relearning drawing under Paxton. Finally, in the early 1930s, he began work on his allegorical paintings. In purely formal terms, they are often stunning images, brilliantly composed, with complex groups of carefully drawn figures and a vivid sense of color. But in terms of facial expression, gesture, and overall emotional impact, they generally fall short, lacking an expressive power equal to their apocalyptic themes, which suggest a virtual obsession with death, destruction, and retribution.

That work may well have taken its toll on Gammell. By the end of the decade, he was exhausted, overcome by a growing sense of despair and isolation. The First World War and the Depression had transformed American society and culture. The other painters of the "old school" were dying off, and their elegant, well-crafted pictures were being relegated to museum storerooms, along with the work of the nineteenth-century French academic artists, reviled by the modernists. Not only was there little likelihood of a wide audience for his own idiosyncratic work, it seemed that the entire Western painting tradition

was in jeopardy. Moreover, a second great war threatened to annihilate civilization itself. Gammell sank into a profound depression. When he emerged from that dark period, however, it was with renewed purpose and a significant shift of focus. Seeing himself as the guardian of a priceless cultural tradition on the brink of extinction, he began to write and, eventually, to teach—as well as continuing to paint.

Gammell's first book was *Twilight of Painting*. Written in the early years of World War II, it was published in 1946. (Long out of print, it is soon to be reissued.) It was, the author said, "a painter's book about painting," addressed to the general public and to the future artists who might someday undertake to revive the "all-but-lost art of picturemaking." He explained in the opening chapter:

> The ultimate importance of Modern Painting in the history of art will be seen to lie in the fact that it discredited and virtually destroyed the great technical traditions of European painting, laboriously built up through the centuries by a long succession of men of genius. The loss of these traditions has deprived our potential painters of their rightful heritage, a heritage without which it will be impossible for them to give full scope to such talent as they may possess.

Gammell's purpose was constructive: to show how this unfortunate situation had come about and to propose a remedy. He was concerned only with painting as it was traditionally conceived, that is, having representation as an essential element. The representation can be literal or stylized, he emphasized, but the things represented must be recognizable to the average observer. "Nature provides the starting point of the rendering, as well as a criterion by which the truth of the finished product may be judged," he later wrote in an essay on Paxton. (With respect to "modern art," Gammell said surprisingly little in *Twilight of Painting* about the trend toward total abstraction, and lamented instead the incompetence of the "modern" painters, their sheer lack of professionalism, of craftsmanship.) Because the creation of an effective expression or illusion of three-dimensional reality on a flat surface is, Gammell stressed, a "heartbreakingly difficult art" (as he wrote in another context), only a few individuals are born in each generation with sufficient talent to be good painters, fewer still to be great ones.

Analyzing the factors responsible for the collapse of painting, Gammell clearly identified, first, the pernicious influence of French Impressionism (although he was quick to acknowledge its contributions as well). Most damaging, in his view, it had created a false dichotomy between the "academic" and "impressionist" approaches to painting—approaches which should be viewed as complementary, not as opposing and mutually exclusive, Gammell argued. In its wholesale rejection of academism, the Impressionist movement had made its gravest error in repudiating draftsmanship and discipline (although the first-generation Impressionists were well-trained, and more academic in their working habits than one might suppose). The disastrous effects of that error have become more apparent with each succeeding generation, owing in large measure to the impoverished system of art instruction that developed in the late nineteenth century, as Gammell detailed in a chapter on impressionist teaching (reprinted in *Aristos*, May 1990). His analysis of academism and impressionism in nineteenth-century French art remains invaluable, debunking many of the myths that have distorted commentary on that and later art, as well as calling attention to political factors that probably contributed substantially to the ultimate triumph of Impressionism and the concomitant suppression of academic art.

Finally, Gammell also blamed the collapse of painting on the growing influence of art experts, critics, and amateurs who "specializ[ed] in the art of painting without having mastered its craft" and who "ceased to rely on their instinctive reactions of liking or disliking . . . a painting, but tried to estimate its merit according to self-consciously elaborated esthetic principles." Their "misplaced intellectualism imposed on ignorant execution," he said, "is the guiding principle of painting today."

The remedy Gammell proposed in the concluding chapters of *Twilight of Painting* was a return to the atelier method of training, with its intensive, systematic program of individualized instruction. Moreover, some years later, he opened his own studio to a select number of talented students and devoted the next three decades of his life to providing such instruction. A number of today's most accomplished painters studied with Gammell or with his students. And several of them, in turn, have set up ateliers of their own.

Following *Twilight of Painting*, Gammell wrote a monograph on one of the finest of the late-nineteenth-century Boston painters, *Dennis Miller Bunker*; compiled and edited *Shop-Talk of Edgar Degas*; and wrote a collection of essays posthumously published as *The Boston Painters 1900–1930*—apart from much still unpublished material. Evident in his writing are some of the qualities that must have contributed to his effectiveness as a teacher of painting: breadth of vision, clarity of thought and expression, erudition without pomposity, and above all a passionate dedication to the art of picture making—a dedication informed by a virtually encyclopedic knowledge of the history and methodology of Western painting.

By all accounts, Gammell was a strict, often crusty, teacher, but he was also extraordinarily generous. He took no fees from his students, and frequently defrayed their studio expenses as well as their room and board, in addition to ensuring that they were exposed to a broad cultural program (also at his expense), which he considered essential to the development of an artist.

In the final pages of *Twilight of Painting* Gammell had written:

> There are painters who, though having an excellent command of many of the abilities needful for the making of pictures, are unable to utilize these very effectively in making . . . their own. Their pictures may be intelligently put together, competently made and skillfully executed, and yet be lacking in artistic interest of a high order. . . . These painters have learned to make the maximum of their limited talents and in so doing have come to a clearer understanding of their own way of working than is always possessed by greater artists, who are able to rely on instinct to pull them through. For this reason [such painters] . . . are often excellent teachers. It may well be that they are the best teachers of all.

The words could apply to Gammell himself. For undoubtedly it was as a teacher and a critic and commentator, rather than as a painter, that he made his most significant contribution. Indeed, if the great painting tradition that is one of the glories of Western civilization survives and flourishes into the twenty-first century, it will be due in no small measure to R. H. Ives Gammell's teaching and writing on this art he loved and understood so well.

Understanding and Appreciating Art

In January 1991, when Louis Torres and I began to publish a monograph in *Aristos* on Ayn Rand's philosophy of art—which eventually developed into the book *What Art Is*—we expressed our conviction that Rand had outlined "a profoundly original theory, defining the essential nature and function of art, and linking it to the conceptual nature of human consciousness." As we noted, however, her theory had had little impact—in part, because no serious scholarship or commentary had been devoted to it, even by her philosophical disciples.

A major factor in that neglect was Rand's idiosyncratic pronouncements regarding particular works and styles of art. Even for her keen admirers, such dicta were lamentably off-putting—as Barbara Branden poignantly documented in *The Passion of Ayn Rand*.[1] They had the effect of discouraging anyone with substantial knowledge about art and keen interest in it from delving deeply into her esthetic theory. My purpose here, therefore—as in prior work by Torres and me—is to show how the basic principles of that theory can be reconciled with a much broader experience of art than Rand's often narrow personal dictates suggested.

Chief Points of Rand's Theory

To begin, I will briefly summarize what I regard as the essence of Rand's theory. It is her thesis that humans create art because of a deep

Talk given at the Atlas Society conference in Nashua, New Hampshire, on June 19, 2015. A video of the talk with slides is accessible on YouTube.

psychological need, both cognitive and emotional, to give concrete external form to our inmost ideas and feelings about life and the world around us. As she understood (and is increasingly confirmed by neuroscience), emotions are directly tied to sensory perceptual experience, whereas ideas and values are mental abstractions from that experience. Without external embodiment, such abstractions remain vaguely unreal, detached from our emotional life. Through the arts' sensory immediacy, we reconnect our thoughts and feelings about things that matter to us, and are thus made more fully conscious of them. As Rand succinctly put it: "Art brings man's concepts [about things of long-term importance, as she elsewhere emphasized] to the perceptual level of his consciousness and allows him to grasp them directly, as if they were percepts."[2] That, in her view, was "the crux of the Objectivist esthetics."

Since (as Rand emphasized) human action is largely voluntary, not governed by instinct, we must constantly make choices that affect both present and future well-being. In so doing, we need to remain mindful, amid the myriad demands and distractions of daily life, of what we believe and what is important to us, not just at the moment but in the long term. Art serves as a powerful reminder of one's values and view of life.

The strength of Rand's theory lay in her largely correct understanding of the relationship between direct perceptual experience, thought, and emotion. Though writing in the 1960s, before the prominence of neuroscientists such as Gerald Edelman and Antonio Damasio, she recognized that emotions are based on values. As she understood, the arts engage the crucial connection between perception, abstract thought, and value-charged emotion. In so doing, they help to give us a heightened awareness of what we believe, what we value, what we hold as important in the long run.

Like the other major art forms, the arts of painting and sculpture serve that important psychological function. The carefully wrought images that talented artists create embody their values and reflect their view of life in riveting form. They are not only striking to behold, they have the potential to move us as well. As Rand held, they serve to make us more aware of what we think and how we feel about the world and our life in it, as well as about the alternative

worlds we might imagine. For the individual and, by extension, for society, they bring those ideas and values more fully to mind.

The points I extract from Rand's theory as most relevant to understanding and appreciating art are the following:

- Visual art consists of value-laden imagery that "selectively re-creates reality."

- That re-creation is based on what the artist regards as important.

- It involves both cognition and emotion.

- The meaning-content of a work emerges from the way the subject is handled.

- Both the creation and the appreciation of art are highly personal.

- They engage the individual's deeply held values and worldview.

How can those principles inform and enhance your appreciation of visual art?

Unfortunately, as I've already indicated, Rand herself was a generally poor mentor when it came down to specifics. Despite her profound insight into the essential nature and function of art, she was not a very reliable guide to the incredible richness and variety of the world's art. To begin with, she didn't have a lot to say about the visual arts per se. To make matters worse, what little she did say about particular works, artists, or styles of art tended to consist of idiosyncratic dicta framed as moral judgments—praising (or, more often, condemning) the artist's worldview and "psycho-epistemology" (his habits of thinking).

Rand enthusiastically approved of heroic themes. She also strongly preferred a realistic style. Objectivists have therefore comfortably appreciated work such as Michelangelo's monumental figure of *David*. And they would probably feel equally at home with a more recent work that is less well known—*The Vine*, by the twentieth-century American sculptor Harriet Frishmuth.

Much as I value these splendid works, however, I would be impoverished if all I knew of art were in the same vein. So what I'd like to tell you about here are quite different works that have enriched my life and that I discuss in *Who Says That's Art?* I will

also explain how the principles of Rand's esthetic theory serve to shed light on the experience of these and other works of visual art. Does this mean that you will or should necessarily respond to these works as I do? Absolutely not. As Rand rightly emphasized, the response to art is deeply personal and highly subjective. What I *do* hope is that my examples may suggest to you new ways of looking at art that may enable you to find your own new pleasure in previously unexpected places.

Pleasures of Medieval Art

Since Rand was particularly scathing in her denunciation of medieval art, I'll begin with a work from the early thirteenth century that I have loved from the first moment I saw it. It is the sculptural group of *Abraham and Isaac* from a portal of the great French cathedral of Chartres. The subject is one of the most controversial passages of the Old Testament—God's apparent testing of Abraham's faith by commanding him to sacrifice the beloved son of his and Sarah's old age. Most depictions of this scene show the pair in the terrible moment when Abraham is about to sacrifice Isaac on the altar—as in a much later example by the Italian painter Caravaggio.

But the unknown Chartres sculptor depicts them at a moment of rest. Trustingly, they gaze upward toward the angel sent to stay Abraham's hand (which is holding but not brandishing an axe) ready to slay Isaac, whose feet are bound for the sacrifice. Just how beloved Isaac is, the sculptor touchingly conveys by Abraham's gentle caress of the boy's head. It has long been, for me, an unforgettable image. Such a gesture of paternal affection is all the more striking in the midst of the austere patriarchal figures surrounding it.

Also notable in contrast to many later interpretations of the biblical narrative, Isaac is depicted as a slender young boy, not yet fully grown—which adds to the poignancy of the scene. Finally, two ingenious compositional devices complete the story, with great economy in the confined architectural space. The angel who saves the day appears in the sculptured canopy above the head of the adjoining figure, while the ram to be substituted for the sacrifice serves as a pedestal for Abraham and Isaac.

An equally touching depiction for me is a work from the late medieval / early Renaissance period—an early fifteenth-century *Virgin and Child* by the Burgundian sculptor Claus de Werve. The tenderness of this monumental yet intimate work is evident, even to a young child—as I discovered with my granddaughter on one of our first museum visits together. When we paused to look at it and I told her it was one of my favorite works, she studied it for a moment and then said softly: "That's sweet." As indeed it is—though the nuns for whose convent it was created would probably have also understood it in a deeper theological sense.[3] Like the *Abraham and Isaac* and other works of religious art, however, it can be experienced and appreciated on a simply human level, without necessarily understanding or embracing its specific religious or theological implications. Rand herself rightly emphasized that complex works of art can be understood and appreciated on more than one level. That principle is certainly true of these religious sculptures.

In any case, there is surely quite a lot more to these works than what Rand dismissed as medieval art's "deformed monstrosities and gargoyles . . . as [its] only reflection of man's soul."[4]

What is important to bear in mind with regard to the examples I've just cited is the principle that we respond to art based on the values we perceive embodied in it. Heroism and physical beauty are significant values. But human tenderness and affection, as expressed in these works, are also values worthy of our attention.

Other Aspects of Human Experience

So, too, old age can be represented as an aspect of life worth reflecting on. In a loving portrait of his elderly father—entitled *The Writing Master*—for example, the nineteenth-century American painter Thomas Eakins has represented more than simply an old callig-rapher at work. Through the figure's intense concentration and the care with which his expressive face and age-worn hands are depicted, Eakins conveyed his veneration for his father's dedicated skill during a lifetime of labor. At the same time, the image implies, more generally, the value of skilled work and the dignity it confers, magnified by old age.

In a totally different vein—but no less compelling for me—is a work by the nineteenth-century American painter George Caleb Bingham. In this almost surreal image, entitled *Fur Traders Descending the Missouri*, a dugout canoe is seen gliding down the glassy surface of the river with three striking passengers, while behind them rise clumps of bushes shrouded in mist below a brightly lit sky. The atmospheric effect is wondrous—Bingham was a master of the "luminist" style of painting, which specialized in such stunning representations of natural light.

Equally marvelous are the canoe's passengers. A fierce-miened bearded man resolutely wields the paddle as he glares out at us with a slender pipe clenched between his sullenly downturned lips. In stark contrast, his raven-haired "half-breed son" (identified as such in the painter's original title for the work) leans languidly on his elbow and stares dreamily into space, while a pet bear cub stands sentinel in the prow. Looking in outline more like a large cat than a bear, the cub resembles images of the sacred cat of Ancient Egypt. It forms a mysterious formal punctuation point in Bingham's intriguing composition, whose poetic effect is doubled by reflection in the glassy water.

Other scenes of man immersed in nature that have endlessly delighted me are from the justly renowned series of paintings on the theme of the seasons by the sixteenth-century Flemish artist Pieter Bruegel. Of the five surviving panels, *Hunters in the Snow* and *The Harvesters/Haymakers* present the most arresting contrasts of nature—from the cold gray light of the snowbound winter landscape through which returning hunters trudge to the golden heat of late summer, in which peasants make hay while the sun shines. Both splendidly composed panels offer a deep view to the horizon beyond the narrow confines of peasant life, as if to suggest that the world is a much larger place than that occupied by these simple folk. And yet Bruegel takes care to show their lives in vivid detail, whether at work, at play, or merely in repose. Nature is a major player in his scenes, however, not a mere backdrop for its human habitants.

Getting Vermeer Right

Ayn Rand's favorite painter was Vermeer—whom she regarded as the "greatest of all artists." She admired him for his "brilliant clarity

of style." But she mistakenly claimed that he "devoted his paintings to a single theme: light itself."[5] That is an astonishing claim coming from Rand, in view of her own principles of art, as well as of her correct emphasis on the contextual nature of cognition. She should have known better than to suggest that an abstract property such as light could be a work's "single theme"—in other words, the essence of its meaning. To my mind, her claim falls into the same error as that of modernist critics who say of abstract work that it's "about color," or "about energy." Given the nature of cognition, which Rand so well elucidated, such properties are relatively meaningless absent a context.

To make matters worse, Rand derisively characterized Vermeer's subjects as "the folks next door . . . to kitchens."[6] and she wished that he had "chosen better subjects to express his theme."[7] That view was not only uninformed. It was wrong-headed. Because Vermeer's subjects had little meaning for her, Rand mistakenly inferred that they also had little meaning for him.

A wonderful exhibition devoted to Vermeer's *Milkmaid* at the Metropolitan Museum a few years ago provided considerable insight into the work's probable meaning. I say *probable* meaning, because no direct documentary evidence on the work is extant. The show's excellent curator, Walter Liedtke (who was tragically killed in a commuter train crash earlier this year), necessarily relied on stylistic, compositional, and iconographic features to evaluate the work in relation to Vermeer's total oeuvre and interpret it within a broader cultural context. By comparing *The Milkmaid* to contemporary and earlier works dealing with similar subject matter, he illuminated the significant ways in which Vermeer transformed existing prototypes, both stylistically and iconographically, and thus shed light on the work's likely intent.

As Liedtke documented, images of milkmaids and kitchen wenches in Dutch and Flemish art had long had erotic associations, often indicated with vulgar explicitness, as in the youth's lascivious expression and extended middle finger and the maid's skewering of a chicken in a *Kitchen Scene* by Peter Wtewael. Since Vermeer was undoubtedly familiar with that tradition, the ways in which he departed from it are probably significant. In notable respects, he elevated the theme. He not only avoided crudely obvious iconog-

raphy, he also simplified and focused the composition to enhance the maid's dignity and importance, omitting any companion. Her sculpturesque figure is almost monumental in effect. At the same time, he endowed her pensive face with a psychological depth and subtlety of expression totally new to the theme.

As Liedtke convincingly demonstrated, Vermeer treated the painting's female subject with remarkable sensitivity, even respect, in comparison with the standards of his day—seeming to suggest that, appealing though she is, she is no mere object to be trifled with. Such an interpretation, firmly grounded in the work's cultural context, strongly suggests that light was just one revealing element of Vermeer's image—not the "single theme" inferred by Rand.

Neo- and Post-Impressionism

In praising Vermeer, Rand contrasted the clarity of his style with what she referred to as the "silliness of the dots-and-dashes Impressionists who allegedly intended to paint pure light." Her reference to "dots-and-dashes" suggests that what she had in mind was not the Impressionists, however, but the "pointillist" style of *Neo*-Impressionists such as Georges Seurat.

I will therefore leap to Seurat's defense with one of my favorite paintings of all time—his masterpiece, *A Sunday Afternoon on the Island of La Grande Jatte*. (If you live in or visit Chicago, by all means see this work in person at the Art Institute.) While representational, it is a highly stylized depiction. Rand did not object, in principle, to stylization in art. However, her own taste for extreme realism of style prejudiced her against what I see as the considerable charm and artistry of this work. To my mind, Seurat beautifully captured the simple pleasure of a day of leisure in the balmy sunshine of a summer day.

Ironically, a Marxist-inspired art historian has characterized this benign image as an "anti-utopian allegory" reflecting "the most advanced stages of the alienation associated with capitalism's radical revision of urban spatial divisions and social hierarchies of [Seurat's] time."[8] Such a politicized interpretation is completely at odds with what an unbiased viewer is likely to see in the painting, however. As a high school student who wrote to Torres and me put it: "It's a

beautiful Sunday afternoon. . . .[P]eople are having a great time with friends, the weather is perfect, the water is perfect, the clothing and people are perfect, it just seems like something taken out of a dream."

A *Post*-Impressionist work that I have loved since I learned of it in high school is also highly stylized, but in a very different manner from Seurat's. It is by a painter I suspect Rand would have had no use for—Paul Gauguin, whom she probably would have condemned as a "primitive." Depicting a lush tropical paradise, this mural-sized work presents a densely woven visual tapestry of deep blues and greens populated by various native figures. Much of the painting's initial fascination for me no doubt lay in its exotic subject matter. As a teenager, I was also fascinated by the musical *South Pacific*—perhaps drawn to it by much the same primal appeal that moved Gauguin to abandon home and family to journey to the South Seas. But just as *South Pacific*'s theatrical impact ultimately depends on the engaging characters who animate the play, Gauguin's painting would be little more than a merely decorative tapestry without its human figures.

Far from academically "correct," these figures nonetheless impress me with their deeply serious, meditative mien, as if rapt in contemplation of the unfathomable mystery of life. Nor does that impression depend on knowing the title Gauguin gave the work—*Where Do We Come From? What Are We? Where Are We Going?* The impression is conveyed by the panorama of human life depicted, beginning with the infant asleep on the ground at the right and ending with the crouching figure of an old woman at the left. Near the center, a golden-skinned native figure reaches up to pluck fruit from a tree, while to the left a seated child eats a similar piece of fruit—an evocative allusion to the Tree of Knowledge in the Garden of Eden. Presiding over this Eden in the middle ground to the left is the boldly frontal figure of a Maori idol—a looming, eerily blue, ghostlike apparition that adds to the aura of mystery.

Characteristically, Gauguin greatly simplified and stylized the figures, flattening them and demarcating them from the background with clear outlines. Yet he managed to capture the essence of meaningful pose, gesture, and facial expression in each, endowing the main figures with a palpable dignity. The resulting image strikes me as not only gorgeous on a purely sensuous level but pro-

foundly significant as well—a combination that is the hallmark of Gauguin's eccentric genius but was never before or after achieved by him on such a scale.

Dignity, Not Deformity

A more recent work that I am moved by is *Christina Olson*, by the American realist painter Andrew Wyeth. In all likelihood, Ayn Rand would have approved of its crisply realistic style but might have criticized it as expressing a "malevolent universe" premise.[9] I see it quite differently.

The subject of the painting is the reclusive Maine neighbor who a year later inspired Wyeth's far more famous image *Christina's World*. Seated here in profile on the sill of an open doorway, Christina gazes out into the brilliant sunlight, which casts sharp angular shadows behind her. Her frail figure is subtly misshapen, owing to a congenital disorder that had severely crippled her. Her slender form is dwarfed by the scale of the weatherbeaten door she leans against. Yet this homely woman seems almost regal in her upright bearing and quiet repose—an effect that Wyeth enhanced by projecting a bold triangle of shadow from the back of her head to the floor.

I see it as an image of great dignity, eliciting empathy and respect rather than pity. Moreover, as I've only recently learned from Wyeth's excellent biography, that is exactly what he intended. What drew him in friendship to this physically marginalized woman—what he saw as her "essence"—was not her "deformity" but her "dignity," her fierce self-reliance in the face of extreme physical hardship and material deprivation.[10] Aren't those values and virtues that any Objectivist ought to appreciate?

This painting also offers a telling example of Rand's principle that all art is a "selective re-creation of reality." Although his work appears to be almost photographic in effect, Wyeth was anything but a "photo-realist" artist. While all his work was ultimately based on direct observation, paintings like this were in tempera, a slow and painstaking medium, and his protracted creative process involved innumerable, often subtle, changes from what he had observed at any one moment in time.

Artworld Nonsense Debunked

Much of *Who Says That's Art?* deals with debunking the contemporary artworld's notions about art, and the sort of work those ideas support. And Rand's theory is invaluable in that regard. One of her most important insights was her understanding that the emotional response to art is based on deeply held values. That fact provides the best rebuttal to those who defended a highly controversial painting—*The Holy Virgin Mary* by Chris Ofili—against the huge public outrage it elicited in 1999.

The work presents a highly stylized image of the Virgin, with cartoonishly exaggerated Negroid facial features—an aspect that was little noted at the time but undoubtedly contributed to the public's negative response. Aspects that were cited as offensive included, most notably, a protruding breast fashioned from a clump of elephant dung, as well as images of genitalia from pornographic magazines that surround the figure. When New York's then-mayor Rudolph Giuliani learned that the work would be included in the now-notorious *Sensation* exhibition at the Brooklyn Museum, he threatened to withdraw municipal support for the museum, arguing: "You don't have a right to government subsidy for desecrating somebody else's religion." He further declared: "The idea of having so-called works of art in which people are throwing elephant dung at a picture of the Virgin Mary is sick."

Ofili—who happens to be a practicing Catholic—defended his work by explaining: "As an altar boy, I was confused by the idea of a holy Virgin Mary giving birth to a young boy. Now when I go to the National Gallery and see paintings of the Virgin Mary, I see how sexually charged they are. Mine is simply a hip-hop version." The prominent philosopher-critic Arthur Danto also defended the piece, observing that the elephant dung was probably not *intended* to besmirch the image, since Ofili is of African descent and "Africa is a place where certain magical properties are ascribed to elephant dung."

In so arguing, both Ofili and his defenders ignored that the response to art is based on deeply ingrained values. In Western culture, any form of excrement, elephantine or otherwise, is generally

regarded as filth and defilement. Thus it is quite natural and not at all reprehensible that ordinary Americans and other Westerners responding spontaneously to Ofili's work found it offensive. Nor is it helpful to attempt to talk them out of their response by providing information regarding the meaning of dung in another culture. Such an argument takes the piece out of the emotional realm proper to art and turns it into a purely intellectual exercise. As I concluded in *Who Says That's Art?*, artists who wish to be understood need to understand their audience's context.

Truly "Conceptual" Art

One of the most absurd and destructive notions in today's artworld is that of so-called "conceptual art." It is an entirely spurious category, which falsely implies that earlier art did not deal with ideas. In contrast, Rand correctly understood that all works of art, properly speaking, embody ideas.

A telling instance of truly and profoundly conceptual art is a work by the seventeenth-century French painter Nicolas Poussin entitled *Landscape with the Ashes of Phocion*. As a narrative painting, it is dependent for full appreciation on familiarity with ancient Greek history. Yet even without knowledge of its story, the image is visually striking. It represents a perfectly harmonious vista—a serenely well-ordered landscape studded with luxuriant trees and elegant classical buildings. Most of the scene is bathed in warm light from a bright but partly clouded sky. In the middle ground of this sunlit space, diverse figures pursue various pleasures. Engaging in archery, bathing in a stream, making music, they are apparently oblivious of the two women in the center foreground, who are the focal point of the painting. These figures are cast in shadow, except for a glint of sunlight on the white-capped head and outstretched forearms of a woman kneeling on the ground, who seems to be gathering up a pile of ashes. The companion standing beside her turns as if to guard against a possible intruder. Poussin's skillful handling of light, composition, and gesture makes it impossible to ignore these figures. And even if we know nothing of the story they played a part in, one can sense that something important is at stake.

The story behind the image would have been familiar to the educated viewers of Poussin's work, however. Well versed in ancient history, they would have known that the woman gathering ashes was the widow of Phocion, a virtuous Athenian statesman who had been falsely accused of treachery, sentenced to death, and denied a proper burial. In retrieving his ashes to give them a fitting interment, therefore, she was heroically defying the state that had wronged him.

Armed with that knowledge, we too can grasp the depth of this image. On the simplest and most direct level, it is a tribute to wifely loyalty and courage. But it may also be read as a profoundly philosophic reflection on universal truths about human life and suffering. In the midst of what appears to be a perfectly ordered and civilized world, this grieving woman risks death to right an injustice, while others go about enjoying their daily lives, oblivious of her plight. Viewed in those terms, the image becomes not only a subtle portrayal of heroism but a poignantly ironic expression of the gulf between personal adversity and the public sphere.

It is not surprising that when the great Italian sculptor Bernini viewed Poussin's work, he is said to have tapped his forehead and declared, "Signor Poussin is a painter who works from there." As a powerful embodiment of ideas, such work helps to elucidate Rand's theory. And it demonstrates by contrast the poverty of the ill-conceived "conceptual art" that dominates today's artworld.

Two Exhibitions Worth Praising

Refreshing relief from the artworld's standard offerings of "modern" and "contemporary" art has been provided by two of this year's exhibitions in New York: *Thomas Hart Benton's America Today Mural Rediscovered*, which just closed at the Metropolitan Museum; and *Hebrew Illumination for Our Time: The Art of Barbara Wolff*, at the Morgan Library & Museum through May 3.

Strikingly though they differ in medium, style, and content, both shows demonstrate the power of visual art to stir the heart and mind. They also reveal the ways in which talented artists can build upon tradition to create something vibrantly new. Barbara Wolff's exquisitely crafted miniatures—made to illustrate religious texts (Psalm 104 and the story of Passover in the *Haggadah*)—were inspired by medieval and Renaissance illuminated manuscripts, examples of which are included in the Morgan exhibition.[1] Benton's murals, in sharp contrast, are on a secularly heroic scale, loosely emulating the great fresco cycles of the Italian Renaissance. They present a dynamic panorama of American life in all its teeming diversity in the Roaring Twenties.

Especially delightful in the Morgan show are Wolff's images inspired by Psalm 104, "You Renew the Face of the Earth"—a hymn in praise of creation. Her charming depiction of *Among the Branches They Sing*, illustrating line 12 of the Psalm, includes no fewer than twenty-eight identifiable species of birds—a graphic evocation of nature's astonishing variety. In *The Mountains Rose* (line 8 of the Psalm), a giant wave crashes over the upper left border of the image,

For Piero's Sake, April 22, 2015.

while jagged gilt-and-silver layers below snow-capped mountains and green hills are studded with prehistoric shellfish and trilobites, whimsically suggesting a scientifically updated interpretation of Genesis. Equally whimsical is Wolff's evocation of the ancient Egyptian pantheon in *Against All the Gods*, a page in the *Haggadah*.[2]

Extensive research and preparation went into both projects. Not for these artists the "spontaneous" expression or mere chance favored by modernists. Wolff, for example, delved into Biblical and Egyptian archaeology, the European tradition of illuminated manuscripts, and the ecology of Israel's flora and fauna—not to mention drawing upon her own extensive familiarity with botanical and animal illustration. For his part, Benton had traversed the United States, notebook in hand, for four years in the mid 1920s.[3] As reported in an excellent article in *Smithsonian* magazine,

> He went down rivers, up mountains, along country roads; camped and hiked and bunked in farmhouses; into the heartland of farms and confronting the cities of roisterers and skyscrapers-in-the-making, obsessively sketching.[4]

Sketches and paintings included in the Met's exhibit indicated the truth of Benton's claim that "Every detail of every picture is a thing I myself have seen and known. Every head is a real person drawn from life."

Another significant commonality between these disparate artists is that neither of them is part of the art historical "mainstream" represented in standard accounts of American art. Barbara Wolff has had a long and very successful career as a botanical and natural science illustrator—a pursuit requiring the dedicated skill in depiction that the artworld mainstream has flouted. Thomas Hart Benton (1889–1975), after spending his early years first studying in Paris and then as a respected instructor at the Art Students League in New York for a decade, turned his back on those cultural capitals, becoming a leading "Regionalist" painter and an outspoken critic of the art establishment.[5] Most important, despite the ascendancy of abstract art in subsequent years, he never wavered from representation, focusing on the manifold people and places of America that impressed and engaged him. Ironically, one of his art students was Jackson Pollock

(he was the model for the sinewy worker in the right foreground of panel entitled *Steel*)—whose fame in time lamentably eclipsed Benton's. Perhaps the long-overdue attention to Benton's work generated by the Met show will help to reverse that unfortunate fact.

Till now, I have never been a fan of Benton's mannered style, but it is wonderfully apt in this context. Bristling with energy, in unstoppable motion, it spans the gamut of American life in the twenties—from the imposing figure of a cotton picker in *Deep South* to the muscular heroism of the miner dominating *Coal* and the curvaceous forms of a subway straphanger and her praying counterpart in the panel encompassing sin and salvation in *City Activities with Subway*.

While the Wolff exhibition can be seen at the Morgan through May 3rd, I greatly regret that I was unable to post this review before the Met's splendid Benton show closed. However, Met representatives have assured me that the murals will at some point be reinstalled permanently elsewhere in the museum. If you weren't lucky enough to see it before, put it on your list for the future, for it is a work that, more than some, must be experienced firsthand to be fully appreciated.

I should add that both Wolff's and Benton's projects were the result of commissions by visionary patrons. In 1930, Benton was invited to decorate the boardroom of the New School for Social Research by the school's co-founder and first director, Alvin Johnson. Though Johnson lacked funds to pay him, Benton considered it a good opportunity at that point in his career, and agreed to do the work pro bono if Johnson would supply the eggs needed for his chosen medium of tempera. Just a few years ago, the New York philanthropists Daniel and Joanna S. Rose commissioned Wolff to create *The Rose Haggadah* and *You Renew the Face of the Earth: Psalm 104* for their family, and then generously decided to donate both works to the Morgan's superb collection of illuminated manuscripts, for the public to enjoy.

Today's "Public Art"
Rarely Public, Rarely Art

"One senses that public art is gathering new momentum daily and receiving such significant acceptance that neither party politics nor economic recession nor our serious energy and environmental problems can reverse the trend." That sanguine prophecy was issued nearly a decade ago by Professor Sam Hunter—of the Department of Art and Archaeology, Princeton University—in the Preface to Donald W. Thalacker's *The Place of Art in the World of Architecture*. Thalacker was then, and still is, director of the federal "Art-in-Architecture" program, begun in the early 1960s to incorporate the fine arts into new government building projects. His book documents the often stormy history of works commissioned under the program between 1972 and 1979—works such as Claes Oldenburg's 100-foot-high steel-lattice-work *Batcolumn* (shaped like a baseball bat) in front of the Social Security Administration building in Chicago, and George Sugarman's *Baltimore Federal*, an expansive, multicolored metal construction, part of which roughly resembles a gigantic ornate bathing cap.

Hunter, who teaches, writes, and consults frequently on this subject, was half right. In one sense, "public art" programs are gathering momentum: government-funded projects for so-called art in public places have proliferated in the past decade, as state and local agencies across the country have followed the federal lead in advocating

Aristos, May 1988.

(sometimes mandating) that a percentage—generally one per cent— of new construction and major renovation costs for public buildings be allocated to art. Contrary to Hunter's prophecy, however, "significant" public acceptance of the products of such allocations seems no closer now than ten, or twenty, years ago.

Though contemporary "public art" (corporate-sponsored as well as government-funded) is increasingly conspicuous in America's cities, much of it is either ignored or rejected by the majority of the public, including more than a few professionals and intellectuals outside the current art establishment. Federal judges, for example, were among the most outspoken critics of two major Art-in-Architecture projects: Sugarman's "sculpture" for Federal Courthouse Plaza in Baltimore, and Minimalist "sculptor" Richard Serra's now notorious *Tilted Arc* in New York City. One judge who testified against the Serra piece (Paul P. Rao, of the U.S. Court of International Trade) declared:

> If the *Tilted Arc* ever came before our court, and I was called upon to write an opinion, I would be obliged to state that it is not a work of art.

(Judge Rao's brief testimony did not indicate the reasoning behind his judgment, and an in-depth analysis of the nature of art cannot in any case be undertaken within the scope of this article; but it may suffice to say here that *Tilted Arc*—like any abstract work—is not art, in part because it does not, indeed cannot, communicate, outside explication notwithstanding, fundamental human values, or ideas.)

A number of academics, too, have rejected modernist works, as university campuses have become the frequent "beneficiaries" of "public art" programs. At Western Washington University, for example, a symposium organized in the spring of 1986 on the subject of Western's "world-class" collection of contemporary "sculpture" drew seven essentially negative assessments (out of eight) by faculty participants from various humanistic disciplines, including music, philosophy, foreign languages, liberal studies, and—most remarkably, in view of today's almost monolithic art establishment—art and art history. Like the federal judge quoted above, these academics questioned, directly or implicitly, whether the works under discussion are indeed art at all. One of the seven critical papers—by Thomas

Schlotterback, the maverick professor of art and art history who co-organized the event—was the basis for his article "Two Public Monuments a Century Apart," abridged in the May 1988 issue of *Aristos* from a paper he had delivered at the 1986 symposium.

Toward a "Humanizing" Effect

The principal federal influence on today's "public art" projects is through the National Endowment for the Arts (NEA), America's foremost arts agency, created by act of Congress in 1965. By way of its own extensive "Art in Public Places" grant-making program and as an advisory body to the sizable Art-in-Architecture program of the General Services Administration (GSA), which manages federal facilities, the NEA has overseen many hundreds of public projects across the land. Though a strong case can be made, in principle, against any direct government support of the arts, the purpose of this article is only to address the negative effects of existing public art programs.

Beginning with the NEA's own Statement of Mission, the prevailing rhetoric on public art gives lip service to the ideas that art is essential to man's self-knowledge and psychological well-being, and that it is a vital link in the continuum of human history. The powerful role of art in past cultures is stressed, and we are frequently told that public art adds a vital *humanizing* element to the twentieth-century's stark, depersonalized urban and suburban vistas. But the rhetoric ignores (or denies) that the most effective examples of public art from past cultures have a humanizing effect precisely because they depict the *human figure*, which has been virtually excluded from today's "public art" programs. (The NEA's token "realist" is George Segal, who "sculpts" by pouring plaster over ordinary people in various banal attitudes and is not loath to pontificate on the significance of the results.) In place of meaningful depictions of the human figure, the public today is confronted mainly with industrialized constructions, as cold and impersonal as the cityscapes they are intended to humanize. At best, even to advocates like Hunter, such "public art" is "oblique in content and meaning"; at worst, to its critics, it is totally unintelligible, even devoid of meaning. More often than not, for

most people, it not only fails to humanize the urban environment, it exacerbates the sense of dehumanization and alienation.

The Serra Case

The public debate over Richard Serra's *Tilted Arc* provides a classic illustration of the great gulf still dividing "the minority that accepts modern art and the majority that does not," as one critic phrased it. Installed in 1981, Serra's work (a curving tilted slab of intentionally rusted steel 12 feet high by 112 feet long) transects the elegantly paved plaza in front of an otherwise nondescript federal office building in downtown Manhattan. When ongoing objections from a host of disgruntled government employees and others who work in the area prompted the General Services Administration to consider relocating the work, three days of public hearings were held. *Tilted Arc* was variously described by its detractors as "the Berlin Wall of Foley Square," a "calculated offense," a "piece of scrap iron." The summary comment of one citizen at the hearings was: "It looks barren, it is barren."

Members of the "international art world" rallied to the defense of *Tilted Arc*, of course, generally praising it as a serious work by a major artist of our time. Asked to comment on proposed relocation of the piece, the director of the Brooklyn Museum went so far as to claim: "The more controversy there is at the time [a work] is created by a tried-and-true artist, the more chance that it is a significant statement. Therefore, I see this as the destruction of a masterpiece."

In alluding to Serra as a "tried-and-true artist," the museum director echoed the frequently expressed view that the "art professionals" (appointed by the NEA) who had selected Serra for the commission had expert knowledge of the value of his work, and that an amateur should no more question their judgment than challenge the findings of a nuclear physicist in his field (ignoring, of course, that reputable science is based on rigorous rules of logic and verifiable evidence, subject to objective tests, whereas today's reigning "art professionals" adamantly reject any objective standards in the realm of esthetics).

Predictably, Serra has become something of a martyr in the arts community. The American Council for the Arts (ACA)—a prominent advocacy organization based in New York, which has, among

other activities, lobbied for expanded funding of the NEA—has published a blatantly biased study entitled *Public Art, Public Controversy: The Tilted Arc on Trial.* Robert Porter, ACA's director of publishing, states that the project was spearheaded by a graduate student zealous to "chronicle the great injustice" done to Serra. (Despite the dire implications of that phrase, the GSA has decided, at last report, not to move *Tilted Arc*, because Serra persuaded an NEA-appointed[!] review panel that the work is "site-specific"—i.e., "integrally related to the masses, forms, and lines" of the architectural environment where it is placed—and that to relocate it would be to destroy the "artistic value." No mention was made of the fact that Serra has devised several *similar* arcs for very *different* sites.

Nevertheless, Porter rather disingenuously claims that the ACA book is not intended "to trumpet one viewpoint over another, although the testimony presented admittedly weighs substantially in favor of the artist's position." Substantially indeed. Of the 118 speakers who supported Serra's position, 94 are represented in the ACA volume, whereas only 6 of the 63 speakers who argued for the relocation of *Tilted Arc* are represented. Moreover, the "expertise" of the defense statements is underscored by their being grouped under appropriate headings (art critics, art dealers, art historians, etc.), while *none* of the testimony from art professionals who spoke *against* the work is represented. As we shall see, the stance taken here—denying serious consideration to any departure from the modernist orthodoxy—pervades existing public art programs.

The Role of "Experts"

From their inception, federal programs in the arts have depended on the "expert" advice of outside consultants. Vulnerable to the charge that government support might lead to government control of the arts, the NEA emphasized in its Statement of Mission that the Endowment "*must not, under any circumstances, impose a single aesthetic standard or attempt to direct artistic content*" (emphasis added). To minimize the risk of such control, the agency adopted a peer panel review process, in which all substantive decision-making—on grant awards, programs, policies, etc.—is guided by allegedly qual-

ified members of the arts community, including artists, curators, critics, art historians, administrators, and prominent patrons. This process has generally been thought to ensure artistic freedom and maximum diversity of creative expression. To quote historian Arthur Schlesinger, Jr. (from the first annual ACA-sponsored Nancy Hanks Lecture on Arts and Public Policy, delivered in Washington in April 1987), the peer review process "relieved the artistic community's fears of bureaucratic control" and "extended [their] participation."

In effect, however, the Endowment's dependence on "recognized experts" has led to a *de facto* entrenchment of the avant-garde in national arts policy and practice (and, concomitantly, to a virtual exclusion of traditional figurative art and artists)—since the big names, the prominent "artists" and "experts," in the artworld today are modernists of one stripe or another. Their "vanguard" mentality is discernible in every aspect of the GSA and NEA public art programs, beginning with the very guidelines and policy statements.

One sure symptom of the modernist mindset directing these programs is their "blurring of distinctions" between art forms and their emphasis on "experimental" work. For example, although the GSA's Art-in-Architecture program is explicitly intended to integrate fine arts in federal buildings, the current policy includes not only forms traditionally encompassed in such a context (sculpture, murals, and frescoes) but various new categories—among them, "lightworks" (e.g., abstract arrangements of neon tubing) and "fiber arts" (diverse configurations of fiber strands or fabric hung from ceilings or walls). Even more telling is the breakdown of projects actually completed. Of some fifty-five individual projects profiled in Thalacker's book, for instance, forty-six were totally abstract, three contained extremely stylized or "primitive" representations of the human form, and one was Oldenburg's *Batcolumn*, whereas only five were realist or figurative works in the traditional sense, reflecting a close observation of nature. How, one might well ask, does such predominantly abstract work "reflect the dignity, enterprise, vigor, and stability of the American National Government," as stipulated in the Art-in-Architecture guidelines?

The language of the NEA documents is equally problematical, with a similar emphasis on "new genres," such as "conceptual" art. That term, not defined in the guidelines, refers to "art" in which the

idea or *concept* (expressed verbally or diagrammatically), as opposed to the *form* or *appearance*, is the most important—sometimes the only—aspect of the work. This, under the NEA's *Visual Arts* Program—which encompasses Art in Public Places.

Among the Visual Arts review criteria, "innovation and timeliness" are stressed, as well as work reflecting "serious and exceptional aesthetic investigation." What do these terms mean in practice? One such project, funded under Art in Public Places, is Joseph Kinnebrew's *Fish Ladder Sculpture*, in Grand Rapids, Michigan. As described by the authors of a hefty volume entitled *Public Art: New Directions*, this "innovative approach to art and the environment" allows salmon to swim up the Grand River to spawn.

> The functional sculpture, which allows people to walk across the ladder and watch the salmon leap over the rapids, is a prefabricated mortar platform bolted to the top of the concrete, box-shaped fish ladder.

John Beardsley, a curator of the Corcoran Gallery of Art in Washington, D.C.—who wrote the text for *Art in Public Places* (1981), a survey of NEA-supported projects—reports that Kinnebrew's work "fulfills both [Kinnebrew's own] objectives and those of the Department of Natural Resources." Beardsley sees such an "extra-aesthetic function" as one step toward evolving a public art that is both "pertinent and relevant," and envisions that projects like this may in time become "the paradigms for successful public sculpture." Never mind that "extra-aesthetic functions" of any kind are outside the realm of art.

"Going Public"

Just how prevalent this level of non-thought or "doublespeak" is in the field of public art today is made painfully clear by a recently issued volume entitled *Going Public*, prepared by the Arts Extension Service (University of Massachusetts Division of Continuing Education) in cooperation with the NEA's Visual Arts Program. Intended as a "workbook" on public art, this 300-page publication is the product of the "Public Art Policy Project" initiated by Richard

Andrews, former director of the Visual Arts Program. Through three sets of two-day task-force meetings of public art specialists (selected with advice from—yes—NEA panelists) and a survey of information on programs across America, the project aimed to gather together into one resource "some of the best knowledge and experience in the country" on the administration and preservation of public art. A major impetus was the *Tilted Arc* controversy—a source of no small embarrassment to those involved with public art programs.

The introductory essay of *Going Public* sets the tone; it is entitled "Stretching the Terrain: Sketching Twenty Years of Public Art." Its author, Kathy Halbreich—credited as a curator and arts consultant (and member of the Massachusetts Council on the Arts and Humanities)—served on the task force and was, in Andrews's words, an "essential advisor" to the project. Not surprisingly, given the title of her essay, Halbreich's sympathies lie with "pioneering" projects, such as the work done in the 1960s by Carl Andre (whose media in those years included bales of hay) and Richard Serra (whose 1967 *Scatter Piece* consists of ragged scraps of rubber latex strewn over a studio floor). Halbreich also admires Scott Burton, who "blurred the distinction between life and art in a series of activities in which he appeared dressed as a woman, drugged (to sleep at a gallery opening), or naked." (Burton, we are told, "wanted to make art of moral consequence.") As for the present decade, Halbreich reports approvingly on the work of "performance poet" David Antin and "sound sculptor" Max Neuhaus (among others), who are currently devising a project for the Miami International Airport. (Remember, all of this is in the context of the Visual Arts Program.)

With such an introduction, what sort of conclusions are possible? The closing statement of *Going Public* acknowledges that "contemporary art continues to present a challenge for the viewer"—meaning, of course, that the public doesn't like or "understand" it. What solution is envisioned?

> As in other fields where new advances may be difficult to understand but are, nonetheless, respected [another allusion to science], we must develop methods of meaningful involvement and education which enable the public to respect that which public art contributes to our lives and culture.

That is, the problem is not with the "art" but with the public, which must be "educated" to understand "difficult" work. The people who will do the educating are, of course, the approved "experts"—whom Tom Wolfe has aptly dubbed the "art clerisy."

One Memorable Image

In spite of the misguided thrust of the influential NEA and GSA programs, some genuine public art *has* been created in recent years. No doubt the boldest example is Raymond Kaskey's *Portlandia*, a colossal figure created (under a one-percent-for-art program) for a major new municipal building in Portland, Oregon. Like all public art worthy of the name, *Portlandia* embodies and celebrates, in one memorable image, widely shared civic, cultural, and esthetic values. How did so traditional a work come to fruition in today's modernist climate? Not by public referendum (as Tom Wolfe mistakenly implied in *Newsweek*) but because the architect stipulated that the work must be a figure in the classical style. Had he not done so, the Portland Building might now display some vacuous abstraction.

Instead it is graced by the heroic figure of a young woman, solemn and benign in expression, with hair and drapery blown by an eternal wind. Half kneeling atop the entrance portico, she carries a trident (ancient symbol of the sea, to which the city is bound in commerce) and reaches down to extend her right hand to the people. According to media accounts, local citizens—apparently untroubled by the lady's anachronistic imagery or her titanic proportions (the crouching figure measures more than 37 feet high)—have enthusiastically embraced her, beginning with a gala maritime reception. Not since the arrival of the Statue of Liberty in New York harbor has a work of public art been greeted with such jubilation. Indeed, *Portlandia* is Miss Liberty's daughter in matter as well as spirit, since Kaskey painstakingly revived the demanding sculptural technique used by Liberty's creator, Auguste Bartholdi—that of hammering copper sheets over a honeycomb-like framework.

Almost a decade ago, Professor Sam Hunter—whose words served as introduction to this article (and who, it should be noted, participated in the Public Art Policy Project)—would have had us believe

that "contemporary monuments can no longer plausibly celebrate national heroes, patriotic or personal virtue, or great historic events" because "both the mythologies and the sustaining artistic conventions for such themes have vanished." Contemplating the phenomenon of *Portlandia*, one can only conclude that this professor (like so many of his "expert" colleagues today) knows not whereof he speaks. What is most lamentable is that present government (and corporate) "public art" programs enable voices like his to lend undeserved legitimacy to false art, while many genuine artists languish among us for want of recognition.*

* Suggested further reading: Suzie Boss, "Hail, Portlandia!," *ARTnews*, December 1985, 12–14; Douglas Stalker and Clark Glymour, "The Malignant Object: Thoughts on Public Sculpture," *The Public Interest*, January 1982, 3–21; George F. Will, "Giving Art a Bad Name," *Newsweek*, September 16, 1985, 80; and Tom Wolfe, "The Worship of Art," *Harper's*, October 1984, 61–68.

"Public Art" for Whom?

The recent installation of a newly commissioned work entitled *Masks (Pentagon)* by Thomas Houseago in New York's Rockefeller Plaza highlights the latest of a long list of bizarre projects spearheaded by the Public Art Fund. Like numerous other projects organized by the Fund and supported by prominent public officials and business leaders in recent years, it promotes the "anything goes" agenda of the contemporary artworld far more than it serves the public.

The Public Art Fund is a 501(c)(3) organization that receives support from individuals, corporations, and foundations for temporary exhibitions of "contemporary art" in New York City. Its stated aim is to "*redefine public art in relation to the changing nature of contemporary art*" (emphasis mine). Redefining art is, in fact, what the art establishment has long been bent on doing. The public, however, has not been buying the redefinition.

It is too soon to tell what the response of most ordinary people to the Houseago project will be. However, only yesterday (a beautiful spring day), very few of the many pedestrians I observed around the Plaza seemed even to be looking at the piece.

I asked three of them how they liked it. "Not very much," answered one, with a decided frown of disapproval. A second woman, who was struggling to get a picture of it with her cell phone, replied in some frustration: "I don't know what it is." Just one of the three answered that she found it "very interesting." (In *The Use*

For Piero's Sake, May 5, 2015.

and Abuse of Art, cultural historian Jacques Barzun aptly criticized "the Interesting as an esthetic category"—observing that it is "the first word [used] about the new and usually also the last," generally referring to "the offbeat, the Absurd, the Minimal or any other form of the unexpected.")

Also indicative is the public response to last year's Rockefeller Plaza installation of *Split-Rocker*—a floral construction by artworld megastar Jeff Koons. As judged from remarks following articles online, it ranged from confusion and boredom to a frank indictment as "crap."

Nor did the public respond with enthusiasm to an earlier, more expansive and expensive Public Art Fund project—Olafur Eliasson's *New York City Waterfalls*. Costing millions to construct (and resulting in substantial damage owing to the saline spray it produced), that project consisted of artificial waterfalls in four waterfront locations, one of them under the Brooklyn Bridge. The Fund's "most ambitious project" to date, it was actively promoted by Mayor Bloomberg. As indicated by countless comments following a post on a *New York Times* blog, however, the response of ordinary people to the *Waterfalls* project was overwhelmingly negative, often questioning its status as "art." A typically irreverent remark was: "Looks like the Brooklyn Bridge taking a leak if you ask me . . . an expensive leak." One person aptly quipped: "This is not art, it is plumbing!"

Houseago's project—a quasi-sculptural installation of five giant mask-like structures—is at least not plumbing. But it intrudes upon one of New York's most urbane public spaces. And its status as art is equally questionable.

Flouting the traditional view of art as something made with great skill and care, for example, the piece entailed such creative processes on Houseago's part as his incorporating the footprints left by his young daughter's dancing on damp clay and his "hurling lumps of clay down from a ladder." Not quite the techniques employed by the likes of Michelangelo or Donatello. The work also involves the interactive gimmickry of enabling visitors to view their surroundings through openings in the masks. Such spurious approaches to art-making are standard fare in today's artworld, which embraces virtually anything—except traditional painting and sculpture, that is.

What has been the point of the Rockefeller Plaza exhibitions? According to Jerry Speyer—chairman of Tishman Speyer (the owner of Rockefeller Center), which has co-organized them—"It's been an interesting way of educating the public." Educating the public about what? one might ask. The likely answer would be: about the establishment's view of what constitutes "contemporary art."

That view was succinctly expressed a couple of years ago by Glenn Lowry—the director of the Museum of Modern Art, of which Speyer also happens to be chairman. When I asked Lowry whether what some "contemporary artists" are creating might no longer be "art," he replied that, thanks to Marcel Duchamp (the putative creator of *Fountain*—a urinal that was purportedly transformed into "art" by his signing it with an assumed name), we can no longer ask that question. "If an artist does it, it's art," Lowry declared with finality.

That dictum has long been the mantra of the art establishment—with little thought being given to what qualifies someone as an "artist." Such an attitude does not "redefine" art. It undefines it. Ordinary people seem to get that.

Perhaps the time has come for the public to educate the Public Art Fund—as well as its all-too-willing cadre of public officials and business leaders (not to mention art experts such as Lowry)—who have for too long been imposing their distorted view of "contemporary art" on the rest of us.

Picasso's Sculpture
Much Ado about Very Little

The comprehensive retrospective *Picasso Sculpture*, which recently closed at the Museum of Modern Art in New York, elicited rapturous proclamations from prominent critics during its run.[1] In the eyes of *New York Times* critic Roberta Smith, for example, it was not merely "great" but a "work of art" in its own right.[2] It even prompted some art lovers to travel considerable distances to see it. A visitor I happened to talk with at the show told me her brother planned to fly down from Canada just for that purpose.

Despite the exhibition's exhaustive and exhausting scope (141 works spanning six decades of the artist's life), the bottom line for me was a net loss. For all his abundantly evident cleverness and invention, Picasso left me with a largely empty feeling. There was almost nothing I could connect with on an emotional level—other than in some cases a measure of disgust.

The show's "greatest coup," according to *The Guardian*'s "dyed-in-the-wool Duchampian" critic, was reuniting all six versions of Picasso's *Glass of Absinthe*—each of which incorporates an actual absinthe spoon.[3] Much ado about very little either in size or substance, to my mind. But perhaps I needed to be high on absinthe to fully appreciate these psychedelically cubist distortions.

Next in line for critical kudos were five monumental plaster heads of Picasso's hapless mistress Marie-Thérèse Walter (e.g., *Bust*

Aristos, February 2016.

of a Woman). These grotesque phallic-nosed sculptures were very likely among the pieces that *The Guardian*'s critic found "bracingly and thrillingly ugly." They struck me as sickeningly repulsive (the natural human response to anything ugly)—the more so, when I considered the lovely young woman who inspired them. If Picasso had ever submitted to psychotherapy, these works surely would have provided rich fodder for his shrink. In that connection, it is worth citing psychiatrist Carl Jung's view that a side of Picasso was "fatefully drawn into the dark," following "not the accepted ideals of goodness and beauty, but the demoniacal attraction of ugliness."[4]

Non-human animals fared a bit better in Picasso's three-dimensional oeuvre. And it was in works such as *She-Goat* that I found the few pleasures the show afforded me. In that captivating assemblage (incorporating elements as disparate as a wicker basket, palm leaf, and ceramic flowerpots), Picasso managed to embody the essence of a pregnant goat. Most tellingly, in contrast with his vastly overrated *Bull's Head*, one can lose sight of the assemblage's components to engage with the object represented. Equally effective for me in this regard was his *Crane*. And some pieces of decorative art with animal motifs, such as his *Owl (Vase)* with a fetchingly egg-shaped body, were also delightful.

The concluding gallery included two sheet-metal sculptures that have served as models for major public pieces. *Sylvette*—a cubist deconstruction inspired by the living beauty of Sylvette David, a young woman engaged to one of Picasso's neighbors on the Côte d'Azur—has been loosely reincarnated in cement on the grounds of New York University. (I'm reminded here of art historian Wilhelm Worringer's theory that abstraction is driven by an impulse to distance oneself from reality and thereby seem to control it.[5] Was that perhaps a factor in the psychology of this piece by an aging artist, recently abandoned by his longtime mistress Françoise Gilot, and besotted by the loveliness of a neighbor's fiancée?)

The other sheet-metal work in question, *Maquette for Richard J. Daley Center Sculpture*, gave rise to this urban monstrosity in the heart of Chicago. Though the Daley piece is said to have become one of Chicago's "beloved icons," I suspect that its popularity owes more to Picasso's fame and its utility as an unintended

jungle gym (visitors reportedly use the work's base as a slide!) than to its esthetic attributes.

In the end, I exited from this highly touted exhibition wondering if the vast majority of works in it would have gained anyone's attention were it not for the Picasso brand name and its attendant aura of "genius."

What's Wrong with Today's Protest Art?

What's wrong with today's "protest art"—which occupies so much of our public space? Mainly this: it's long on protest and virtually devoid of *art*. That sad fact has been vividly demonstrated of late by two New York exhibitions: *Art and China after 1989: Theater of the World* (closed January 7 at the Guggenheim) and *An Incomplete History of Protest: Selections from the Whitney's Collection, 1940–2017*, now on view at the Whitney Museum.

Words in Place of Images

The first work encountered by a visitor to the Whitney exhibition epitomizes the shortcomings of recent "protest art." It consists merely of a black flag emblazoned with the statement "A Man Was Lynched by Police Yesterday" in bold white letters. Created by Dread Scott (the pseudonym of arts activist Scott Tyler, b. 1965), the flag referred to the 2015 shooting of an unarmed black man, Walter Scott, by a white police officer in North Carolina. But one would have to read the wall label to learn that.[1]

I should add that Dread Scott first attained notoriety with his 1989 protest piece *What Is the Proper Way to Display a U.S. Flag?*, which he called an "installation for audience participation." The participation it invited was for viewers to step on the American flag while writing their thoughts in the comments book displayed above

For Piero's Sake, February 11, 2018.

it. That this participatory installation was part of an exhibition orga-
nized by Scott's fellow students at the School of the Art Institute of
Chicago tells you something about the caliber of art instruction at
that institution. Yet degrees from such institutions are what qualify
someone as an "artist" these days.

When Scott's 1989 flag piece provoked a national furor, he
claimed (perhaps disingenuously) that his intent "was not to des-
ecrate the flag" but to "open up discussion about America, U.S.
patriotism, and the . . . flag." As is often the case with such "concep-
tual" installations, however, the piece was viewed quite differently
by the public—not least, members of Congress. In any case, Sena-
tor Bob Dole, for one, was entirely justified at the time in referring
to Scott as a "so-called 'artist.'"

By the same token, Scott's "A Man Was Lynched" flag is so-called
art. Although it manages to trigger a momentary emotional response
by Scott's having substituted the negatively charged verb "lynched"
for the blander but more precisely relevant term "shot," it pales in
comparison with the impact of a genuine work of art dealing with
the same theme. For example, Paul Cadmus's drawing *To the Lynch-
ing* (1935)—unlike Scott's flag—chillingly embodies the brutality of
a lynch mob. So, too, Elizabeth Catlett's linoleum cut *And a Special
Fear for My Loved Ones* (1946) starkly conveys the power of the
lynchers and the helplessness of their victim.

Moreover, by representing the human dimension of such acts,
these images transcend the particular circumstances of any single injus-
tice to convey something more universal. That is what makes them art,
in contrast with Scott's mere verbal protest against one unjust event.
Since both of these works are actually in the Whitney's collection, why
were they not included this exhibition? (The 1940 starting date could
have easily been extended back five years to accommodate the Cad-
mus drawing.) Might it be that such works of genuine art would have
revealed the relative feebleness of more recent protest pieces?

The vast majority of the works displayed at the Whitney, like so
much "contemporary art," rely heavily, if not exclusively (as in Scott's
lynching flag), on verbiage to get their message across. Those that
employ imagery do so mainly through photographs—not through
the arts of drawing or painting.

In a gallery devoted to Vietnam war protests, two whole walls comprise anti-war posters that make use of both words and photographs, as well as of some simple imagery. According to the docent I happened to hear, they were "not meant as art," however, but were intended as "ephemeral" items to be posted on one's dorm room wall, for instance, and then discarded. When I asked why they are being exhibited in a museum of art, she responded that we can now appreciate their "artistic qualities." Just what those qualities are she did not say.

Nor are "artistic qualities" evident in Martha Rosier's video piece *Semiotics of the Kitchen* (1975)—a mildly amusing feminist-inspired parody of Julia Child's *French Chef* TV series. According to the Museum of Modern Art, the piece expresses the "rage and frustration of oppressive women's roles." Never mind that Child saw her role in the kitchen as anything but "oppressive."

Perhaps the most absurd of the Whitney's exhibits is *Spaces and Predicaments*, comprising two abstract installations: *Pyramid Up and Down Pyramid* (1969), by Melvin Edwards, and *Internal I* (1977), by Senga Nengudi. The wall text informs us that these artists "chose personal, oblique, and allusive means to question how social spaces are made, engaged, and controlled." Oblique and elusive might have been a more accurate description. Activist-artist David Hammons is quoted as saying that their work is "abstract art with a message." I defy anyone to discern the message from the work alone, however. Like most contemporary work, it is unintelligible without a verbal gloss.

Animal Cruelty and Other "Conceptual" Aberrations

The Guggenheim's *Art and China after 1989* provoked heated public controversy even before it opened, thanks to a *New York Times* article previewing it ("Where the Wild Things Are: China's Art Dreamers at the Guggenheim," September 20, 2017). The main objection was to several "conceptual art" pieces involving the exploitation of live animals. As described by the *Times*, one was a seven-minute video showing

> four pairs of American pit bulls tethered to eight wooden treadmills. The camera closes in on the animals as they face each other, running at high speed. The dogs are prevented from touching one

another, a frustrating experience for animals trained to fight. The dogs get wearier and wearier, their muscles more and more prominent, and their mouths increasingly salivate.

Although animal cruelty was the main public concern, some of the many comments posted by readers in response to the *Times* article astutely questioned whether such work should even qualify as art.

As I noted on Facebook on October 12, the Guggenheim withdrew the three most offensive pieces. But far from acknowledging that such pieces were in fact morally reprehensible, the museum's press release merely cited "concerns for the safety of visitors, staff, and participating artists after ongoing and persistent threats of violence in reaction to the incorporation of live animals in the creation of the works." Moreover, it missed the larger point made by many *Times* readers, including me. Such "conceptual" pieces should not be regarded as art.

Yet the Guggenheim show consisted almost exclusively of such work. As I've indicated in "Is Ai Weiwei an Artist?" (*For Piero's Sake*, February 11, 2015) and argued more fully in *Who Says That's Art?*, however, "conceptual art" is an entirely bogus genre. It began as a deliberate anti-art phenomenon, just one of the many bizarre postmodernist reactions against the dominance of Abstract Expressionism. In fact, its first theorist, Henry Flynt, is explicitly characterized as an "*anti-art* activist" (emphasis mine) on his authorized website.

Apart from the troubling fact that "conceptual" work invariably "defie[s] easy explanation" (as the Guggenheim itself acknowledged in its introductory wall text), the term falsely implies that what is distinctive about such work is that, allegedly unlike traditional art, it deals with ideas. Genuine art has always dealt with ideas, however. The difference is that in traditional work the ideas are embodied in intelligible imagery. They are conveyed directly.

Consider, for example, two of the few paintings that were included in the Guggenheim show. Wang Xingwei's *New Beijing* depicts a street scene in which two bloodied penguins lying supine on a wooden stretcher are being hurriedly transported by bicycle past two staring onlookers. The image has the impromptu quality of a news photo captured on the run. Created soon after Beijing had won its bid for the 2008 Summer Olympics, *New Beijing* is an

ironic allusion to the tragic Tienanmen Square Massacre of 1989, in which peaceful protestors were brutally shot down by government forces. Also chilling is Liu Xiaodong's *Burning a Rat*, showing two well-dressed young men standing on a river embankment, enjoying the spectacle of watching a rat die that they have set fire to. It is a disturbing embodiment of utter anomie.

Such works were notable exceptions to the countless protest pieces that have no relation to art, however.

Ai Weiwei Is Not an Artist

Protest is a vitally important recourse in any society short of a utopia. But absent art, it has no place in an art museum. That caveat applies to Ai Weiwei—China's most famous "artist-activist"—no less than to the innumerable others in that category. Given Ai's fame, of course, it is no surprise that his work was featured in the Guggenheim show. In addition to an ongoing documentary film series co-curated by him (*Turn It On: China on Film, 2000–2017*)—which included some of his own work—Ai's nearly lifesize photographic triptych *Dropping a Han Dynasty Urn* (1995) filled a large wall. According to *The Art Story* website, this piece "demonstrates his show-stopping conceptual brilliance." It strikes me as a rather heavy-handed gesture in more ways than one, however—whose political message was vitiated amidst tangential speculations regarding the actual value of the crockery involved.[2] In any case, it isn't art any more than Marcel Duchamp's "readymades" (a chief source of inspiration for Ai since his years as an art student in the U.S. in 1981–1993) are art.[3]

More effective as political protest but even farther removed from the realm of art was Ai's most acclaimed instance of anti-government activism, his *Sichuan Earthquake Names Project*—prominently featured at the Guggenheim. Heartrending videos of survivors testifying to the loss of loved ones in the face of bureaucratic evasions and irresponsibility were displayed alongside a list of the thousands of victims identified by the project.

Moving though this testimony to tragic loss and monumental wrongdoing was, it constitutes a species of documentary reportage, not a work of art. Curators and museumgoers alike should recognize the difference.

Cy Twombly in
Mr. Morgan's House?

Among other trends I deplore in *Who Says That's Art?* is the post-modernist artworld's growing incursion into institutions devoted to world-class private collections of the past. Such incursions—in clear violation of the founders' tastes—are achieved by directors and curators bent at all costs on introducing "contemporary art" (a deceptive term encompassing only anti-traditional, "avant-garde" work). They could not do so without the complicity of trustees, however—some of whom collect such work. Still worse, financial support for exhibiting this work of dubious artistic value often comes from the dealers who trade in it.

Cy Twombly: Treatise on the Veil, which closed last week at the Morgan Library & Museum, is symptomatic of this lamentable trend. So much was wrong about it that I hardly know where to begin. I'm hard pressed to say which is worse, for example—the execrable work? or the inane curatorial glosses upon it?

The show's featured work was Twombly's "monumental" *Treatise on the Veil*—a 33-foot-wide expanse of gray house paint, relieved only by a strip of thin white lines. "Monumental" properly refers to more than mere size, however; it also connotes importance—significance. The significance of Cy Twombly (1928–2011) we're told, is as "one of the most important artists to emerge in the wake of Abstract Expressionism." What is his work noted for? Its "rich repertoire of

For Piero's Sake, February 3, 2015.

marks, scrawls, scribbles, doodles, and scratches"—a contradiction in terms if ever there were one.

We gain a sense of that "rich repertoire" from the series of preparatory "drawings" that flanked *Treatise on the Veil* at the Morgan. These indeed offer "a fascinating window into the artist's creative process." One such "drawing" was glossed as follows:

> [Twombly's] folded strips, . . . smudges, and illegible scrawls create a rich and layered surface and reveal the artist's pleasure in the process of making. Note, for instance, the use of different kinds of tape [used to fasten the folded strips].

I'm tempted to add: I'm not making this up—cliché though it may be. (For an appreciative review that outdoes in inanity even the Morgan curator's glosses, see "Cy Twombly's Remarkable Treatise," *Hyperallergic*, December 21, 2014.)

The introductory wall text for the Twombly exhibition informed visitors that *Treatise on the Veil* was inspired by a "musical" piece entitled *The Veil of Orpheus*, by the French composer Pierre Henry. If you fail to discern the "increasingly lyrical feel" the Morgan curator imputed to Twombly's work, never mind. You won't hear it in Henry's *musique concrète* either.

Finally, readers of *Who Says That's Art?* should not be surprised to learn that partial funding for the Twombly exhibition was provided by none other than the Gagosian Gallery—Twombly's dealer. Asked by the Gagosian's director, Mark Francis, what prompted the exhibition, Morgan curator Isabelle Dervaux explained that it fits into the museum's decade-long program of exhibiting the work of twentieth-century artists "for whom drawing was an important medium and who have made a particular contribution to its history." (See the upcoming *Embracing Modernism: Ten Years of Drawings Acquisitions*.)

Twombly's "marks, scrawls, scribbles, doodles, and scratches" may be Dervaux's idea of drawing, but they were surely not Mr. Morgan's. The trustees of the Morgan should hang their heads in shame at this latest travesty of his legacy.

Folded Paper and Other Modern "Drawings"

Is a piece of paper folded and then unfolded a "drawing"? A curator at the Morgan Library & Museum thinks so. And the Associate Dean of the Yale School of Art agrees with her. The "folded paper drawing" in question is by "conceptual artist" Sol LeWitt (1928–2007). It is one of more than a hundred works (few of them meriting praise in my view) featured in the exhibition *Embracing Modernism: Ten Years of Drawings Acquisitions*, at the Morgan through May 24. Among other unconventional items included in that show is Gavin Turk's *Rosette*, a "drawing" he created by placing a sheet of paper on his van's exhaust pipe and then starting the engine.

Belonging to the old school that regards drawing as the art or act of representing people, places, or things on a surface chiefly by means of lines (as in Picasso's *Portrait of Marie-Thérèse Walter*, also on display at the Morgan), I was moved to ask the curator of the show, Isabelle Dervaux, how she defines "drawing." Surrounded by eager members of the press, she did not hesitate to reply: "anything on paper." (As was clear from the aforementioned examples, she literally meant *anything*.) Then she quickly added, rather testily: "I hate splitting hairs over what a drawing is."

Hardly splitting hairs, Dervaux's wall label for the LeWitt piece informs us that he

For Piero's Sake, March 31, 2015.

radically transformed the medium of drawing . . . [in part,] by exploring . . . different ways of producing a drawing—for instance, by tearing or folding paper. Here, he created a grid by folding and unfolding the sheet. "I wanted them to be another kind of drawing," he said. "They do make lines."

As for Gavin Turk, Dervaux notes that he was one of the Young British Artists "who gained notoriety in the 1990s" by creating "sculptures and installations that question traditional notions of authorship." Nonetheless, she calls his exhaust pipe drawing "elegant." Apparently unwilling to split hairs over the meaning of that word either, she ignores that it generally means a "refined and graceful" style and implies discriminating selectivity on the part of the maker. Having replaced himself as maker with his van's undiscriminating exhaust fumes, Turk has in fact rendered the notion of "elegance" preposterous.

On the very next day after the press preview for the Morgan show, I happened to attend a panel discussion at the Art Students League on the revival of drawing instruction in art education. In the Q&A following the panel's presentation, I introduced myself as the author of a new book dealing in part with the concerns discussed by the panel, and cited the example of LeWitt's "folded paper drawing" at the Morgan as cautionary evidence of the contemporary artworld's ignorance regarding the discipline of drawing.

Far from being applauded as a significant reminder of the challenges to be overcome, my remark met with a load of invective from one of the panelists—the Associate Dean of the Yale School of Art, Samuel Messer. Assailing me for daring to suggest that LeWitt's work was not a drawing, he accused me of seeking to "impose" my view of art on others through my book (*Who Says That's Art?*)—the title of which I had mentioned. None of his fellow panelists ventured to agree with me on the status of LeWitt's "drawing" (although two of them later confessed privately to wholehearted agreement). Nor did James McElhinney, who teaches drawing at the League and had organized the panel, utter a word in defense of my position. Nor, finally, was there a peep of comment from any of the dozens of people in the audience.

I sat there in stunned silence, waiting till discussion of other points had ended, and then went up to Messer. He was wrong, I said,

to impute an authoritarian motive to me without having read my book, the goal of which is in fact to stimulate intelligent debate. With considerable emotion, Messer proceeded to inform me that LeWitt had worked the way he did because he was a "very devout Jew"—as if that explained why he had eschewed all forms of depiction and was driven to creating "folded paper drawings."

As it happens, the piety ascribed to LeWitt by Messer is not mentioned in any of several biographical accounts I have read. But even if it were true it would scarcely suffice to legitimate Lewitt's unconventional approach to "drawing." As another very different show now at the Morgan attests (*Hebrew Illumination for Our Time: The Art of Barbara Wolff* [see "Two Exhibitions Worth Praising," above, pages 54–56]), Jewish artists have long found ways to engage in pictorial representation without transgressing the Second Commandment—which most authorities agree was intended to prevent idolatry, rather than to suppress all imagery.

Nor does LeWitt's *wanting* folded paper "to be another kind of drawing" (since "they do make lines," to quote Dervaux's wall label) *make* them *drawings*, properly speaking. Because unlike drawings, they do not *represent* something, which is the whole point of drawing—a basic fact that is evidently beyond the ken of both Dervaux and the associate dean of one of America's most prestigious schools of art.***

**In recent rankings, *U.S. News & World Report* rated the Yale School of Art first in the United States for its Master of Fine Arts programs.

Bill Viola's *Passions*
No Kinship to Rubens

"Video artist" Bill Viola's latest exhibition, *The Passions*, recently closed at the Getty Center in Los Angeles. It will also be shown at the National Gallery in London and the Munich State Paintings Collection. As those august foreign venues suggest, Viola (who represented the United States at the 1995 Venice Biennale) has become one of the biggest names on the international art scene. When one considers that the London and Munich collections boast masterpieces of European painting by the likes of Leonardo, Jan van Eyck, Velazquez, Rembrandt, and Vermeer, however, it is reasonable to ask what entitles Viola, who is not even a painter, to enter their eminent ranks.

According to a press release issued by the Getty, *The Passions*

> explores how changing facial expression and body language express emotional states using flat-screen monitors of various sizes, some resembling portable altarpieces of the late Middle Ages and the Renaissance. After filming the actors at very high speeds, Viola replays the action in extreme slow motion, with riveting results.

"Riveting" perhaps—possibly even "moving," as many viewers indicated in comments posted on the Getty's website. Such responses are understandable, since human beings are predisposed to be drawn to, and affected by, expressions of emotion in their fellow beings. But what makes Viola's "explorations" (a notion much abused by post-

Aristos, May 2003.

modernist critics) *art*? Surely his work's claim to that status must rest on more than a superficial resemblance between his flat-screen monitors and portable altarpieces of medieval and Renaissance Europe.

In their attempt to shore up Viola's shaky artistic credentials, the Getty curators claim a kinship between him and the great Flemish baroque painter Peter Paul Rubens, because (as noted in the production credits on the museum's website)

> Rubens had to be a producer, an organizer, and a supervisor of a team of assistants, a collaborator with other specialist painters and printmakers, and a manager of an ambitious enterprise for picture-making—in short, a virtuoso. [Similarly,] *The Passions* couldn't have been made without a rare ability to mobilize and inspire a lot of other people, understand their specialties, organize their work, and delegate authority.

"Much like Rubens," concludes John Walsh, Curator and Director Emeritus of the Getty, "Viola had to call upon his ability to mobilize and inspire actors and a large production crew to make *The Passions* come to life." This may sound plausible enough to uninitiated museumgoers. Walsh, however, should know better. Having served as a curator of painting at the Metropolitan Museum of Art and the Museum of Fine Arts, Boston, he must surely be aware that Rubens's reputation as an artist is due to more than his mobilizing, inspiring, and organizing other people; that it has mainly to do with his astonishing ability to give vivid form to events of great historic, religious, or mythic moment, to bring them so throbbingly to life on such a monumental scale that even viewers repelled by the beefy proportions of his figures can be struck by the drama of the scenes.

Contrary to Walsh's vacuous analogy, it was primarily Rubens's keenness of observation and extraordinary powers as a draughtsman—not his management of other people—that enabled him to vividly embody the visions spun out by his fertile imagination. These were the attributes that made Rubens—or make anyone—a great visual artist (all the rest is of secondary, tangential significance). And these are precisely the capacities that Viola and other "video artists" lack. These would-be artists employ video because they cannot draw

or paint. In the main, they are simply videographers—technicians recording aspects of reality, much as photographers do.

Like the postmodernist photographer Cindy Sherman, Viola goes to considerable lengths to stage and manipulate the scenes he records, so that they become, in effect, *tableaux vivants* or a species of performance art—neither of which amounts to a true art form. And despite his employment of video, Viola's work in fact resembles still photography in more than one respect. By making use of slow motion and mechanically repeated "loops" (a favored device of postmodernists), Viola deliberately downplays the temporal nature of his images, so much so that they often become nearly static in their effect. Most important, he does not attempt to provide the dramatic or narrative coherence necessary to art in temporal media such as film and video.

Notwithstanding the pretensions of curators and publicists, it is not to the artistic tradition of Rubens that Viola belongs, but to the anti-art impulses of the 1960s—impulses still being played out in the artworld. Viola's true predecessors were not the Old Masters of European painting, they were the "video art" pioneers Nam June Paik and Bruce Nauman.

Happily, not all museumgoers are gulled by the artworld hype surrounding Viola's work. "I longed for the context that Viola has said he purposefully doesn't provide," remarked one astute visitor to the Getty. "You call this art?" quipped another.

The Apotheosis of Andy Warhol

Does one need yet more evidence of the intellectual, esthetic, and moral poverty of today's artworld? If so, *Regarding Warhol: Sixty Artists, Fifty Years* at the Metropolitan Museum of Art supplies it in abundance.

Since the emergence of Andy Warhol (1928–1987) on the art-world scene in the early 1960s, his work has by most accounts exerted an incalculable influence on what passes for contemporary culture. This is the first major exhibition to examine the nature and extent of that influence, however. The problem is that it has come only to praise Warhol, not in any way to bury him.[1]

Breathlessly heralding Warhol's "transformative contributions to the worlds of art and media" as "cultural milestones of the modern era," the Met then proceeds to document them. First, there was his "fascination and engagement with the imagery of everyday life" and his "interest in commonplace or banal subject matter found in newspapers and magazines." Presumably, they have given us such artistic achievements as Robert Gober's *Untitled* (1992). The label next to the Met's version says it was made of "photolithographs and twine." But you would be forgiven for supposing it was just stacks of newspapers tied up for recycling.

Then, too, Warhol's groundbreaking *Brillo Soap Pad Boxes* (1964) paved the way for notable works such as Damien Hirst's *Eight Over Eight*—not to mention a whole new theory of art promulgated by philosopher Arthur Danto, arguing that works of art need no longer

Aristos, December 2012.

be perceptibly discernible from non-art (see pages 580–84 of his influential essay "The Artworld").[2] Hirst, by the way, thinks that his piece is "sculpture," but no one could blame you for thinking it is nothing more than a display case lifted from your local pharmacy.

There was also Warhol's "engagement with portrait making"— which consisted mainly of lifting photographic images from the mass media and having his "Factory" assistants revamp them through largely mechanical silkscreen processes.[3] So much for the idea that a portrait "does not merely record someone's features . . . but says something about who he or she is, offering a vivid sense of a real person's presence" (to quote the Met itself from its web page on "Portraiture in Renaissance and Baroque Europe").

The exhibition's third section—entitled "Queer Studies: Camouflage and Shifting Identities" —"outlines Warhol's importance as an artist who broke new ground in representing issues of sexuality and gender in the post-war period." That breakthrough is credited with ushering in a "new openness toward different varieties of queer identity . . . largely through work by photographers such as . . . Robert Mapplethorpe."

Never mind that jurors in the infamous 1990 Mapplethorpe obscenity trial expressed a concern no doubt shared by many reasonable people. They deemed the images in question to be merely "obscene"—defined as "appealing to prurient interests and depicting sex in a patently offensive way." It was only the testimony of purported experts from the artworld as to the images' "artistic" merit that saved them from being ruled as pornography.

Then, too, Warhol's "interest in artistic partnership through filmmaking" produced such stellar achievements as his film *Lonesome Cowboys* (1968). The Met's wall label praises its "exuberant energy." If you were to sample a YouTube clip from the film (not in the exhibition), however—showing two cowboys gabbing about hair care, fashion, and ballet positions—you might find it mind-numbingly boring. And if you paused at the exhibition to view the more provocative clip that was screened there, you would have good reason to wonder if you were really in an art museum or had instead stumbled upon a pornographic peepshow.

In a lengthy 2010 *New Yorker* article entitled "Top of the Pops: Did Andy Warhol Change Everything?" cultural critic Louis Menand

argues that the "essence of Warhol's genius was to eliminate the one aspect of a thing without which that thing would . . . cease to be itself, and then to see what happened." As Menand observes, Warhol

> made movies of objects that never moved and used actors who could not act, and he made art that did not look like art. He wrote a novel without doing any writing. . . . He had other people make his paintings.
>
> And he demonstrated, almost every time . . . , that it didn't make any difference. His Brillo boxes were received as art, and his eight-hour movie of the Empire State Building was received as a movie.

True. But that is not a testament to Warhol's "genius." It is instead compelling evidence of the artworld's folly.

Did anyone at the Met consider whether Warhol's influence might be more *destructive* than *creative*, more negative than positive? At the press preview, I put that question to Marla Prather (Curator of the Met's Department of Modern and Contemporary Art), who co-curated the exhibition. She replied: "We didn't, but many people do." Since many people do, shouldn't she and her co-curator, Mark Rosenthal, have acknowledged such dissenting views—rather than simply perpetuate the misguided notion of Warhol as a latter-day culture hero?

When I further suggested to Prather that in promoting "contemporary art" along Warholian lines the Met systematically excludes painters and sculptors adhering to a more traditional view, her assistant objected. The museum had just held a "wonderful" exhibition of Ellsworth Kelly's *Plant Drawings*, she declared.

Could Kelly's unimpressive minimalist drawings have gained notice, however, had he not already been an artworld celebrity "for his rigorous abstract painting" (to borrow the Met's words)? Though I did not get to pose that question, the answer is "not likely." (For comparison, see work by accomplished little-known artists featured in the *15th Annual International* exhibition of the American Society of Botanical Artists.) In any case, the conversation ended with Prather's opining that "art can't just be painting and sculpture any more—*that's over*," before she walked away.

Fake Art
The Rauschenberg Phenomenon

The phenomenon of fake news is on everyone's lips in the realm of politics these days, but the equivalent of fake art in the contemporary artworld has yet to be adequately reckoned with. Google the term and you'll find ample news of forgeries—work imitating that by famous artists and passed off as actually by them. What I'm referring to is far more insidious. It is the *creation and promotion of original work that passes for art in the eyes of the cultural establishment but is not art by any meaningful standard, much less by the purported artists' own statements about it.*[1]

To witness this phenomenon in full swing, you could find no more telling instances than the exhibition *Robert Rauschenberg: Among Friends* (which opened this week at the Museum of Modern Art in New York) or the exhibition catalogue by co-curators Leah Dickerman of MoMA and Achim Borchardt-Hume of Tate Modern (where the exhibition originated). They demonstrate—in spades—both the creation and the promotion of fake art.

Collaboration to Produce Anti-Art

The theme of the show—the first major retrospective since Rauschenberg's death in 2008—is his lifelong penchant for collaboration, not only with others in the avant-garde artworld but also with scien-

For Piero's Sake, May 24, 2017.

tists, engineers, and technicians. That aspect of his work appealed to Dickerman because—as she stated at a press preview on May 17—it dispels the "myth of a genius working in solitude" and substitutes the "creative power" of collaboration.

So let's take a look at some of the products of such "creative" collaboration by this alleged "genius." A notorious early example is Rauschenberg's *Erased de Kooning Drawing*. His "collaborators" were Willem de Kooning, who gave him the original drawing, and Jasper Johns—who persuaded him to exhibit the erased result in a gilt frame, labeled with the foregoing title. The piece was inspired, the MoMA wall text informs us, by Rauschenberg's just "wanting to know whether a drawing could be made out of erasing." He might have saved himself the month's effort and forty erasers he later said he had devoted to it had he simply consulted dictionary definitions of "drawing" and "erasure." In a sophistic gloss on this absurdity, however, Dickerman observes: "Rauschenberg set out to liberate the negative term, the unmaking from the making."[2]

Like other work by Rauschenberg (with or without collaborators), *Erased de Kooning Drawing* is, in fact, a piece of *anti-art*. In the spirit of the Dadaists who inspired him, his primary aim was to challenge prior art, not to create something new in its place. Tellingly, the section of Dickerman's essay in which that piece is discussed is entitled "The Destruction of Painting." At later stages of his career, Rauschenberg was similarly involved in the destruction of sculpture, dance, and drama as coherent forms of expression. In Dickerman's view, such activities were "creative."

Can destruction be creative? True, many economists recognize the phenomenon of "creative destruction" in the economic sphere. In it, the new economic order displacing the old is itself seen to be of value. Thus it is truly "creative," having produced a new economic value. But can any sane person not besotted by artworld sophistry honestly say that Rauschenberg's erased drawing—or his *Tire Print* (a collaboration with John Cage)—has *artistic* value in itself? Only by ignoring or denying that art has a definable identity. Which is of course what Rauschenberg and his defenders have done.

Ignoring Essential Distinctions

Like many observers, Dickerman rightly stresses that what Rauschenberg was engaged in was an "assault on Abstract Expressionism." What she misses, however, is that the utterly daffy forms his assault took negated not just the overrated and misguided work of the acclaimed abstract painters he hung out with at the Cedar Tavern but also the genuine art that had been produced since time immemorial and that was still being created by painters such as Andrew Wyeth. While Abstract Expressionism's "claims of . . . psychic and existential significance" were indeed insupportable, those of traditional art were not.

Much is made in the MoMA exhibition materials of Rauschenberg's famous claim that he aimed to work in the "gap" between art and life. Has anyone located that "gap" apart from Rauschenberg's reference to it? I think not. Because there is no such *gap*. There is, however, a *distinction*. It consists in this: *art* is *about life*—a fact that implies it is *different from* (though profoundly related to) life itself. Failing to grasp that principle, Rauschenberg consistently flouted it. As Dickerman uncritically observes, he not only "admitt[ed] ordinary things into the domain of art," he also "imagin[ed] . . . an art that did not separate itself from lived experience." She regards that as "welcom[ing] the quotidian." I see it as obliterating art.

Rauschenberg once explained: "I was working either with devices that would let the work compose itself, or stepping back enough to let the accidents take over." On another occasion, he declared: "I don't want to be in full control." Like numerous other statements made by him, those declarations are tacit admissions that what he was doing was something other than art, since the concept of art, at root, implies control by the maker. Nor did Rauschenberg intend to convey meaning or "express a message," though works of art had always done so.

At the press preview, I asked Dickerman whether, in view of such statements, one might be making a big mistake in treating Rauschenberg's work as if it were art. A long, awkward pause followed. She then responded: "For me, that doesn't resonate." Rauschenberg's approach to art was "very egalitarian," she explained (echoing a notion prominent in her catalogue essay). He thought that "all things should be admitted [in art]," she added.

Rauschenberg's "Combines"

The works that most fully exhibit Rauschenberg's "egalitarian" approach are his so-called Combines—a term he coined to characterize the bizarre pieces for which he is probably best known. Neither paintings nor sculptures (nor art), they incorporate a motley assortment of two- and three-dimensional objects. Combines displayed at MoMA include *Monogram* (featuring a stuffed goat girded with a tire[3]), *Black Market* (comprising, among other things, a street sign, four clipboards, and an old suitcase), *Pantomime* (containing two electric fans), and *Gold Standard* (a gilt folding screen cluttered with diverse objects and tethered to a ceramic dog on a bicycle seat). To my mind, they suggested what might be produced in the occupational-therapy ward of a mental asylum that could only afford to supply its inmates with materials collected from the town dump.

Many MoMA visitors I observed smiled at the sight of the Combines—as one might smile at the antics of a dotty uncle. But shouldn't we expect more from the work of a "defining figure of contemporary art" (to quote the MoMA press release)? Such idiotic fake art, like other examples by Rauschenberg, is far more insidious than forgeries, because it undermines the very idea of art.

One should not blame the dotty uncle, however. He could not help it if he was slightly daft.[4] The principal blame for such a travesty of art belongs to the curators, institutions, and sponsors (from the Terra Foundation for American Art to Bank of America and Bloomberg Philanthropies) who elevate the dotty uncle's antics to the status of art—not to mention the critics who help legitimize it, such as Holland Cotter of the *New York Times*.[5]

Old and New Art
Continuity vs. Rupture

For today's art establishment (including once-conservative institutions such as the Metropolitan Museum of Art and the Morgan Library), contemporary art must be radically "new"—the more unprecedented or deskilled in form and transgressive or inscrutable in content the better.[1] An intrepid group of dedicated contemporary artists begs to differ, however. They are the largely neglected painters and sculptors known as Classical Realists. Devoted to continuing in the grand tradition of Western art since the Renaissance, they spend years honing their craft, striving to be worthy of the estimable predecessors who inspire them.[2]

The *Unbroken Line: Old and New Masters*, a modest exhibition at the Robert Simon Fine Art gallery (a stone's throw from the Met) through June 8, begins to give them their belated due at last. As the title implies, it juxtaposes work (mostly portraits and still lifes) by faculty and recent graduates of the Grand Central Atelier with pre-modernist paintings and drawings from the gallery. (GCA is one of the many ateliers that have been created in recent decades to provide the sort of classical training generally missing from academic BFA and MFA programs these days.) The juxtaposition demonstrates that these relatively young artists clearly hold their own alongside the Renaissance and Baroque work Robert Simon specializes in.

For Piero's Sake, June 7, 2018.

Simon, by the way, is the art historian who discovered and identified the lost *Salvatore Mundi* by Leonardo that sold for a record-breaking sum last year. So he knows a thing or two about the finer points of "fine" art. The idea for this unprecedented exhibition came to him after he had enrolled as a student at Grand Central to improve his understanding of the technical side of painting, a peripheral aspect of his training as an art historian. The quality of the work he saw at GCA so impressed him that he proposed this show, which he curated with two GCA artist-instructors—Colleen Barry and Anthony Baus (both b. 1981). Barry and Baus selected works from the atelier, which Simon then paired with "sympathetically similar" images from his stock.

These Comparisons Are Not Odious

An especially apt pairing was of *Sea Bass* by Justin Wood (b. 1982) with *A Still-Life "Pronk"* by Joris van Son (b. 1623). For me, the recent work loses nothing by the comparison, and is even more appealing in its relative simplicity—as good as anything by the still-life master Chardin. Though I've never been a fan of dead-fish paintings, Wood's sea bass is compelling in its plump iridescence, as is the huge brass pot standing ready to receive it. Two other still lifes by Wood in the show are also of impressive quality.

A more unexpected juxtaposition placed *David*—an unpretentiously secular contemporary portrait by Jacob Collins (b. 1964), GCA's founding force—next to *Christ Blessing* by Vittore Carpaccio (b. ca. 1465–70). Notwithstanding the works' vastly different significance, they demonstrate the riveting power of a direct frontal gaze.

Mastery of the human figure is evident in two drawings by Baus—*Nude in Attitude of Defeat* and *Study for an Allegory*—alongside seventeenth-century drawings by Benedetto Luti and Francesco Monti, respectively.

But the strongest suit of the show is portraiture. Especially fine are the examples by Barry—most notably, *Black Hat* and *Portrait of the Artist's Mother*—sensitive depictions of pensive youth and somewhat worn and wary age. Also striking are *Portrait of a Young Woman* by Rachel Li (b. 1995) and an untitled *Portrait* by Will St. John

(b. 1980), side by side with a similarly toned seventeenth-century Bolognese *Portrait of a Boy*.

Despite their evident similarities with earlier art, each of the new works is a unique take on aspects of humanity or things we value. Most significantly in today's context, each subject is endowed with a degree of gravitas. Moreover, these paintings and drawings are as fresh and important now as the comparable works from the past were in their day. Only the foolish modernist insistence on originality at all costs would prompt the dismissive judgment "It's been done" regarding such contemporary work in a traditional vein.

Can it be a hopeful sign that curators from the Metropolitan Museum were spotted in the crowd at the show's opening? Might they have carried word back to their esteemed institution suggesting that its view of "contemporary art" needs revising?

The Establishment View of Contemporary Art

As one might expect, the establishment view—in sharp contrast with the work shown at Robert Simon—is widely shared by art critics, including members of the International Association of Art Critics (AICA), to which I was recently admitted. Last month I attended the annual meeting of AICA's U.S. section, at the offices of *The Brooklyn Rail*. I alternated between feeling like Daniel in the lion's den and the fox in the henhouse.

On the way to the meeting from the subway station, a longtime AICA member, Suzaan Boettger, struck up a conversation with me. An art historian who teaches at Bergen Community College, she specializes in "environmental art," having written the book *Earthworks: Art and the Landscape of the Sixties*—regarded as the "definitive history" of such work by the *New York Times Book Review*. I, on the other hand, consider "earthworks" to be one of the sixties' *anti-art* phenomena, a topic for sociology perhaps but not for "*art* history."

Other AICA members I met included Kaoru Yanase, visiting from Japan, where she serves as chief curator of the Nakamura Keith Haring Collection. On its website, Haring's work is said to embody "the importance and preciousness of life, containing strong themes of peace, freedom, hopes, and dreams of humanity." Nothing is said

of the extent to which Haring's schematic, cartoonish, street-art style undercuts the seriousness of such themes, however.

Another member, by chance seated near me at the group's business meeting, was Norman Kleeblatt, who served for many years as a curator at the Jewish Museum in New York. As it happens, I had commented critically on a 2002 exhibition organized by him featuring "conceptual art"—*Mirroring Evil: Nazi Imagery / Recent Art.*[3]

Also telling was the cover of the latest issue of the *Rail*, depicting a minimalist installation by the German sculptor Wolfgang Laib. Inspired by Eastern religions and philosophy, his work is at the inscrutable end of the contemporary art spectrum.

But perhaps the most unsettling indication of the artworld's prevailing inclinations is the work of the two painters featured in a panel discussion on art writing at the AICA meeting, which was moderated by the *Rail's* co-founder Phong Bui. They were David Salle, "who helped define postmodern sensibility," and Carroll Dunham, whose paintings even the *Los Angeles Times* has considered "vulgar beyond belief."

That prompts me to ask whose work should be more highly regarded—David Salle's "conceptual" painting featuring dead fish, say, or Justin Wood's still life of the same subject? Carroll Dunham's vision of humanity or that of Anthony Baus? My answer is too obvious to need stating.

Contemporary Art Worth Knowing

Two exhibitions this spring have powerfully belied the artworld pretense that all contemporary art is in an anti-traditional "cutting-edge" vein. And unlike the contemporary work that fills today's leading museums and galleries, they offer art lovers something to rejoice in.

The smaller of the two shows is *Self-Portrait* (April 20–June 20)—at the Eleventh Street Arts gallery, affiliated with the Grand Central Atelier in Long Island City. The other is the Art Renewal Center's *12th International Salon Exhibition* (at the Salmagundi Club in New York, May 1–June 1)—culled from entries submitted from more than sixty countries. Both exhibitions include work by some of the very best Classical Realist painters from around the world, a movement lamentably ignored by both art teachers and the art establishment.

The works most prominently featured on the two exhibition websites are not the ones I would have chosen. But I found other works in both shows to be truly memorable.

Self-Portraits

To begin with the self-portraits, the sheer diversity of images on display at Eleventh Street Arts is impressive—lest any reader assume that work in the academic tradition is likely to be stale and repetitive. From the keenly penetrating gaze of Louise Fenne's *Working*

For Piero's Sake, June 9, 2017.

on a Self-Portrait and Colleen Barry's pensive *Self-Portrait with St. Jerome* to Jacob Collins's rugged *Winter Self-Portrait* and Gregory Mortenson's anxious *Self-Portrait with Scarf*, these works testify to the infinite variety of human individuality. They remind us how crucially we depend on reading the face to discern character, mood, and emotion. And in a culture seduced by the vulgar triviality of Andy Warhol and Jeff Koons, it is restorative to see images conveying a sense of dignity and gravity.

Other works I was drawn to were Will St. John's large-scale *Self-Portrait with White Scarf* (27 x 35 in.) and Charles Weed's much smaller *Plain Old Self-Portrait* (7.8 x 9.8 in). They struck me as twenty-first-century counterparts of early and late Rembrandt portraits, respectively. Gazing out at the viewer with sober confidence, St. John cuts an imposing figure, poised with the instruments of his art (the white scarf wound around his neck recalls, perhaps intentionally, the white ruffs prominent in so many 17th-century Dutch portraits). In contrast, Weed's intimate, slouch-hatted image, like Rembrandt's late work, suggests self-knowledge deepened by experience. If I read it correctly, the sadness or weariness reflected in the eyes is offset by the faint play of a smile about the mouth—consistent with the self-deprecating humor of his title.

Of Joshua LaRock's two entries, I found his 2016 *Self-Portrait* especially appealing. Seated before his easel (with a self-portrait in progress), he turns, palette in hand, as if to greet an unexpected visitor to the studio. His mouth slightly open in surprise, and his right arm jauntily braced against his thigh, he does not seem to welcome the intrusion!

Kudos to artist Colleen Barry for curating this excellent little show, and to Milène Fernandez of *Epoch Times* for writing about it.[1] Will the benighted *New York Times* critics ever discover the value of such work?

ARC Salon

Unlike the Eleventh Street show focusing on one genre, the ARC exhibition comprised work in multiple categories. Of the landscapes, the two that made the greatest impression on me were not the award

winners but Joseph McGurl's luminous *Transfiguration* and Katsu Nakajima's luxuriant *Stream of the Shadow*.

Photographic though they may seem online, they are in fact *selective re-creations of reality* (to borrow Ayn Rand's apt phrase), shaped in loving detail over time, as if honoring every blade of grass. They bear witness to a reverence for the beauty of the natural world. That reverence is made explicit in the artists' statements, but the viewer scarcely needs those verbal confessions.[2]

Nor does one need Grace Kim's feminist-inspired artist's statement to be transfixed by the penetrating eye of her *Indian Peahen*. Vividly alive, it seems to say "don't mess with me!"

Two captivating paintings in the still life genre were *Ascolta, ti Ricorderà*, by Miki K. T. Chart, and Carmen Ruiz Segura's *Don Quijote*. Both are boldly imaginative and effectively realized. To anyone familiar with Cervantes's classic send-up of chivalric literature, Segura's paper specter rising from the pages of a book, ready to tilt with a paint-brush lance against an oil lamp, is the perfect embodiment of the novel's protagonist. No title or artist's statement needed. So, too, Chart's image speaks for itself, as art should do. Her tiny canary perched atop an old-fashioned mandolin, singing its heart out, is clearly a nostalgic evocation of the musical traditions of Italy—as further alluded to by an antique map depicted in the background.

In the final chapter of *Who Says That's Art?* I suggest that what is needed to counter the artworld's "cutting-edge" mentality is a 1913 Armory Show in reverse, on a grand scale. The ARC salons are the closest thing to that idea that have yet occurred. But they require better publicity. And the cause may not be well served by some of the top awards bestowed.[3]

This year's Best in Show, for example, was *Semillas*, by Tenaya Sims. It struck me as an ambitious but puzzling and oddly repellent image, too dependent on the artist's long-winded verbal explanation for understanding his intention. And last year's *Absolute Trust – Sleeping Beauty*, by Arantzazu Martinez, left me equally unmoved. What should be the most telling part of the picture—the face of the sleeping princess—was far less interesting than her sumptuous garb and the plethora of props and birds surrounding her, which seemed a mere pretext for displaying technical virtuosity. Then, too, there

is the matter of her hair, inexplicably windblown when the drapery around her shows no sign of movement.

In contrast, let me cite the work from this year's show that has made the most lasting impression upon me—Shana Levenson's *Sibling Bond*. It is an unpretentious yet moving embodiment of the love between a small, sad-eyed boy and his not-much-older sister, who enfolds him in her protective embrace and seems to set her mouth firmly against adversity. It called to mind for me tender moments I've witnessed between my own grandchildren, as well as fictional accounts of such a bond—most recently, the characters of Florence and Paul Dombey in Charles Dickens's *Dombey and Son*. Here is surely an enduring human theme, deeply felt and touchingly rendered.

For today's art teachers exclusively focused on politically and socially "relevant" contemporary work of dubious artistic quality, this painting should serve as a counterexample worth knowing and teaching about. As it indicates, there is much more to our lives than the social and political dimension. The personal dimension is of profound importance as well, and should not be neglected in the art education of our children.

Dismaying Exhibition of De Waal Installations at the Frick

Edmund de Waal is the justly acclaimed British author of *The Hare with Amber Eyes*, a superb history/memoir of the Ephrussi banking family, of which he is a scion. He is also the creator of an unprecedented temporary exhibition now at the Frick Collection in New York City. Entitled *Elective Affinities*, it is the first exhibition of work by a living artist in the museum's main galleries. Lamentably, it presents a dismaying contrast with the Frick's permanent collection—as well as with his admirable book. It also exemplifies much of what is wrong with the contemporary artworld.

Elevating "Pots" to "Sculptures"

In his book, De Waal refers to himself quite simply as a "potter" by profession. Publicity materials about him tend to use the fancier term *ceramicist*. Either way, it means a *craftsman* who shapes pottery on a potter's wheel and bakes it a kiln.[1] Unlike traditional pots, which serve a primarily practical function, De Waal's ceramic creations are made only for display, in minimalist installations made to convey meaning of some kind. Remarkably nondescript and repetitive in themselves, his pots allegedly gain import from their mainly site-specific arrangements (more on that below). Such work has brought him prestigious commissions—ranging most recently from the Frick

For Piero's Sake, June 23, 2019.

exhibition to his *Psalm* in Venice's Jewish Ghetto in conjunction with this year's biennale—as well as numerous artworld accolades.

Appropriately enough, the Frick show was organized by Charlotte Vignon, the curator of *decorative arts*—as befits an exhibition of ceramic pots. Yet its press release and other materials repeatedly refer to De Waal's work as "sculptures" and to him as a "sculptor." As it happens, Henry Clay Frick collected sculptures, as well as vases, furniture, and other works of *decorative art*. I have no doubt that he knew the difference between them. In today's artworld, such meaningful distinctions have been dispensed with. But it is particularly disturbing to witness a traditionally conservative institution like the Frick succumb to the muddling of concepts and debasement of standards.

Unrealized Intentions

At a press preview for the Frick exhibition, De Waal spoke with the utmost sincerity of his reverence for the permanent collection and the home it is housed in, which he first visited at the impressionable age of seventeen. In a lecture given at the Frick, he recalls the "epiphany" he experienced on seeing Chardin's *Still Life with Plums* there. Remarkably, De Waal was primarily struck not by the objects themselves but by Chardin's placement of them—by "the way they were placed in the world, . . . which had presence, which had some kind of meaning in the world." As he explains, inspired by Chardin's example, he is still dealing with *how objects are placed in the world*.

What De Waal missed in that life-changing epiphany seems so obvious as not to need stating. The meaning in Chardin's painting mainly emerges not from how the objects are placed but from what they *are*—objects of everyday life that we have some experience of and can therefore relate to—luscious plums, a refreshing glass of water, a glossy carafe, etc. In contrast, what meaning can be gleaned from De Waal's abstract arrangements of nondescript pots and slabs? He has said that he intends them to create a "dialogue" with the collection. I would argue that they are utterly mute partners in that dialogue. They are, in effect, jarringly anomalous intruders—if one notices them at all (surprisingly, De Waal has stated that he doesn't mind if one misses them).[2]

The inability of these works to speak for themselves (as the paintings and sculptures in the permanent collection so effectively do) very likely prompted the curatorial decision to provide viewers with audio files of the "artist" explaining each work, as well as of the music that he says helped to inspire it. Much as I love music, knowing what De Waal chose to listen to while he worked is of minimal interest to me. What matters is what he made of that inspiration—which, I insist, is very little indeed.

Ironically, the unpretentious miniature sculptures known as *netsuke* figures—which play such a prominent part in De Waal's family narrative—are far more eloquent than his ambitious installations of pots aspiring to the condition of sculpture.

What Would Mr. Frick Think?

At a press preview for the De Waal show, the Frick's director, Ian Wardropper, made much of the fact that Mr. Frick himself had collected "contemporary art"—as if that gave license to the present exhibition. The analogy is preposterous. The contemporary work collected by Frick consisted of relatively traditional works of realist painting and sculpture. Millet was a particular favorite. There were no installations of abstract ceramics in industrial-looking vitrines.[3] Installation is a postmodernist genre whose origins lay in the anti-art impulses of the 1950s and '60s, long after Frick's death.

Henry Clay Frick died in 1919. His acquisition of contemporary art is amply documented in the insightful biography by his great-granddaughter, Martha Frick Symington Sanger—who discerns a "profound psychological relationship between the man and his paintings." As she persuasively argues, many of his acquisitions of both old and new art were probably inspired by their visual resemblance to people and places from his past.

Frick's interest in contemporary art was sufficient for him to attend the 1913 Armory Show. But the only work he bought there was a still life of flowers by Walter Pach—though he is also reported to have expressed strong interest in Paul Cézanne's *Femme au Chapelet (Old Woman with a Rosary)*, which had already been sold. These were hardly revolutionary works, however. Moreover, I suspect that the

appeal of the Cézanne, in particular, was mainly personal, stemming primarily from his deep attachment to his maternal grandmother—a devout woman who was "his spiritual mainstay and most ardent supporter," according to Sanger, who cites several Frick acquistions that she suggests were similarly inspired.

If Mr. Frick's museum now wishes to exhibit contemporary work truly consistent with his taste, they would do well to turn to the classical realists (see, for example, "Contemporary Art Worth Knowing," above, pages 97–100), rather than to the latest artworld stars such as De Waal.

In today's anti-traditional artworld, such a turn would be revolutionary indeed.

Commemorating Andrew Wyeth

What does it say about today's artworld that not one of our nation's major museums mounted an exhibition honoring the centenary of painter Andrew Wyeth (1917–2009)? Quite a lot, I think, and none of it good.[1] All the more reason to be thankful to the smaller museums that judged the occasion worth marking: the Farnsworth Art Museum in Maine (several exhibitions), the Greenville County Museum of Art (GCMA) in South Carolina, and the Brandywine River Museum in Wyeth's hometown of Chadds Ford, Pennsylvania, jointly with the Seattle Art Museum.

I will necessarily limit myself to an overview of the exhibitions I was lucky enough to see: Greenville's *Wyeth Dynasty* (which included work by other family members) and *Victoria Wyeth: My Andy* (an intimate photographic memoir by the painter's only grandchild); and the Brandywine-Seattle collaboration, *Andrew Wyeth: In Retrospect*. My observations on them incorporate information and insights gained from Richard Meryman's revelatory biography of Wyeth, as well as from Wyeth's expansive conversations with art historian Thomas Hoving, who wove them into both the catalogue for the Metropolitan Museum show he curated in 1976 during his tenure as director of the Met and the "autobiography" he helped to produce in connection with a landmark 1995 Wyeth exhibition.

This review was prepared in 2017 for a special issue of *Aristos* devoted to Wyeth. Publication of that issue was delayed for reasons beyond my control.

Greenville's *Wyeth Dynasty* Exhibition

Message to the smug urbanites of our major metropolises: The GCMA in Greenville, South Carolina, boasts what Wyeth himself considered "the very best collection of my watercolors in any public museum in this country." Its recent *Wyeth Dynasty* exhibition culled some of that collection's treasures, with a few choice temperas, to set them alongside works by members of his prodigiously talented family: his father, the famed illustrator N.C. Wyeth, his painter sisters Carolyn and Henriette, and his son Jamie, also a painter. In so doing, it fittingly conveyed that Wyeth's art was deeply rooted in family ties and traditions, especially the places they called home in rural Pennsylvania and Maine.

Among the openers for the exhibition was a striking pencil *Self-Portrait* (1945). Done at the age of twenty-eight, it has the sort of brooding intensity that characterizes much of Wyeth's later work, but in no way prefigures the affable, joyous, weatherbeaten grandfather lovingly captured in Victoria Wyeth's *My Andy*. Perhaps the young artist still felt in thrall to his accomplished father, whose masterly illustration for the novel *Anthony Adverse* was also on display in Greenville. Although Wyeth revered his father and was devastated by his death only a few months after that self-portrait was done, he later spoke of not really coming into his own as an artist until he had experienced that loss. And at the time of the self-portrait, he was still struggling to free himself from his father's influence and find his own expressive course.

Wyeth once declared: "I paint for myself"—adding "within the tenets of my own upbringing and my standards." That upbringing and those standards is suggested by his watercolor *Before Six* (1988), a nostalgic recollection of the living room in his childhood home in Chadd's Ford, complete with its bust of Beethoven on one of the window sills. Having visited that home, now open to the public, I instantly recognized the scene and felt how charged with emotion it must have been for the artist.

For Wyeth, emotional connection was a crucial component of his work: "One's art goes as far and as deep as one's love goes," he declared in a 1964 interview for *Life* magazine with his future biog-

rapher, Richard Meryman. "I see no reason for painting but that. If I have anything to offer, it is my emotional contact with the place where I live and the people I [paint]." And he would find ways to keep that connection alive during the extended time involved in the creation of a tempera, the painstaking medium he employed for the subjects that were especially important to him. Contrast that with pseudo artist Andy Warhol's telling confession that his mechanical approach to creating images stemmed from the fact that he didn't "love roses or bottles or anything like that enough to want to sit down and paint them lovingly and patiently."[2]

Two of the human subjects Wyeth was emotionally drawn to, returning to them again and again, were Christina Olson and Helga Testorf. They were pictured at Greenville in two keenly perceptive watercolor and pencil portrait studies—*The Apron* (1967) and *Study for Night Shadow* (1973), respectively. A subject with whom the politically conservative artist probably had a pricklier connection was *The Liberal* (1993), whose steely-eyed, self-contained mien was deftly captured by him in a drybrush watercolor, a medium that approximated the meticulousness of his temperas (which generally took months to complete) while allowing some of the spontaneity of watercolor.

One of the most memorable watercolors in Greenville for me was *Cranberries* (1966), in which warm light streams in through an old wooden window onto weathered containers brimming with fruit. As captivating as a Chardin still life or a sixteenth-century Dutch interior, it demonstrated a side of Wyeth that could be content with simply conveying the visual beauty of everyday objects.

Two especially striking watercolor landscapes were *Last Light* (1988), with the Wyeth family Christmas tree improbably propped up on a pole (to keep the needles from littering the house, it was said), and *Free Rein* (1994), depicting what appears to be the house and barn of his Chadds Ford neighbors the Kuerners—seen across a snowy vista, diagonally bisected by a row of sparse vegetation. But I must confess that the riderless white horse running in the distance toward the barn—which gave *Free Rein* its name (Wyeth's wife, Betsy, generally named his works)—seems a superfluous touch in an otherwise perfect winter scene.

Wyeth's deeply personal work often contained allusions known only to him, however. Information about such private references can add another layer of understanding and appreciation. Yet some level of meaning is always accessible from the images themselves. Perhaps the horse in *Free Rein* meant something particular to Wyeth. But the work can be enjoyed simply as a very fine evocation of a wintry rural scene.

The Centenary Retrospective

Many of the works included in *Andrew Wyeth: In Retrospect* (which I saw at the Brandywine River Museum in Chadds Ford before it traveled to Seattle) gave moving testimony to Wyeth's private side.[3] One of the most unforgettable for me was *Winter 1946*. A tempera painted the year after N.C. died, it depicts a boy hurtling alone down a barren hill, his left arm flying out loosely at his side as though reaching for something. His expression is markedly troubled, and his angular shadow adds an ominous note. He seems to be running to or from something terrible. This haunting image gains in significance with the knowledge of what inspired it.

In October 1945, N.C. had been crushed to death when the car in which he was driving with the three-year-old grandson who bore his name was struck by a train at the foot of Kuerner's Hill in Chadds Ford. The child, thrown from the car, was also killed. Some months after the accident, as further recounted in the exhibition catalogue, Andrew

> was walking past Kuerner's farm, close to the tracks where his father had died, when he spotted a local boy, Allan Lynch, running crazily down Kuerner's Hill. . . .
>
> Allan had been one of the first to arrive at the scene of N.C. Wyeth's fatal crash. It was he who guarded the body until firefighters came to cut it loose, he who pushed away the fierce dogs that had gathered to lick the blood.

Winter 1946 powerfully evoked that life-changing event for Andrew. He depicted Allan running down the hill, almost lost in its bleak expanse, above which can be seen only an empty sliver of white sky. As Wyeth told his biographer Richard Meryman, "The boy was me

at a loss, really. His hand, drifting in the air, was my hand almost groping, my free soul."

Another haunting image fraught with personal significance was *Trodden Weed* (1951). Even without one's knowing its genesis, this strange depiction of boots advancing toward the viewer on a desiccated turf has a menacing effect. That was in fact exactly what Wyeth intended, as his account of this unconventional "self-portrait" makes clear:

> It was [created] after a dangerous eight-hour operation on my lung. [While convalescing] I walked and walked the country around Chadds, . . . wearing these French cavalier's boots which belonged to the painter Howard Pyle. As I walked, I had to watch my feet because I was so unsteady. And I suddenly got the idea that we all stupidly crush things underfoot and ruin them—without thinking. Like the weed here getting crushed.

Chillingly, Wyeth further recounted:

> Before my operation I had been looking at Albrecht Dürer's works. During the operation they say my heart stopped once. At that moment I could see Dürer standing there in black, and he started coming at me across the tile floor. When my heart started, he, Dürer—death—receded. So this painting is highly emotional—dangerous and looming.[4]

Indeed it is. And that effect comes through directly, thanks to the image's bold conception and the intensity of its meticulous execution.

Wyeth always regretted that he had never painted a portrait of his father. But the Brandywine exhibition included an incisive pencil sketch of *Pa with Glasses* (1936).

An early work that was less personal for Wyeth but touched an especially personal chord for me was his bleak tempera of a rural farm foreclosure in *Public Sale* (1943), which reminded me of a painful experience of my own childhood. In the late 1940s, my family was living in relative poverty in a small backwater in the foothills of the Catskill Mountains. Before a planned move to New York City, I rode with my father to a local auction to attempt to sell a few sticks of furniture we weren't taking with us. To our chagrin, not one of them

found a buyer. Wyeth's stark image vividly conjured up for me the sting of poverty in that experience.

Chadds Ford Friends

An important aspect of Wyeth's life and work that was well represented at Brandywine was his deep affinity for members of the poor black community that had resided in the vicinity of Chadds Ford since the Civil War. As a sickly, home-schooled child, he had always felt himself to be an outsider, a "misfit," and he thus identified with others outside the middle-class mainstream of American life. Despite his father's narrow-minded objections, Andrew's childhood boon companion was an African-American boy named David ("Doo-Doo") Lawrence. In time, other members of that working-class community became close friends as well, and were among his most frequent models, whom he depicted with sensitivity and respect.

An especially beloved figure was Adam Johnson—a proud, deeply religious man of philosophic bent, who raised pigs and chickens in addition to doing various odd jobs. In the tempera *Adam*, his great bulk, bundled up for winter, is set against a makeshift pigpen fashioned from castoff scraps of lumber. His poverty and outward simplicity notwithstanding, he was for Wyeth a "fantastic figure," who "could have been a Mongol prince."

A more poignant frequent subject pictured in the retrospective was a mentally retarded man, James Loper, who had been adopted by another Chadds Ford denizen, Ben Loper. He is instantly recognizable from his peculiar posture, in which his head half disappears between hunched-up shoulders. *April Wind* (1952), also on view, shows him from the back, seated alone on the massive trunk of a dead tree. His head is barely visible, and his jacket—blown back by the wind—seems like a sail on which he could take flight into space over the hill beyond.

Another African American, Willard Snowden, showed up on Wyeth's studio doorstep one day seeking work, and stayed for nearly a decade, becoming one of his most memorable models. One of his best portraits, *The Drifter* (1964), is the cover picture for the exhibition catalogue. Though I've often thought that contemporary

portraiture suffers from the banality of contemporary dress, Wyeth remarkably managed to make Snowden's shabby, faded corduroy jacket as visually interesting as the most elaborate period costume. And contrary to the exhibition catalogue, I see no sign on the sitter's sensitively rendered, pensive countenance of the "puffy, alcohol-ravaged face" that Wyeth depicted in other images of him.[5]

Significantly, when the U.S. State Department asked Wyeth to make his paintings of blacks available for a special exhibition in Russia, he demuurred, explaining: "I'm not a painter of Negroes. I'm a painter of people. They're friends of mine who are the most subtle to understand. To me they are really part of the earth—more in contact with what I'm interested in than a lot of white people." In short, he saw "great dignity" in them, and generally embodied it in his paintings.

Chief among the white people Wyeth was drawn to in Chadds Ford were the German immigrants Karl Kuerner and his wife, Anna. Their no-nonsense working farm, discovered by him when he was only thirteen, became a second home, inspiring many of his most important paintings. Two portraits of the Kuerners included in the retrospective were especially remarkable for their psychological depth. The tempera *Karl* (1948) is a tour de force of realist painting, down to the last pore and strand of hair. Brilliantly lit from the side, the head is so skillfully modeled that it appears to emerge from the panel in three dimensions. Kuerner's expression is warily confrontational, subtly suggesting the underlying brutality that was an aspect of his domineering personality. The portrait's menacing effect is enhanced by the ceiling hooks and cracks above him, the only features in an otherwise blank background. Not surprisingly, Wyeth regarded this as his best portrait.

The Kuerners (1971), a drybrush watercolor double portrait, depicts an older but still menacingly handsome Karl, heading out with his rifle to hunt. Behind him at some distance, ominously in the line of his rife, is the wizened figure of Anna, glowering at him in intense disapproval and resentment. Unlike her overpowering husband, Anna had never adapted to life in America, and had increasingly retreated into isolation and despair, suffering from chronic depression and mental instability that required repeated hospitalizations. Of this portrait of the unhappy pair, Wyeth aptly observed, "I don't think

you could get a clearer picture of these two people and what their life has been like."

The Kuerner farm also figured in numerous works on display at the Brandywine—among them, two drybrush and watercolors *Young Bull* (1960) and the mysterious *Evening at Kuerners* (1970), the dramatically expressionistic watercolor *Wolf Moon* (1975), and the tempera *Spring Fed* (1967). In *Spring* (1978), Wyeth anticipated Karl's impending death by embedding him in the hill that bore his name. It is a surreal vision in which his still-rugged face, gnarled hands, and thin white legs protrude from a small mass of ice remaining on the gray-brown turf. Significantly, the eye of the ever-wary Karl is slightly open.

Finally, it was at the Kuerners that Wyeth met Helga Testorf, the statuesquely handsome Prussian-American neighbor who was nurse to Karl during his long illness. This shy, reclusive mother of four would become Wyeth's model for fifteen secretive years. The scandal-ridden release, in 1987, of the "Helga paintings," many of them highly sensuous nudes, had the unfortunate effect of trivializing them and detracting from their artistic merit, as well as from Wyeth's seriousness as an artist, although the event was largely engineered by the unscrupulous collector who had bought them, not by Wyeth himself. Moreover, the sensational aura clinging to the nudes has tended to eclipse what seems to me to be the most compelling aspect of Wyeth's Helga images—that is, her strong, expressive face (see, for example, *Helga the Prussian*, not included in the exhibition). The face, after all, is where the visible signs of the soul reside, not in the nude body.

Following the devastating criticism heaped on him for the Helga pictures, the consummately realistic Wyeth created one of his most fantastic images—*Snow Hill* (1989), one of the closing works in the exhibition. In it he conjured up six of his principal Chadds Ford models (all but one of them dead by then) in a sprightly dance around a Maypole atop Kuerner's Hill in the dead of winter. Well aware of the physical and emotional toll exacted on his models through the countless tedious hours of posing for him, Wyeth joked that they were dancing for joy at having been liberated. But the two years devoted to this large tempera suggests that it was cathartic for him as well—a deeply felt reprise of his Chadds Ford past.

Maine People and Places

The other pole of Wyeth's life and art was Maine, where his family had summered since his boyhood. It was there that he met his future wife, ardent promoter, and savvy business manager, Betsy James. And it was she who introduced him to Christina Olson (1893–1968), the disabled Maine woman who inspired *Christina's World*, his best-known painting (not in the exhibition).[6] Wyeth's legendary friendship with Christina and her brother Alvaro was strongly represented at the Brandywine. Included were *Oil Lamp* (1945), his only tempera of Alvaro, as well as three major portraits of Christina.

In the earliest of the three, *Christina Olson* (1947), Wyeth memorialized a moment in which he had seen her seated on her back door step gazing out to sea, and portrayed her with all "the power of the queen of Sweden" that he read in her character. *Miss Olson* (1952) depicts a more nurturing side of Christina, who is again shown in profile, this time tenderly cradling a sick kitten against her ample bosom. Finally, in *Anna Christina* (1967), painted only months before she died, Wyeth showed her in three-quarter view, her powerfully forthright gaze confronting the viewer directly. The depth of Wyeth's friendship with her, clearly implied in that remarkably candid portrait, was further evidenced years later, by the choice of his final resting place—alongside the Olsons near their home in Maine, rather than in the Wyeth family plot in West Chester, Pennsylvania. Alvaro had died in late December 1967, and Christina followed a month later. Wyeth filled the void of their loss by turning in a surprisingly different direction. His new subject, the teen-aged Siri Erickson, was as young, healthy, and innocent as Christina had been old, infirm, and wise. In 1968, with her parents' permission, Wyeth began a series of temperas depicting her in the nude, a genre he had never before explored in depth. One of them featured in the exhibition was *Indian Summer* (1960). It shows her from the back, standing at the edge of a rocky ledge, facing a dark forest—perhaps a metaphor for her entry into the unknown mysteries of adulthood. The image of her that I prefer, however, is *Siri* (1970), which captured her in all her rosy-cheeked, golden-haired freshness. Her golden strands alone are a miracle of the painter's art.

In many of Wyeth's portraits, the human subject is implied rather than depicted. The birds woven into the tattered lace curtains of *Wind from the Sea* (1947), also on view, drew upon the curtains in Christina's bedroom, and represented for him the delicacy of "the real Christina." So, too, the weatherbeaten rowboat seen commanding the foreground of the watercolor *Teel's Island* (1954) was a surrogate for its then-failing elderly owner, the lobsterman Henry Teel—the last member of the family that had inhabited the island since time immemorial. Even without such particular knowledge, however, the viewer can glean the sense of loss implied in the abandoned boat being overgrown by weeds.

Adrift (1982) in effect anticipates the death of another Maine lobsterman, Walt Anderson. He had been Wyeth's bosom summertime buddy since their youth, when he was painted as a handsome *Young Swede* (1938). By the time of the later tempera, his health had begun notably to decline into what would be his premature death. Wyeth depicted his now grizzle-bearded friend lying in his skiff in a deathlike sleep, his gnarled hands clenched over his chest. The white skiff drifts on a dark sea that is marked only by a thin white wave approaching from the top of the picture, perhaps to carry the aging Swede away like an old Viking.

The Brandywine exhibition fittingly ended with Wyeth's last work, the large tempera *Goodbye* (2008). It depicts a big white building sitting atop a low hill and shimmeringly reflected in a stretch of water below. To the left, a sailboat veers off toward the picture's edge, leaving a prominent diagonal wake behind. The building is an 1822 sail loft that the artist's wife, Betsy, had had reconstructed for him—to serve as a gallery for his paintings—on one of the Maine islands they summered on. She presented it as a gift for his ninety-first birthday in July 2008. (The picture is an imaginative construction, however, as the actual building is too far removed from the water to be reflected in it.) In October of that year, Wyeth suffered a bad fall. It led to his gradual decline, ending in his death in January 2009. *Goodbye* is a final testament to the fact that in his art, as he had often stated, he had painted his life.

Part II

Abstract Art

Kandinsky and His Progeny

Two exhibitions at the Museum of Modern Art in New York this spring strikingly illuminate the ostensibly opposing poles of twentieth-century avant-garde "art"—that is, modernism and postmodernism. Without at all so intending, they serve to reveal how closely related these two seemingly disparate aspects of modern culture actually are.

The smaller, quieter of the two shows is *Kandinsky: Compositions*, which traces the origins of abstract painting through the work of the acclaimed Russian modernist Wassily Kandinsky (1866–1944). Focusing on the large canvases Kandinsky considered his most important work, the exhibition highlights his transition from figurative to nonobjective painting, and documents the philosophic and spiritual concerns that prompted him. At the heart of the exhibition are his *Compositions V–VII*, painted between 1910 and 1913 and widely reputed as masterworks of abstraction.

The exhibition brochure explains that most of the *Compositions* deal with themes of cosmic catastrophe and renewal, inspired by traditional religious subjects such as the Deluge and the Apocalypse, but that none of this is made "visually explicit." Indeed, even with the help of a detailed description for *Composition VII*, for instance, it is impossible for the viewer to discern either the "abstracted, universalized form" of a reclining couple intended as a "sign of renewal," or the "imagery of destruction and catastrophe" said to be represented on the opposite side of the canvas. All that is readily evident to

Aristos, May 1995.

the viewer is a brilliantly hued, dynamic (if chaotic) arrangement of lines, shapes, and subtly modeled areas of color. On a formal level, the work is visually engaging. But any attempt to *understand* it, to discover in it a coherent intention or objective meaning, is inevitably frustrated.

At the other end of the twentieth-century avant-garde spectrum is the Museum of Modern Art's boisterous, rambling retrospective of "multimedia" works by the prominent postmodernist Bruce Nauman (b. 1941). (This show, by the way, is the third largest retrospective in the museum's history, smaller only than those for Picasso and Matisse.) Nauman's mostly large-scale, often noisy "installations" are neither painting nor sculpture. They range from early pieces such as *Run from Fear, Fun from Rear* (1972), which is nothing but a neon sign bearing those words, to recent pieces such as *Poke in the Eye/Nose/Ear* (1994)—a series of greatly enlarged, close-up video sequences show-ing the "artist" brutally sticking his finger in his eye, nose, and ear. As if such repugnant *images* were not sufficient, many of Nauman's installations involve ear-splitting *sound* components—from the deaf-ening drumming in the video *Learned Helplessness in Rats (Rock and Roll Drummer)* to the spine-chilling, grating noise of mutilated animal effigies being dragged around on the ghoulish piece entitled *Carousel*. Small wonder that even some friendly critics have compared this exhi-bition to an insane asylum. Still less wonder that one of them reported hearing a little girl wailing to her mother: "I don't like it here!"

Not surprisingly, the Nauman and Kandinsky exhibitions have received markedly different reviews from art and culture critic Hilton Kramer, editor of the neoconservative journal *The New Criterion*. A persistent gadfly with respect to postmodernism, Kramer has predict-ably blasted the Nauman retrospective, calling it "contemptible" and "nihilistic," the "single most repulsive show" he has seen in nearly fifty years of museum-going—though, tellingly, he continues to refer to the work as *art*.[1]

By contrast, Kramer has effused praise for the Kandinsky show. In a *New Criterion* article on it, Kramer credits the exhibition with calling attention to "one of the pivotal moments in modern cultural history," and notes that Kandinsky gave us "some of the most beauti-ful [abstract] paintings that have ever been created." Kramer has also

used the occasion of the exhibition to enlighten the "vast public that now takes abstract art for granted" as to the intellectual origins of this "art that makes no direct, immediately discernible reference to recognizable objects." Kramer explains that "the emergence of abstraction early in the second decade of this century represented for its pioneers a solution to a spiritual crisis." He continues:

> [T]he conception of this momentous artistic innovation entailed a categorical rejection of the materialism of modern life; . . . abstraction was meant by its visionary inventors to play a role in redefining our relationship to the universe.[2]

How that relationship was to be redefined was explored by Kandinsky not only in his paintings but in his influential treatise *Concerning the Spiritual in Art* (originally published in German in 1911), which played a key role in disseminating, and gaining acceptance for, the principles on which nonobjective art was based. An attentive reading of Kandinsky's treatise, however, reveals just how thin his theoretical argument is.

In his zeal to escape what he regarded as "the nightmare of materialism," Kandinsky fell into two fundamental errors. First, he held that the "internal truths" of the spirit could be rendered in an entirely new way, severed from the external forms in which we inhabit, and perceive, the world. "The more obvious is the separation from nature," he maintained, "the more likely is the inner meaning to be pure and unhampered."[3] But we human beings are *in* and *of* nature. And it is precisely through *external* forms and features that our *inner* meanings become visually manifest—first and foremost, through the expressiveness of the human face and figure; and secondarily, by psychological projection, in the expressive qualities of other creatures and in the infinitely variable character of the natural landscape.

Kandinsky's further error, equally devastating in its influence on the course of art, was to force painting—as well as the other arts—into an extended analogy with music. "In the striving towards the abstract, the non-material," he announced, "the various arts are drawing together," and "are finding in Music the best teacher."[4] Even if we grant that color is, as he observed, somewhat analogous to musical tones in having a direct effect on the emotions, it is not primarily

through color and *abstract* form, but rather through the *particular* forms and aspects of the natural entities noted above, that we "perceive" (more precisely, infer) spiritual values in the visual realm.

As Kramer makes clear, Kandinsky's "fateful leap into abstraction" was inspired not only by his revulsion for modern life but by a growing belief in the metaphysics of the occult—a belief he shared with Mondrian (whom Kramer also greatly admires), among other early modernists. Remarkably, however, while Kramer discusses Kandinsky's treatise in detail and emphasizes that it was heavily influenced by the theosophical doctrines of Madame Blavatsky—a notorious Russian psychic—*he never questions its validity*. (It is worth noting that *Smithsonian* magazine offers this assessment of Madame Blavatsky: "one of the most accomplished [and] ingenious . . . impostors in history."[5]) Kramer's admiration for the early modernists remains undiminished, for he earnestly believes that abstraction "emancipated" them (and, presumably, everyone else as well, not least himself) from "the mundanity of the observable world."[6]

Ironically, Kramer (along with other eminent apologists for abstract art) fails to recognize that Kandinsky—whom he credits with innovating a form of "high art"—in fact paved the way for the postmodernists whose work he holds in deserved contempt. First, in seeking to divorce painting from the perceptible world, Kandinsky in effect sundered it from the values that give shape and meaning to human existence and thereby sustain it. Thus, in their strikingly different ways, the work of Kandinsky and Nauman alike implies a morbid alienation from actual human existence—Kandinsky's abstractions, by attempting to retreat into a mystical other-world of "pure," disembodied spirituality; Nauman's bizarre "installations," by degrading, deforming, and "deconstructing" everyday experience.

Moreover, by advancing the notion that painting need not concern itself with the visible world, by advocating that artists must be permitted *absolute freedom* from nature, and by minimizing the differences between the various arts, Kandinsky led a frontal assault on the integrity of the diverse art forms. Nearly a century later, we reap the whirlwind of what he sowed: the insanity of postmodernism, as exemplified by Bruce Nauman's barbaric multimedia concoctions—as devoid of artistic integrity as they are of life-enhancing meaning.

Hilton Kramer's Misreading of Abstract Art

In the December 2002 issue of *The New Criterion*, the neoconservative journal of art and culture that he co-founded and edits, Hilton Kramer poses the question "Does abstract art have a future?" Since he is a prominent critic and has been an ardent champion of abstract painting and sculpture for half a century, his observations on the subject are of particular note. They indicate not only what he finds of value in this modernist invention but also why he thinks its future is now in jeopardy. On both counts, his views must be called into serious question.

Kramer keenly laments that "the place occupied by new developments in abstract art on the contemporary art scene . . . is now greatly diminished from what it once was." He recalls with nostalgia the 1950s and 1960s in America

> when new developments in abstract art had shown themselves to have the effect of transforming our thinking about art itself. This is what Kandinsky, Mondrian, Malevich and others accomplished in the early years of abstract art. It was what Pollock, Rothko, de Kooning, and others in the New York School accomplished in the 1940s and 1950s. And, for better or for worse, it was what Frank Stella, Donald Judd, and certain other Minimalists accomplished in the 1960s.[1]

As Kramer goes on to make clear, what he misses now is not primarily the actual works produced by abstract painters and sculptors

Aristos, May 2003.

but rather their influence on esthetic theory—the "group impact on aesthetic thought, . . . not [the] individual talents." This view is astonishing in two respects. First, it appears to give greater importance to theory than to practice, to the thinking about art than to the making of art works. Second, it implies that the aesthetic thought generated by the various abstract movements—from the pioneers (Kandinsky, Mondrian, and Malevich) to Abstract Expressionists such as Rothko and Pollock to the Minimalists Stella and Judd—was of value in itself. Kramer does not bother to say what he finds estimable in the diverse ideas about abstract work. Nor, apart from the tentative qualification "for better or for worse" regarding Minimalism, does he offer any hint that theories as disparate—even contradictory—as those of the abstract pioneers, the Abstract Expressionists, and the Minimalists cannot possibly all be right. Yet one has no reason to share Kramer's regret that abstract art no longer has "the effect of transforming our thinking about art itself" if the successive transformations he alludes to have no objective value—if (as Louis Torres and I have argued at length in a chapter entitled "The Myth of 'Abstract Art'" in *What Art Is*) they make no sense in relation to human existence.

Kramer's failure to deal adequately with such issues is evident in the account he offers of the history of abstract art. He acknowledges that, from its inception nearly a century ago, abstract art has raised doubts about its "artistic viability." And he devotes several paragraphs to an overview of both the "good minds" and the "benighted" that have expressed such doubts. Yet he never deals with the substance of the doubts themselves, much less resolves them. Moreover, his notion that abstract painting "derives, aesthetically, from representational painting" can be understood only in purely formalist terms: referring to properties of line, shape, color, and pattern that are pleasing to the senses but convey no meaning. Though all too common, such a usage completely belies the intent of the artists who invented abstract painting, not to mention the original meaning of "aesthetic."

In the sense intended by Alexander Baumgarten, the eighteenth-century German philosopher who coined the term, *die aesthetik* referred to a new branch of philosophy, which he defined as "the science of perception." Baumgarten's aim in exploring this new field was to persuade his fellow philosophers that the arts contain

important forms of knowledge, as worthy of serious consideration as the abstract spheres of thought with which German philosophy had previously concerned itself. On Baumgarten's view, then, "aesthetic" forms were not merely sensuously pleasing, they were meaningful as well (see my further comments on this point in "Art and Cognition," below, pages 253–62). In that light, Kramer's formalist application of the term "aesthetic" to abstract art is unwittingly ironic.

Kramer's claim that abstract work derived from representational painting is mistaken in another respect. Prior to the abstract movement, painting, however stylized and simplified in form, had always maintained a recognizable reference to the sorts of things that constitute human experience. The pioneers of abstract painting deliberately abandoned such reference. In so doing, they were neither guided nor inspired by superficially similar formal properties in representational painting, as Kramer's claim implies. They were impelled by a host of radically extreme, often daft, assumptions about the nature of reality—not least, about human nature (one idea held by Malevich, for example, was that humans might literally be able to see through solid surfaces). They were attempting to create a radically new art, and through it a radically new human nature. Since their flawed assumptions are analyzed in some detail in *What Art Is*, I will not elaborate on them here. I will only stress that the goal, albeit never attained, of the first abstract artists was to embody profound meaning in their work, it was not to create arrangements of color and form that were merely sensuously pleasing.

Kramer, however, thinks of "aesthetic" value only in such formalist terms, not in relation to meaningful representations. This is clear from his objections to recent exhibitions of twentieth-century art. In his view, the series of *MoMA 2000* shows (at New York's Museum of Modern Art), for example, fell short because the numerous examples of abstract art "were in every case presented to the public on the basis of . . . their so-called 'content,' and not on the basis of their abstract aesthetic."[2] So, too, he is critical of the Tate Modern in London for its "discernible hostility to all aesthetic considerations," a hostility evidenced by the fact that "painting and sculpture of every persuasion were similarly presented to the public on the basis of their thematic 'content.'"[3]

The implicit opposition of *aesthetic form* to *content* in such remarks reveals Kramer's profound misunderstanding of the nature of art. As Baumgarten's early treatises on aesthetics suggested (and other writers have also argued), form and content are inextricably linked in works of art. Perceptually graspable forms are the means by which content (meaning) is conveyed in visual art. Form without intelligible meaning or content does not constitute a work of art; nor can there be content in the absence of identifiable forms. And by "identifiable forms" I do not mean abstract shapes such as circles, squares, or stripes; I mean visual representations of persons, places, things, and events (whether real or imagined), representations that are meaningful in relation to human experience.

Contrary to Kramer's view, the entire history of twentieth-century avant-garde movements, beginning with abstraction, can be understood as a series of misguided attempts to do away with either or both of these essential attributes. While the abstract pioneers earnestly sought to create meaningful work, they made the mistake of dispensing with the familiar forms of perceptual experience through which meaning is conveyed in painting and sculpture. And the sorts of occult metaphysical concepts they were attempting to convey may in any case simply not have lent themselves to visual embodiment at all. Later influential advocates of abstract art—most notably, Alfred Barr (the founding director of MoMA) and the critic Clement Greenberg—completely ignored the pioneers' intent, treating their work as if it were not meant to convey ideas, and evaluating it instead in purely formalist terms. Kramer largely subscribes to their formalist notions of esthetic value with respect to abstract work.

Kramer also offers a dubious analysis of postmodernism in the visual arts—which he aptly characterizes as the "fateful shift of priorities away from the aesthetics of painting, both abstract and representational, in favor of a political, sexual, and sociological interest in art-making activities." First, he claims that the emergence of the Minimalist movement "went so far in diminishing the aesthetic scope and resources of abstraction that it may in some respects be said to have marked a terminal point in its aesthetic development." Lurking beneath this verbiage is an apparent misunderstanding of the actual nature and intent of Minimalism, however. Despite the

superficial resemblance between some Minimalist paintings and those of early abstract painters such as Malevich, their work is worlds apart in intention—so much so that Minimalism should not even be considered an instance of abstraction. Kramer correctly notes that, like the Pop Art of Andy Warhol and others, Minimalism "constituted a programmatic assault . . . on the Abstract Expressionism of the New York School." But he mistakenly claims that this was also an assault "on the entire pictorial tradition of which the New York School was seen to be a culmination."[4]

Abstract Expressionism was decidedly *not* a culmination of the pictorial tradition of Western painting (though in their reaction against it the postmodernists appeared to act as if it were)—since, prior to the twentieth century, that tradition had always involved depiction, or representation, as the very term *pictorial* implies. In any case, the Minimalists in effect rejected *all* prior tradition and practice, whether abstract or representational. Purporting to create an art that dispensed with both content and aesthetic form, they simply presented *things*, or *objects*, for what they are, mainly by exhibiting arrangements of the most banal of industrial materials, such as bricks, paving materials, and cubes or slabs, or (in painting) by presenting shapes as mere shapes, as two-dimensional objects having no further reference or significance. "Eschewing representation, illusion, and expressive form, Minimal objects aspired to the ontological status of furniture or other real things, but without practicality or function"—to quote the *Encyclopedia of Aesthetics*.[5] There was no intention to represent or express anything—to *abstract* (in the proper sense of that term) any meaning or emotion from reality. "What you see is what you see," as Frank Stella put it.[6] Of course, the crucial question ignored by Kramer and other critics is, What (if anything) makes such objects *art*? It is a question that neither the Minimalists nor anyone else has ever adequately answered. Indeed, their work prompted Clement Greenberg to observe: "[I]t would seem that a kind of art nearer the condition of non-art could not be envisaged."[7] I would argue that Minimalist work, like other postmodernist genres, *is* non-art, that it is, moreover, a type of *anti-art*, since it springs from a deliberate rejection of the essential attributes of art.

Kramer makes the further astonishing claim that for the militant Minimalist Donald Judd "art itself had become a utopian project," as Judd was attempting to "sever all ties to the cultural past."[8] A careful reading of the interview with Judd which Kramer cites reveals the hollowness of that claim. Whereas the notion of a utopian project implies an ideal scheme generally applicable to others, Judd clearly stated that his vision was more narrow. Rather than conceiving a universal new art of the future, he was, as he put it, "just talking about what my art will be and what I imagine a few other people's art that I like might be."[9] Moreover, it is clear that his rejection of the whole Western tradition of visual representation ultimately stemmed not from any utopian idealism but (as in the case of many other avant-gardists) from his own inadequacy in the face of daunting precedents. Referring to that tradition as "this painterly thing," Judd was candidly explicit: "I can't do anything with it. It's been fully exploited." He then added, almost peevishly, "and I don't see why [it] exclusively should stand for art."[10] Why, in other words, should art be something he wasn't capable of creating?

The connection Kramer posits between Judd and utopianism was inspired by analogy with a passage he cites from an essay by Lionel Trilling, regarding an earlier utopian vision—which I quote here only in part:

> [T]he world is an aesthetic object, to be delighted in and not spec-ulated about or investigated. . . . [I]n Morris's vision of the future, the judgment having once been made that grandiosity in art is not conformable with happiness . . . , the race has settled upon a style for all its artifacts that is simple and modestly elegant, and no one undertakes to surprise or shock or impress by stylistic invention.[11]

Never mind, Kramer advises, that Trilling's context was entirely different: he was writing about a work of utopian fiction, William Morris's *News from Nowhere*. Kramer further ignores that Trilling characterized Morris's fiction as a vision of "an achieved perfection of human existence"—which, as I've suggested, has nothing in common with Judd's Minimalist project—and that Minimalism never aimed at the sort of aesthetic delight alluded to by Trilling. Ignoring so much makes it easy for Kramer to assert that Trilling's comment "neatly

defines the spirit that came to govern [Judd's] utopian project and
so much else in the Minimalist movement."[12] On top of his vacuous
utopian analogy, Kramer's reference to stylistic invention in relation
to Judd's work adds yet another layer of error. To speak of style in
regard to Judd's Minimalism is inane, since his work involved no
attempt at either communication, expression, or practical function,
and no transformative employment of a true medium—the sorts of
contexts in which the concept of style is applicable.

According to Kramer, the second major factor contributing to
the artworld we know today was that the 1960s counterculture,
which included Pop Art, "left all prior distinctions between high
art and pop culture more or less stripped of their authority."[13] As
Louis Torres and I suggest in *What Art Is*, however, the main factor
in postmodernism was not a breakdown of distinctions between
"high art" and "pop culture" (as Kramer terms them) but, more
fundamentally, between *art* and *non-art*. Abstract work had itself
initiated this breakdown by severing the crucial connection between
art and intelligible meaning—and that, by the way, is why it should
have no future. In its superficial, trivializing way, Pop Art was an
attempt to re-introduce recognizable subject-matter into painting
and sculpture, just as "conceptual art" constituted another perverse
postmodernist approach to putting content back into visual art.

In the epigraph of his article, Kramer quotes this observation by
Frank Stella: "It is hard to tell if abstract painting actually got worse
[after the 1960s], if it merely stagnated, or if it simply looked bad
in comparison to the hopes its own accomplishments had raised."[14]
In truth, all abstract art suffers much the same lack of a standard of
comparison and evaluation. By contrast, representational art, how-
ever stylized, can always be judged in relation to what the viewer
knows or feels about life and the world—judged not in the crude
sense of determining how photographically realistic a work seems,
but in the deeper sense of considering how effectively it conveys
something significant about human concerns and interests. Since the
meaning-content of abstract painting and sculpture is inscrutable, a
work can be judged only by completely subjective means, without
appeal to any objective standard or criterion. Critical assessments of
abstract work generally boil down to "It's good (or bad) because I like

(or dislike) it." And the liking or disliking depends on an idiosyncratic gut response to mere color and form, rather than to any sense of how compellingly the artist conveyed an idea or feeling relevant to human life. To the editor of a journal pointedly entitled *The New Criterion*, that lack of an objective criterion for judging abstract work, whose cultural value he is so insistent upon, should present a troubling contradiction.

Has the Artworld Been Kidding Itself about Abstract Art?

One hundred years after the invention of "abstract art," many ordinary art lovers remain baffled by such work and question its value. Yet artworld insiders insist that it was an important addition to the meaningful forms that art could take. Who is right?

That question was tellingly—albeit unwittingly—answered by the exhibition *Inventing Abstraction, 1910–1925* at New York's Museum of Modern Art earlier this year. While aiming to celebrate and illuminate the beginnings of "abstract art" a century ago, the exhibition inadvertently highlighted the shortcomings of such work. Both by what it acknowledged and by what it left unsaid, *Inventing Abstraction* cast serious doubt on the viability of "abstract art" as a vehicle of meaning.

In addition to broadly surveying diverse currents involved in the cultural deluge that began with the first publicly exhibited "abstract" (nonobjective) paintings in 1912, the exhibition touched on tentative forays into abstraction in the two preceding years. Wide-ranging in scope, it comprised some 350 works, not only from the visual arts but also from the realms of dance, literature, and music. Its underlying premise was that the resulting transformation was an artistically and culturally fruitful one, worthy of commemoration as a "watershed moment in which art was wholly reinvented."

The show's primary theme was that this sea change in the artworld was not due to a few solitary inventors but was instead the

Aristos, December 2013.

product of a densely connected network of individuals in Europe and America. That network was graphically represented at the entrance to the show and elaborated throughout in the placement of works, as well as in the accompanying descriptions.

Center stage was of course occupied by the visual arts. Thus the key question inevitably raised was this: What led some painters and sculptors in the early years of the twentieth century to take the unprecedented step of completely "rewriting the rules of artistic production" by "shunning the depiction of objects in the world" (to borrow phrases from the exhibition catalogue)? A corollary question was, Why did some artists choose not to do so? Neither question was adequately dealt with by the exhibition's curator, Leah Dickerman.

A Glaring Omission

Dickerman's catalogue essay cites the quest for "pure painting," "absolute art," and "the expression of pure reality" that inspired the proponents of abstraction. Yet it ignores the explicitly occultist metaphysical notions that led the key figures in the movement to reject the "long-held tenet of artistic practice: that paintings describe things in a real or imaginary world." Nary a word is said about Madame Helena Blavatsky—the controversial co-founder of the occultist Theosophical movement, which numbered many leading modernists in its ranks.

Instead, Dickerman devotes half a paragraph to Wilhelm Worringer's influential idea that abstraction aimed to wrest objects "out of the unending flux" of life, to approximate their "absolute value."[1] Worringer was not dealing with "nonobjective art," however. It had not yet appeared on the scene. He was referring to work that was abstractly stylized yet retained a discernible connection to real objects. What the chief advocates of wholly "objectless art" (in particular, Mondrian and Kandinsky) *were* inspired by were Theosophical speculations. It was Theosophy which explicitly supported their impulse to reject the material world and their desire to create a realm of "pure spirit" in and through their art.[2]

Yet the futility of such a desire was soon recognized by the artists themselves. "An immobile abstract form does not do much of any-

thing," one abstract painter aptly observed. Moreover, Dickerman acknowledges that when Kandinsky himself asked the crucial question "What is to replace the missing object?" he raised

> the problem posed by abstraction in a nutshell, and artists and their allies betrayed a great deal of anxiety on this score. First was the fear that the art object might be seen as merely decorative, and therefore insignificant.[3]

Faced with that fear, the proponents of abstraction, "compensated with words," Dickerman observes. Abstract paintings (she terms them "pictures," though they depict nothing) "rarely if ever existed in isolation; rather, many words circulated within their orbit—titles, manifestos, statements of principle, performative declamations, discursive catalogues, explanatory lectures, and critical writing by allies."

With nearly every work came "a proliferation of text, a parallel papery world." Remarkably, rather than viewing the accompanying "torrent of words" as a telltale sign that the new art had utterly failed, Dickerman approvingly concludes that abstraction served "as a foundation" for what followed in the postmodernist artworld with the advent of such things as "text presented as image."[4]

Dickerman's admiration for the abstract movement's "radical innovations" also prompts her to approve the manner in which social interaction between its advocates advanced the cause. But that cause seems slim indeed when one actually looks at what was produced. I doubt that many viewers beyond the artworld would share Dickerman's enthusiasm for a work such as Katarzyna Kobro's *Abstract Composition*, for example—which was spoken of at the press preview with the excitement one might feel on finding a lost work by Michelangelo—or of a wall of paintings by Malevich, which Dickerman also rhapsodized on. While she lauds such work as the product of fruitfully interconnected creativity, others might with good reason view them as the sorry result of artworld groupthink.

Misunderstanding the Nature of Art

Most tellingly, when Dickerman considers the role photography may have played in the decline of representational painting, she reveals a

fundamental misunderstanding of the nature of visual art. She notes, for example, the oft-cited claim that the mimetic role of painting was displaced by photography. Since images could now be created by the camera, the reasoning went, "painting no longer had to do mimetic work . . . [and] was liberated for other tasks."[5] Dickerman suggests that "mechanical reproduction may also have put the artifice of mimetic representation on full display, undermining it as a source of authority, certainty, and authenticity." Such reasoning mistakenly assumes that the images created by sculptors and painters are meant to be merely literal representations, having no import beyond their obvious pictorial content.

Similarly misleading was Duchamp's claim (uncritically cited by Dickerman) that he aimed "to put painting at the service of the mind."[6] The true art of painting had always been "at the service the mind"—by embodying ideas in imagery. It had never consisted of mere imitation for its own sake.

At the press preview, as in the exhibition itself, Dickerman made much of the fact that Picasso had briefly flirted with total abstraction but had quickly recoiled from it. When Picasso insisted that painting must remain tied to depiction of things in the world, she implied, he was simply retrograde in his thinking, unable to join in the grand new adventure taking place around him.

During the Q&A, I suggested that perhaps Picasso was right after all—given the abstract painters' persistent fear that their work would be viewed as merely decorative, and their consequent need to support it with words. To which MoMA's director, Glenn Lowry, responded that, as he sees it, Picasso's "inability" to pursue abstraction was analogous to Einstein's inability to embrace quantum theory.

Rather than press Lowry on that dubious analogy, I questioned whether the general public has ever embraced abstract work as fully as the artworld has. He replied that public resistance to modern art is mainly "generational." In his view, "today's generation has grown up with art that isn't just pictures; they have no problem with such work—as evidenced by the popularity of modern art museums." He paused for a moment and then added, with a sheepish smile, "But maybe I'm kidding myself."[7]

That possibility, extended to the whole history of the abstract movement, merits serious consideration.

Abstract Art Is an Absurd Inversion of American Values

Perhaps the oddest twist in the history and mythology of abstract art was the U.S. State Department's advocacy of Abstract Expressionist work—from Jackson Pollock's notorious "drip" paintings to Mark Rothko's canvases of colored rectangles. In the Cold War struggle against communism in the 1950s, the CIA actively promoted such work as representative of individual freedom, sponsoring exhibitions across Europe.[1] That political and cultural development was ironic on several levels.

To begin with, the American critics and scholars who had been the influential early champions of abstract art had had strong communist ties, however loosened or played down they were in later years. Both the critic Clement Greenberg and the art historian Meyer Schapiro published their first essays promoting abstract work in communist-inspired journals such as *The Marxist Quarterly* and *Partisan Review*.[2] Moreover, the Abstract Expressionists themselves were strongly leftist in their sympathies, often being quite vocal in their condemnation of what they called bourgeois values, capitalism, and the American way of life.

On a deeper level, advocating abstract painting as a haven of personal expression fundamentally misrepresented the mindset that had led the pioneers of abstract art to take the unprecedented step of abandoning representation in the first place. Far from seeking to

Epoch Times, May 23, 2017, reprinted by permission, with endnotes added.

express their individualism, the abstract pioneers were profoundly, even metaphysically, collectivist in their outlook. In art as in society and politics, they explicitly advocated the eventual obliteration of everything "individual."[3]

Piet Mondrian, for example—who achieved fame with his brightly colored, gridlike compositions—envisioned a radically new art and life for mankind. It required avoiding "express[ing] something 'particular,' therefore human." We can then "create a direct expression of beauty," he argued, "a beauty without natural form and without representation."[4]

Mondrian also adamantly denied the significance of the personal "hand of the artist."[5] His fellow abstract pioneer Wassily Kandinsky likewise rejected "the personality, individuality, and temperament of the artist."[6] In light of all this, it seems folly indeed to regard the Abstract Expressionists' various "signature styles"—from Pollock's "drip" paintings to Rothko's "multiform" rectangles—as ultimate expressions of individualism. Yet that is precisely what was done by champions of Abstract Expressionism oblivious of the early history of the abstract movement.

Finally, the importance officially conferred by the State Department on unintelligible abstract work subtly, if unwittingly, undermined the commonsense attitude that has been a prime virtue of American society. From the outset, abstract artists declared that their work would be beyond the understanding of most people. The abstract pioneers actually professed to belong to a spiritual elite endowed with psychic powers not yet attained by most mortals![7] As Kandinsky put it, they were "solitary visionaries" doomed to be abused as charlatans and madmen until their fellow men had evolved sufficiently to ascend to their lofty plane. Similarly, the modernist intellectuals who have adamantly defended abstract work as high art have smugly deprecated the ordinary philistines who fail to appreciate such work.

Jousting with Mark Rothko's Son

Christopher Rothko—the highly affable son of the famed not-so-affable Abstract Expressionist painter Mark Rothko (1903–1970)—has written a volume of essays lovingly re-examining his father's life and work. Entitled *Mark Rothko: From the Inside Out*, it was published last November by Yale University Press, and its author has been promoting it with a passion inspired by devotion to the parent whose suicide left him bereft at the tender age of six.

As my readers are probably aware, I'm no fan of Rothko's work.[1] So it's not surprising that I welcomed the opportunity to go head to head with Christopher earlier this month on the subject of his father's paintings.

The unlikely venue was the New York City Junto. I say unlikely because that monthly discussion forum—founded three decades ago by investor Victor Niederhoffer (who has generously hosted it ever since)—has focused on matters related to free markets, the Objectivist philosophy of Ayn Rand, and investing. Ayn Rand notwithstanding, art has rarely been more than a tangential topic of discussion.

This month's surprising departure from that pattern was due to Gene Epstein, the Junto's main moderator in recent years. Epstein's day job is as the economics and books editor of Barron's weekly business magazine. But he happens to be married to abstract painter Hisako Kobayashi—who initiated him into the ranks of Rothko admirers, as he explained in his introductory remarks.

For Piero's Sake, June 22, 2016.

There was a particular irony in a Junto session devoted to Mark Rothko's work, however, for Ayn Rand made a compelling case against the idea that *any* abstract work could be an objectively meaningful form of art. So I gladly accepted Epstein's kind invitation to present my contrarian view—as summarized in a brief presentation (appended below) and fleshed out in dialogue with Christopher Rothko.

Rothko's overriding aim as an artist, his son explained, was to find a "universal language" for his work—in order to move the maximum number of people, in a way comparable to music. As Christopher put it, Rothko was actually a painter who aspired to be a musician. With the proper training, that is the vocation he would have chosen. Feeling a particular kinship with the music of Mozart (his favorite composer), he sought to create a visual analogue that would convey an emotional sense of the "human condition"—the "darker side" of life along with its joyful aspect—much as Mozart's music does.

In that connection, color was for Rothko "almost synonymous with emotion," Christopher noted. By applying layers of color, the painter hoped to suggest different emotions. Yet he seems to have discovered for himself that the analogy between abstract art and music soon breaks down, as I argued in my remarks. Consequently, he moved away from his early use of bright colors, because—Christopher explained—people read them as more "joyous" than he had intended (in contrast, would one ever hear intentionally sad *music* as joyous?).

Over time, therefore, Rothko's palette became darker and darker and his canvases increasingly "minimalist," Christopher noted, until they reached the nearly black monochrome aspect of his murals for the Rothko Chapel in Houston. That work came up in relation to the claim, quoted by Epstein from Christopher's book, that Rothko was a great painter in part because "he pushed painting to do things it wasn't necessarily designed to do." Asked by Epstein what he thought painting was not necessarily designed to do, Christopher responded that it centers on the way we need to bring ourselves to the paint- ings—the need to slow down, spend time, and "lose yourself in them." Of the Rothko Chapel, he observed, it's a space "you can walk into and say 'there's nothing here' and be absolutely right"—*if*, he added, you don't spend the time to complete the "interactive process" the painter aimed for.

Early in the discussion, Christopher had noted that his father believed "the most powerful expression of an idea is *abstract*." Yet he *loved* figurative paintings such as Rembrandt's *Jewish Bride*. Moreover, as I later discovered. Rothko much admired the work of another representational painter, Piero della Francesca (to whom, Christopher noted, my blog happens to be dedicated!)—once arguing that he might have been the greatest artist who ever lived.

That is not the only contradiction begging to be reconciled regarding Rothko's abstract work. In response to my remarks, Christopher surprisingly avowed that he actually agrees with most of what I said. In particular, he urges in his book that his father's biography be left out of consideration in response to the work. Further, despite his prior emphasis on color, he now acknowledged that it is "secondary" to form, and cited an essay in his book entitled "The Quiet Dominance of Form." On that point, he reported that his father was almost obsessive in adjusting the dimensions and proportions of the rectangular forms in his paintings. That limited repertoire of minimalist shapes is scarcely what I think of as meaningful "form" in painting, however—a term that instead conjures up for me the wealth of human figures, objects, and settings depicted by representational artists such as Rembrandt or Piero.

Although Christopher, like his father, loves the representational work of those and other masters, he said he struggles to find meaning in such work, insisting that to be art it must be about something more than the mere image. That is another point on which we happen to agree. Though I hadn't touched on it in my brief remarks, I've stressed it throughout my work, including *Who Says That's Art?*. Imagery in art is not an end in itself. It serves to embody values and a view of life.

One of the most telling moments of the evening occurred during the Q&A. Recounting a visit to the Rothko Chapel, a young woman seemed to echo what Christopher had said. "At first," she confided,

> I was perplexed by it, . . . and it felt like there was nothing there speaking to me. But I sat for a while, quietly, . . . and then I felt something. And the longer I sat there, the more I felt—the more energy and depth I felt from the paintings, which at first had felt very flat. And suddenly I realized that this whole space was humming, and it was quite powerful.

My question is, how much of that feeling was evoked by sitting in enforced silence in an enclosed, relatively bare space designated as a "chapel" (whose design had been largely overseen by Rothko)—rather than by the alleged power of the paintings themselves? In other words, how much of the "interactive process" Rothko aimed for in truth boils down to a viewer's projection of self-generated feelings onto the nearly blank slate provided by the paintings?[2]

Readers can easily guess what my answer would be.

My Brief Presentation at the Junto[3]

Since the Junto was inspired in part by Ayn Rand's ideas, I want to note here that she made a compelling case against the idea that *any* abstract work could be a meaningful form of art.

Let me emphasize that I by no means agree with Rand on everything she said about art. An illustrated talk I gave last year makes that fact clear. It's entitled "Understanding and Appreciating Art" (above, pages 41–53), and it summarized what I find most valuable in Rand's theory, as well as my points of disagreement.

I insist that Rand was *absolutely* right, however, in holding that art must employ imagery to be objectively meaningful. She was right because she understood the way the mind works. We don't experience the world in terms of blotches of color. We grasp it in terms of recognizable entities—meaningful percepts of people, places, and things—such as those depicted by Rembrandt in *The Jewish Bride*. Color is but one attribute of such entities, and decidedly not the most important one.

As neurologist Oliver Sacks observed in numerous case studies, people can function very well in a world without color—but not in one without form. The life of the unfortunate "Man Who Mistook His Wife for a Hat," for example, was tragically constrained by his neurologically impaired ability to recognize the objects he saw.[4] In contrast, the subjects of Sacks's book *Island of the Colorblind* were able to lead quite normal lives.

Accomplished artists have long known that representational form is more crucial than color. The great Venetian painter Titian—who was renowned as a colorist—is said to have observed that it is "not bright colors but good drawing that makes figures beautiful." Fur-

ther evidence of this basic truth lies in many meaningful works of monochromatic art, as well as in black-and-white reproductions of countless representational paintings.

In taking the unprecedented step of dispensing with imagery, the pioneers of abstract painting in the early twentieth century earnestly sought to convey meaning through color and shape alone, divorced from the representation of objects. A crucial yet rarely noted fact of art history, however, is that those abstract pioneers—including Kandinsky and Mondrian, the two most famous—constantly feared that without imagery their work would be dismissed as merely "decorative." That fear haunted their successors as well—not least, Mark Rothko. My husband Louis Torres and I cited numerous instances of such fears in *What Art Is: The Esthetic Theory of Ayn Rand*, and I note them in a chapter entitled "What's Wrong with Abstract Art?" in my recent book, *Who Says That's Art?*.

True, color alone can evoke emotional response—which has led many advocates of abstract art to claim an analogy with music, as Christopher [Rothko] has done. That analogy ignores fundamental differences, however. Unlike a musical composition, a painting is static. At best, it resembles a single chord of music. But musical compositions don't consist of just one chord. They comprise a coherent series of chords or tones over time. Attempts have therefore been made to create "color symphonies," by producing sequences of abstract patterns of color. But can anyone cite an example that achieves the powerful effect of [a piece by], say, Mozart or Schubert? Such compositions ultimately derive their power from music's deep connection to our innate ways of expressing emotion through movement and vocal expression—which are implicit even in purely instrumental works.

Finally, what about individuals who sincerely report being deeply moved by Rothko's work? I don't doubt their response, but my guess is that they are mainly moved by what they know of his artistic and personal struggle (including his suicide), and that they project their feelings about that on to the essentially blank slate his canvases provide. The true test of Rothko's work, in my view, would be the spontaneous response of viewers who know nothing about his life or his profoundly serious intentions. I doubt that such viewers would be moved by it.

Part III

Art Education

Where's the *Art* in
Today's Art Education?

Advocates for art education have long been striving to establish the visual arts firmly as a subject of study in school curricula. In recent decades, they have made inroads toward that end at both the national and state levels. To all those who value art, this may seem like good news, at least from a distance. On close examination, however, there is cause for deep concern, for, while many schools have been taking steps to integrate art education into their curricula, serious art of high quality has been rendered more and more marginal to the content of their programs. In many cases, it is being displaced by often trivial works of popular art, as well as by cultural artifacts of all kinds, selected more for the hidden sociopolitical messages that can be wrung from them than for their expressive power or esthetic value.

The group that has been most influential in promoting K–12 education in the visual arts is the National Art Education Association (NAEA). Founded in 1947, it now draws members not only from all of the United States and its possessions but from Canada and twenty-five other foreign nations as well. Aiming to promote art education through professional development, research, publication, and outreach, the NAEA involves educators at every level of instruction, early childhood through postcollegiate, and also includes a variety of other individuals concerned about the quality

Arts Education Policy Review, March/April 2003; an earlier version was published in *What Art Is* Online, November 2002.

of art education. Historically, in both its publications and its conferences, the organization has provided an open forum for a broad diversity of viewpoints regarding content and pedagogical approach. Such diversity appears to be on the wane in recent years, however, as postmodernist assumptions about the nature of art, combined with the increasingly politicized goals of some educators, have tended to quash competing viewpoints in a movement to reform visual art education. Although perhaps still numbering only a minority of the NAEA's membership, the would-be reformers constitute a highly vocal, often strident, faction which, by purporting to take the moral high ground, can easily intimidate or sway the less assertive majority.

For its latest advocacy campaign, the NAEA has adopted the slogan "Where's the art?"—meaning, What place, if any, does art education now occupy in our schools? To judge from many of the sessions I attended at the NAEA's annual meeting held in Miami Beach in March 2002, however, as well as from recent articles in the organization's two journals, *Art Education* and *Studies in Art Education*, the question that should be asked is, "Where's the *art* in today's art education?"

A "Paradigmatic Shift"

What is now happening in art education is, quite naturally, a reflection of trends in other cultural arenas. In the opening pages of *What Art Is: The Esthetic Theory of Ayn Rand*, Louis Torres and I called attention to disturbing trends in the academic study of art history, for example.[1] As we noted, academic art historians—whose focus has traditionally been the visual arts of painting and sculpture (with an emphasis on those works considered to be of particular esthetic value and cultural significance)—increasingly believe that no works are "more deserving and rewarding of attention" than any others. In addition, many claim that the "*so-called* key monuments of art history" are worthy of study only for what they reveal about unacknowledged sociopolitical "agendas and investments." We also noted the growing tendency to interpret art and culture solely in terms of the contemporary politics of division—with its emphasis on issues of race, class, gender or sex, and ethnicity. That divisive tendency is

exacerbated by growing doubt that there exists any such thing as a common American culture.² Finally, we cited the astonishing recommendation by some art historians that they should now concern themselves broadly with "visual culture"—in particular, with "*images that are not art*." In other words, some art historians now hold that that they should ignore the very distinction between art and ordinary imagery that lies at the base of their discipline.

Such notions have made their way through the educational system with breathtaking rapidity. Coupled with an already widespread "multiculturalist" emphasis, they are compromising every level of education in the visual arts. What is underway is nothing less than a "paradigmatic shift, a redefinition of content and practice in art education"—to borrow the words of Pat Villeneuve in an editorial in *Art Education* in May 2002.³ Evidence of this shift from art education to a hybrid endeavor termed "visual culture art education" is abundant. A paper prepared last year for the Council for Policy Studies in Art Education (a group unaffiliated with the NAEA) was entitled "Visual Culture: Broadening the Domain of Art Education."⁴ Teachers College Press is issuing a new textbook, *Teaching Visual Culture* (2003). The author, Kerry Freedman, is coeditor of the NAEA's *Studies in Art Education*, which has solicited—in conjunction with *Art Education*—papers for an issue of each journal to be devoted to visual culture. This comes hard on the heels of the May 2002 issue of *Art Education*, which focused on classroom approaches to visual culture studies, and contained Villeneuve's portentous editorial, entitled "Back to the Future: [Re][De]Fining Art Education," advocating the new emphasis.⁵

The "Postmodern Trap"

A key factor in the shift to visual culture studies has undoubtedly been postmodernism—which has all too swiftly gained wide currency among art educators, as in the artworld itself. (Not surprisingly, Freedman's *Teaching Visual Culture* features a section on postmodern concepts, an excerpt from which was distributed at the 2002 NAEA meeting in Miami.) As lamented by one dissenter, John Stinespring, postmodernism is now "all the buzz" among art teachers. Offering

a well-articulated contrarian view in an NAEA session entitled "Moving from the Postmodern Trap," Stinespring argued that postmodernism is governed by a series of major fallacies, which teachers have uncritically accepted.[6] They include the following:

- an "ever-broadening definition of art"

- the acceptance as of equal value anything put forward as art

- the rejection of all standards of qualitative judgment

- the denigration of individual creativity and originality

- an emphasis on "multiculturalism" at the expense of the personally meaningful

- the insistence that all art makes implicit or explicit statements about socioeconomic or political issues—with the implication that there is only one "right" position on each issue, invariably to the left of center

Echoing a concern expressed several years ago by the prominent Stanford University educator Elliot Eisner, Stinespring strongly objected to postmodernism's tendency to make art a "handmaiden to social studies." Since he is himself a former social studies teacher, who subsequently earned a Ph.D. in art history (he now teaches art appreciation in the School of Art at Texas Tech University), Stinespring's remarks warrant particular attention. But the sparse attendance at his session, in contrast with the ample turnout at that of Olivia Gude—a vocal proponent of postmodernism in art education—indicated that Stinespring's message is failing to get much of a hearing among his colleagues.

"Visual Culture" vs. Art Education

The tendency to make art a handmaiden to social studies is glaringly evident in the visual culture art education movement. This tendency should be of concern even to those who place no great value on the arts as such, for underlying it is a fundamentally political agenda for "social reconstruction," in which teachers of art will presume

to enlighten (more often indoctrinate) students regarding complex social and economic problems. Predictably, it is a direct outgrowth of the politically inspired "multicultural" emphasis Torres and I were critical of in our discussion of art education programs in *What Art Is*.

Proponents of visual culture education pay lip service to the fact that visual culture includes art. If one reads carefully, however, it is clear that they are more interested in other forms of cultural expression than in estimable works of painting and sculpture—to which they impute no greater value or significance than to a magazine advertisement, a documentary photograph, or a child's toy. Some adopt the phrase "art/visual culture education," indicating that they would make no "sharp distinction between the visual arts and visual culture." Nor do they even limit themselves to cultural *imagery*. According to Freedman and her fellow advocate Patricia Stuhr, "Visual culture is the totality of humanly-designed images *and artifacts* that shape our existence."[7] In their view,

> The increasing pervasiveness of visual culture, and the freedom with which these forms cross traditional borders, can be seen in the use of fine art in advertising, realistic computer-generated characters in films, and the inclusion of rap videos in museum exhibitions. The visual arts are part of this larger visual culture, including fine art, advertising, popular film and video, folk art, television and other performance arts, housing and apparel design, mall and amusement park design, and other forms of visual production and communication.

That is quite an inventory. Invariably, it is the non-art elements of visual culture that these educators are most apt to focus upon, however. In an article entitled "Analysis of Gender Identity Through Doll and Action Figure Politics in Art Education" (*Studies in Art Education*, Spring 2002), Anna Wagner-Ott—who teaches in the Department of Art at California State University in Sacramento—concluded: "Teachers may find that . . . [as another educator has observed] everyday objects 'are more influential in structuring thought, feelings and actions than the fine arts [are] precisely because they are the everyday.'"[8] Wagner-Ott thereby echoed the view expressed in the same journal three years earlier by Paul Duncum, a prominent advocate of visual culture studies who teaches at the University of

Tasmania). Duncum had called for an "art education of everyday aesthetic [experiences]," including the study of such things as "shopping malls, theme parks and television."[9]

Evident throughout the visual culture movement, then, is a fundamental lack of understanding or appreciation regarding the distinctive nature or value of art. Desperately seeking to be socially "relevant," art teachers who have never sorted out the contradictions of either modernism or postmodernism hold so confused an idea regarding the nature of their proper subject matter that they are easily seduced by urgent claims of the need to train students in "visual literacy," to enable them to detect the powerful subliminal messages conveyed by popular and commercial culture.

To quote Duncum, from an article in *Art Education* entitled "Clarifying Visual Culture Art Education":

> Mainstream art education begins with the assumption that art is inherently valuable, whereas VCAE [visual culture art education] assumes that visual representations are sites of ideological struggle that can be as deplorable as they can be praiseworthy. The starting point [for VCAE] is not the prescribed inclusive canon of the institutionalized art world, but students' own cultural experience. A major goal is empowerment in relation to the pressures and processes of contemporary image-makers, mostly those who work on behalf of corporate capitalism, not the cherishing of artistic traditions and the valuing of artistic experimentation. The basic orientation is to understand, not to celebrate.[10]

One could spend an entire article analyzing the mistaken premises and misleading implications of this brief passage, but suffice it to point out here that, though Duncum begins by questioning the traditional assumption "that art is inherently valuable," his emphasis on "contemporary image-makers . . . who work on behalf of corporate capitalism" reveals that he is, in fact, concerned almost exclusively with visual representations that are not art.

A Lesson in Misinterpretation: Teaching Visual Illiteracy

"Visual literacy" may well deserve a place in the school curriculum, as visual culture advocates insist, but it should not be confused with "art

education." Nor is there good reason to think that art teachers are the best qualified to pursue it. Indeed, there is disturbing evidence to indicate that some of the leading proponents of visual culture studies are not at all qualified for the task. A case in point is the *Art Education* article "Multicultural Art and Visual Cultural Education in a Changing World" by Christine Ballengee-Morris and Patricia Stuhr, offprints of which were distributed at one of the NAEA sessions that I attended in Miami.[11] As leaders in the movement to transform art education into "visual culture education," the authors—who teach at Ohio State University, which boasts one of America's leading schools of education—might be expected to exemplify the best thinking on the subject. As I will show, however, their article is rife with erroneous assumptions, mistaken inferences, and muddled logic. It should give pause to all responsible educators, regardless of political orientation.

To begin with, though Ballengee-Morris and Stuhr refer to the "unique contributions of individuals from diverse groups," and they advocate multicultural education as a means of "providing more equitable opportunities for disenfranchised individuals and groups," their main focus is not on individual self-realization but on group identity and biological and cultural determinism. Their account of "personal cultural identity" cites such factors as age, gender, class, religion, ethnicity, and racial designation, for example, but says nothing about the role of personal choice in diverging from the group identities one is born into, much less of the role that art can play in the forging of a personal identity. Their bald assertion that "national culture is primarily political" further suggests that, though they advocate "multiculturalism," they fail to grasp the essence of American culture—its profound individualism.[12] Moreover, their premise that "making and interpreting . . . art" can in itself "disenfranchise" anyone plays fast and loose both with the nature of art and the concept of disenfranchisement—which means "depriving someone of legal rights or privileges."

Equally misleading is the authors' claim that "Global culture is largely fueled by economics." (Chinese university students who faced government tanks in Tiananmen Square in 1989 armed with a makeshift replica of the Statue of Liberty would no doubt offer quite a different perspective on global culture, as would Afghan women

recently liberated from the tyranny of the Taliban.) Although Ballengee-Morris and Stuhr mention the World Wide Web as one of the conduits of global culture, they seem to ignore that it was created not by "capitalist manufacturers' desires for global sales" but as a purely noncommercial venture. At the same time, were it not for the "capitalist manufacturers" they malign, there would be no worldwide network of relatively inexpensive computers on which some of the truly disenfranchised individuals all over the world can gain access to information (and, thereby, power).

Since "global capitalism" has evidently been targeted as a prime scapegoat by the new breed of art educators, it is not to be expected that such complexities would be readily recognized, much less acknowledged, however. In the absence of peer review from individuals better informed about these multi-faceted social and political issues, art teachers freely disseminate misinformation and simplistic analyses, without the sort of challenge to their claims that a social studies or history teacher might encounter from a knowledgeable colleague or department chairman. That absence makes the efforts of such visual culture educators doubly dangerous.

The sample lesson proposed by Ballengee-Morris and Stuhr further demonstrates how unsound their thinking is, not to mention how far it departs from *art* education. In a lesson designed to teach sixth-graders about the concept of violence, for example, they do not even focus on a work of painting or sculpture on this theme, but choose instead to discuss an advertisement: a promotional page for *Time* magazine. As for how to instruct students in "visual literacy," they suggest:

> The students might first write a description of what they see in the ad (young white male, carrying a gun, dressed in camouflage, and showing a design border of a red rectangle, and TIME written over the image—race, gender, age, occupation issues are raised). They could write their personal reaction to the image and what they felt this image was meant to sell. . . . Students might then look at historical issues of magazines to see if and how children were portrayed in violent images and if these images were ever used to sell merchandise. . . . Based on class discussion, the students as a group could establish the criteria that they think are important in constructing an effective ad image.[13]

The evident implication of this passage is that the *Time* ad is an example of a violent image used to sell something. If I were to grade Ballengee-Morris and Stuhr on their "visual literacy" based on this assignment, however, I would have to give them an "F." First, the image is not violent, by any stretch of the imagination. The "young white male" the authors refer to is actually a little boy, probably no older than a toddler; he is smiling sweetly (the red rectangle with the word "TIME," indicating the magazine, is placed over his smiling face); and he is merely shouldering the gun he bears, not aiming it at anyone. Moreover, the authors completely ignore the most important clue to the intended message of the image—the caption (barely legible in the reproduction accompanying their article), which reads:

> *Make sense of anything.*
> *Almost.*
> The world's most interesting magazine.

Rather than using violence to sell magazines (as Ballengee-Morris and Stuhr imply), therefore, the *Time* ad seems to enter a subtle plea *against* violence by suggesting that one thing the "world's most interesting magazine" *cannot* "make sense of" is how or why sweet little boys play with guns or one day become soldiers and go to war. This is surely far from the message that the writers ascribe to it.

Even with respect to visual literacy skills, then—skills which advocates of "visual culture education" insist art educators are most qualified to inculcate—these leaders of the movement are woefully deficient. If such an article in a major art education journal represents the advanced thinking in the field, we should all shudder to think what overworked teachers may make of it in the classroom.

Rescuing Art from Visual Culture Studies

Current efforts to transform art education into Visual Culture Studies (VCS) constitute a deeply disturbing educational trend. Much like the now largely discredited developments in literary studies of recent decades (whose bankruptcy it apparently ignores[1]), this movement aims quite explicitly at a radical transformation of American society and is, therefore, primarily social and political in its intent. Its influence is not only likely to dull the next generation's aesthetic sensibilities and thereby coarsen the general level of culture but may also extend far beyond the arts themselves. I have previously argued that in both their aims and their methods, such studies have no place in art education, the proper focus of which is the visual arts.[2] Nevertheless, much more needs to be said about the problematic aspects of this trend.

From the standpoint of art education, the overriding objection to this movement is its blatant disregard of essential differences between works of visual art and other types of cultural artifacts.[3] By *visual art*, I mean what is broadly termed "painting" and "sculpture" (traditionally termed *fine art*): that is, two- and three-dimensional re-creations of reality whose purpose is to concretize ideas and values in an emotionally compelling form. In contrast with the decorative arts, the crafts, or

Arts Education Policy Review, September/October 2004, 25–31. Based on an earlier version published in *Aristos*, January 2004, from a talk entitled "Rescuing Art from 'Visual Culture'" at the annual convention of the National Art Education Association in Minneapolis, Minnesota, April 7, 2003.

the various fields of design, such works have no physical function, but instead serve a purely psychological or spiritual need.[4] This and other fundamental differences are ignored by the proponents of VCS.

A Dubious Approach to Interpretation

The disregard of important distinctions in VCS is especially evident in how the field treats images. Works of art convey meaning largely through the depictive and expressive qualities of their imagery. Rather than seeking meaning in such features, however, VCS emphasizes "decoding" (or "deconstructing") images in terms of information and associations that are symbolic or verbal, not pictorial. Moreover, the overwhelming focus is on artifacts other than works of fine art. In an article in the journal *Art Education* in March 2003, for example, Terry Barrett—an influential professor of art education at Ohio State University—aims to show (in his words) "how teachers, college students, middle-school students, and preschoolers have deconstructed a painting by [Michael Ray] Charles, a cover of *Rolling Stone* magazine, printed tee-shirts, cereal boxes, and teddy bears."[5] The *Rolling Stone* cover featured the words "Booty Camp" and a photograph of three provocatively posed and scantily clad young women.

The only work of purported art among the items considered by Barrett is the "painting" by Charles. Titled *Cut and Paste*, it is a work so schematic in its rendering that it is not a painting in the full sense at all, however, but merely a diagrammatic line drawing in black and white acrylic, simulating a child's paper cutouts—a crude cartoon, in effect. Its significance is deliberately and wholly dependent on what one writer, quoted by Barrett, has referred to as "the ossified stereotypes still rumbling around the American subconscious." Conspicuously absent are the subtleties of observation, draftsmanship, and expression that principally contribute to the distinctive value of works of fine art. Any schematic representation of the objects depicted by Charles (from the running figure of an African-featured man in boxing shorts and gloves to the knife, banana, and other artifacts that are displayed around him) would do as well to convey the idea intended. Once one gets the point, there is no need or desire to dwell further on the image itself. It has nothing more to say.[6]

Decoding through Social and Political Abstractions

Furthermore, the decoding undertaken in VCS emphasizes abstract social and political issues at the expense of more concrete personal experience. Lamenting that "the [personal] consequences of racial stereotyping are dreadful," Barrett claims that "the teachers [who] interpreted *Cut and Paste* . . . were in a position to intellectually and emotionally identify with the tragic meaning of the artwork."[7] The work itself, however, fails to convey anything of the personal or emotional dimension of racial bias—whether of the anguished feelings of exclusion and debasement it often engenders, or of the dignity that may be maintained in spite it, or of the impassioned sense of outrage and rebellion that it can inspire. The viewer must imagine such things for himself, lacking the stimulus that the sensitive concretization in a work of art might afford.

By focusing on abstract questions of race, class, gender, and ethnicity, moreover, the visual culture approach to interpretation lays stress on politicized issues that divide society, rather than on shared human values and concerns. As the National Standards for Arts Education emphasize, the arts "have served to connect our imaginations with the deepest questions of human existence."[8] Such questions are far more universal than the current preoccupation with matters of racism, gender bias, or social status would suggest. Tending to view the world in terms of competing interest groups, the proponents of VCS wrongly assume that all individuals within a given group necessarily share the same set of values and concerns and that these distinguish them from other groups. This aspect of the movement is particularly insidious, for it belies both the principle of individualism that lies at the heart of American society and the fundamental conviction that, despite our great diversity, we share certain core values.

Distortion of Focus

Although the values embodied in art often transcend politics, economics, and social status, viewers who follow the promptings of VCS to ferret out the purported subtexts contained in every image are, in effect, primed to ignore the artist's actual focus—and the entirely

legitimate values it may imply. I am here reminded of the wall text in a Metropolitan Museum of Art exhibition of nineteenth-century art some years ago. Referring to a painting of a small child grasping the sturdy hand of a nursemaid (who, as I recall, was pictured only from the neck down[9]), the text expounded upon the marginalization of nannies in the culture of the period. The unwary viewer was thereby encouraged to view the painting in a rather negative light. As a result, one might have overlooked that the nursemaid's firm grasp—which was a focal point of the picture—betokened trust and security, implying that the child, the main focus of the painting, was well cared for, as befits a cherished offspring. Speculations about the marginalization of servants, which might have been appropriate in a sociology class, had very little, if any, relevance for this painting as a work of art.

Finally, since the attitude of suspicion fostered by the decoding approach in VCS impedes a sympathetic engagement with works of art, it is likely to deprive children of the deep emotional enrichment that painting and sculpture can afford. The main emotions inspired by this approach are all on the side of anger, resentment, and moral outrage, leaving little place for a host of other feelings, from reverence, tenderness, and love to pride, courage, grief, and compassion. In contrast to the negative emphasis of such studies, the national educational standards refer to the "joy of experiencing the arts"[10]—though "joy" is not the best word here; it is too narrow. What is involved in the authentic experience of art is a deepened sense of life and oneself, a mental and emotional grounding that can include joy but is hardly restricted to it. It emerges from the profound psychological need to see our ideas and feelings about the world projected into sensory form, and it contributes in important ways to the well-being of the individual, as neurologist Oliver Sacks has eloquently testified in accounts of diverse patients he has observed.[11] Such an experience can only be stifled by the detached, analytical approach adopted in VCS.

What Characteristics Distinguish Works of Visual Art?

In their rush to embrace VCS, art teachers immersed in postmodern culture—and in the postmodernist work that now passes for art—have lost sight of the salient qualities of works of visual art.

As a result, their interpretations are prone to error, blurring major differences not only between painting, sculpture, and other types of imagery but also between works of visual art and artifacts that are not images at all.[12]

In what follows, I consider how art works differ from two other major categories of imagery often emphasized in VCS: commercial art (advertising) and photography.[13] Needless to say, artifacts that are not images are even more dissimilar.

The nature of the image. In works of art, the manner of representation is of prime importance, contributing significantly to the ultimate import of what is depicted. Imagery in art is highly selective, tending toward subtlety of detail, nuance of expression, and intensity of focus. It invites close, lingering attention on the part of the viewer. Postmodernism in the visual arts deliberately flouts such qualities, however (as the example of *Cut and Paste*, cited above, illustrates). It instead relies heavily on ordinary found objects, mechanical techniques of image-making, stereotypes, and appropriated images rendered stale by repetition. For those and related reasons, Louis Torres and I have argued that postmodernist genres such as Pop art, installation art, and video art have nothing essential in common with the traditional visual arts and should, therefore, not be classified or studied with them as art.[14]

Like the spurious art of postmodernism, advertising images tend to employ visual stereotypes or exaggerations and rely heavily on accompanying verbal captions or text to convey their intended meaning. Under normal circumstances, they rarely elicit protracted attention. Photographic images differ in yet other ways, which I detail below.

The creative process. As one might expect, such differences in visual characteristics derive from fundamental disparities in the creative process. A work of art is the product of an artist's personal engagement with the subject matter at hand, and the process of making it is painstakingly selective and searching, as well as relatively fluid. By the term *fluid* I mean that, although the artist starts with an idea of some kind, its embodiment is achieved gradually over time, and the idea may be clarified as the work takes shape. Historical evidence of this process lies in the *pentimenti* (forms subsequently painted over) that are at times revealed even in the works of the great masters, indicating

a change of mind in the process of composition. Furthermore, the focus of a work of art is long-term and metaphysical. It reflects what the artist regards as important in human life or in his conception of the divine or supernatural realm. In some measure, every artist is engaged, albeit most often subconsciously, with such questions as, What aspects of human experience do I regard as important? What is worth remembering? What do I value—or abhor? Finally, during the creative process, an artist is concerned first and foremost with getting the work right in his own judgment. Although he may refer to such things as aiming to please God or the gods, the work is nonetheless governed by his own conception of what will best achieve that end. At every stage of the work, the implicit question is, Does this say what I think it should?

In contrast, a commercial artist typically focuses on the client's needs. Because the primary purpose of commercial art is the selling of a product or an idea or to a third party, the artist's main concern is with how others will view the image. The artist is therefore more detached and less emotionally engaged. He aims to get the job done to satisfy others. The point of the image is immediate, short-term, particular—for example, Buy this car, or Say no to drugs. In this connection some are inclined to ask, What about religious art—isn't it like advertising? Does it not aim to sell something? Such questions miss an important distinction, however. Unlike commercial art, religious art deals with profound metaphysical values, which engage the artist in a way that creating an advertisement for Coca-Cola or Cheerios would not.

Photographic images differ from both fine and commercial art (in which every detail is determined by choice) in being largely dependent on the impersonal spontaneous process by which light creates an image on a photo-sensitive surface. (This is initially true of digitalized images as well, though the original image can then be infinitely manipulated. For the sake of clarity, I limit my remarks here to traditional photographic techniques.) The very term photography means "drawing by light," implying that the image is made by the action of light, not by an artist. Although the photographer exercises some selectivity and control, the image is ultimately formed by an automatic photochemical process that is not under volitional

control in every detail. Finally, unlike a work of fine art, even of commercial art, photographs are an actual record of some aspect of reality mediated mainly by an automatic inanimate process, albeit one initiated by a human being. They are a selective record of reality, not a selective re-creation of it.

The viewer's perspective. On some level, if only subliminally, the viewer is likely to be aware of the differences I have outlined regarding the creative process and intent. In the case of art, one knows that a painting or drawing, even when done directly from life, is filtered through the imagination and sensibility of the artist. One senses, therefore, that the image is meant to imply something about human values—a view of the world—beyond the particulars that are represented. In contrast, because one is aware that an advertisement is aimed at selling a specific product or a relatively transitory idea, one dismisses notions of any deeper significance.

The viewer's perspective also tends to differ with regard to photographs. One is always aware that a photograph is a document of real particulars, made in large measure by a mechanical process. Photographs have been traditionally valued as visual documents of real things that were in the camera's field (a value that has been lamentably undermined by digitalization). Their significance, therefore, tends to be specific to a time and place. For example, the power of Dorothea Lange's famous Depression-era photograph *Migrant Mother* is inextricably linked to the history of that period and the feelings it has inspired. By contrast, a painting of the same subject would be more likely, as an abstraction from reality, to transcend its time and place, thereby implying the suffering caused by poverty in general.

Furthermore, while one assumes that everything about a painting is the result of choices made by the artist, one can never be sure, when looking at a photograph, which aspects were selected as important or meaningful by the photographer, and which were accidental or incidental. Chance always plays a part in photography, and it often plays a very great part, even in photographs that are highly valued. The historic photograph of the American flag-raising at Iwo Jima, for example, was shot under such chaotic conditions of battle that when the photographer snapped the picture he was exercising virtually no control; he was even unable to compose the scene through the view-

finder, as he later recounted. Many fine photographs are largely lucky accidents of this kind, whereas no true work of art ever is. Every thoughtful viewer and teacher should be mindful of this distinction.

The artist's engagement with the subject. As I noted previously, a distinctive characteristic of art is that the maker feels a personal connection to the subject. What I mean by such personal engagement can be illustrated through a drawing by a child I know—my grandniece Sophie, who was, at the time of the drawing, eight years old. In making it, she was attempting to create a visual recollection of a particularly memorable day that she had spent at the seashore.[15] Her fascination with birds and other wild creatures was evident in the care with which she rendered them—from the great blue heron with his gracefully curving neck and characteristic tuft of feathers on his crown to a group of little sandpipers scurrying along the water's edge and the seal poking his head through the waves that were being whipped up by the wind. In drawing each of these elements from memory, Sophie had to think about them intently to recall and re-create their distinctive features and expressive characteristics. In so doing, she took possession of them and of the experience that she had had that day, in a far deeper way than her simply snapping a photograph would have done. So, too, one can sense when looking at her drawing that it was important to her and that the care that went into its making reflects more than casual or perfunctory interest on her part.

This principle informs every work of art by mature artists as well. It is perhaps most evident in the art of the portrait. Portrait painting cannot rise to the level of art when the painter feels no affinity for or keen interest in the sitter. Velazquez's most compelling portraits, for example, are those of the court dwarves, jesters, and common people whom he painted on his own initiative—not the formal royal portraits required of him in his capacity as court painter (consider his *Don Diego de Acedo*, for example, as contrasted with one of his portraits of Philip IV). Nor is it any accident that Rembrandt's most moving portraits are of himself, his son, and the women whom he loved. Finally, the American painter Thomas Eakins rarely accepted portrait commissions, choosing to limit his subjects to individuals whom he knew intimately

or greatly admired—such as his wife, Susan Macdowell Eakins, or his student and fellow painter Henry Ossawa Tanner.[16]

Natural versus Symbolic Meaning

I briefly alluded above to the principle that works of visual art convey meaning primarily through depictive and expressive means, rather than through symbols. The eminent art historian Erwin Panofsky clearly articulated the distinction between these sources of meaning many decades ago in an essay that should be required reading for anyone seriously interested in the visual arts.[17]

As Panofsky noted, the primary source of meaning in a work of painting or sculpture is what he termed its *natural subject matter*—that is, forms which are intelligible simply by virtue of our shared human experience, without any specialized cultural knowledge. Natural subject matter, he further explained, can be both factual and expressive (his term was "expressional"). Factual subject matter consists of recognizable, although not necessarily realistic, representations of such things as human beings, animals, plants, and everyday objects. Expressive subject matter has more to do with the manner in which they are represented—that is, with emotionally evocative qualities of pose, gesture, facial expression, atmosphere, and so forth.

The secondary source of meaning in visual art is what Panofsky termed the *conventional subject matter* of a work. Understanding the meaning of conventional subject matter—including, most notably, symbols of all kinds—requires culture-specific knowledge, which is extra-pictorial rather than intrinsic. I should note that Panofsky's concern in his essay involved interpreting images (in particular, the iconographically complex images of Renaissance art), rather than with evaluating them. Nevertheless, I think that he would have agreed with my point, which is that the emotional power of works of visual art depends far more heavily on their natural subject matter than it does on their symbolic content.

Teachers who emphasize the need to help students decode images place an undue emphasis on symbolic content. A painting often cited in this regard is Jan van Eyck's justly famed wedding portrait of Giovanni Arnolfini and his young bride, Jeanne Cenami. True,

van Eyck included many details having symbolic as well as natural meaning (from the figure of a little dog, as a sign of fidelity, to the burning of a solitary candle, signifying the all-seeing Christ). These indicate the sacramental character of the image as bearing witness to the Catholic union of this couple.

Knowledge of these symbols can indeed enrich one's understanding of the painting. The primary power of the work derives not from its symbolic content, however, but from its natural subject matter, and its depictive and expressive qualities—such as the intensely sober facial expressions of the young couple, their gesture of joining hands, and the aura of tranquil solemnity in the elegant bedchamber. These are the qualities that make it a great work of art, an emotionally meaningful image that transcends the particular historic moment being represented and conveys something about the gravity and importance of marriage in general. Unlike the symbolic elements, these qualities require no decoding; they are immediately and naturally accessible to attentive viewers. It is such qualities, in my view, that art teachers should be most concerned with encouraging their students to respond to in works of art.

Modernist and postmodernist work has so dominated thinking about art in recent years that many teachers have lost sight of the expressive qualities of true art—qualities that are absent both from abstract painting and sculpture, on one hand, and from postmodernist genres such as pop art, installations, and photography-based work, on the other. A useful corrective, therefore, is to spend some time simply looking at a broad range of images that exhibit these qualities. A related goal of the National Standards for Arts Education is that students should gain "an informed acquaintance with exemplary works of art from a variety of cultures and historical periods."[18] As indicated by the group of works that I have chosen as examples, the subjects and themes that have most inspired painters and sculptors across the ages have remained remarkably similar, however different they may be in their treatment.[19] They pertain to certain universals of our human condition—universals that transcend the currently politicized issues of race, gender, and social class that have increasingly but mistakenly become the focus of art education.

Questions and Answers

Not surprisingly, the talk on which this article is based was challenged by questions and comments from school teachers, college professors, and museum art educators in the audience, most of whom have adopted at least some of the assumptions and methods of VCS. Their objections and my responses follow in a form somewhat revised from that in my original talk.

The beauty of craft objects. One teacher asked whether a craft object such as a beautifully shaped piece of pottery can be spiritually uplifting and convey human values through the expressive power of form in itself. In my view, any object of human use that is made with great care and is lovingly shaped into a sensuously pleasing form can indeed be uplifting and can imply certain values. For that reason, well-made craft objects are very important enhancements to human life. But abstract form alone is incapable of conveying the sort of themes and values that can be embodied in works of representational art—ideas such as the love of a mother for a child, the horrors of war, or the gravity of marriage vows. That is why it is crucial to maintain a distinction between craft and art. The flouting of that distinction in recent years, by craftspersons aspiring to be artists and by the curators and dealers who promote their work, has resulted in a plethora of worthless objects serving no practical utility and conveying no meaning. Among the more notorious examples of this trend in the crafts is the work of "furniture artist" Wendell Castle, which is said by some to have moved into the sphere of art by "becoming sculpture." Castle's arbitrary concoctions no longer function as furniture, yet they fail equally as sculpture, for they are utterly meaningless.[20]

Decoding images. Another teacher asked why I maintained that students cannot derive joy from decoding images. Arguing that a gay person or a person of color can derive joy from such an activity, he observed, "My lesbian and gay students, for example, enjoy uncovering the homophobic attitudes embodied in some work—it's very important to them." I replied that, although one may indeed derive some satisfaction from such decoding, I would hesitate to characterize it as joy. My chief concern was that as long as students are focused on detecting alleged racist, sexist, or elitist assumptions, they

are likely to miss the sorts of broader human values and concerns that have been central to the visual arts since prehistory (in addition, there is the danger of evoking false readings, of detecting biases where they do not, in fact, exist). In any case, no work should be expected to have the same effect on everyone, in my view. Each student should be encouraged to seek out and understand what it is that he or she responds to, whether positively or negatively, in a variety of works. Students should not be primed to look only for the purportedly problematic subtexts, however.

An artist's vision. A third participant questioned whether an artist's expression is personal, or communal and cultural. My answer was that it is both. Every artist, although an autonomous individual, lives and functions in a cultural context. That context—its assumptions, values, language, and manners—inevitably exerts an influence. The degree and result of that influence, however, varies widely from individual to individual. No one need simply be a creature of the Zeitgeist, doomed to reflect only the dominant assumptions of his culture. As an individual, an artist is always free to reject, question, or challenge what he sees around him. And some, though surely not all, of the world's great art has been created by individuals who did just that. Goya—whose *Third of May* and *The Sleep of Reason Produces Monsters* are included in my group of exemplary works—comes to mind here.

Spiritual values in abstract art. Another person asked, "Didn't abstract artists such as Mondrian and Kandinsky attempt to convey important spiritual values through their work?" It is certainly true that the pioneers of the abstract movement intended to embody deep metaphysical meanings in their work, as Louis Torres and I have argued at length in *What Art Is* and elsewhere. They failed, however, because no one can even begin to discern such intentions from their paintings alone. Although their intentions were both serious and sincere, they were operating under profoundly mistaken views, not only about the nature of external reality but also about the interrelationship between perception, cognition, and emotion. In sum, the sort of meanings they intended simply could not be conveyed through abstract forms and color alone.

The expressive power of abstract art. An artist-teacher reported that her abstract paintings feel more like a direct form of expression for

her than her figurative work, and asked what my view was on this. In response, I asked her, "Is what you were expressing accessible to anyone else? You may indeed feel that you are expressing yourself more directly through an abstract painting, and you may derive personal satisfaction from the process. But if you show the work to others, can they sense what you felt you were expressing?" When teachers and curators present abstract work in the public context of a classroom or a museum, the implication is that the work is of value to others, not merely to the person who made it.

Analogy with advanced mathematics. Another teacher compared inaccessible art to other difficult fields, arguing that students often say, "I don't get it" when they are first introduced to the quadratic formula in mathematics, for example, and teachers go on to explain it to them. Why, he asked, should we treat their failure to understand abstract painting and sculpture any differently? My answer is simple. Unlike mathematics, the arts should not require specialized technical knowledge to be understood. Because they have their origin in fundamental aspects of human nature that we all share, their comprehension should not depend on technical expertise. True, the creation of art requires a degree of technical mastery. We all have it in our power, however, to understand and appreciate genuine works of art, simply by virtue of being human. Work that makes no sense at all without a purported explanation is, in my view, either bogus or failed art.

Art education. A final questioner inquired whether I think the understanding and appreciation of art can be enhanced through education. In my view, understanding and appreciation of authentic works of art can indeed be enhanced by informed discussion of its features, its cultural context, the life and goals of the artist, and so forth. What I am arguing against is explanations purporting to justify work that is utterly incomprehensible on its own terms. More and more these days, viewers enter a museum or gallery of "contemporary art" (a misused term invariably implying anti-traditional postmodernist work) and say: "What is the *point* of all of this? What am I doing here?" Often, without the wall texts, they cannot even be sure whether what they are looking at is meant to be part of the exhibition or is simply an everyday object, piece of equipment, or a bit of trash left behind.

Why Teach Art?
Reflections on Efland's
Art and Cognition

A work of art is . . . a representation of the world outside of art—
often the everyday social world. . . . [W]ithin general education,
the purpose of art education is *not* to induct individuals into the
world of the professional fine arts community. . . . [It] is to enable
individuals to find meaning in the world of art for life in the every-
day world.

—Arthur Efland, *Art and Cognition*

The place of the arts in American general education has always
been a tenuous one. This being a pragmatic nation, our schools
have naturally focused on areas deemed to be of practical value. And
since the arts have long been regarded as having no practical utility,
they have naturally been marginalized in public education. Only liter-
ature, solidly integrated into the study of languages, has been assured
of a permanent place in the curriculum. The visual arts and music
are perennially treated as educational frills. "Pleasant enhancements"
if time and money permit, they are the first pursuits to be dispensed
with when resources are scarce or more pressing educational needs
arise. Those concerned with the teaching of music and art are there-

Arts Education Policy Review, March/April 2007, 33–39 (typographical and
copyediting errors in that version are corrected here); an earlier version was
published in *Aristos*, December 2006.

fore under constant pressure to justify themselves, to demonstrate to schools and communities that what they do matters.

A common strategy in recent years has been to emphasize the intellectual attributes of art. Thus, a professor of art education writes in a recent article in a professional journal: "Recognizing that artmaking requires complex and reasoned thinking is a vital step in convincing the public that art education deserves a rightful and substantial role in the public school curriculum."[1] Such an emphasis is also evident in the book *Art and Cognition: Integrating the Visual Arts in the Curriculum*, by Arthur Efland. The author is professor emeritus in the Department of Art Education at Ohio State University, one of the largest and most influential of such departments in the country. Published in 2002 by Teachers College Press, his book is aimed primarily at professionals in the field of art education. Yet it merits wider consideration, however belatedly, for while many of its premises are sound, its main conclusions are indicative of major fallacies that beset the field and are likely to have a baneful influence not only on the future teaching of art but also, by indirect consequence, on the making of art (or of what passes for it).

Unlike colleagues who promote "visual culture" studies with a vengeance and seem ready to dispense with art altogether, Efland has held to the conviction that works of visual art have a substantial cultural value and that their study warrants a permanent place in general education, a place more central than their present one. By emphasizing the crucial connection between art and cognition, he seeks to enhance the status of art and to explain how it can contribute significantly to the cognitive goals of education. In particular, he aims (pages 6–7) "to look at more recent understandings of the mind and the nature of human intelligence, and at how these bear on the question of the intellectual status of the arts," as well as (far more problematically) "to show the contributions [that] educational activity in the visual arts might make to the overall development of the mind."

What Efland Gets Right

In his first three chapters, Efland provides an informative overview of the ways in which earlier theories of cognitive development have

influenced the teaching of art. As the author of *A History of Art Education: Intellectual and Social Currents in Teaching the Visual Arts*, he knows as much as anyone on the subject, and his overview provides a historical context against which to assess new approaches. He recognizes, and deplores, the extent to which the materialist philosophy of the late nineteenth century and the behaviorist psychology of the early twentieth tainted attitudes toward art education. Because such purportedly objectivist views ignored the role of human volition and purposeful intention, they were bound to undervalue the arts, which can never be reduced to a mechanistic stimulus-response analysis.

Efland properly emphasizes that by contrast to behaviorist-oriented psychology, the cognitive revolution underway since the 1950s has taken account of the complex role played by the mind itself in the processing of experience and the formation of knowledge, and has made great strides toward understanding it. He recognizes (138–39) the following basic cognitive principles:

> We learn about the natural world through our senses. . . . We also learn within a social world through interactions with family members, peers, and the community at large. . . . We organize our world on the basis of common attributes. . . .
>
> . . . Categorization involves thinking about things in terms of commonalities, not about the uniqueness of individual cases. This action is mostly automatic and unconscious, giving rise to the view that objects and events in the world come in natural kinds. . . .
>
> . . . [Categories] are cognitive structures that have developed as a result of learning and hence are not properties of the world but cognitive achievements. They emerge from the mind's effort to organize what is given in perception so as to secure meaning. Were it not for the capacity to categorize, we would soon become "slaves to the particular."

Efland further emphasizes (142) that categories are "abstracted from multiple experiences that are largely perceptual in character, and . . . are 'natural' in the sense that they arise from distinctive actions of the body such as grasping, touching, or seeing" Although they are cognitive achievements, "they are not disembodied."

As Efland makes clear in his third chapter, the cognitive revolution has comprised a diversity of approaches, of unequal value. He

rightly rejects their polar extremes—which view knowledge either as constructed solely by the individual mind in direct response to objective reality or as a mainly sociocultural construction, absorbed by the developing individual from his surrounding culture.[2] Instead, he embraces an integrated theory of cognition, which holds that each individual constructs his own view of reality in the light of his personal, social, and cultural context. According to this integrated theory, each of us is guided by our own interests and purposes in seeking to understand the world through our experience of it. Yet we inevitably employ the cognitive tools provided by the culture in which we live, tools ranging from language to a body of scientific knowledge. In principle, therefore, while Efland recognizes the crucial influence of cultural context, he does not deny the efficacy of the individual as a thinking and acting being (nor does he appear to doubt that there is an objective reality, independent of anyone's view of it). I say "in principle," however, because there are times that he seems to forget these key ideas in practical application, as I will point out below.

Just as Efland adopts an integrated view of cognition, he also adopts an integrated view of the nature of art. Reacting against a former tendency in education to regard the arts as belonging solely to the affective realm of feelings, Efland insists that they are about ideas as well, that they are vehicles of meaning, efforts to interpret the world. He notes, for example (105): "Works of art are more than formal designs that arouse interest. They . . . are about the life and death issues that affect people . . . , issues affecting their social and personal worlds [such as] war and peace, the need to belong, equity, justice, morality, and the like." (Note that these examples are more social than personal—a focus that biases Efland's subsequent recommendations for art education, as it ignores such worthy genres of visual art as landscape painting and portraiture.) Efland further argues (106) that the arts are educationally important "if and to the extent that they enable individuals to integrate their understanding of the world" (*help* might be a better word than *enable* here). And again (162): "A work of art is about something. It is an artist's interpretation of what he or she has seen, felt, or undergone. It is an imaginative reordering of that experience . . . embodi[ed] in a medium. . . . Artistic productions capture and mirror the artist's interpretive vision."

Efland also emphasizes (162) that unlike music and literature, visual art can be apprehended directly, merely "'by looking,' without the need to decipher musical notation or the symbol systems of written language." He further observes (166): "The understandings, feelings, and emotions they give rise to are part and parcel of that experience and have an immediacy and directness by virtue of the sensory origins of the encounter." Yet to suggest, as he does, that those characteristics offer an argument for including the visual arts in general education, seems off the mark. However true the observations are in themselves, they do not make a valid case for teaching art.

Misconceived Goals and Content of Art Education

The main problems arise when Efland proceeds to practical considerations—namely, the goals and methods of art education. There he often ignores or belies the principles he identified at the outset. With respect to the goals of art education, for example, he places virtually exclusive emphasis on the cognitive content of art, despite his prior insistence that art involves both emotion and cognition. Thus, he suggests, rather astonishingly (131), that the study of art is valuable because it "provides occasions for the acquisition of cognitive strategies to carry out interpretive forms of inquiry." I, for one, would hate to see a student's experience of Michelangelo's Sistine Ceiling, say, or of a late portrait by Rembrandt, the Parthenon sculptures, or a Sung Dynasty landscape, treated as an occasion for "the acquisition of cognitive strategies to carry out interpretive forms of inquiry."

An even more disturbing aspect of Efland's approach is that such time-tested masterpieces do not appear to have a place at all among the works that he would choose for study. Notwithstanding his earlier emphasis on the relative immediacy and perceptual accessibility of visual art, the examples he focuses on for the classroom tend to be "difficult" and relatively inaccessible works, drawn mainly from the controversial ranks of the avant garde of the past hundred years. He thus ignores nearly all of art history. Of the fewer than twenty works cited by him, moreover, only seven indisputably qualify as art. They are by Chagall, Degas, Poussin, Renoir, Seurat, and van Gogh. The remainder are by Marcel Duchamp, Adolf Gottlieb, Jasper Johns,

Roy Lichtenstein, René Magritte, Robert Rauschenberg, Man Ray, Cindy Sherman, Andy Warhol, and Krzysztof Wodiczko (a Polish-born postmodernist cited by Suzi Gablik in *The Reenchantment of Art*)—pseudo artists all, in my view.

Even if one were willing to grant the output of such antitraditional "artists" the status of art, it is surely atypical. Wodiczko's *Homeless Vehicle Project* (praised by Efland), for example, consisted mainly of "design[ing] a vehicle, based on the shopping cart, that could be used for transport and storage, and might even serve as a temporary shelter for people who are compelled to live a nomadic life in the urban environment" (as described by Gablik[3]). In his enthusiasm for this quasi-utilitarian project, Efland ignores that such a work falls outside his own definition of art as "a representation of the world." Nor does it qualify as "an imaginative reordering of . . . experience . . . embodi[ed] in a medium." Nor does it "capture and mirror the artist's interpretive vision" (162). Efland makes a case for regarding it as a thought-provoking and action-inspiring sociological "statement" of some kind, but he offers no reasons why we should consider it to be art. Surely his own prior emphasis on the cognitive principle of "organiz[ing] our world on the basis of common attributes" should lead him to conclude that focusing on such atypical work (work tellingly characterized even by those sympathetic to it as "anti-art"—see, for example, Thomas McEvilley, *The Triumph of Anti-Art*) is pedagogically unsound, unless one were to use it as a foil to highlight, by contrast, the chief characteristics of what is commonly regarded as art.

Efland is not unaware of the pedagogical difficulties inherent in dealing with nontraditional work. He notes, for example, that most students are likely to regard modern art as an object of jokes, "a world given to madness" (8). He also suggests that some works "might serve to reveal sites of conflict, especially when they violate our expectations of what art should be about, or *even whether . . . the object is art at all*" (165–66, emphasis added). But far from exploring the underlying reasons for such views and assessing them in relation to the theory of concept formation (categorization) that he embraces, he simply assumes that they are mistaken and that the works are indeed art. In his view, the goal of teachers should be "to enable learners to form connections with [such] works" (8)—that is, to treat them as art.

Efland's emphasis on enabling students to interpret visual art is evident from the outset. The very first work he cites in the opening pages of his book is characterized by him as "a source of puzzlement, mystery or bewilderment": Magritte's surrealist painting *The Telescope* (1963). In it a bright, cloud-studded sky is seen through the panes of a partly open casement window but is illogically replaced by total darkness in the narrow space glimpsed between the panes. "What could Magritte have had in mind when he painted this picture?" Efland asks. Such works, in his view, "often make heavy cognitive demands on thinking" and "awaken intellectual inquiry." Moreover, "the meanings derived from this effort may bear on our lives in the social and cultural worlds we inhabit" (2).

Underlying Efland's argument, of course, is the assumption that Magritte's work has some meaning that might "bear on our lives" in the real world, and that the painter expected it to be understood. Such an assumption is entirely belied by what Magritte himself famously said about his work in general, however:

> My painting is visible images which conceal nothing; they evoke mystery and, indeed, when one sees one of my pictures, one asks oneself this simple question "What does that mean"? *It does not mean anything*, because mystery means nothing either, it is unknowable.[4]

Urging students to interpret Magritte's *The Telescope*, then, is a bit like asking them to solve a mathematical problem that is in fact insoluble.

Like many critics who write on art today, Efland mistakenly assumes that every would-be artist hopes that his work will be "understood," that its gist will be grasped, or at least graspable, by the viewer. Since the onset of radical modernism in the early twentieth century, that assumption is no longer universally valid, however. As Louis Torres and I have documented in *What Art Is*, many modernists considered their work far too "advanced" to be graspable by any but a very select few.[5] Still worse, many postmodernists, not unlike the surrealist Magritte, have quite explicitly stated that they do not intend their work to have meaning.[6] Such attitudes, by the way—much more than the boundaries referred to by Efland (102) "that began separating high culture from popular culture" in the late

nineteenth century—have been the main problem in the artworld of the past hundred years.

Disregard of artistic intention vitiates Efland's interpretation of other works as well. Although he wisely rejects modernism's formalist approach to the analysis of art, he all too readily accepts the opposite extreme—politically inspired postmodernist readings that have doubtful validity. Such readings pay a lot of attention to the sociopolitical context of a work but virtually no attention to evidence regarding what the artist in question may have had in mind.

In suggesting a possible lesson for a high school art class studying American painting after World War II, for example, Efland unquestioningly accepts a highly dubious interpretation of a work by Jasper Johns. He approves the notion disseminated by the critic Robert Hughes (in his televised *American Visions* series) that the "submerged text of Johns's target paintings connects to the stresses of Cold War America" (125–28). In addition, he accepts Hughes's claim that Johns's *Target with Four Faces* (1955) may also relate to the sense of personal paranoia that Johns, a homosexual, probably felt in a period when homosexuality was thought to have (as Hughes put it) "secret affinities with Communism."

Such interpretations fly in the face of everything Johns has ever said about his work, however. To judge from his own repeated statements, his creative choices were arrived at casually, the product more of whim and happenstance than of paranoiac feelings of any kind. On his use of flags and targets as subjects, for instance, he told *Time* magazine in 1959: "[P]ainting a picture of an American flag . . . took care of a great deal for me because I didn't have to design it. So I went on to similar things like the targets—things the mind already knows."[7] He told another interviewer: "My primary concern is visual form. The visual meaning may be discovered afterward— by those who look for it. . . . I feel that what I am doing is quite literal."[8] And another: "[Such subjects] are just the forms that interest me and which I have chosen to limit and describe space."[9] Finally, Leo Steinberg, the art historian who first put Johns on the artworld map, has reported: "I . . . once ask[ed] why he had inserted these plaster casts [in the target paintings], and his answer was, naturally, that some of the casts happened to be around in the studio." As for

why Johns cut off the masks just under the eyes, he told Steinberg: "They wouldn't have fitted into the boxes if I'd left them whole."[10] So much for paranoia—Cold War or homophobic.

Far more troubling than Efland's embrace of Hughes's ill-founded interpretation of the Johns work, however, is his treatment of Georges Seurat's *Sunday Afternoon on the Island of La Grande Jatte.* I say far more troubling, because this painting is the only genuine masterpiece discussed by him at such length, and the disservice wrought by mis-interpretation is in direct proportion to the value of the work itself. Here again Efland uncritically accepts a sociopolitical postmodernist reading that entirely ignores contradictory evidence about the artist's likely intent. Rejecting the "naïve" sort of understanding exemplified by the student who interprets the work simply as "a happy scene in the park," Efland instead adopts (113–14) art historian Linda Nochlin's Marxist-inspired interpretation of it as an "anti-utopian allegory."[11] Nochlin's view—based on inferences drawn from the subject matter and style of the work in relation to social and political currents of the day—is overwhelmingly belied by what is known about Seurat's predilections and concerns as an artist, however.

According to Nochlin, the painting not only reflected "the most advanced stages of the alienation associated with capitalism's radi-cal revision of urban spatial divisions and social hierarchies of his time" but in it Seurat "actively *produc[ed]* [such] cultural meanings through the invention of visual codes for the modern experience of the city."[12] As another scholar has more convincingly argued, however: "Nothing we know about Seurat's history, neither his own statements, the eye-witness accounts of acquaintances, nor the writings of contemporary critics who knew him, supports such [readings]."[13] In fact, when one studies the primary sources available regarding Seurat, the logical conclusion is that Efland's putative novice who sees the painting as being "'about people enjoying them-selves in the park—no more, no less'" (111) comes much closer to the likely original intent of the artist than Nochlin's purportedly expert anti-utopian thesis.[14]

On the whole, in fact, Efland is far too ready to accept the opin-ion of contemporary artworld "experts" over that of the novice. In his view (114):

[T]he expert's knowledge base is likely to be organized around a more central set of understandings that enables him or her to see relationships between and among concepts. This organizational structure connects key ideas and procedures in meaningful ways. By comparison, a novice's knowledge base typically is organized into rigid and isolated cognitive structures.

As I have indicated, however, the convoluted interpretations of today's experts are often less reliable than the untutored responses of novices, which are more directly related to the qualities of the image itself. Art teachers would therefore do well to view today's "expert" testimony skeptically, rather than automatically accept it as authoritative.

With regard to interpretation in general, Efland maintains (160–61):

[W]hat a work of art might have meant in one generation will likely change when it is interpreted *by* and *for* another. This also applies to individuals, who will construct different meanings about a given work. . . .

. . . [O]ne answer to the question of why the arts are cognitively significant is that they provide encounters that foster the capacity to construct interpretations.

But surely not all interpretations are equally valid. And those that are clearly belied by information about the artist that sheds light on his probable intent should be emphatically rejected. Not to do so would be to undermine the value of art-making as a meaningful activity, for the idea of intention lies at the very root of "meaning" in its most basic sense.

Regarding standards for expertise, Efland (110) quotes another scholar, R. S. Prawat, who observed: "When good reasons for accepting a knowledge claim can no longer be marshaled, the claim is refuted." It is unfortunate that with respect to interpretation (as to much else) in today's artworld, that standard is not always maintained.

Undue Emphasis on Metaphor

Another fallacy in Efland's approach to art education is his emphasis on visual metaphor. Impressed by the illuminating work that linguist George Lakoff and philosopher Mark Johnson have done on the

centrality of metaphor in human cognition, he approves (167–68) their claim that metaphor and narrative provide the basis for "an imaginative rationality . . . [that] is one of our most important tools for trying to understand what cannot be fully comprehended: our feelings, aesthetic experiences, moral practices, and spiritual awareness." All well and good if one is referring to literature. But Efland attempts to apply the idea to visual art as well. He argues, for example (153), that,

> the arts are places where the constructions of metaphor can and should become the principal object of study, where it is necessary to understand that the visual images or verbal expressions are not literal facts, but are embodiments of meanings that can be taken in some other light.

Here and elsewhere Efland wrongly suggests that metaphor is, or can be, as central to the visual arts as it is to literature. True, images in art should not be viewed merely literally: they should, as Efland argues, be regarded as embodiments of meaning beyond the concretes represented. But the primary means by which they convey such import is directly representational and mimetic, not metaphoric. In fact, metaphor is rarely involved in painting or sculpture. In contrast, it is fundamental to the literary arts (as to verbal expression, in general) because literature employs the abstract medium of language. Metaphor lends sensory immediacy and concreteness to verbal expression. Visual art has no need of metaphor, because it already possesses "immediacy and directness by virtue of [its] sensory origins" (to borrow Efland's words)—that is, by its very nature.

It is telling that despite Efland's theoretical emphasis, he cites very few examples of visual metaphor, and all are of limited value. (So, too, an article on visual metaphor in *Studies in Art Education* suffers from a lack of compelling examples.[15]) Of the three main instances Efland cites, moreover, only Marc Chagall's *Time Is a River without Banks* qualifies as a work of art.[16] Yet even this work functions more as an enigma to be solved than as an effective image in its own right. Of still less value are Efland's other two examples: Man Ray's *Le Violon d'Ingres* and an anti-drug-abuse public service announcement that depicts, in Efland's words (153–54), "a brain affected by

drugs as an egg being fried." Since the latter image is not art, it is not relevant to a discussion of art education per se. As for Man Ray's photographic montage, even if one were willing to classify it as art, it amounts to little more than a clever visual pun—one not fully explicated by Efland. The French expression *violon d'Ingres* derives from the fact that the painter was an amateur violinist, and it means "hobby." Thus, Man Ray's image (of an Ingresque odalisque with the *f*-holes of a violin superimposed on her back) irreverently implies that beautiful nudes, too, were Ingres's hobby. At best, it elicits a chuckle from the viewer who gets the verbal and visual pun. Unlike a true work of art, however, it neither invites lingering attention nor tends to elicit deeper reflection or emotion.

This is not to say that visual art never employs metaphorical allusion effectively. One work that does so, without recourse to the sort of illogical surrealist juxtapositions employed in Chagall's *Time Is a River*, is Andrew Wyeth's *Chambered Nautilus*. In it, a woman sits up in a canopied four-poster bed in an otherwise almost bare room—gazing out into the bright daylight through a large window. Her gnarled hands are tightly clasped around her raised knee. Her brightly illuminated face, turned away in profile, is barely visible, but seems calm, self-contained. Yet her unkempt wisps of hair suggest that she is not well. Alongside her pillow is the work basket she has set aside. On a bench at the foot of her bed, next to one of the sturdy bedposts, is the fragile but firm shell of a chambered nautilus. A breeze stirs the wisp of drapery hanging down from the bed's canopy and seems to move like a spirit across the meticulously painted image.

According to the catalogue of a 2006 Wyeth exhibition at the Philadelphia Museum, the motif of the nautilus shell "echoes the claustrophobic enclosures of the room and the bed hangings, while also standing in for the fragility and private inwardness of the artist's mother-in-law, who is the subject of the picture."[17] Such an interpretation is not only plausible on the face of it but essentially true to the artist's intent as well. In his account of the painting's creation, Wyeth has explained that he sought to capture both the physical frailty and the inner strength of this woman, whom he deeply loved and who was slowly dying of a rare wasting disease. As he recalled, he seemed to feel her life force slipping out the window.[18]

The nautilus shell served as a rich metaphor to conjure up the complex thoughts and emotions evoked in Wyeth by this experience. Nonetheless, what should be emphasized about his *Chambered Nautilus* is that even without such a metaphorical reference it would still be a compelling image, because of its representational, expressive, and formal properties. And its value as a work of art stems mainly from those properties, not from the inclusion of the nautilus shell or the reference to it in the title. Such expressive properties are what should be stressed in the teaching of art.

Although visual metaphor is relatively uncommon in traditional painting and sculpture, it is often employed in postmodernist work— no doubt because it is a facile device for expressing an idea without having to master the more subtle means of purely visual representation that make a work such as Wyeth's *Chambered Nautilus* so haunting an image. In any case, metaphor does not warrant the emphasis given to it by Efland in a general discussion of art and cognition.

Finally, the example of Wyeth's deeply intimate work, which is unlike any of the works discussed by Efland, serves to highlight what I see as the most serious shortcoming of his *Art and Cognition*—its nearly total neglect of the personal dimension of art. Like all too many of his colleagues, Efland appears to have concluded that the only things of real importance in art pertain to the social and cultural dimension. That emphasis is evident in his concluding summary statement on the purpose of the arts, which reads in part (171):

> The function of the arts throughout human cultural history has been and continues to be the task of "reality construction." [This unfortunate term unwittingly implies, contrary to Efland's following sentence, that there is no objective reality.] The arts construct representations of the world, which may be about the world that is really there or about imagined worlds that are not present, but that might inspire human beings to create an alternative future for themselves. Much of what constitutes reality is socially constructed, including such things as money, property, marriage, gender roles, economic systems, governments, and such evils as racial discrimination. The social constructions found in the arts contain representations of these social realities.
>
> Therefore, the purpose for teaching the arts is to contribute to the understanding of the social and cultural landscape that each

individual inhabits. The arts can contribute to this understanding because the work of art mirrors this world through metaphoric elaboration. The ability to interpret this world is learned through the interpretation of the arts, providing a foundation for intelligent, morally responsive actions.

True, one can learn much about the social and cultural landscape from works of visual art. But to think of art mainly in terms of "understanding" and "interpreting" the world is profoundly mistaken, in my view. What the arts are mainly about is valuing. And the kind of valuing that is evident in an image such as Wyeth's *Chambered Nautilus* has nothing to do with such things as money, gender roles, or racial discrimination. It has everything to do with such things as love, and death, and the lasting imprint of the spirit despite the fragility of life. Such concerns are not "socially constructed." They are intrinsic to the human condition. If those charged with determining the educational content of our schools are blind to their educational value and can be impressed only with matters of evident social utility or relevance, then perhaps it would be better to have no "art education" at all.

The Hijacking of Art Education

Parents and others who think that children are mainly learning about painting and drawing in today's art classrooms should consider this: a movement has for some time been afoot to hijack art education for purposes of often radical political indoctrination. This effort—which I have warned of in "Where's the *Art* in Today's Art Education?" (above, pages 143–51) and "Rescuing Art from 'Visual Culture Studies'" (above, pages 152–64)—has gained a major platform in the 2010 convention of the National Art Education Association (NAEA), the chief organization of K–12 art teachers and of the professors who train them. It also threatens to influence art education requirements in the nation's Elementary and Secondary Education Act, formerly dubbed "No Child Left Behind," whose re-authorization is pending.

I do not believe that this politically tainted approach to art education represents the view of many, much less most, of the more than 20,000 members belonging to the NAEA. But it is all too common among those in higher education who are training the next generation of teachers, as well as among many in leadership positions in the association, as evidenced by the theme of this year's convention and the recent thrust of the association's journals, *Art Education* and *Studies in Art Education*. Unless teachers, parents, and others who disagree with this approach let their objections be known, loud and clear, the hijacking of art education by a misguided minority will succeed.

Aristos, April 2010.

To understand the extent of the threat posed and combat it effectively, it is essential to recognize the nature of the views being advocated and the ways in which (and by whom) such views are already being injected into "art education." That is what I aim to shed light on here.

Art Education and Social Justice—the 2010 NAEA Convention

A telling sign of the nature of this movement is the logo adopted by the NAEA for its 2010 convention, whose theme is "Art Education and Social Justice." It is the raised-clenched-fist symbol commonly associated with radical, even violent, political activism. Nor should one be much comforted by the fact that this fist is holding a pair of paint brushes.

Needless to say, art has often dealt with injustice—from moving interpretations of biblical themes such as the *Massacre of the Innocents* to Goya's *Disasters of War* and *Third of May* to Picasso's *Guernica* and work by the still living artist Elizabeth Catlett depicting the brutal effects of racism in America. The NAEA convention theme is conceived mainly in terms of politics, however, not art.

According to the "2010 National Convention Notes from the Program Coordinator": "Education is always political. The teacher has to ask, what kinds of politics am I doing in the classroom. That is, in whose favor am I being a teacher." That quote is attributed to the Brazilian Marxist and education theorist Paulo Freire—whose *Pedagogy of the Oppressed* has, lamentably, become required reading for future teachers in many American schools of education.[1]

Just what does the term *social justice* mean? The NAEA web page informs us that "Within the realm of education, [it] alludes to the notion of education as a political act, and when coupled with the term *art education* hints at models of resistance—teaching as a form of activism." Resistance to what? And activism for or against what or whom? What, for example, are we to make of the declaration that Art Education and Social Justice "questions" such things as *American democracy, truths,* and *accomplishments,* while "embracing" *democracy, not knowing,* and *social literacy*? To gain some sense of what these

opposing notions point to, one has to dig deeper and examine the sources cited regarding the convention's theme.

Harnessing the Arts to the President's Agenda

One of the chief sources cited in the 2010 NAEA program coordinator's notes is a White House Briefing on Art, Community, Social Justice, [and] National Recovery held in May 2009. According to a published report, the purpose of the briefing was, in part, to determine "how the remarkable mobilizing power of community arts can be used by the Obama administration as a tool and a pathway for national recovery" and "to identify existing efforts within the cultural and social justice movements that are in alignment with the national agenda . . . on such issues as green jobs, health care and economic justice."[2]

The artists and "creative organizers" who attended came away with the feeling that they "were being challenged to come up with promising and attractive ideas about how artists can work for the administration's agenda." As one attendee put it, they could act as "a think tank to serve the administration's aims." These aims were made clearer in various post-briefing strategy sessions planned as a continuation of the briefing. The Healthcare Reform session, for example, identified multiple roles "that artists can play in support of health care reform," such as creating "a counter narrative to the [Frank] Luntz memo/Republican talking points designed to destroy health care reform."

The NAEA does not refer to such partisan concerns. Nor does it note that the only artists and groups involved in the meeting represented "alternative" or "underground" forms such as rap, hip hop, and "street art" or graffiti—surely not the sorts of art most parents expect their children to learn about in school. But its reference to the briefing clearly implies tacit approval. As does its quoting White House Deputy Social Secretary Joseph Reinstein's declaration that "The administration believes the arts play a critical role beyond art education in saying what a democracy is." Many Americans across the political spectrum would object to such a role for the arts, still more so for art education. When one considers the views of "democracy" that emerge in further examination of the NAEA's sources, there is even greater cause for concern.

Democracy, the Arts, and Maxine Greene's "Progressive" Vision

A clue to the general thrust of the social justice theme lies in the following statement quoted in the NAEA's notes on the 2010 convention: "[T]he arts will help disrupt the walls that obscure . . . spheres of freedom." The source of that rather poorly phrased motto (does one "disrupt" walls, and what exactly are "spheres of freedom"?) is Maxine Greene, an influential professor of education at Teachers College in New York for more than forty years. Her keen interest in the arts, as well as her "progressive" social and political views, are well known in education circles.

As Philosopher-in-Residence at the Lincoln Center Institute for the Arts in Education since 1976, Greene conducts workshops focusing on literature as art, lectures at its summer sessions, and has inspired the creation of an alternative high school devoted to "Arts, Imagination and Inquiry." In 2003, she founded the Maxine Greene Foundation for Social Imagination, the Arts, and Education, to support "the creation . . . and informed appreciation of works [of art] that . . . move people to perceive alternative possibilities for the making of humane communities."

Greene Grants of up to $10,000 are awarded to teachers who "go beyond the standardized and the ordinary," artists "whose works embody fresh social visions," and individuals "who radically challenge or alter the public's imagination about social policy issues." The 2008 grantees included the Education for Liberation Network—whose 2007 conference, entitled "Free Minds, Free People: A Conference on Education for Liberation," bore the following slogan on its program cover: "If education is not given to the people, they will have to take it."

The source of that quote is Ernesto "Che" Guevara, the Latin American revolutionary whose vision of the path to democracy included "the acrid smell of gunpowder and blood, . . . the bestial howl of the triumphant proletariat," and the violent "slaughter" of his political adversaries.[3] As Fidel Castro's chief executioner during the Cuban revolution, Che is alleged to have referred to judicial procedures as "an archaic bourgeois detail" best ignored by a revolutionary, who "must become a cold killing machine motivated by pure hate." If those precise

words are not his, he nonetheless enacted them through the summary execution of countless political prisoners, often at his own hands, without benefit of trial. When he referred to the people "taking" things, therefore, he did not limit himself to peaceful means. As for what he did for them once he gained power, it is well documented that he steered the Castro regime in "a radically repressive direction," as one professor of political science and history has put it. In addition to stifling basic freedoms of religion, speech, press, assembly, and protest, he imposed severe economic controls that were nothing short of ruinous.[4]

"School Reformer" William Ayers

Though Che is hardly a model of democratic action to be held up to anyone, much less to all-too-impressionable young people, he is clearly admired by William Ayers—a prominent member of the Greene Foundation's board of directors—whose connection to the NAEA appears to be growing. This former Weather Underground terrorist is now a professor of education at the University of Illinois, where his office door may still display a picture of Che (among others) as the *Chicago Tribune* reported it did in 2008.[5] Ayers co-authored one of the four sources cited by the NAEA regarding its social justice convention theme, and will be presenting a session at the 2010 convention entitled "Art and the Freedom School Curriculum." That session will instruct teachers "how to empower their students by exploring the action-based research methods made available through [a] presentation of the Mississippi Freedom School Curriculum."[6]

The Mississippi Freedom Schools, some readers may recall, were temporary, alternative free schools developed as part of the 1964 Freedom Summer civil rights project. Their main thrust was to engage African Americans in the South in the political process through education and voter registration drives. At a time when blacks were still largely disenfranchised and disempowered by discriminatory laws and practices, the Freedom Schools met an urgent need. But one may well wonder whether today's conditions are really comparable and just how relevant the Freedom School Curriculum is in the present educational environment (more on that later), much less to art education per se.

Like his mentor Maxine Greene—with whom he studied at Teachers College in the 1980s, earning his doctorate in education there in 1987—Ayers views the arts mainly as a vehicle for social and political change. In a review of a book about Greene's educational philosophy, in a recent issue of the NAEA's research journal *Studies in Art Education*, he indicates his admiration for her "'unique attention to literature and the arts,'" as well as for "her radical commitment to social imagination." Like her, he places great value on the effect of art's imaginary realms on the development of "the self." But one needs to look elsewhere to find what he means when he praises her view of "the different ways of knowing and being" presented in the arts and "the obstacles to our humanity" that they can help uncover.

Ayers has often been characterized as a "school reformer." According to education writer Sol Stern, however, "calling Bill Ayers a school reformer is a bit like calling Joseph Stalin an agricultural reformer." Stern—who was an editor and staff writer for the New Left magazine *Ramparts* in the turbulent years from 1966 to 1972—argues that Ayers explicitly aims "to indoctrinate public school children with the belief that America is a racist, militarist country and that the capitalist system is inherently unfair and oppressive."[7] That characterization of Ayers's view of the United States is certainly corroborated by remarks he made in an interview with *RT* (*Russia Today*) as recently as December of last year. In it he suggested, among other things, that "white supremacy" is a potent force in America, albeit one dealt a "real blow" by the election of President Obama; that America's presence in Afghanistan is "an invasion and an occupation"; that America is largely run by "militarists and cryptofascists"; and that in sum "the idea that we've been a force for good [in the world] for the last six decades is utter nonsense."[8]

As for what "different ways of knowing and being" Ayers admires, we can gain some idea from a speech he gave in Caracas, Venezuela, to the World Education Forum in 2006, with President Hugo Chávez at his side. Lauding "the profound educational reforms under way" in Venezuela under Chávez, Ayers declared: "We share the belief that education is the motor-force of revolution. . . . I look forward to seeing how . . . you continue to overcome the failings of capitalist education as you seek to create something truly new and deeply humane."[9]

Further implying that "education without revolution" is impossible, Ayers maintained that capitalism "promotes racism and militarism—turning people into consumers, not citizens." In conclusion, he proclaimed: "Venezuela is poised to offer the world a new model of education—a humanizing and revolutionary model whose twin missions are enlightenment and liberation." He then raised his clenched fist, chanting: "Viva Presidente Chávez!"

Judged by other eyes, however, Chávez looks less and less like Ayers's hero of the people and more and more like a totalitarian dictator. In recent years, he has moved to stifle all opposition by shutting down independent media outlets and adopting harsh measures against political opponents. He has also harassed various religious groups and has openly fueled anti-Jewish sentiment. At the same time, his economic controls have contributed to high inflation and shortages of many staple consumer goods.[10]

In short, the grim realities of Venezuelan life cast an ominous shadow upon Ayers's idealized view. Such evidence of his defective judgment is all the more disturbing when one considers that he is now serving as the Vice President for Curriculum Studies in the American Education Research Association, the nation's largest organization of education school professors and researchers. Credentials like that no doubt make it easy for some art educators to regard him as a respectable colleague. Some of them even signed a petition in his defense in 2008 that stated, in part: "The current characterizations of Professor Ayers—'unrepentant terrorist,' 'lunatic leftist'—are unrecognizable to those who know or work with him. . . . His participation in political activity 40 years ago is history; what is most relevant now is his continued engagement in progressive causes, and his exemplary contribution . . . to the field of education."

Those who signed that petition are either disingenuous or terribly naive—or they simply share Ayers's distorted views.[11]

Where's the Art in "Social Justice Art Education"?

One of the signers of the Ayers petition was Therese Quinn, an associate professor of art education at the School of the Art Institute of Chicago. Quinn is the author of "Out of Cite [*sic*], Out of

Mind: Social Justice and Art Education," one of the sources cited by
the NAEA regarding its 2010 convention theme. (Quinn also co-
authored another of those sources with Ayers, and will co-present the
aforementioned Freedom School session with him.) Quinn's article
could well be regarded as sounding the keynote for the conference.
Tellingly, she spends most of her 20-page paper discussing the con-
cept of social justice and almost none of it discussing *art*.[12]

In Quinn's view, social justice encompasses both "recognition
and redistribution" (a phrase borrowed from feminist theorist Nancy
Fraser). The concept of redistribution, Quinn explains, refers to "the
equitable allocation of resources"—a goal implying that government
should intervene to ensure equality of results. In the view of many
Americans, however, that idea smacks of socialism, and is antithetical
to the founding principles of our nation. In any case, it pertains to
the economic realm, and its connection to art education is therefore
indirect at best.

"Recognition," on the other hand, is more closely related to art
education, since it pertains to the cultural realm. This goal ostensibly
aims at accentuating multiculturalism and diversity, but it amounts,
in effect, to a narrowly limited view of diversity. While emphasizing
and honoring diversity in terms of countless *group* identities—from
race and gender to religion and ethnicity—advocates of "social jus-
tice" resist acknowledging *individual* differences in talents, abilities,
and sheer hard work (not to mention in what Martin Luther King,
Jr., referred to as "the content of [one's] character"), and seem to
ignore that such differences naturally result in different levels of
achievement. They also fail to recognize that diverse cultural and
religious traditions may differ in the degree and quality of their con-
tribution to humanity.

That egalitarian attitude may help to explain the otherwise baf-
fling fact that *accomplishment*s are listed among the things that the
NAEA's Art Education and Social Justice theme "questions." Such
egalitarianism is completely at odds with the principle of meritocracy
that lies at the heart of the American political system and way of life,
however. The concept of political equality embedded in the Decla-
ration of Independence and Constitution refers to equal protection
under the law and equal freedom to pursue one's life. It does not guar-

antee either equal attainments or equal recognition for one's person and achievements, however modest they may be. Under this system, true social justice consists of honoring individuals in proportion to their achievements, while recognizing that those achievements also tend to benefit the larger community.

Conspicuously absent from Quinn's quasi-keynote paper is any consideration of genuine *art* in education. While she quotes Maxine Greene's assertion that "the arts will help disrupt the walls that obscure . . . spheres of freedom," she cites no actual works of art to indicate how they might do so. Ignoring genuine art entirely, she instead focuses on "visual culture" and the sort of postmodernist work that I and others have argued is at root *anti-art*.[13] At the same time, she mischaracterizes the discipline-based approach to art education that she seeks to displace, when she quotes without objection the claim that in Disciplined-Based Art Education (DBAE) "aesthetics is taught disconnected from its social context." In truth, a defining characteristic of the DBAE approach is that it considers the cultural contexts in which art is created.[14]

Arguing that "[s]ocial justice art education would necessarily address the kind of contextual issues raised via visual culture" (that is, by things other than art), Quinn observes that it is particularly compatible with "postmodern approaches to art," and with certain "tendencies in contemporary cultural practice, [such as] a move away from art as product and solo endeavor, toward collective work not (always) aimed at artifact creation, including temporary, activist, and online projects." So much for the paint brushes clutched in the fist of NAEA's 2010 convention logo!

In that connection, Quinn cites an essay entitled "Some Call It Art" by Gregory Sholette, a founding member of PAD/D (Political Art Documentation/Distribution). Sholette advocates "[retooling] the bankrupt idea of artistic autonomy" in order to create "a model for sedition, intervention, and ultimately political transformation." Such a transformation, in his view, "requires a final emptying-out and decomposition of artistic autonomy as a bourgeois ideology." He therefore welcomes the widespread "'de-skilling' of artistic craft" that has occurred in the artworld since the 1960s. As he observes, the artworld's acceptance of "conceptual art" (one of postmodernism's

anti-art genres) dispensed with skill and led, in effect, to "the total disappearance of the art object"—as did the use of "ephemeral materials, dead-pan performances and aimlessly shot video" that produced work "indistinguishable from advertising and pop-culture."[15]

As Sholette recognizes, these developments in the postmodernist artworld have paved the way for politically engaged work employing similar media and exhibiting a similar lack of skill. But that does not make such work art, any more than work by the contemporary artworld stars who employ these means truly qualifies as art. Nonetheless, Sholette believes that "art activists" have succeeded in creating "an informal political aesthetic." As examples, he cites work by such collaborative "interdisciplinary" groups as RTMark, Critical Art Ensemble, and the Center for Land Use Reclamation, which are also cited approvingly by Quinn. While the work of these groups is undoubtedly *activist* and *political*, its "aesthetic" has nothing to do with *art*. Nor would it be recognized as such by most people. Not surprisingly, that is of no concern to Sholette. He concludes that instead of asking "what is art?" we should be asking "what is politics?"

Ayers, too, is far more concerned with politics than with art. Although he begins the book review cited above with a literary quote from Charles Dickens's novel *Hard Times* alluding to the need for cultivating the imagination over mere "facts," he has little to say about *visual* work, which is what the NAEA purportedly deals with. The only such works he refers to are Andres Serrano's *Piss Christ* (his controversial photograph of a crucifix submerged in a container of urine), Chris Ofili's painting *The Holy Virgin Mary* (notorious for its inclusion of clods of elephant dung), and photographs by Robert Mapplethorpe (best known for his highly graphic images of men engaged in sadomasochistic homoerotic acts). For Ayers, such works—all of which have provoked intense public controversy—exemplify the "arts as potential, as stimulants of the *social* imagination, [which] threaten the people who are drunk on power, [who are] focused on facts without ethics" (emphasis in the original). For many ordinary people, however, the value (even the status) of such works as art is highly questionable, as Louis Torres and I have argued.[16]

Future Federal Policy on Arts Education

As I've indicated above, "visual culture art education," closely allied with "social justice art education," is also more concerned with politics than with art. Advocates of both approaches are attempting to influence federal policy on arts education. A National Education Taskforce (NET) headed by Dennis Fehr—an associate professor of "visual studies" at Texas Tech University—has proposed inserting new language into the federal Elementary and Secondary Education Act (ESEA), requiring both the study of "visual culture" and the "examination of social justice and ethical questions posed by artworks."[17]

According to the NET website, the purpose of the taskforce is quite general—to "produce current research on education issues for the U. S. Congress." When I inquired about the possibility of its publishing remarks that I had submitted to a Department of Education hearing on ESEA reauthorization,[18] however, Fehr informed me that the "NETwork" is devoted solely to "publish[ing] emergent ideas about visual culture," not to considering other viewpoints.[19]

Moreover, the political bias driving Fehr's efforts was evident between the lines of a talk he gave at a symposium sponsored by the University Council for Art Education last September on the future of arts education.[20] To demonstrate the urgent need to improve "visual literacy" in America, he presented two media images that he claimed had influenced presidential elections. One was a 1984 televised image of President Ronald Reagan seated before a row of American flags that made him look very patriotic, allegedly blinding viewers to criticism of his policies. The other showed the 1988 Democratic presidential candidate Michael Dukakis looking rather ridiculous atop a military tank—an image intended to show that he was strong on defense. Visual illiteracy regarding the implications of these images, Fehr implied, had had dire consequences for the country (Reagan won re-election, and Dukakis lost to George H.W. Bush). In Fehr's view, this served as compelling proof that teaching about such things in the art classroom is essential for our future.

Setting aside for the moment the basic question *Why the* art *classroom?* we might ask why Fehr chose those examples but overlooked a case in which media images were far more widely acknowledged to

have influenced a presidential election—the 1960 televised debates between Richard Nixon and John F. Kennedy. In those debates, Nixon's haggard, unattractive physical appearance, alongside the fit-looking handsome figure of Kennedy, weighed heavily against him and he lost the election, despite minimal differences in the substance of the debates.[21] Can it be that Fehr is untroubled by the influence of media images when he is happy with the outcome? If the influence of visual media is taken up as a subject by teachers, shouldn't the main point be that voters should decide elections based on issues and values, not on superficial appearances? In any case, let me repeat what I argued in "What Hope Is There for Art Education?": such questions belong in social studies and civics classes, not in the art classroom.

Paulo Freire and "Critical Pedagogy"

The social justice theme in art education is intricately linked to "critical theory"—and, more particularly, to what is called "critical pedagogy." These methodologies derive from the Marxist-inspired approach to philosophic and social analysis known as the Frankfurt School.

Critical theory was first defined by the Frankfurt thinker Max Horkheimer in 1937, but its main conduit into American education has been Paulo Freire's *Pedagogy of the Oppressed*, cited above. The purpose of critical theory is not just intellectual, it is practical, aiming (in Horkheimer's words) "to liberate human beings from the circumstances that enslave them" by critical questioning of dominant institutions. In the late 1950s and early 1960s, Freire adopted such an approach in teaching disenfranchised peasants in rural Brazil to read and write, so that they could vote and be mobilized to elect reform candidates.

Rejecting what he called the "banking concept of education"—in which the teacher "deposits" content into passive students that merely reinforces the existing power structures—he encouraged his students to assume an active role in their own education. Through a "dialogic" process in which teacher and students were considered equals, learners were presumably brought to grasp the relationship between their personal problems and experiences and the social contexts in which they were embedded. Having achieved impressive literacy outcomes with that approach, Freire began writing books based on his teaching

experience. His *Pedagogy of the Oppressed*, written in 1968, was preceded by *Education as the Practice of Freedom*. Such work prompted Harvard University to host Freire for a visiting professorship in 1969. Since then, his *Pedagogy* has become an education school bible in the United States.

Critical pedagogy emphasizes the importance of social and historical context. Yet advocates of Freire's work have been remarkably blind to its inappropriateness in the present context of K–12 education in the United States. Freire's rejection of the "banking" approach to education in favor of greater student-teacher equality and interchange may have made sense with respect to adult learners, who came to the process with considerable life experience. But his view that "[l]iberating education consists in acts of [active] cognition, not transferrals of information" could verge on the absurd if applied literally in a class of very young children. And its application in the higher grades is also problematic. Education requires both transferrals of information (even if indirect) and active discovery.

Moreover, although critical theory purports to leave students free to discover truths on their own, it in fact guides them toward the "truth" according to its own Marxist worldview. (I can personally attest to that fact, having attended a leadership conference at Hampshire College some years ago that employed critical theory techniques.) Finally, with respect to the role of active discovery in education, the ideas of Maria Montessori, with their greater emphasis on the individual, provide a far more reliable guide than the essentially collectivist notions of Freire.

If students today are "oppressed," it is neither by the capitalist "power structure" nor by the alleged flaws in "American democracy"—which "critical pedagogy" aims to remedy. It is mainly by their own ignorance (and sometimes that of their relatives and neighbors)—which education is supposed to remedy. The recent film *Precious* offers moving testimony to that truth, as do the many accounts of ambitious young blacks confronted by the taunts of peers when they strive to lift themselves out of poverty by study and hard work.[22]

In any case, whatever inequities or injustices now exist in American society are scarcely comparable to the sort of institutionalized injustice Freire confronted in the essentially feudal society of rural

Brazil, where a large segment of the population was illiterate and politically disenfranchised. Nor is the United States where it was in the early 1960s, when the Freedom Schools met a real need in the institutionally segregated South. Since then, we have come a long way, not only with respect to civil rights for blacks but also with regard to attitudes and practices affecting women and homosexuality.

Freire's *critical pedagogy* should not be confused with the methodology of *critical thinking*, which is a very different matter.[23] Teaching critical thinking aims to develop students' powers of reasoning by helping them to recognize faulty arguments—arguments based on insufficiently defined concepts, unsupported assertions, invalid generalizations, and appeal to unreliable authorities. Such teaching should begin in age-appropriate ways as soon as children have acquired basic language skills and reasoning capacity.

Regarding the goal of human liberation sought by "social justice" advocates, critical thinking skills might be productively applied, by all concerned with this issue, to the basic question of which has been the greater net force for true human liberation: the collectivist Marxist ideals underlying Freire's critical pedagogy or the Enlightenment values of individualism, property rights, the rule of law, and limited government that are at the heart of "American democracy"—or, more accurately, the American republic.

What Will Be the Future of Art Education?

"Social justice" and "visual culture" studies are already openly ensconced in leading schools of art education—from New York University's Steinhardt School to Ohio State University and the University of Illinois—where the next generation of art teachers is being trained. What will such studies lead to in K–12 classrooms? Judging from representative articles published in the NAEA's journals *Art Education* and *Studies in Art Education* in recent years, we can expect lessons ranging from anti-capitalist critiques of Build-A-Bear Workshops and the local shopping mall to student emulation of graffiti artists whose work purportedly "forces pedestrians to revise their conceptions" regarding complex social and political issues such as attitudes toward sexuality or the Israeli-Palestinian conflict.[24]

If the hijacking of art education by "social justice" and "visual culture" advocates prevails, students will be disserved in multiple ways. They will not only be politically indoctrinated, in a context relatively insulated from opposing views. They will also be more and more deprived of the truly humanizing experiences that the making and appreciation of *art* can provide—art dealing not just with issues of social justice but with the myriad other themes of personal and social significance that art everywhere has always been concerned with. Finally, they will be subtly led to believe that the only things that really matter in life are those in the social realm; that the private, personal dimension of their lives is of trivial significance. That, perhaps, would be the most lamentable consequence of all.

Now is the time for those who understand the importance of such concerns to speak out.

The Great Divide in Art Education

In "The Hijacking of Art Education" (above, pages 179–93), I suggested that the politically charged view of art education I was critical of is probably not shared by most of the National Art Education Association's 20,000 or more members. Yet it seems all too common among the professors of art education who are not only training the next generation of K–12 teachers but are also the NAEA's most influential members.

Three encounters during my first hour at the 2010 NAEA convention tended to confirm this view. Taken together, they can be seen to epitomize the great divide now affecting visual art education. That is the sharp pedagogical and political divide between many K–12 art teachers, on one hand, and the art education professors who now seem to dominate the field, on the other.

On my way to the Baltimore convention center from my hotel, I happened to meet two classroom teachers from Louisiana. One taught on the elementary level; the other, in a high school. When I asked what they thought of the social justice theme of this year's convention, they responded that they hadn't thought much about it. On reflection, one of them added: "Social justice means a lot of different things to different people"—by which she seemed to imply that it was difficult to know what to make of it. In any case, their response suggested that the conference theme was not what had brought them to Baltimore. Like many teachers, they were no doubt there to gain practical knowledge that would help them be more effective in the classroom.

Aristos, November 2010.

My second encounter was with Beth Olshansky, who has been doing impressive work for two decades training classroom teachers to combine writing with hands-on art activities for students with various learning styles and needs (she now directs the Center for the Advancement of Art-Based Literacy at the University of New Hampshire in Durham). Though her convention presentation had just ended when I arrived, I could see at a glance from the materials on display the high level of creativity displayed by her pupils. Fortunately, we were able to arrange to meet later so that I could learn more about her work—more on which, below.

My third experience contrasted sharply with the first two. Entitled "Unframing Immigration," it was a politically charged session focusing on anti-traditional "contemporary art." The presenter was Dipti Desai, who directs the Art Education Program at New York University's Steinhardt School of Culture, Education, and Human Development. Her aim was to encourage teachers to explore work by contemporary artists who employ "a wide range of practices" to criticize U.S. immigration policy—practices, I should emphasize, that most ordinary people would be unlikely to consider art.

Politics in Place of Art

Like the "social justice" theme of the convention itself, Desai's viewpoint was pointedly politicized. As I noted in a recent *Wall Street Journal* article,[1] one of the works she cited was *Brinco*—in which the purported artist, Judi Werthein, distributed specially produced sneakers to workers about to cross the Mexican border into the U.S. The shoes were fitted with a compass, map, flashlight, and medication to assist their recipients in entering the U.S. illegally. After passing them out free to migrants, Werthein sold similar pairs for $215 each in a "limited edition" at a fashionable boutique in downtown San Diego, where they were supposed to stimulate discussion about immigration, according to a BBC News report.[2]

Though Werthein's actions were in truth a mere political gesture, involving no artistry whatever, they belong to the postmodernist artworld genre of "performance art," now commonly accepted by art teachers as a legitimate art form. Another such piece recommended

by Desai was *Art Rebate*, in which three San Diego-based "artists" handed out $10 bills to illegal immigrants seeking day labor near the border. Studying works like these, Desai maintained, would help students understand "what it means to be American"—by serving to "raise their consciousness" about issues ranging from low wages for immigrant workers to "the increased criminalization of immigrants." Tellingly, she omitted the word "illegal."

When I asked why actions of this kind qualify as art, Desai replied that the function of art has "always been to break down prior conceptions," and that artists have been doing things like this since the 1960s. What she failed to note was that the "artists" who invented "performance art" in the '60s did so to *subvert* art, not create it. That is why they flouted the distinction between works of art—which are always *about* life, not an active participant in it—and life itself. Why should we now regard this species of *anti-art* as *art*?

Taken as a whole, Desai's session exemplified the dominant characteristics of "social justice art education" as conceived by its most vocal proponents. It focused on anti-traditional genres of "contemporary art." It was more concerned with political and social issues than with art as such. And it was relentlessly critical of the U.S., pointing only to alleged shortcomings, not to any of the nation's virtues.

An Anti-Capitalist Mentality

The anti-American bias of higher ed practitioners like Desai goes hand in hand with an unremittingly negative critique of capitalism. This tendency is glaringly evident in the speaking and writing of Jan Jagodzinski.[3] A prominent proponent of anti-capitalist views, he is a professor in the Department of Secondary Education at the University of Alberta in Edmonton, Canada, and was a presenter in no fewer than five sessions at the 2010 NAEA conference.

The pejorative term "designer capitalism" peppers Jagodzinski's work and that of his intellectual disciples. In an often unintelligible essay entitled "A Mondofesto for the 21st Century" (a shorter version of which was published in the NAEA research journal *Studies in Art Education*), Jagodzinski defines it as a "society of control" in which "the freedom of movement and the ability of free choice have become

illusionary democratic privileges."⁴ Following the lead of two French theorists, Gilles Deleuze and Félix Guattari, he argues that leisure travel and material goods made available through capitalism are "illusionary" freedoms because

> their exercise is subject to password controls, capital, [and] privilege. . . . What appears [to be] an open society is [actually] composed of thresholds, boundaries, and gateways, all open and free for movement provided the holder has the right pass—be it a passport, a PIN number, credit card, degree, drivers license, and so on.

While Jagodzinski's discourse is laden with sometimes clever (more often, distracting) puns and with references to abstruse foreign theorists such as Deleuze and Guattari, it is remarkably devoid of common sense. What he most dislikes about capitalism, for example, is that personal profit is the guiding motive and people must pay for goods and services. What does he advocate as an alternative? Such things as free software downloadable on the Internet. In other words, he envisions a world in which manna falls from the sky and no one need be troubled to earn his own bread. Never mind that those who offer freeware on the Internet can sustain such efforts only if they have some other means of supporting themselves—which brings us back to economics.

What sort of economic system would Jagodzinski propose in place of capitalism to achieve his Utopian ends? Admitting that socialist and communist models have not done a better job of providing such goods and services than capitalism has, he merely speculates that we might "someday devise" a better system, as yet not conceived of. When I asked him if it might be irresponsible to prejudice impressionable young minds against capitalism without offering something better in its place, Jagodzinski told me that he doesn't present such views to young students, only to "more sophisticated" hearers like myself and other conference attendees. That is a disingenuous claim at best, of course, as his views are likely to influence countless students through the classroom teachers he and his intellectual disciples are engaged in training.

A Narrow Focus on "Contemporary Art"

Just as Jagodzinski's view of economics ignores obvious facts regarding human survival, his view of art, too, is grossly distorted. Aiming

first and foremost to promote "art practices and [art] education that challenge [the] edifice [of designer capitalism]," he focuses almost exclusively on anti-traditional work produced since the 1960s— from the "video art" of Matthew Barney[5] and Bill Viola to the French postmodernist Orlan's surgical manipulations of her own body. Like Desai, Jagodzinski ignores that the "art practices" employed by these postmodernists originated as expressly *anti*-art gestures and therefore lack legitimate claim to their present artworld status as art.

Completely disregarding the traditional art practices that produced meaningful representations in painting and sculpture for millennia before the 1960s (even some that might have been interpreted, rightly or wrongly, as critical of capitalism), Jagodzinski also ignores contemporary artists who continue to employ these practices. As Louis Torres and I have documented in "What About the Other Face of Contemporary Art?," such a bias pervades today's artworld and is unfortunately shared by many in art education.

A case in point is provided by the annual Manuel Barkan Award Lecture presented at the 2010 NAEA convention—the latest in a series devoted to honoring individuals whose published work in NAEA journals is deemed to have contributed "a product of scholarly merit to the field." The 2010 Barkan lecturer, Dónal O'Donoghue (Chair of Art Education in the Department of Curriculum and Pedagogy at the University of British Columbia), posed the question, *What does the art of our time do?* Tellingly, his view of the art of our time was confined to "work that doesn't rely on traditional art-making processes or produce a traditional product" but instead depends on a "relational" art and aesthetics that "moves us away from reliance on naked objects" (such as painting and sculpture) and "requires a shift in our understanding of what art is." In other words, his attention was explicitly devoted only to anti-traditional postmodernist genres such as installation and "performance art," completely excluding the traditional art forms that some contemporary artists still pursue.[6]

One of the "relational" pieces highlighted by O'Donoghue was something called *Ought Apartment*, by the Canadian postmodernist Reece Terris. According to the description on Terris's website, it was

> a six-storey installation of six full-scale apartments stacked one upon the other. Each apartment level was fully furnished

exclusively with original items from the 1950s though [*sic*] to the present decade and includes a kitchen, living room and bathroom. Each floor represents the look of one particular decade, thus becoming emblematic of that period's interior design and domestic living.

Commissioned by the Vancouver Art Gallery, *Ought Apartment* was intended as "a critique of the ethical and environmental costs to which we will satisfy the ideal that our home is a reflection of ourselves." Despite Terris's claims for it as a work of art freighted with serious meaning, however, what it may have most resembled to ordinary viewers was a time warp in a furniture store or a changing life styles exhibition at a world's fair. Nonetheless, *Canadian Art* magazine named it one of the Top 10 Exhibitions of 2009—a sure sign of the poverty of the contemporary artworld.

Another project lauded by O'Donoghue was a "performance" piece entitled *Free Irish Scones*, created by Sarah Browne, an Irishwoman living in Poland. As you might guess from the title, it consisted of her distributing free Irish scones. Does that sound familiar—remember *Brinco*, cited above? But to savor the full flavor of Browne's "relational" art, one should read her exposition of the scones piece, which typifies the thinking behind this sort of work:

> [M]y intervention in the city [of Krakow] attempted to initiate a modest point of contact by addressing bodily needs and points of cultural similarity/difference. I made a bricolage version of the [ubiquitous] Polish stall[s that sell *obwarzanki*, Polish pretzels] from a discarded bedframe, painted it green, and replaced the otwarzanki [*sic*] with a few hundred Irish scones, to be given away in the main city square.
>
> Using tourist clichés as visual props, this work was an attempt to spark a social interaction and 'cultural exchange' . . . on a micro level. . . . This activity prompted a number of conversations with other visitors, city dwellers and bread sellers, as well as people who wished to photograph me, thinking I was some kind of curious tourist attraction.[7]

According to O'Donoghue, work of this kind relates to "our keenest insights into problems of contemporary life" and is "guided by our finest ideals as to what it means to be a person."

Actual Practice in K–12 Classrooms

The professors of art education I have just cited are miles apart in their assumptions and concerns from teachers who are immersed in the day-to-day realities of dealing with young children, often of widely differing abilities, from various backgrounds. The highly successful approach developed by Beth Olshansky, for example, was informed by her own practical experience as the mother of a child with initial reading difficulties. By combining art-making with reading and writing she has been able to help teachers achieve remarkable results in both areas.

Children engaged in Olshansky's literacy-through-art approach learn how thoughts and feelings can be conveyed through images as well as words. In contrast with the postmodernist "installation" and "performance" pieces praised by Desai, Jagodzinski, and O'Donoghue—pieces employing fabricated or appropriated utilitarian objects—Olshansky's students are doing what true artists have always done. They are expressing their thoughts and feelings through the age-old, inborn visual language of *imagery*, albeit using simple techniques such as crayon-resist painting and collage made from hand-painted papers—the latter inspired by the picture books of Eric Carle, Leo Lionni, and Ezra Jack Keats.[8] Moreover, for them as for others, imagery serves as a crucial bridge to verbal expression.

As early as first grade, students in Olshansky's literacy-through-art programs not only create their own images and stories, they learn the ways skilled professionals employ pictorial and verbal means to communicate effectively. An important part of this process consists of the teacher's guiding them in analyzing exemplary illustrations (and texts), to discover the pictorial devices that work. Some of the questions considered with respect to the images are, What key elements of the story are conveyed by the book's opening picture? What visual aspects—color, texture, perspective, etc.—help to establish a mood and convey pertinent information about the setting? What visual devices draw the reader into the picture?

In other words, children do not simply "express" themselves spontaneously. They are engaged in a thoughtful consideration of what they are doing and how best to do it. Nor are they subjected to a disembodied introduction to the elements and principles of design.

Instead, they learn about the role those elements play in the creation of meaningful imagery—imagery that has the capacity to engage their emotions and thereby have a more lasting impact on cognition.

Also instructive in this regard is the experience of JoAnn Memmott—Utah's 2010 Art Educator of the Year—in a research project employing an art-infused approach (not unlike Olshansky's) for improving literacy among kindergartners. In a session about the project at the 2010 NAEA conference, Memmott and her co-researcher from Brigham Young University emphasized that what was paramount for her students was the meaning-content of images, not their abstract formal properties. As they reported, when students were asked for their responses to works of art they offered thoughtful, engaged, and engaging comments on the meaning of the works under discussion, but exhibited no interest in the elements and principles of design in themselves, which are commonly the focus of early childhood art education. Memmott further observed that the least-structured art-making assignments, allowing the greatest freedom to the individual child's imagination, yielded the richest results.

As one might expect, both Olshansky and Memmott have found that art-infused teaching is especially fruitful with recent immigrants thrust into an English language environment. The natural ability to communicate through the universal language of pictures helps such students navigate the difficult transition to a new culture and verbal framework. In addition, I should note, the personal story books they create offer a poignant contrast to the relentlessly jaundiced perspective on U.S. immigration offered by Desai, and by the "artists" she praises.

An unforgettable example is *My New Life,* by a fourth grader in a Manchester, New Hampshire, elementary school that uses Olshansky's methods in its ELL program. One of its images conjures up this boy's unhappy life in Russia before an American couple adopted him and his sister.[9] His sad little face peers out from the bleak, prison-like grid of an otherwise faceless orphanage, confronting a snowy landscape devoid of people. The boy's story, like that of countless immigrants before him, however, ends on the happy note of his hopeful new life here—clearly depicted in warm, "happy" colors, in contrast with the grim aspect of his orphanage image.

Equally touching is a page from *Iraq to Syria to America*, by another fourth-grade ELL student, recalling the threatening scene of a "man with gun" who would kill if need be to take fresh water from people waiting to get it from the truck that came "sometimes everyday, sometimes every week" to his former village in Iraq.[10] This child reflected with relief that such experiences would not be part of life in America.

Combining art and language study need not be limited to young children. Olshansky has employed it successfully with grades K–12. And longtime art-education advocate Sylvia Corwin developed such a program in New York City high schools for promising art students who were behind grade in reading. Owing to local requirements, the focus of her *Reading Improvement Through Art* (RITA) program was on language remediation, and results in that area were impressive enough for the program to gain validation from the New York State Education Department in 1979 and be replicated statewide. It is important to note, however, that students in the program did not only show marked improvement in their reading skills. As one participating teacher observed, "more meaningful art experiences and finer art work always result from the 'verbal-visual partnership.'"[11]

Finally, an integrated art and language approach can benefit all students, not simply those in need of remediation. In the 1970s, Louis Torres, then a high school English teacher, developed a fruitful English elective for eleventh graders in which they experienced works of art (and music) and wrote about their personal responses to each work before being told anything about it. Information about the work came later. In addition to engaging students in writing assignments that stretched their powers of perception, introspection, and description, the approach nurtured meaningful familiarity with, and appreciation of, estimable works of art. For many students, this was their first exposure to such works.[12]

"Visual Culture Studies" and "Critical Pedagogy" Re-Visited

Unfortunately, under the influence of postmodernist thought, the question of whether estimable works of art—rather than "popular art" and "visual culture"—should be the primary focus in today's art

classrooms has been hotly debated in recent years. More damaging, the very notion that some works are of greater cultural value than others (and therefore deserve greater attention) has itself been called into question. And many teachers argue that popular culture is so pervasive that it must be dealt with in the classroom.

One middle school teacher, for example, tells of a seventh-grade student in her class writing "I want to be exactly like Lauren from [the TV show] *The Hills* because she is really cool and exactly like me." The teacher argues that student pre-occupations of this kind warrant discussing such "visual culture" in the art classroom.[13] I see this problem quite differently. To begin with, I might tactfully try to learn from the girl's mother why a seventh grader is permitted to watch a show dealing with the love life of women in their twenties.

As for the student herself, I would say something like the following: TV shows and movies of this kind are not what we deal with in art class. As popular forms of drama—literary forms that involve a plot and characterization—they are related to the verbal art forms studied in English class. Visual arts such as painting and sculpture are what art classes should be devoted to. They involve the skillful creation of two- and three-dimensional images, not stories that are played out over time by actors.

Finally, I might add that school is a place where students come to learn about things that they don't already know, and about people who are not just like them and might give them something to look up to and strive for. Otherwise, both they and their teachers are wasting their time.

Ironically, some of the most vocal proponents of "visual culture studies," and of its accompanying neo-Marxist "critical pedagogy," are now questioning the value of these approaches. This may seem like good news, but it is doubtful that their new lines of thinking will prove any more fruitful for art education. In a session considering "What's Next?" after a decade of visual culture studies, professors Paul Duncum, Kerry Freedman, and Kevin Tavin all indicated that they have come to find that approach to be seriously wanting. (This should prove a cautionary tale to those who are all too ready to jump on the next art education bandwagon!)

While Kerry Freedman, for example, still "believe[s] in the ideas of critical pedagogy," she now doubts that they can work in the class-

room, and thinks that more attention should be paid to the role of creativity in artistic production. As a recent *Art Education* article by her indicates, however, her view of artistic production is narrowly postmodernist, focusing on the sort of anti-traditional work that I discussed above, not on what most ordinary people would rightly regard as art.[14]

Kevin Tavin, too, is "re-thinking the way he used the language of critical pedagogy," and is coming to grips with the fact that "things are more complex" than its analysis of culture suggested. Among other things, he has come to realize that it is far too easy to get students to simply "parrot" the ideas of critical pedagogy, without arriving at any deep understanding. While he offers the promising view that such psychological considerations as "pleasure and memory" are extremely important, he is inclined to view them through the foggy lens of Lacanian psychoanalytic theory. In place of critical pedagogy—which regards individuals as victimized by the power politics of class, gender, and race—Lacanian theory regards them, in effect, as victims of their unattainable desires.

Not one of these three professors of art education maintains a clear distinction between works of art and other components of visual culture, or even sees such a distinction as an important concern for art teachers. In explaining his position on this point, Duncum recalled a professor early in his own education who pointed out the flaws in all the major definitions of art then known and then came up with his own definition, which was simply unintelligible. As a result, Duncum gave up on the idea that art can ever be defined. In his view, we shouldn't ask *What is art?* but rather *When is [something] art?* His answer to the latter question is "when something functions as art, it is about embodying meaning"—an answer that ignores the particular ways in which works of art, as contrasted with other aspects of visual culture, embody meaning.[15]

Contrasting Versions of Socially Minded Art Education

Though a social justice approach to art education is not yet widespread in K–12 classrooms, it would be inaccurate to suggest that it is non-existent. An example of classroom practice following such an

approach was provided by a session at the 2010 NAEA convention entitled "What Would Marcel Duchamp Do? (A Dadaist Approach for K–8 Poetic Protest)." Presented by Anne Thulson—a teacher at The Odyssey School, a charter public school in Denver—it was described in the convention catalogue as follows:

> Explore *The Pedagogy of the Oppressed* with K-8 students through projects that poetically disrupt power cultures and enable children to radically intervene as protagonists of change through appropriation and re-contextualization practices.

As that description clearly indicates, Thulson (like many higher-ed advocates of social justice art education) relies mainly on anti-traditional contemporary work as models for students to emulate, and is inspired by the neo-Marxist cultural analysis found in Paulo Freire's *Pedagogy of the Oppressed*. She therefore values work like Krzysztof Wodiczko's Warsaw "projections," because it "questions narratives of power"—instead of being "all about me and my own gesture" as Jackson Pollock's work was. Her contrast with Pollock reveals a remarkably short-sighted view of art history, however. Much like Jagodzinski, she ignores the fact that since time immemorial before the postmodernists reacted against Abstract Expressionism, artists had been creating images that were not simply about themselves and their "own gesture." There is also an unwitting irony in her session title's reference to Duchamp as an inspiration for protest art. Despite his loose association with the politically motivated Dadaists, Duchamp was notoriously disengaged from politics.[16]

Also problematic was Thulson's biased choice of images to document how American Indians have been represented historically. Showing only the worst caricatures from popular culture (taken from Buffalo Bill posters, Walt Disney movies, and the Lone Ranger radio show), she completely ignored the existence of respectful and often sensitive depictions by artists such as George Catlin. Thus her students were very likely left with the mistaken impression that Indians were never viewed fairly by anyone. Such an approach, I would argue, might prompt destructive feelings of victimhood among students of Indian descent, as well as feelings of unwarranted personal guilt among those of European heritage.

Thulson's harshly polarized view contrasts sharply with the experience offered students by Nancy Brady, a teacher at the Solomon Schechter Day School of Albuquerque. At the 2010 NAEA convention, Brady reported on the cultural exchange she arranged between the Jewish students at her school and a school in a nearby Pueblo community. The emphasis was on respectful learning about another cultural tradition and discovery of the common values they shared—in particular, their mutual aspirations for peace and harmony among the diverse peoples in the world. Not strictly limited to visual art, the project incorporated dance and music, as well as inspiring representations by the students of their visions of such a world. Its theme was, Brady pointedly stressed, "not anti-war, but pro peace." Such an approach differs fundamentally from those prevailing in visual culture studies and "critical pedagogy," which focus on issues of conflict and the alleged domination or subordination of various ethnic, racial, or gender groups. Would a psychologist care to suggest which approach is likely to prove more beneficial for the mental well-being of young people?

What Conclusions Can Be Drawn?

The two sides of the great divide I have outlined are by no means monolithic. Just as there are some K–12 teachers who have enthusiastically embraced the politicization of art education, there are professors of art education who adamantly reject it—as indicated by many of the comments in the "Forum on Social Justice Art Education" in the November 2010 issue of *Aristos*. Yet such exceptions are, I think, rare, and do not negate my basic argument.

One remedy I would call for is a far more equitable balance of viewpoints at the highest levels of the NAEA, particularly in its periodicals.[17] This would require more participation by classroom teachers like those whose work I've praised here, and by higher-ed members who appreciate their perspective (see, for example, the comments by Deborah Kuster and Richard Ciganko in the SJAE-Forum just cited). And if, as I suspect, there is a largely silent majority of members—whether K–12 teachers or professors of art education—who are uncomfortable with recent trends in the organization, they need to make their voices known now.

Museum Miseducation
Perpetuating the Duchamp Myth

In an effort to reach students by engaging them on the electronic turf they familiarly traverse, art museums are developing sophisticated online resources, many of them interactive, geared specifically to young children and teenagers. Attractive though the idea may seem, the value of such efforts is no better than the quality of the content offered, however. And that quality leaves much to be desired. Parents and teachers—not to mention students themselves—should be wary.

A case in point is the Red Studio, an outreach effort by the education department of New York's Museum of Modern Art. As described on its website, the Red Studio was developed "in collaboration with high school students, and explores issues and questions raised by teens about modern art, today's working artists, and what goes on behind the scenes at a museum." One of its features, titled "Behind the Scenes," presents small groups of students in conversation with MoMA staff and curators, exploring such weighty questions as *What makes modern art modern?* and *How do we define what is and is not art?*. The entire apparatus is designed to convey an aura of insider expertise. What follows, sad to say, is anything but expert.

In a discussion of Marcel Duchamp's *Bicycle Wheel*, for example—a discussion led by Joachim Pissarro, a curator in the Department of Painting and Sculpture—a student inquires: "What

Aristos, June 2008.

was the response by the public when it was made in 1913?" To which, curator Pissarro responds with a combination of quiet authority and engaging informality: "Huge outrage, scandal, incomprehension. 'What's this bizarre piece of crap doing in an art exhibition?'" He then briefly draws an analogy with other modern artists who were initially misunderstood, such as van Gogh and Cézanne. "That's the quick answer to your question," he concludes.

Well, it *is* quick, but it's also dead wrong. And it betrays an appalling ignorance on Pissarro's part. Duchamp's first *Bicycle Wheel* was never publicly exhibited in 1913. In fact, the work (if one can call it that) was not seen by the public until decades later—in the form of a replica exhibited in a gallery show in 1951—when it suited the purposes of an artworld on the cusp of postmodernism. Nor does there appear to be any evidence of "huge outrage" provoked by that event. Yet Pissarro goes on to inform his attentive circle of students that in the view of many art historians, "This may be the single most important art object of the twentieth century." Such a claim is true of course only if *Bicycle Wheel* is in fact an "art object."

Most instructive in that connection is what the students were not told regarding what Duchamp himself actually had to say about this object generally credited with changing the course of art history:

> When I put a bicycle wheel on a stool the fork down, there was no idea of a 'readymade,' or anything else. *It was just a distraction.* I didn't have any special reason to do it, or any intention of showing it or describing anything [quoted in Pierre Cabanne, *Dialogues with Marcel Duchamp*, 47, emphasis mine].

In case that were not clear enough, students might have further benefitted from hearing that when asked how he had "come to choose a mass-produced object, a 'readymade,' to make a work of art," Duchamp had replied in no uncertain terms: "Please note that I didn't want to make a work of art out of it." At that point they might have engaged in a truly probing consideration of how and why something *never intended as a work of art* has become in the minds of many art historians today "the most important art object of the twentieth century."

Instead, the students were led to regard *Bicycle Wheel* as a work of art. One of them was even congratulated on having progressed from

initially regarding it as "crap" to viewing it as a "pretty interesting" art object, because Duchamp had rendered both the bicycle wheel and the stool "useless"—which, all were assured by Pissarro, is an essential attribute of artworks.

Such miseducation is all the more disturbing when one considers that Pissarro is not a volunteer docent or mere member of the museum's education staff. A great-grandson of the noted French Impressionist Camille Pissarro, he is the author of an important biography illuminating his great-grandfather's contributions to the Impressionist movement. And he is one of the three curators who were charged with the task of guiding the Museum of Modern Art following its major expansion and renovation a few years ago. According to the University of Texas, Austin, where he earned a Ph.D. in art history, "his scholarship in modern art has received widespread acclaim."

Clearly, there are major gaps in that scholarship.

How NOT to Be an Arts Advocate

Google my first and last name with the words "art education" and the first item you will find (as of this writing) dubs me "The Joe McCarthy of Art Education." Which prompts me to respond at this late date to that scurrilous blog post written in 2010. The author, Richard Kessler, then headed The Center for Arts Education—a non-profit organization dedicated to promoting K–12 arts education in New York City public schools. He is now Dean of the Mannes College of Music, one of America's top music conservatories. And he epitomizes how *not* to be an arts advocate.

What had provoked Kessler to launch his ad hominem attack was my *Wall Street Journal* opinion piece "The Political Assault on Art Education" (June 25, 2010). Focusing with "liberal" blinkers on the political questions I raised, he conveniently ignored the work of "art" that had triggered the article: Judi Werthein's *Brinco*—a piece that consisted of her distributing specially designed and equipped sneakers to Mexicans waiting to cross the U.S. border clandestinely. Not exactly what most people think of as art.

Like all too many arts advocates, Kessler defends virtually anything put forward as "art" (especially if it carries the properly "liberal" message)—regardless of its actual merit as art. In his view, "art" in general is a public good, and as such warrants public support in keeping with social justice. He had therefore objected (in an earlier post entitled "Arts Education and Social Justice") to my account of "The Hijacking of Art Education" (above, pages 179–93). In that

For Piero's Sake, September 1, 2016.

article, as in the much shorter *Wall Street Journal* piece, I argued that concerns for political issues such as social justice were eclipsing concerns for art among influential art educators.

Ignoring that crucial matter, Kessler pointed instead to the urgent need to provide "kids in urban centers . . . [with] a well rounded education that includes the arts." As if I would deny it! Lamentably, he had not a word to say about the dubious sorts of "art" advocated by art educators I cited. Nor did he consider whether such work would in fact contribute anything of lasting value to inner-city kids, or anyone else for that matter. One artist/writer/activist I quoted, for example, applauds the widespread "'de-skilling' of artistic craft" that has occurred in the artworld since the 1960s. Further, he praises "conceptual art" for having entirely dispensed with the need for skill and having led, in effect, to "the total disappearance of the art object." Kessler's silence on such points was deafening.

Arrogance Compounded with Ignorance

In fact, Kessler's arrogantly indiscriminate defense of any "art"—however far removed from customary standards—is grounded in ignorance, as evident in a still earlier post, "My Dinner with Merce and Its Connection to Cultural Policy." In it, he urged that "great artists" such as avant-garde choreographer Merce Cunningham be federally funded, as generously as possible, freely enabling them "to create, to experiment, to fail, to succeed." Moreover, he lauded John Cage, Cunningham's lifelong partner and collaborator, as among the "great, great composers" Merce had worked with. Such a judgment issuing from the future Dean of the Mannes College of Music is more than a little disconcerting. Considering that Cage's most famous/infamous piece, *4'33"*, entirely dispenses with musical tones in favor of ambient noise, it was the deliberate antithesis of music.

In a comment, I argued:

> If avant-gardists such as Merce Cunningham and John Cage were indeed national "artistic treasures," they should have been able to attract generous private support. The problem is that their work (unlike that of choreographer Mark Morris, for example) has never been able to appeal to a wider audience than artworld insiders. Forc-

ing the public to foot the bill for their "experiments" is a deplorable idea. By their own admission, such experiments amounted to anti-art (that is why the public has rejected it). For evidence, see the analysis of their work and what they said about it in *What Art Is* (pages 220–29)—which I co-authored. The relevant pages can be viewed at Google Books: http://www.tinyurl.com/nnvhpm.

Needless to say, it is unlikely that Kessler had the intellectual curiosity to follow that link. Instead he posted this smug rejoinder, regarding Mark Morris:

> I think that Mark would laugh pretty hard being presented as a mainstream counterbalance to Merce Cunningham. Apparently, Ms. Kahmi [*sic*], you've never heard Mark speak and most likely know little about his work.

Au contraire, Mr. Kessler. Here is what I had written five years earlier in "Mark Morris—a Postmodern Traditionalist" (*Aristos*, December 2005), after hearing Morris speak at Barnard College:

> Unlike postmodernist choreographers such as Merce Cunningham, Morris (who speaks of being "smitten by music" at an early age) understands that *music—true music*—is the essential foundation of dance.

In contrast, I should add here, Cunningham was notorious for choreographing his "dance" pieces without music and only joining them to a musical score (often not very musical) at the time of performance. The result was, in his own words (cited in *What Art Is*), a "non-relationship."

As I further reported on Morris's talk at Barnard:

> Most provocative, given his own early reputation as a rebel, was what he had to say about the avant-garde. Asked for his view of Cunningham's work, for example, he cryptically answered that he "respects and appreciates *the fact that he's done it*," then paused and pointedly added: "That doesn't necessarily mean I *like* it."

Thus Morris and Cunningham represent what I referred to as "wholly antithetical views of dance." That fact was made even clearer by Morris's subsequent remarks on the contemporary dance world. As I reported, he said

he rarely attends "downtown" (i.e., avant-garde) dance programs, even those by friends. "I'm not of the Last Wave Generation that says if it lasts all night and you can't understand it, it's great," he declared. . . . Nor is he interested in watching "really crappy, politically motivated work. . . . If it works as propaganda, it doesn't work as art." Most telling was the advice he then offered to his audience, made up largely of students and faculty associated with the [Barnard College] dance program. They would do well, he said emphatically, to read (or re-read) Arlene Croce's controversial 1994 *New Yorker* article ["Discussing the Undiscussable"] on Bill T. Jones's *Still/Here* and to "think about it carefully." (Croce had refused to see and review *Still/Here*, arguing that its use of videotapes of workshops with terminally ill patients was beyond the pale of art and therefore outside her purview as a dance critic.) For those who might not yet have gotten his point about such work, Morris added: "Just 'cause you mean it, doesn't mean it's good."

I concluded: "Artists in every discipline could learn from him." So could arts advocates like Richard Kessler.

Understanding Contemporary Art

Why is so much "contemporary art" difficult to understand? As I'll argue here, both art history and cognitive science shed light on that knotty question. Much of what I'll say challenges established beliefs on the subject, however. I therefore urge readers to beware the "Semmelweis reflex." Few are likely to recognize that term. But medical students know it well. It's used to caution them against the natural human tendency to reject new ideas that contradict generally accepted beliefs and practices.

Ignaz Semmelweis was a young Hungarian doctor working in Vienna in the mid-nineteenth century. While serving in the maternity ward of a leading Viennese hospital, he made an astonishingly simple life-saving discovery. He found that the high mortality due to childbed fever could be drastically reduced if doctors would follow his advice to wash their hands with a chlorine solution before examining women in labor. But because what he recommended challenged both the status and the preconceived ideas of the medical establishment, he was vilified, and years passed before his simple practice was fully instituted. As a result countless women needlessly died.

Aristos, August 2012. Based on talks given at two art education conferences: "Assessing Creativity and Innovation in Contemporary Art: What Can We Learn from Art History and Cognitive Science?" New York State Art Teachers Association, Tarrytown, N.Y., November 18, 2011; and "Understanding Contemporary Art: Emerging Perspectives from Art History and Cognitive Science," National Art Education Association, New York City, March 3, 2012.

In the artworld, misguided ideas are not likely to have such dramatic consequences. Yet the decades since the 1970s have witnessed many questionable practices in the name of "art"—ranging from self-mutilation and animal cruelty to public endangerment.[1] Moreover, the broad cultural impact of such practices may be more damaging than we realize.

What's Wrong with "Contemporary Art"?

Let me set the stage with a revealing observation about contemporary art from an article in the journal *Art Education* in 2008:

> Some art can seem so far removed from our everyday experience that it is hard to understand. Contemporary art and art from cultures foreign to our own can be especially difficult.[2]

Think about that. It's not at all surprising that art from cultures foreign to ours would be difficult to understand. But why should this be true of art from our own time and place? Since we share the same broad context as the artists, why should their work be largely inaccessible to us? Here are some typically candid answers to that question by ordinary people:

> "Much modern art isn't about art or communicating ideas," responds one woman on Yahoo! Answers, "it's about showing yourself to [be] 'better' and more 'complicated' than ordinary mortals who just can't get it."

> A blogger notes: "Some artists . . . attempt to rationalize their work and put it into a broader societal context through writing . . . 'artist statements,' which generally turn out to be incomprehensible esoteric gibberish. The goal is to sound smart while keeping it so confusing that no one can understand it, leaving [viewers] unable to take issue with your art."

> A visitor to the New Museum (of contemporary art) in New York City remarked: "The vast majority of the work [looked like] things that . . . preschoolers could accomplish while blindfolded."

> Another quipped: "We named one of the pieces: 'Things I found in my recycling bin.'"

Are such people simply philistines or ignoramuses? Many artworld professionals seem to think so. Assuming that the problem lies with the viewers, not with the work, they argue that such people simply aren't aware of the ideas and theories underlying "cutting-edge" art. That argument of course implies that the ideas and theories themselves are valid. So it's prudent to apply some critical thinking to those assumptions and judge for ourselves whether they make sense.

How the Term "Contemporary Art" Is Used

First, one needs to be clear about what the term *contemporary art* has come to mean. It is generally defined as referring to "work created after World War II." As it's used by critics, curators, and teachers, however, it really refers only to work that is considered avant-garde, or cutting-edge. In particular, it means abstract work and the various postmodernist genres, from "Pop art" to "installation" and "performance art."

Since the advent of postmodernism in the late 1950s, moreover, "contemporary art" has come to include virtually anything—from a pile of wrapped candies on the gallery floor, as in Felix Gonzalez-Torres's *Untitled (Lover Boys)*, to Damien Hirst's *The Physical Impossibility of Death in the Mind of Someone Living*, consisting of a dead shark preserved in a tank of formaldehyde. As even one artworld insider has noted, the term *art* "has come to mean so many things that it doesn't mean anything any more."[3]

But the one thing "contemporary art" doesn't mean in today's artworld is painting and sculpture that is clearly in the broad spirit and practice of pre-modernist Western art. If you visit museums and galleries of "contemporary art," you'll find modernist abstract paintings such as one from Joseph Albers's *Homage to the Square* series or a typical work by Mark Rothko. You'll also find postmodernist pieces such as an installation of fluorescent lights (*Untitled*, 1970) by Dan Flavin or *Five Plates, Two Poles*, by Richard Serra. There will also be lots of "video art"—from Bruce Nauman's *Clown Torture* (at the Art Institute of Chicago) to Bill Viola's series of five videos *The Passions*.

What you're not likely to find, however, are works of accomplished realist painting such as Andrew Wyeth's *Christina Olson* (1947). And

you'll certainly not see works by lesser-known contemporary artists working in traditional forms—works such as a *Self-Portrait* (2005) by *Aristos* Award winner Daniel Graves or *Dairy Barn, Virginia* (2005) by Jacob Collins. Nor will you find a piece such as *9/11* (2001/2012), by sculptor Meredith Bergmann, though it poignantly memorializes an event of momentous national significance. You won't even see works such as *Leader of the Pride* or *Charging Bison* by Lubomir Tomaszewski— an artist who employed unconventional materials and techniques yet achieved wonderful effects, owing to a keen grasp of expressive form.

Needless to say, these works are equally "contemporary," for they've been created since World War II, most of them quite recently. When people speak about the "difficulty" of "contemporary art," however, they are not referring to works like these, since these are not what is generally displayed in galleries and museums. Yet if we take a long, wide view of art history, we realize that art has consisted of just such imagery for millennia. Artists have depicted the animal kingdom (as in many prehistoric examples, both painted and carved), their fellow humans (ancient Egypt's *Queen Nefertiti*, ca. 3300 BCE, is a wondrous example), and themselves (a mid-seventeenth-century *Self-Portrait* by Rembrandt is but one of many outstanding examples). They have also represented the world they inhabited, as in Vermeer's luminous *View of Delft* (ca. 1660–61), and the divine realms they imagined, such as *Heaven and Hell* (from the twelfth-century Hindu temple of Angkor Wat in Cambodia). The imagery was often highly stylized—ranging from a seventeenth-century West African *Memorial Head* and an Indian miniature to the woodblock print *The Great Wave off Kanagawa*, by the Japanese artist Hokusai (1760–1849), featured on this book's cover. As even such a brief sampling suggests, the long tradition of representational painting and sculpture has included a wide range of styles and subject matter. But the images always resembled, in some degree, things in the real world. Most important, they were understandable because people were familiar with such things.

What Prompted Modernism's Invention of "Abstract Art"?

In view of the incredibly long and rich history of visual representation we must ask, What caused some artists in the early years of

the twentieth century to entirely abandon it? Fortunately, we don't need to guess. The three most influential early modernists—Wassily Kandinsky (1866–1944), Kazimir Malevich (1878–1935), and Piet Mondrian (1872–1944)—left extensive treatises expounding their views. As those documents reveal, the pioneers of abstraction were motivated by radical, if arguably mistaken, assumptions—not only about the nature of art but also about human nature.[4]

At root, these painters believed that art belongs to a higher spiritual realm that is completely detached from life. In their view, this other-worldly realm could be represented only by work in which no recognizable objects at all were depicted. Through the use of abstract shapes, color, and line alone, they aimed to represent that realm of "pure spirit"—"untainted," as they saw it, by material reality. Moreover, these inventors of "nonobjective art" expected that their work would help humanity attain the higher plane of reality they imagined. Mondrian, for example, referred to his work as a completely "New Art" that would nurture a completely "New Man" with an evolved form of consciousness unlike any before. To bring this about he insisted that all subject matter "*must be banished* from art."[5]

Only if the representation of physical objects were entirely eliminated, Mondrian argued, could a "pure art" develop that would express the new consciousness toward which humanity was evolving.[6] Malevich and others referred to this newly evolved consciousness as "beyond reason." And they actually believed that it would not only endow them with clairvoyance but would enable them to see through solid objects!

How Do Ordinary People Regard Such Work?

Despite the abstract pioneers' lofty intentions, their work is incomprehensible to the poor viewer who has not yet evolved "beyond reason." We cannot begin to guess their intended meaning just from looking at their work. We know it only from their theoretical writing—the equivalent, in effect, of today's artists' statements. To the ordinary viewer, a typical Mondrian "composition," for example, conveys no meaning. It's simply an interesting pattern, with or without color. And as such it has inspired various decorative products, from bath-

room design to high-fashion clothing. Mondrian, I should add, would have been totally dismayed to see his work used in this way. Like other abstract painters, he always feared that his work would be seen as merely "decorative," rather than as deeply meaningful.

And what can the ordinary person make of one of Malevich's black squares on a white field? Could anyone guess that the black square was meant to represent "feeling," while the white field was meant to be "the void beyond this feeling"?[7] Yet Malevich, like many later abstract painters, thought that he could represent emotion directly through such purely abstract shapes.

Finally, a viewer might easily enjoy the riot of color in a typical Kandinsky *Composition*. But who would regard it as the expression of an "awakening soul" liberated from the "nightmare of materialism"? Yet that was what Kandinsky intended it to mean.[8]

In What Respects Did These Modernists Misread the Human Mind?

Given what science has taught us in recent years about the way the mind works, it isn't surprising that such paintings failed to communicate their makers' intentions. We simply cannot divorce ourselves from material reality as the abstract pioneers wished. Why not? Because both our understanding of the world and our emotions depend fundamentally on our direct, sensory contact with physical reality—on what we hear, taste, smell, touch, and most of all on what we see. Sight is our most important faculty, and our entire visual system is geared toward recognizing people, places, and things that impact on our survival and well-being. Art teachers, in particular, should be mindful of these basic facts of human nature.

Ironically, the early abstractionists themselves paid unwitting tribute to this most important of human faculties. Although they professed to reject material objects (which are of course the focal point of vision), they nevertheless attempted to represent spirit in visible, and therefore material, form. In contrast, artists the world over have long understood that immaterial (and therefore invisible) things such as "spirit" can be represented visually only by *embodying* them in some way—that is, by showing their effect on a material

(and therefore visible) being. Consider, for example, the inner spirit conveyed through facial expression in a *Bust of Buddha* or a figure of *The Crucified Christ.*

Yet modernism sought to sever the crucial connection between visual art and the everyday life experience that makes such images intelligible. This was the case even for art critics and theorists who were not mystically inspired. As early as 1914, the influential British critic Clive Bell, for example, declared that "To appreciate a work of art, we need bring with us nothing from life, no knowledge of its ideas and affairs, no familiarity with its emotions."[9]

Cognitive science has proven Bell to be quite mistaken, however. Numerous studies have demonstrated that images activate the same areas of the brain as comparable real-life experiences. Our understanding and appreciation of art is inseparably linked to our life experience. Moreover, brain scans have shown that abstract, Mondrian-like patterns (in contrast with images of people, places, and recognizable things) fail to activate the "regions of the brain traditionally associated with higher cognitive functions"—in particular, the areas that manage both emotion and long-term memory.[10]

The influential mid-twentieth-century critic Clement Greenberg was no less mistaken than Bell. His views on art were equally divorced from any meaningful connection to life experience. Greenberg insisted that in the truly "advanced art" of his time—by which he meant abstract painting—both subject matter and content had become "something to be avoided like a plague." Ironically, Greenberg completely ignored the spiritual aims of the artists who had invented abstract art in the first place. Nonetheless, he did more than perhaps anyone else to persuade the cultural establishment that the work of Abstract Expressionists such as Jackson Pollock was a major artistic achievement. And his assumptions about the value of abstract art remain entrenched in the cultural establishment.

Significantly, both early and late modernists shared a self-servingly elitist view regarding the public. Much like the abstract pioneers, who thought that understanding their work required a newly evolved form of consciousness which only they purportedly possessed, the later advocates of abstract art thought that such work could be appreciated by only a select few like themselves. It was a counterfeit form of elit-

ism, dependent on a mere assertion of superiority, with no objective basis to support it. They proclaimed the value of the abstract work but said little or nothing to justify it. And if you failed to see how Pollock's drip paintings could justify Greenberg's claim that he was "one of the major painters of our time," you'd surely be counted among the *philistines*—the ultimate term of critical contempt.

How Did Postmodernists React?

Just as the history of modernist abstract art sheds light on why such work is difficult to understand, the history of postmodernism is equally revealing. As I've stressed, the pioneers and advocates of abstract work did not really expect it to be understood by ordinary people. Not surprisingly, postmodernists reacted against that view. But in rejecting it they went to another extreme, equally wrong-headed in my view.

Leading early postmodernists such as Robert Rauschenberg (1925–2008) and Andy Warhol (1928–1987) produced work in which there was nothing *to understand*, because they didn't intend it to mean anything. With respect to almost every aspect of modernist theory and practice, in fact, postmodernists adopted a diametrically opposite approach—regardless of how little sense the alternatives made. Moreover, the first postmodernists even doubted whether what they produced should be called *art* at all.

Since modernism dealt with artists' lofty but inaccessible intentions and their claims to profound emotions, postmodernists began by virtually dispensing with personal intention and emotion altogether. Since modernism was concerned with the personal styles of artists who had dispensed with imagery, for example, postmodernists embraced imagery—but in a highly impersonal, largely mechanical manner, with little concern for style or meaning, and no emotional connection.

Warhol, for instance, once explained that the reason why he didn't create paintings was because he didn't "love roses or bottles or anything like that enough to want to sit down and paint them lovingly and patiently." On another occasion he said that the reason why he used mechanical methods in his work was that he wanted "to be a machine." Needless to say, machines have neither intentions nor emotions.

Instead of creating images themselves, as artists had always done, Rauschenberg and other postmodernists "appropriated" existing images in their entirety, from photographs, advertisements, and previous art works—as in a typical Rauschenberg silkscreen such as *Persimmon* (1964). Warhol used the same impersonal, mechanical approach to represent not only banal commercial objects such as Campbell's Soup cans and Brillo Soap Pad boxes but also world personalities, from Marilyn Monroe to Mao Tse-Tung.

Found Objects and "Anti-Art": The Duchamp Myth

In addition to employing borrowed images, postmodernists also used found objects, simply arranging them in "assemblages" or "installation art." Typical examples are Rauschenberg's mixed-media pieces, or "combines," such as *Monogram* and *Bed*. Critics and curators have tried to find meaning in Rauschenberg's odd juxtapositions of objects and images, but he made clear that no meaning was intended. When a curator attempted to find one in his silkscreens, for example, he remarked: "You mean I had a direction? It's a damned good thing I didn't know that before I did [them]. When I know what I'm doing, I don't do it."[11] As for whether his work should be considered art, Rauschenberg once declared: "I don't think of myself as making things that will turn into art."[12]

Much the same admission applies to Marcel Duchamp's earlier "readymades," such as *Bicycle Wheel* (1913) and *Fountain* (1917). As noted by the Grove *Dictionary of Art*, the readymades are generally regarded as having "decisively altered our understanding" of what constitutes a work of art. That view ignores what Duchamp (1887–1968) himself had said about these pieces, however. When asked why he had chosen "a mass-produced object" to make a work of art he replied:

> "Please note that I didn't want to make a work of art out of it. . . . [W]hen I put a bicycle wheel on a stool, the fork down, there was no idea of a 'readymade,' or anything else. It was just a distraction."[13]

So much for the work that has "redefined" what the artworld regards as art. Such work has been more aptly referred to as *anti-art*, even by

critics who praise it.[14] Its anti-art nature is especially evident in the recurring emphasis on blurring the very boundary between art and life. The influential early postmodernist Allan Kaprow (1927–2006) wrote whole essays on that subject. He also invented "Happenings"—the precursors for installation and performance "art." Those kookily staged events involved spectators in a series of incoherent actions in odd settings. Kaprow aimed to create pieces "as open and fluid as . . . everyday experience." In so doing, he was not making *art*, however. Blurring the distinction between art and life in effect does away with art altogether. In fact, Kaprow himself admitted that he was "not so sure" whether what he was doing was "art" or, as he put it, "something not quite art."[15]

Similar doubts were expressed by Henry Flynt (b. 1940), the postmodernist who first wrote about "concept art," later termed conceptual art. He claimed that "concept art is a [new] kind of art of which the material is language." Yet he observed that his notion of such a new form in the realm of visual art was rather contradictory. He even suggested that it might be better to recognize such work as "an independent, new activity, *irrelevant* to art."[16] (What he failed to note was that an art form employing language had long existed. It's called *literature*.) In truth, so-called *conceptual art*—later defined as forms "in which the idea for a work is considered more important than the finished product, if any"—eliminates *art* altogether. What matters in genuine art is precisely the finished product.

When I say that the early postmodernists dispensed with intention in their work, I mean that they didn't intend to do what artists had always done—that is, to express something meaningful relevant to human life. They did have one intention, however. It was to challenge and undermine the status of art as defined by the modernists. But in reacting against modernism—in particular, against Abstract Expressionism—the inventors of postmodernism seemed to ignore that art had had a long and rich tradition before the abstract movement, and had produced countless works that were truly meaningful. It's one thing to challenge the status of abstract paintings such as Franz Kline's *Chief* (1950) or Agnes Martin's *Untitled* (1963). It's quite another to imply that accomplished works of representational painting and sculpture have no value—Thomas Eakins's *Portrait of*

Henry Ossawa Tanner (1897), for example, or Mary Cassatt's *The Child's Bath* (1893) or, in a very different vein, Auguste Rodin's *Burghers of Calais* (1889) or, from an earlier age, Michelangelo's *Creation of Adam* (ca. 1511).

Today's Postmodernists

As observed by Thomas McEvilley in *The Triumph of Anti-Art*, countless works in the "conceptual" and "performance" genres over the years have been made to "render foolish" attempts at interpretation and to defy normal understanding. In his words, much of it has been deliberately "unaccountable"—that is, inexplicable and unintelligible. Many recent practitioners in these categories, however, aspire to make work that is meaningful. But by their very nature, these anti-art genres obscure their makers' intentions.

The shock value of such work as a reaction against Abstract Expressionism has long since worn off. Why, then, do so many of today's would-be artists continue to employ its anti-art forms, and even invent new ones in a never-ending proliferation? It cannot be because these are the most effective means to convey their ideas. As indicated above, public reaction testifies to the contrary. At least in part, it's because they are what the artworld accepts as truly "contemporary." Creating traditional painting and sculpture would mean being ignored by the art establishment. Equally likely, these postmodernists were never adequately trained in the demanding disciplines of drawing, painting, or sculpture on which traditional work depends.

On that point, consider the case of artworld superstar Damien Hirst. At the height of his fame and wealth for creating installations of pickled animals such as *Away from the Flock* (1994) and the infamous shark cited above, he made a remarkable confession. He declared that he'd really like to be able to "represent the three-dimensional world on a two-dimensional surface," but he had tried it and he just "couldn't do it."[17] A truly astonishing admission. Here was a man who had pursued an undergraduate program at London's prestigious Goldsmiths College and who had earned a fortune as an "artist." Yet he had never learned to draw—though drawing is the foundational skill of the visual arts.

Nonetheless, Hirst did try his hand at figurative painting a few years ago. The results were so amateurish (see, for example, *Skull with Ashtray and Lemon*) that he soon resumed the production of his commercially successful but utterly undemanding "spot paintings," executed entirely by assistants and requiring no artistic skill—only his considerable skill at marketing.

An entire generation of would-be artists like Hirst have graduated from art schools here and abroad with little or no real art instruction. Contemporary museums and galleries are filled with their videos, photography, and installation pieces, while ignoring the work of contemporary artists who adhere to the traditional media of painting and sculpture and who have attained the skills needed to achieve value in those forms.

The Cognitive Challenge of Postmodernist Work

Since neither "installation" nor "performance art" originated in a desire to create intelligible work, it is clear why contemporary pieces created in these postmodernist genres seem pointless to artworld out-siders. Nonetheless, such work was highlighted in sessions at the 2012 convention of the National Art Education Association—not to bury it but to praise it. Examples are therefore worth considering here.

First, convention attendees were invited to a "Special Educator Opening" of the Whitney Museum's 2012 Biennial Exhibition at which they could speak with "performance artist" Dawn Kasper (b. 1977). Kasper is noted for immersing herself in life-size dioramas simulating her death "in disturbingly and sometimes absurdly gory ways" (to borrow one writer's words[18])—as in an enactment of a fatal motorcycle accident.

Kasper explains that such work explores the idea of death, of her own death in particular. But what would the viewer gain from such "exploration"? My guess is that most people outside the art-world would spontaneously recoil from it, not pause to reflect on it as an "exploration" or meditation on death. Further, knowing that Kasper herself was enacting the bloodied corpse would, I believe, prompt some (like myself) to wonder about her motivation, perhaps even to question her soundness of mind—all the more so regarding

performance pieces in which she has actually inflicted bodily harm on herself, with lasting scars. Such actions are simply beyond the normal bounds of behavior and expression. Unlike a comparable scene in a play or a film—where the story line would shed light on what led to the accident portrayed and on what its consequences might be—Kasper's piece, like other "performance art," presents no such meaningful context.

The piece by Kasper featured in the Whitney Biennial (entitled *This Could Be Something If I Let It*) was even more meaningless. She simply moved all of her worldly possessions to the third floor of the Whitney Museum and lived there for the exhibition's three-month run.[19] According to her audio guide account, she aimed to spend much of her time there "people watching . . . and learning from [her] environment and adapting." For artworld insiders, it was the ultimate "process" piece. For ordinary art lovers, however, interest ultimately lies in the product resulting from the process. And there was no such product in the inartistic flux of Kasper's "living sculpture" (to borrow the Whitney's absurd term)—which was more akin to reality TV than to the art of sculpture.

Another "contemporary artist" featured at the 2012 NAEA convention was Janine Antoni—who achieved artworld notoriety in 1992 with the pieces *Loving Care* and *Gnaw*. In *Loving Care* Antoni dipped her long dark tresses in a pail of black hair dye and mopped the gallery floor with them on her hands and knees. *Gnaw* was created, in part, by her chewing into humongous blocks of lard and chocolate (now displayed at the Brooklyn Museum). In addition to major sessions at the 2012 NAEA convention, Antoni was also a featured speaker at a 2010 Guggenheim Museum education conference entitled *Thinking Like an Artist: Creativity and Problem Solving in the Classroom*.[20]

A piece that Antoni discussed at both conferences was a photograph of herself suspended in midair by means of a harness and ropes tied to the ceiling and furniture of a child's bedroom. Adding to the bizarre aspect of the scene, her lower torso and legs pass through the ceiling and rooms of a doll's house. I suspect that most viewers coming upon such an image without outside input would be either baffled or amused by it. My own immediate response was to wonder if it were showing some sort of eccentric costume, perhaps for

Halloween. On noting Antoni's serious expression, however, and the strange way in which she was suspended in midair, I could not help wondering if she might be a bit "touched." I certainly never guessed that her strange get-up was inspired (as she has explained) by Italian Renaissance images of the Virgin of Mercy, although I'm familiar with such images. Still less did I guess that she intended it to reflect "the complex reality of motherhood."

Few if any persons beyond the narrow precincts of today's art-world, I dare say, would regard such an image as an entirely sane means of expression. Without speculating on Antoni's own mental state or doubting her sincerity (she in fact seems quite earnest), one can surely question the collective sanity of an artworld that encourages such expressions by devoting serious attention to them and according them high honors.

How Should Contemporary Art Be Taught?

Since the argument presented here was first outlined at art education conferences, the question of how contemporary art should be dealt with by K–12 teachers and museum art educators was an important one to attempt to answer. From my critical and art historical perspective, I cannot offer detailed recommendations. But I can suggest a few basic principles.

First, and most important, the existence of traditional contemporary work should be recognized by those involved in art education. For K–12 instruction, this means including such work in the curriculum, as part of an art historical continuum with exemplary works from the past. But what can education departments in museums do? They have no control over the collections they must deal with, and those collections systematically exclude recent traditional work. Nonetheless, awareness of this institutional bias might at least deter museum art educators from referring to nontraditional work as if it were the only "contemporary art."

Second, those who teach about art at any level should bear in mind why abstract and postmodernist work is difficult to understand: the problem lies in the very nature of the work, not in the supposed ignorance of the viewer. Ideally, that awareness would encourage

them to maintain a critical attitude toward such work, as well as toward the artworld claims made about it.

Last but by no means least, hands-on lessons and activities should focus on teaching the traditional skills of drawing, painting, and sculpture—not on the creation of "abstract art" or on projects involving postmodernist genres such as "installation," "performance," or "conceptual art."

How Not to Teach Art History

Just in time for a new school year, the September 2017 issue of *Scholastic Art* magazine features ten paintings that students should know, because they form part of "our collective cultural history." Surely a worthwhile undertaking for a publication aimed at middle school and high school visual art education programs—until one examines the works selected and what is written about them.

Legitimizing the Avant-Garde

Most troubling is that four of the magazine's "10 Paintings to Know" are twentieth-century works that depart so radically from all prior standards that their art historical status is highly questionable. They are Pablo Picasso's *Dora Maar in an Armchair*, Wassily Kandinsky's *Composition 8*, Alma Thomas's *Splash Down Apollo 13*, and Jean-Michel Basquiat's *Untitled (Skull)*. Two of the remaining ten (Georgia O'Keeffe's *Two Calla Lilies on Pink* and Frida Kahlo's *The Two Fridas*), though somewhat less radical, also date from the twentieth century. When one considers that art history encompasses millennia of picture making, this is a staggering disproportion. Not one work from the Italian Renaissance or the Golden Age of Dutch painting or the rich tradition of landscape painting in China—much less work by our own Hudson River School or more recent examples by important American artists such as Thomas Eakins or Andrew Wyeth.

For Piero's Sake, August 7, 2017.

Still worse is the choice of Picasso's savagely cubist portrait of Dora Maar for the issue's cover—a choice that implies this painting is especially worth knowing. Why is such a visually repellent work considered worth knowing? Because—*Scholastic Art* tells its young readers—Picasso is among "the most influential 20th-century artists," and cubism is "one of his most important contributions to modern art."

What did that contribution consist of?—"divid[ing] subject matter into small, simplified forms" and "reject[ing] traditional perspective." In the Dora Maar portrait, Picasso "reduces the subject's face, hair, and body to a collection of geometric shapes" and "places her features in an asymmetrical arrangement, creating an off-balance version of a face" (an understatement if ever there were one!). Picasso also "embraced bright, arbitrary colors" such as "yellow for the face, red for the nose, and blue for the mouth." On the larger questions of this bizarre painting's impact on viewers and the dubious value of reducing the face of a beautiful woman (see photos of Dora Maar) to an arbitrary pattern of geometric shapes eerily akin to the wallpaper behind it, not a word is said. Nor does the article ask whether it is wise to regard such extreme stylistic distortions as a "contribution."

Students are further misled by the poster enclosed with the issue. On one side is a large-scale reproduction of Picasso's *Woman with Yellow Hair* (1931), accompanied by this quote attributed to him below it: "Learn the rules like a pro so you can break them like an artist" (as if art were mainly a matter of breaking rules). The reverse of the poster displays Jean-Michel Basquiat's *Horn Players* (1983). If Basquiat ever learned the rules, I've seen no evidence of it. In any case, are these the two most significant works from the whole of art history that students should have posted before them in the classroom?

What prompted the inclusion of Basquiat's *Untitled (Skull)*—which he appears to have misspelled as *Scull*—in "10 Paintings to Know"? Since the work dates from less than four decades ago, it cannot quite be said to have stood "the test of time" (one of *Scholastic Art*'s criteria for a work's worth knowing about). Instead, his involvement with the New York City street art movement is cited, and the fact that his work was shown "in the city's top art galleries." Also noted is that, despite his death at the age of 27, "he is among the

most commercially successful artists in history"—one of his paintings having been bought by a collector in May 2017 "for a record $110.5 million." Nonetheless—the reader is informed—"many questions about his work [remain] unanswered."

Not mentioned by *Scholastic Art* is the fact that Basquiat was a drug addict, whose premature death was due to a heroin overdose. Relevant questions about his work that remain are what on earth it means and how much of its chaotic aspect might be due to the drug's psychedelic effects, rather than to any great creativity on his part. A further urgent question not raised by the magazine for students to consider is whether today's art market is in fact a reliable indicator of artistic value. Finally, does the crude and confusing nature of Basquiat's work really merit his presentation to students as a model for appreciation and emulation?[1]

Misconstruing Art of the Past

The one incontestable European masterpiece among the ten paintings singled out for study is Jan van Eyck's justly renowned *Arnolfini [Wedding] Portrait*. But what students are told about it leaves much to be desired. This is what *Scholastic Art* deems important:

> [The artist] includes details that provide information about the subjects. The figures wear clothing with thick fur trim, which would have been expensive to own. Many people think the woman looks pregnant. But in reality, she holds the fabric of her dress to show off the costly garment's length. The way scholars interpret these details has changed over time. For years, people thought the dog was a symbol of loyalty. Today experts believe it is simply the family pet.

Not a word to indicate that this is a work commemorating the sacrament of marriage—signified by the couple's joining of hands and the husband's raising of his other hand. Not a word about the painting's aura of solemnity, befitting such a sacrament. No mention of the fact that the mirror behind the couple is framed by miniature scenes of Christ's Passion, further alluding to the painting's sacred purpose. Nor any suggestion that the little dog so prominently placed below the couple's joined hands could be both an image of the household pet

and a token of their fidelity. Most important, there is no indication of why this work still moves viewers nearly six hundred years after its creation. As I argue in *Who Says That's Art?*, it is features such as "the sober facial expressions of the young couple, their gesture of joining hands, and the aura of solemn calm in the elegant bedchamber" (all conveyed through van Eyck's consummate mastery of the art of painting) that "ultimately make it a great work of art, a compelling image that transcends the particular historic moment being represented and conveys something about the gravity of marriage in general."[2]

One Bright Spot

Dismayed though I was by *Scholastic Art*'s September 2017 cover article, I applaud the issue's "Student of the Month" feature. Honoring Grace Lin—an eighth-grade student at the Jay M. Robinson Middle School in Charlotte, North Carolina—it pictures her oil painting *Girl with the Bird*, which won a gold award in the 2017 Scholastic Art & Writing Awards. A remarkably sensitive and accomplished self-portrait for a girl of only 12 or 13, it is an admirable foil to the avant-garde thrust of "10 Paintings to Know."[3] What inspired it? Not the likes of Picasso, Kandinsky, or Basquiat, but the landscape and art of Italy—in particular, she noted, the "sense of dignity and peace" in Leonardo's *Mona Lisa*.

Brava, Grace Lin! Your work would far better serve as a model for your fellow students than that of Scholastic's poster artists Picasso and Basquiat.

The Truth about Pop Art

Having just received a promotional copy of *Scholastic Art* magazine's December 2017 issue, entitled *American Pop Art: Working with Ideas*, I'm moved to comment. But there is so much wrong with it that I scarcely know where to begin.

A logical starting point, I suppose, would be the cover, featuring an Andy Warhol *Campbell's [Tomato] Soup Can* (1964). What ideas, we might begin by asking, is it "working with"? In an article entitled "Ideas that Pop," we're told that Pop artists "found inspiration in daily life" and "presented complex and serious ideas about the world through the subjects they featured and the techniques they used."

As for how a literal rendering of a single Campbell's Soup can conveys a "complex and serious idea about the world," nothing is said. But Warhol's 1962 *Campbell's Soup Cans*—an installation of 32 framed canvases of single soup cans differing only in the names of the soups, and grouped side by side in four rows of eight each—is said to "reflect the abundance of choices a shopper see in any large grocery store." By making them look "mass-produced" and displaying them this way, Warhol purportedly "points to a culture fueled by mass consumption." That, then, would appear to be his "complex and serious" idea.

On another page, however, we learn that Warhol "claimed [he painted the soup cans] because he had eaten Campbell's soup for lunch every day for 20 years." Not what most people would call a "complex and serious" idea. We're also told that Warhol "frequently

For Piero's Sake, March 1, 2018.

had assistants produce his silkscreen prints in an assembly-line system"—in his New York City studio, dubbed "The Factory." Indeed, while the soup can pieces were oil paintings, the bulk of Warhol's later work consisted of mass-produced silkscreen prints.

Most important is what we're not told by *Scholastic Art*—that is, *why* Warhol adopted a minimally artistic, industrial approach for his work. Warhol himself made it abundantly clear, however. As he explained in an *Art News* interview with G. R. Swenson in 1963, he chose not to create paintings because he didn't "love roses or bottles or anything like that enough to want to sit down and paint them lovingly and patiently." He further confided that it was "threatening" to paint something "without any conviction about what it should be." He used mechanical methods, he said, because he wanted "to be a machine." Surely bizarre sentiments for a would-be artist. Yet they were entirely consistent with the zombie-like demeanor Warhol generally exhibited, leading clinical psychologist Louis Sass to compare his words and actions to those of a typical schizoid personality.[1]

No hint of such dysfunction is offered by *Scholastic Art*, however. Instead, we get this tidbit, reported without critical comment:

> Warhol also made movies, but most were conceptual and without a narrative or plot (for example, he filmed a man sleeping for more than five hours).

Are students and teachers to regard that as *serious* movie-making?

Finally, there was Warhol's approach to portraiture. Of his *Self-Portrait* (1966), we're informed that he portrayed himself "more as a product than as an individual." True. He also did so for his acclaimed celebrity portraits. But doesn't that controvert the very point of a portrait? And shouldn't teachers and students be made aware of that?

"Elevating the Everyday"

As for Pop artists in general, *Scholastic Art* credits them with "explor[ing] the mundane aspects of daily life" and thereby "elevating the everyday." Works that "look like they belong in the pages of a magazine" or on "television commercials" (as the magazine notes)

don't "elevate the everyday" or "explore" anything, however. They merely replicate commercial trivia.

For examples of art that truly elevate the everyday, teachers might turn instead to seventeenth-century Dutch genre painting—works such as Vermeer's *Milkmaid* or *Lacemaker*, or the less-well-known *Young Woman Peeling Apples* by Nicolaes Maes (1634–1693). Such paintings elevate their subjects by sensitively depicting them in quiet concentration on simple everyday tasks. In so doing, they also convey a sense of what life was like in their time and place. In contrast, Edward Ruscha's *Standard Station* (1966) makes no "statement about contemporary culture" worth asking students about (as prompted by *Scholastic Art*'s caption for the image). It merely resembles a billboard sign.

Nor does Roy Lichtenstein's *Look Mickey* (1961) "reinterpret an image from popular culture" in any significant sense. As reported, he created it only because his young son had challenged him to paint something "as good as" a Mickey Mouse illustration they were looking at together. All he did was greatly enlarge the image and make some minor formal changes such as simplifying the background and using dark outlines—nothing that substantially alters its significance. In fact, his paintings were little more than abstract formal designs to him. "I paint my . . . pictures upside down or sideways," he once declared. "I often don't even remember what most of them are about."[2]

True, Lichtenstein's work "grabs the viewer's attention"—by its size alone—much as a billboard does. But does it hold one's attention or prompt reflection the way the Dutch paintings cited above can? I don't think so.

Also contrary to *Scholastic Art*'s assertion, Lichtenstein's work scarcely "elevates an illustration from a children's book to the level of high art." If it "invit[es] viewers to think about what qualifies as art and why," shouldn't teachers guide their students toward recognizing the fundamental ways in which it differs from fine art? Moreover, shouldn't they question whether "blurr[ing] the lines between popular culture and high art" constitutes progress—or should be rejected rather than embraced?

Further, if "the use of commercial art as subject matter in painting" is an earmark of Pop art—as Lichtenstein once said in an *Art*

News interview—wouldn't it be appropriate to point out that the subject matter of *fine art* has always been principally drawn from life itself, not from product ads or cartoon illustrations? And shouldn't students be guided to think about the essential differences?

Pop Art in the Classroom

Teachers (and students) are attracted to Pop art for an obvious reason. It is much easier to create hands-on projects imitating Andy Warhol than Vermeer or Nicolaes Maes. A case in point is the Hands-On Project featured in *Scholastic*'s December issue. Entitled "Paint in Pop," it aims to "use what you've learned about American Pop Art to explore repetition and variation." But how much does that teach students about the distinctive cultural value of *fine art*?

Similarly, the "Student of the Month" work is a Warhol-like self-portrait triptych. Awarded a Gold Medal in the 2017 Scholastic Art & Writing Awards, it was created by 14-year-old Hanson Wu, who digitally edited a photo of himself and then used it to produce three self-portrait prints varying only in color. Asked whether the images reflect his personality, Wu answered "Not really." That, too, is in the spirit of Warhol. Happily, Wu doesn't aspire to become a fine artist, however, just a graphic designer.[3]

The Underlying Truth

What teachers, students, and everyone else should know about Pop Art is the truth about the primary motivation behind it. The chief aim of the Pop movement was to challenge the Abstract Expressionists—not to make any "complex and serious" statements about contemporary culture. Thus the path the purveyors of Pop took was merely to do the exact opposite of whatever the Abstract Expressionists had done, no matter how trivial or meaningless the result was.[4] Philosophers, critics, curators, and much of the public fell for it and welcomed it into the realm of "high art." It's long past time for everyone, especially art educators, to exercise greater discretion.[5]

Barking Up the Wrong Trees in Art Education

W*hat's being taught in art classrooms these days?* Lacking a comprehensive survey, I can't offer a definitive answer to that question. But I can point to some prominent examples that should trouble anyone who regards visual art as a potent component of civilization and thus an important part of children's general education.

Abstract Art 101

Barbara Clover (an art teacher soon to retire after two decades at Holy Savior Menard Central High School in Alexandria, Louisiana) was recently named Art Educator of the Year by the National Art Education Association (NAEA). So it's worth asking what we might discover if we could eavesdrop on one of her classes to observe a lesson under way. A recent news account offered the following glimpse:

> All is peaceful as [a] class of juniors and seniors concentrate on a projector screen. Students use colored pencils to sketch what they see.

So far so good. But what did Clover's students see? A typical canvas by the Abstract Expressionist painter Mark Rothko (1903–1970). Not much to sketch there, unfortunately—just some blurred rectangles. Nonetheless, as the reporter noted, Clover had urged her students to try to understand what's being communicated in such work. We

For Piero's Sake, May 12, 2016.

aren't told their answers. But Rothko's rectangles surely gave them very little to go on.

Rothko once claimed that the goal of his work was "expressing basic human emotions—tragedy, ecstasy, doom, and so on—and the fact that lots of people break down and cry when confronted with my pictures shows that I communicate those basic human emotions."

Had any of Clover's students wept at the sight of his work? I doubt it. My guess is that apart from some sensuous pleasure evoked by his use of color, any emotion aroused in them was probably frustration at being expected to discern meaning in such a painting. The reason why is simple. People normally "express" basic human emotions vocally and bodily. They don't reach for a paintbrush and create colored rectangles; they do things like jumping up and down and shouting. I saw a striking example on a crowded bus the other day—a little girl who was clearly not happy to be there. How did I know that? Her brow was wrinkled into a tight frown, and she periodically stamped her foot and emitted little shrieks of anger, while tugging impatiently at her baby-sitter's arm.

The art forms based on such direct expressions of emotion are music, dance, and drama—not painting. Visual artists can represent human emotion, but they do so mainly through depictions of facial expression, bodily posture, and gesture—as in a justly famed fresco representing the *Lamentation of Christ*, by the great early Renaissance painter Giotto di Bodone (d. 1337).

Like many dedicated art teachers, however, Clover has simply accepted the artworld's dubious narrative regarding the value of abstract work such as Rothko's. What she probably didn't tell her students, therefore, is that Rothko, along with other famous abstract painters, was haunted by the fear that viewers would fail to grasp his deeply serious intentions and would regard his paintings as merely "decorative" rather than meaningful.

Nor would students in today's art classrooms be likely to learn that such a fear was fully justified—as evidenced by numerous patently decorative uses of purportedly serious art (uses ranging from Mondrian-inspired bathroom designs to a Rothko reproduction marketed by the Crate & Barrel home furnishings store as a "bright yet soothing . . . contemporary color statement"). Instead, students

are routinely fed the artworld's received wisdom regarding abstract art as a major art historical breakthrough worthy of our attention and esteem.

Postmodernist "Contemporary Art"

Revelations of where a younger generation of art teachers are heading can be found in the "Instructional Resources" featured in the NAEA journal *Art Education*. Let me cite just two. One, from the January 2016 issue, is about the "dizzying work" of Alex Garant—a Canadian painter who uses the "gimmick" (her word) of superimposing several versions of the same face out of sync.[1]

Garant says she aims "to engage the viewer in a sensory journey" and "to create an aesthetically pleasing optical illusion." But I defy you to gaze at one of her odd images for more than a few seconds. I found it impossible. Feeling as if my eyes were crossed, I had to turn away from what was a distinctly *un*pleasant experience.

Yet the adjunct professor and middle school teacher who had "explored" Garant's work as an example of contemporary art for inclusion in her lessons concludes her article by claiming that it "*magnetically draws the viewer in* (emphasis mine), forcing us to question the essence of the figure before us." Which left me wondering if she had ever actually *looked* at those bizarre images for more than an instant, or had questioned why she herself had emphasized their "dizzying effect." Pity the poor middle schoolers who will receive lessons on such "art"!

A passion for "big ideas" in contemporary art led another professor of art education to interview "sculptor" Michael Beitz for an Instructional Resource in the May 2014 issue of *Art Education*.[2] Some of Beitz's "sculptures" consist of casts of body parts attached to buildings—such as *Body/Brick* and *Belly/Brick*. Of these, he confesses: "I often work subconsciously without understanding what I am doing." His professorial interlocutor makes matters clear for us, however. "By placing his own body parts into the construction," she explains, Beitz "addresses issues of anonymity, alienation, and the nature of public space." She further notes that the work reflects such postmodernist practices as "juxtaposition, recontextualization,

hybridity, and layering"—terms given currency in the art ed lexicon through the writing of an influential educator named Olivia Gude.

Other "big ideas" can be found in Beitz's furniture "sculptures"—in which he twists and distorts familiar items such as sofas and tables out of any functional shape, to explore "relationships." One of his favorite pieces is *Knot*. Another, created while he was an "artist-in-residence," is *Dining Table*. Despite his intensely serious intentions about such work, Beitz candidly observes that they "look sort of funny." Does that spontaneous impression give either him or his art ed interviewer pause to question his approach to "sculpture" and perhaps revert to one that is more traditional? Not in the least. Moreover, Professor Hoefferle assures *Art Education* readers that such works are "traditional in the sense that they involve a high level of technique/craft, are a translation or symbol of the artist's experience, and are not the result of a research project."

I must confess that my own view of "traditional" works of sculpture dealing with human relationships is a bit different. It conjures up works such as an ancient Egyptian sculptured couple, Michelangelo's *Bandini Pietà*, or a remarkable latter-day *Madonna and Child* by a little-known Italian sculptor, Alceo Dossena (1878–1937)—not to mention a more recent example such as *Three Soldiers*, by Frederick Hart (1943–1999), in the Vietnam Veterans Memorial. A fruitful lesson might be to ask students to compare their spontaneous responses to these and other genuine sculptures with that to Beitz's concoctions. But no such question was included in Hoefferle's Instructional Resource.

Nor do teachers have any difficulty reconciling anti-traditional works such as those described above with the National Visual Arts Standards arrived at to great fanfare by the NAEA in 2014. Which suggests that what the standards most needed was a solidly reasoned conception of what qualifies as "visual art" and why. What was adopted instead was the contemporary artworld's open-ended view of what art is—which boils down in effect to no standards at all.

Art Education or Miseducation?
From Koons to Herring

If math teachers were instructing school children that 2 + 2 = 5, a public hue and cry would no doubt ensue about fake math. Yet many of today's art teachers are unwittingly engaged in promoting pseudo art, with scarcely anyone taking note of it.

I've long argued that the most important aspect of art education is the nature and quality of the art works students learn about—the reason being that young people are still forming a concept of what art is. What they see in the classroom and on museum visits will not only influence the sort of work that the few who choose a career in art may go on to create but also the kinds of art that students are likely to favor as museum goers, collectors, or trustees in adulthood.

In that light, the works of purported art touted at this year's conference of the National Art Education Association (NAEA) in New York City—attended by more than 7,000 art teachers from around the world—are deeply troubling. Countless sessions revealed an almost obsessive focus on anti-traditional "contemporary art," with little or no reference to exemplary art of the past.[1] Still worse was the lamentable nature of work by featured artists on the program—compounded by the confused ideas behind it.

The roster of contemporary artworld figures featured at the conference (I refrain from calling them "artists") speaks volumes—from Jeff Koons, who opened the first day with a talk about his life and

work in a plenary session in the Hilton Hotel's Grand Ballroom, to the less well-known "experimental artist" Oliver Herring, the last presenter I observed on the third day.

"Elevating the Everyday" with Jeff Koons

The conference program descriptions are telling. Jeff Koons, teachers were informed:

> plays with ideas of taste, pleasure, celebrity, and commerce. Working with seductive commercial materials (such as the high-chromium stainless steel of his *Balloon Dog* sculptures), shifts of scale, and an elaborate studio system involving many technicians, [he] transforms banal objects into high art.

That theme was parroted in the cover story of the February 2017 issue of *SchoolArts* magazine, free copies of which were distributed to attendees. "Written by art educators for art educators," *SchoolArts* is a national magazine "committed to promoting excellence, advocacy, and professional support for educators in the visual arts." Its Koons cover story—entitled "Elevating the Everyday"—began by declaring:

> Throughout history, there has been a trend among artists to question the popular art movements of the day by creating new movements and approaches to art-making. Prominent examples of this include Dada, Surrealism, Pop Art, and Conceptualism.

Remarkably, the examples cited in effect reduce all of art "history" to the avant-gardists of the twentieth century. Koons is then credited with "reinvigorat[ing]" Pop art. Has he truly reinvigorated it? Or has he just re-marketed and perpetuated it? And given Pop art's utter banality, how much reverence does its perpetuation merit?

In his rambling, self-serving presentation, Koons acknowledged his inspiration by Pop art, as well as by Duchamp's Dada-inspired readymades (never mind that Duchamp himself avowed he hadn't intended the readymades as "art"[2]). Koons's production of bigger, glitzier, more costly fabrications "referencing" (a term much used by him) banal objects of contemporary culture does not "elevate the everyday" (as *SchoolArts* claims), however. It merely magnifies it—thereby further trivializing contemporary life. In contrast, an artist who truly elevated

the everyday was Vermeer, as in his justly famed painting *The Milk-maid.* To do so required taking the everyday seriously and highlighting its significant aspects[3]—neither of which is involved in Koons's output.

In discussing his work, Koons assiduously cultivates the art of spin, liberally adorning it with such high-flown terms as "metaphys-ical" and "transcendence," which recurred frequently in his NAEA talk. (He even had the chutzpah to mention his grotesquely gaudy porcelain *Michael Jackson and Bubbles* in the same breath as Michel-angelo's divine *Pietà*.) He also resorts to such terms in promoting his shameless collaboration with Louis Vuitton to produce pricey handbags decorated with images of paintings by the Old Masters. His work doesn't "transcend" anything, however. On the contrary, it wallows in triviality. It does not "transform banal objects into high art." It reduces high art to banal objects.[4]

In sum, Jeff Koons is not an artist. He is a fabricator and pur-veyor of vulgar schlock. His only skill lies in managing an elaborate stable of assistants and in his marketing conmanship. (A sad irony is that many of his assistants are serious, talented artists who work for him to supplement their income in an artworld that ignores their art.) The intrinsic value of his work is inversely proportional to the astronomical prices it fetches. As "art" it is worthless.[5]

Oliver Herring's Happening

My introduction to the Special Session by "experimental artist" Oliver Herring at the NAEA convention was in coming upon a group of students playing with long strips of aluminum foil in the corridor outside one of the Sheraton Hotel's ballrooms. Yes, the students assured me, this was the place for Herring's session. On entering the ballroom, I discovered a chaotic scene with many more students manipulating countless strips of foil in a variety of ways—a free-for-all of spontaneous, undirected activity resembling Allan Kaprow's Happenings of the 1950s and 1960s.

Entitled "Areas for Action," the session was described in the conference program as "an open-ended participatory performance, improvisatory sculpture, . . . real-time collaborative artwork," and "hands-on art experience." Whew! Eager to learn more straight from

the horse's mouth, I located Herring and asked him what the point of the chaos was, as I could discern no coherent product. "Process is an endpoint," he informed me, "not just a means to an end." Like so much of postmodernist thinking, that idea stands logic on its head, however, for *process*, by definition, implies that the actions, changes, or functions involved lead to a result or product of some kind. Nonetheless, I was assured that some teachers have found Herring's free-wheeling approach useful.

One of those instructors was Bart Francis. An engaging and articulate young man who teaches at Mountain View High School in Orem, Utah, he was good enough to talk at length with me about his application of Herring's methods in his classroom. Working with students in grades 10–12, he has enthusiastically applied Herring's idea of TASK— an article about which appeared in the January 2016 issue of the NAEA journal *Art Education*.[6] Each student would write a task for others to do and add it to the Task Box. Tasks might be as diverse, Francis explained, as Draw a picture of your dog, Have a dance party, Play a game of soccer, or Build a robot. Each student would then pull a task from the box and interpret it however he or she liked in a completely open-ended manner, using whatever materials had been provided, Students who were later questioned about the benefit of the exercise, Francis reported, would point to such things as "figuring out creative solutions" and "the importance of play." When I remained skeptical, he urged me to stay to listen to Herring's follow-up discussion, which I did.

The activity ended, participants gathered in a circle to comment on the experience. A teacher who had used Herring's approach in the classroom observed that "most kids are willing to jump into play" (no surprise there!). Referring to a Herring-inspired event involving 140 high school students at one time in the school gym, the teacher noted it gave them "chances to interact in strange ways." Indeed. A student whose first response had been "what are we doing?" and "this is just crazy," said she came to think it "opened the ability to go to school and enjoy learning."

As for what was learned from such exercises, Herring claimed "creativity" and the idea that "anything is possible." Like "process," however, *to create* implies a product, and while "anything" may be possible, it is not necessarily something of value. One student said she had

gained "a sense of community." That is surely of value, but is it a goal of *art* education or are other arenas more appropriate to its development?

A student named Emily, whom I briefly spoke with, said she learned that "it's okay not to be in control of your work—and to let other people contribute to it." Had she learned anything specifically relevant to *art*?, I asked. "That different people react differently to my work, and to be comfortable with that," she replied. Hadn't she known that before? was my rejoinder. "Well, yes, but this reinforced it."

When I asked Herring the inescapable question, "But is it art?," his answer was: "What difference does it make what we call it? Why is that an important question to ask?" That is something that "kids should be talking about in class and questioning," he argued, and ended by repeating his central claim that the end product is less important than the process.

Herring may not think that it's an important question to ask. But teachers—who are accountable to parents and community school boards—should. How can they justify as "*art* education" activities resembling a cross between a Kaprow Happening[7] and a transactional psychotherapy session? As for kids' "questioning" what art is, how meaningful can that process be when the examples they are taught about are rooted in a *non-art* or *anti-art* mentality such as Herring's? "The work that interests me the most is when I don't know if it's even art," he declared some years ago.

Other "Contemporary Artists" Featured by NAEA

Also far removed from traditional notions regarding art is the work of the individuals in the 2017 conference's "Artist Series." According to the program description, Ursula von Rydingsvard, for example, creates works "on a monumental scale" that are "[b]uilt slowly and incrementally from thousands of small cedar blocks, each work reveal[ing] the mark of the artist's hand, her respect for physical labor, and her deep trust of intuitive process." But what does the "intuitive process" involved in her abstract "sculptures" enable her to convey about human values and experience? Nothing that I can discern (sample her work and decide for yourself). Yet that, after all, is what people have always turned to art for.

Derrick Adams is described in the NAEA program as "Jack of All Trades, Master of One at a Time." Though I was unable to attend his session, I would argue that the work shown on his website in diverse media (photo, sculpture, video, performance, and works on paper) suggests that, like virtually all "multimedia artists," he is master of none. His NAEA presentation "on the Multidisciplinary Practice in the Arts-Is a Future Without Categories in Arts Education" was said to deal with "the collapse of division between traditional practice in contemporary arts and the arts institution." Collapse, indeed.

As for Sam Vernon—the third person in the NAEA Artist Series—she was billed as "a 29-year-old artist whose work has been featured at the Brooklyn Museum and in *Huffington Post*'s '[Black Artists:] 30 Contemporary Art Makers under 40 You Should Know,' [and who] uses her multidisciplinary art to confront questions about historical memory and racial bias." She is also a member of "Black Women Artists for Black Lives Matter"—a fact that no doubt stood in her favor, given the conference's pervasive concern with "social justice" issues (on which see the next section). Like Adams, she works in multiple media but is master of none.

"Social Justice" Activism and Art Education

The 2017 NAEA conference included no fewer than seventeen sessions with "social justice" in the title or description, in addition to others about being "socially engaged." As indicated by the program descriptions, the emphasis was often on promoting activism, rather than on the quality of the "art" involved. A session entitled "Use Contemporary Art to Empower Students to Become Advocates for Social Justice," for example, dealt with an inner-city teacher's approach to using contemporary work to stimulate students' thinking about social justice and "motivate them to become agents of change." Another, devoted to "Socially Engaged Art Education," considered how art teachers "might develop socially relevant programs that emphasize community, social justice, and activism." The description for a session subtitled "Stories of a Social Justice and Art Summer Program" referred to a summer partnership between a K–12 school and a teacher-training program that "explored social justice issues." It made no mention of *art*.

Especially troubling in my view were the descriptions of yet two more sessions (neither of which I was able to attend). One—aimed at "adapting art education curriculum to address real life issues"—focused on "social justice in Baltimore amidst the Freddie Gray crisis." Asking if art education could "be part of the solution to the problem of systemic inequity," it seemed to imply that what lay at the root of the complex case of Freddie Gray was one of "systemic inequity." It is the sort of simplistic analysis that is often involved in social justice art education.[8] An example of the sort of work it is likely to engender is the controversial "cops as pigs" painting (inspired by events following the shooting of Michael Brown in Ferguson, Missouri) that caused a Congressional furor earlier this year. I would argue that such a painting merely serves to further alienate communities beset by crime from the police officers they need for protection.

While that session at least included student portfolio preparation as a point of discussion actually relevant to art education, another session blatantly focused solely on social justice content. It advocated shifting the focus of art criticism to "analyzing social justice issues"—aiming to reframe art criticism "as a tool for fostering critical thinking with [future teachers] about pedagogy and social justice issues." As I've argued in *Who Says That's Art?*, however, the proper subject for critical thinking in art education is the question of what qualifies as *art* and why—not the complex social and political questions involved in matters of "social justice," which are entirely beyond art teachers' professional purview. Moreover, the seemingly laudable goal of "social justice" is itself likely to engender destructive unintended consequences, as Nobel-laureate economist F.A. Hayek long ago warned in a book subtitled *The Mirage of Social Justice*.

Disparity between Artworld and Popular Views of What Art Is

The examples I've cited indicate how completely those in art education have adopted the artworld's "cutting-edge" view of contemporary art. Conspicuously absent from the conference were artists such as those I've written about in "Contemporary Art Worth Knowing" (above, pages 97–100) and (with Louis Torres) in "What About the

Other Face of Contemporary Art?" (*Aristos*, June 2008). Hewing to a traditional view of painting and sculpture, these artists spend years honing their depictive skills in those media. And their work is far more acceptable to members of the community at large than the contemporary pseudo art promoted by the artworld and too often highlighted in art education. Significantly, even those who advocate employing such work in the classroom are apt to admit its off-putting nature. In her session on using contemporary art to empower students to become social justice advocates, for example, Barbara Suplee (Professor of Art & Design Education at the University of the Arts) noted that "many teachers feel uncomfortable with teaching [it]," as it can be "alienating" and "controversial."

Nonetheless, even a session about a program with the goal of building communal relationships in an urban middle school through engagement with art included contemporary work outside the traditional mainstream.[9] One of the pieces discussed was *The Former and the Ladder or Ascension and a Cinchin'* (2012), by Trenton Doyle Hancock. A cartoon-like collage depicting a headless figure striding under and through a ladder, it is (like so much postmodernist work) utterly baffling on its own. According to PBS's *Art21*, it incorporates "materials that Hancock accumulated over a fifteen-year period, including scraps from some of his earlier artworks" and "provides a condensed overview of his artistic development to-date." But who could readily discern that, and why would anyone who was not a fan of his quirky and largely baffling other work care about it? In any case, it would be interesting to know how members of the school community responded to the piece without prompting or prior discussion.

An article in a recent issue of the NAEA newsletter sheds light on the view of such baffling contemporary work. It is by Sara Wilson McKay, the professor of art education who organized the foregoing middle school program. Writing of her "profound love for artwork that invokes the dialogic," she values it as "unresolvable, always incomplete, perpetually unfinished."[10] As a prime example of a work whose very theme is dialogue, she cites *Circa 1987*, by Heather McCalla. An odd-looking piece, it consists of two chairs tilted toward each other and joined at the top. In McKay's view: "This sculpture challenges where and if there is room for two heads."

Let's apply some critical thinking to that proposition. To begin with, the piece is not a "sculpture " in any but the dubious post-modernist sense, nor is McCalla a sculptor. Trained as a furniture maker, she has apparently been led by the confusion in today's art-world to think that she can transform furniture into meaningful art. Absent an "artist's statement" or insider commentary such as McKay's, however, her work is likely to seem a merely comical object to most viewers. If urged to find human meaning in it, I would not think it suggests "dialogue," but rather conjoined twins joined at the head. Like such twins, the two chairs comprised in the piece require major surgery to be made whole and functional. In any case, McCalla's piece conveys nothing of the crucially important emotional dimension of a human dialogue. By sharp contrast, a work of genuine art that comes to mind for me that does convey that dimension is Vermeer's *Officer and Laughing Girl.*

A fundamental problem with "cutting edge" contemporary work such as McCalla's is that it fails to communicate on its own. Most people would not even recognize it as art. It requires commentary by the maker or some reputedly expert interpreter. As observed in response to a TedX talk by one such interpreter:

> What's wrong with contemporary art? The artists aren't making anything that can be appreciated without a 10 minute lecture or a degree in modern art.

Art teachers would do well to heed that candid comment and many others like it posted on YouTube.[11]

The gaping chasm between expert and lay views of contemporary work—as reflected in those comments—is a major theme of my book *Who Says That's Art?*, which offers a serious defense of the lay person's commonsense view. And it is a principal reason why a panel of distinguished art educators at the 2017 conference recommended that every art teacher should read it. As one of them argued,

> the case for art that we . . . have repeated for years is not one that actually resonates with folks outside [our] bubble. Art education . . . will simply not win the battle for the hearts and minds of our fellow citizens unless and until we can provide clear and credible answers to those whom we ask to support our practice.[12]

Those clear and credible answers must, I would add, include a more coherent and compelling view of the nature of art than that operative in the contemporary artworld and embraced by far too many teachers. Such a view would emphasize, in part, that the value of art lies in its profoundly personal psychological dimension, which does not require political and social activism for its justification.

Part IV

Art Theory

Art and Cognition
Mimesis vs. the Avant Garde

[A]rtists themselves have been pushing the boundaries of any . . . definition [of 'art'], challenging our preconceptions, and leaving most philosophers, psychologists and critics well behind—to say nothing of the general public. . . . Environmental art pushes the definitional boundaries by placing art outside the museum, in a (more) natural environment. Well known examples include earthworks, e.g., by Robert Smithson, and wrapped buildings by Christos [*sic*].[1]

—Joseph A. Goguen

One of the hottest topics of academic inquiry in recent years has been the relationship between art and cognition. This interest is a natural outgrowth of the cognitive revolution that began in the early 1960s, producing a growing body of knowledge about cognitive processes. As philosopher of art Cynthia Freeland noted in an article on "Teaching Cognitive Science and the Arts," scholars in her field increasingly recognize that the burgeoning understanding of cognition should influence their approach to their own discipline.[2] Along these lines, several prominent colleagues of hers—including Jerrold Levinson, president of the American Society for Aesthetics—

Aristos, January 2003; endnotes have been added. An expanded version, with extensive endnotes, appears as "Mimesis versus the Avant-Garde: Art and Cognition" in *After the Avant-Gardes: Reflections on the Future of the Fine Arts,* ed. by Elizabeth Millán (Chicago: Open Court, 2016).

organized an academic institute entitled "Art, Mind, and Cognitive Science," at the University of Maryland last summer. It was funded by the National Endowment for the Humanities (NEH), with an express aim to develop a set of resources to aid humanistic scholars of the arts wishing to take account of cognitive science and the philosophy of mind in their undergraduate courses.

Scholarly journals have also been active in this area. The interdisciplinary *Journal of Consciousness Studies* (*JCS*)—edited by Joseph Goguen, a computer scientist at the University of California–San Diego, whom I quote in the epigraph above—devoted two special issues to *Art and the Brain* in 1999 and 2000, to be followed by a third, *Art, Brain and Consciousness*, in 2004. In addition, the philosophic journal *The Monist* plans an issue in 2004 entitled *Art and the Mind*.

These are but a few of the many recent explorations of how cognitive processes are involved in the creation and perception of works of art. Nor have such efforts been confined to higher education. Art educators concerned with elementary and high school students have also been keenly pursuing this line of inquiry. Cognitivist approaches to the teaching of art occupied numerous sessions at the annual meeting of the National Art Education Association in Miami in 2002. Further symptomatic of this trend is a book entitled *Art and Cognition*—by Arthur Efland, professor emeritus of art education at Ohio State University—published by Teachers College Press in 2002.[3]

Examining Basic Premises

Little of value is likely to come of all this ferment, however, without a fundamental reassessment of what exactly is meant by the key term, *art*, in relation to cognition. Scholars must begin by asking themselves whether that term can coherently encompass all the modernist and postmodernist innovations of the past hundred years. Some of those innovations are mentioned in the epigraph above, taken from Goguen's Editorial Introduction to one of the special issues of *JCS* on art and the brain. Others mentioned by him in that essay include Marcel Duchamp's "readymades" (such as the urinal he dubbed *Fountain*), Andy Warhol's images of Campbell's Soup cans, and John Cage's use of chance operations in his "musical" compositions. One

would be hard pressed to discover, for example, how such works fit a view of art as "a particularly poignant manifestation of human consciousness"—to quote from the call for papers posted by *JCS* for its forthcoming issue *Art, Brain, and Consciousness*.

The Overview for the NEH summer institute on art and cognition aptly notes that when the eighteenth-century philosopher Alexander Baumgarten coined the term "aesthetics," he envisioned it as pertaining to the study of "sensuous cognition." As the Overview continues:

> Because of the connection of the arts to perception (the sensuous element in this formulation), aesthetics made the arts its central domain. However, the perception of artworks is not merely an affair of sensation. Memory, expectation, imagination, emotion and reason (including narrative reasoning) play an ineliminable role as well. Consequently, since its advent, the field of aesthetics has been concerned with the operation of fundamental psychological and cognitive processes.

Baumgarten was ahead of his time in understanding that the arts constitute a distinctive and significant realm of "sensuous cognition," in which emotion also plays an important part. It was Baumgarten who coined the term *aesthetik* (from the Greek *aisthetikos*, "perceptible to the senses") to designate a new branch of philosophic inquiry—which he defined broadly as "the science of perception." It was with the nature of perceptual knowledge conveyed *through the arts*, however, that he was exclusively concerned. In fact, the work in which he first used the term *aesthetik* was his *Reflections on Poetry*.[4] The treatise aimed mainly to persuade his fellow rationalist philosophers that questions of art were as worthy of their attention as the more abstract spheres of thought with which they had theretofore concerned themselves. Baumgarten's view of art was largely shared by his younger contemporary Immanuel Kant—though Kant has often been mistakenly associated with formalist theories that attempt to divorce art from cognitive considerations.

In the sections of his influential *Critique of Judgement* that focus on the "fine arts" per se (as contrasted with the broader discussion of aesthetic attributes in general), Kant makes clear that the value of an art work depends on its presenting what he terms "aesthetical Ideas." He explains:

> [B]y an aesthetical Idea I understand that representation of the Imagination which . . . cannot be completely compassed and made intelligible by language. . . . [It] is the counterpart (pendant) of a *rational Idea.* . . .
>
> The Imagination (as a productive faculty of cognition) is very powerful in creating another nature, as it were, out of the material that actual nature gives it . . . , and by it we remould experience, always indeed in accordance with analogical laws. . . .
>
> Such representations of the Imagination we may call *Ideas*, partly because they at least strive after something which lies beyond the bounds of experience, and so seek to approximate to a presentation of concepts of Reason (intellectual Ideas), thus giving to the latter the appearance of objective reality.[5]

What Kant seems to be saying is that the arts present perceptual embodiments of important ideas—not only ideas about existential phenomena, such as death, envy, love, and fame, but also conceptions of other-worldly things, such as heaven and hell. In all cases, Kant implies, the products of the artist's imagination are essentially *mimetic*, for they resemble to some degree the appearance of nature, or "objective reality." As he indicates, however, a work of art does not merely *copy* nature, for it embodies concepts more fully than any single instance in nature. Philosopher-novelist Ayn Rand—one of whose four essays presenting her theory of art was entitled "Art and Cognition" (written in 1971, when the cognitive revolution was just getting underway)—suggested much the same thing when she argued that, through the "selective re-creation of reality," art "brings man's concepts to the perceptual level of his consciousness and allows him to grasp them directly, as if they were percepts."[6]

Anyone wishing to understand art in relation to "sensuous cognition" needs to begin by recalling what sorts of objects Baumgarten and other eighteenth-century aesthetic theorists had in mind when they spoke of "art." For them, this term meant, pre-eminently, the *mimetic arts*— which came to be known, however misleadingly, as the "fine arts." What basic forms of expression did they include? According to a broad consensus from antiquity until the mid eighteenth century, the mimetic arts chiefly comprised painting and sculpture (that is, two- and three-dimensional visual representations), "poetry" (which, in Aristotle's view, included all imaginative literature), music,

and dance. The mimetic arts did *not* include either architecture or objects of "decorative art"—whose primary function was physical, rather than cognitive or emotional. Nor, obviously, did they include such things as "abstract" (nonobjective) art, noise music, conceptual art, performance art, film, photography, video, or digital art—none of which had yet been invented.

If the nature of art is now to be examined scientifically in relation to cognition, the question must first be asked, what coherently qualifies as art? Does *every* purported art form invented since the advent of modernism constitute a medium of "sensuous cognition" in the sense meant by Baumgarten? If works of art are held to be "cognitive devices aimed at the production of rich cognitive effects" (to quote *The Monist*'s call for papers on *Art and the Mind*), then aestheticians need to reconsider whether certain phenomena of modernism and postmodernism qualify as art at all. In considering art forms unknown to the eighteenth century, it is easy to envision that feature films, for example, may be readily subsumed by the concept of mimetic art, which has always included forms of dramatic and narrative story-telling. But the status of much "avant-garde art" is highly questionable.

Would what Baumgarten wrote in his *Reflections on Poetry* be applicable to the largely incoherent postmodernist "poems" of John Ashbery, for example? Can they be said to exemplify his concept of sensuous cognition? Further, can the phrase "rich cognitive effects" meaningfully apply to works ranging from Mondrian's grid paintings to Duchamp's "readymades," much less to Minimalist works such as Ad Reinhardt's all-black paintings or Carl Andre's "floor pieces," or to John Cage's chance compositions? Finally, can there be any but the most flimsy connection between "sensuous cognition" and the whole postmodernist category of "conceptual art"—defined by the 1988 *Oxford Dictionary of Art* as "various forms of art in which the idea for a work is considered more important than the finished product, if any"?

In attempting to analyze or define art, contemporary aestheticians are apt to cite avant-garde innovations as conceptually "difficult" cases, implying that they are essentially incommensurate with the traditional categories of art. Yet on the basis of such deviant work, most aestheticians have adopted "institutional" definitions of art—which hold, implicitly or explicitly, that "art is anything an artist declares

it is." While some philosophers of art are critical of such definitions, they nonetheless tend to accept as "art" the contemporary works they subsume, no matter how outrageous or absurd.

To discuss art rationally in today's context, however, requires admitting the possibility that the answer to the ubiquitous question *But is it art?* may well be No. That question appears as the title of a recent book by Cynthia Freeland (a professor of philosophy at the University of Houston), for example.[7] Yet, as is so often the case when it is raised in a title, the question is never dealt with head-on in the text. Nevertheless, Freeland seems to imply that the answer is always Yes, for she discusses as "art" twentieth-century examples ranging from Andy Warhol's *Brillo Boxes* to the French "performance artist" Orlan's surgical manipulations of her own body and the scenarios with "counterfeit currency" enacted by another postmodernist, J. S. G. Boggs. Though Freeland is critical of some aspects of such work, her tacit assumption appears to be that all of it is art.

Re-Examining the History of the Avant Garde

In pursuing the question *But is it art?* it is instructive to retrace the history of the twentieth-century "avant garde," beginning with the development of abstract (i.e., "nonobjective") art in the early 1900s. The art historical record leaves no doubt that the pioneers of abstract painting—Kandinsky, Mondrian, and Malevich—abandoned mimesis because they were seeking escape from the material conditions of existence. While each in his own way earnestly strove to embody metaphysical and spiritual values in his work and to engage the emotions (as artists always have), the means they employed were wholly inadequate to the task. As their ample theoretical writings reveal, they based their work on unwittingly mistaken conceptions of the relationship between perception, cognition, and emotion.[8] All the same, they were well aware that art had always depended on mimesis for the perceptual embodiment of meaning, and they were therefore haunted by fears that, having rejected mimesis, their work would be perceived as merely "decorative"—as indeed it still is by many art lovers, even after a century of cultural habituation. It was owing largely to influential critics,

collectors, and curators that "abstract art" nonetheless soon gained legitimacy in the artworld.

A half century after the European pioneers' invention of non-objective painting, artists in America drastically shifted its focus and aims, attempting to employ it as a means of direct personal "expression." Yet they, too, had persistent doubts that their work would be understood. Like the pioneers of abstraction, leading Abstract Expressionists such as Mark Rothko feared their canvases would be perceived as mainly decorative. It comes as no surprise, therefore, to see a typical Rothko canvas reproduced and advertised for sale in the Fall 2002 home furnishings catalog from Crate & Barrel, with the caption: "Bright yet soothing, this appealing . . . abstract Rothko reproduction makes a contemporary color statement."

The postmodernist reaction that began with Pop art in the mid 1950s was, on the whole, a deliberate reaction to the dominance of Abstract Expressionism, and of all that it stood for in the artworld. Since the view of art that the abstract movement was based on was a largely false one, a reaction was surely in order. But the postmodernists went to another false extreme. True, they reintroduced imagery, on which the intelligibility of visual art depends, but it was an imagery deliberately devoid of values, either personal or social. Their work therefore controverted the very purpose of art. It was, in effect, anti-art. Influential early postmodernists such as Henry Flynt and Allan Kaprow frankly admitted that their work had virtually nothing in common with past *art*, as such. Nonetheless, the term was appropriated for their work. And their successors have shown no hesitation in calling themselves artists, although the means they employ—mechanical reproduction, and the appropriation of both readymade objects and images—are the antithesis of the "selective re-creation of reality" (to borrow Rand's apt phrase) characteristic of artistic mimesis.

While more recent postmodernists have ostensibly reintroduced value and meaning into their work, mainly in the guise of political and social critique, they continue to employ spurious forms such as "conceptual art" and "installations," which grew out of the anti-art impulses of the 1960s. A major tendency of those impulses was the deliberate blurring of the distinction between art and life. But if so-called art works can now be "indiscernible" (to use philosopher-critic Arthur

Danto's term) from the stream of everyday experience, then what becomes of the special significance that philosophers originally placed on art in relation to "sensuous cognition"? If there is nothing distinctive about art, why study it at all in this context?

The "cognitive turn in aesthetics" of recent decades is often attributed to the publication of the late Nelson Goodman's *Languages of Art* (1968)—which focused on the study of "representation and other symbol systems and processes." Goodman's emphasis on *symbol* systems (his book is subtitled *An Approach to a Theory of Symbols*), however, was itself a major step in the wrong direction, in my view, for it diverted attention from the mimetic nature of the major arts. That nature was not only recognized by Western thinkers from Aristotle and Plato to Baumgarten and Kant, but seems clearly implied in the thought of other cultures as well. The language of art is fundamentally *mimetic*, not symbolic, for it depends primarily on what the art historian Erwin Panofsky referred to as the "natural meanings" of representations—in contrast with the arbitrary, culture-specific meanings assigned to symbols.[9]

It must be stressed that (contrary to Plato's view) the mimetic arts never merely "held a mirror up to nature." As classics scholar Stephen Halliwell argues in his recent book, *The Aesthetics of Mimesis*, mimesis applies to a wide variety of artistic styles, ranging from realism to idealism.[10] Imagination, stylization, and selectivity have always played their part in the mimetic re-creation of reality—even in the most ostensibly "realistic" styles—just as the highly stylized art of ancient Egypt, tribal Africa, and the Cyclades are all mimetic, albeit in varying degree. In the Yoruba culture of Africa, for instance, mimesis is said to involve depicting "general principles of humanity, not exact likeness. . . . It is 'midpoint mimesis' between absolute abstraction and absolute likeness"—to quote art historian Robert Farris Thompson. As Thompson has noted, moreover, the distinction between art and reality is always maintained by the Yoruba people (in striking contrast with postmodernist tendencies in Western culture).[11]

Why Mimesis?

One must then ask why mimesis is the primary means by which art performs its cognitive and emotional function. In his *Origins of the*

Modern Mind, published in 1991 (as well as in his more recent book, *A Mind So Rare*), the Canadian neuropsychologist Merlin Donald has proposed a promising answer to this key question. He suggests that mimesis played a crucial role in human cognitive evolution, serving as the primary means of representing reality among the immediate ancestors of *Homo sapiens*, just prior to the emergence of language and symbolic thought. *Mimesis*, in Donald's view, refers to intentional means of representing reality that utilize vocal tone, facial expression, bodily movement, manual gestures, and other nonlinguistic means. As he insists, it is "fundamentally different" from both mimicry and imitation. Whereas mimicry attempts to render an exact duplicate of an event or phenomenon, and imitation also seeks to copy an original (albeit less literally so than mimicry), mimesis adds a new dimension: it "re-enact[s] and re-present[s] an event or relationship" in a nonliteral yet clearly intelligible way. Here, again, I am reminded of Rand's concept of the "selective re-creation of reality."

As Donald further emphasizes, mimetic representation remains "a central factor in human society" and is "at the very center of the arts." While it is logically prior to language, it shares certain essential characteristics with language, and its emergence in prehistory would have paved the way for the subsequent evolution of speech. Yet mimetic behavior, he stresses, can be clearly separated from the symbolic and semiotic devices of modern culture. Not only does it function in different contexts, it is still "far more efficient than language in diffusing certain kinds of knowledge . . . [and in] communicating emotions." Moreover, the capacity for

> mimetic representation remains [fundamental] . . . in the operation of the human brain. . . . When [it] is destroyed [through disease or injury], the patient is classified as demented, out of touch with reality. . . . But when language alone is lost, even completely lost, there is often considerable residual representational capacity.[12]

Commenting on the power of mimetic representation in his *Anthropologist on Mars*, neurologist Oliver Sacks writes of Stephen—an autistic boy whose capacity for abstract and symbolic thought and communication are severely impaired—that he comes fully to life through artistic expression, through his "genius for concrete or

mimetic representations, whether drawing a cathedral, a canyon, a flower, or enacting a scene, a drama, a song." Mimesis, in Sacks's view, is "itself a power of mind, a way of representing reality with one's body and senses, a uniquely human capacity no less important than symbol or language."[13]

If, as Donald suggests, this prelinguistic mode of representation and communication developed relatively early in the course of human evolution, it would have been closely linked to the evolving psychological and physical mechanisms for emotional response, which play a crucial role in both social interaction and the arts. That would help to explain the emotional immediacy of the mimetic arts. Mimesis is not the end of art, but it is the powerful means by which works of art convey their cognitive and emotional content. The avant-gardist tendencies of both modernism (most notably, abstract art) and postmodernism have flouted this basic truth, to the detriment of both art and cognition.

Modernism, Postmodernism, or Neither? A Fresh Look at "Fine Art"

In January 2005, trash collectors in Frankfurt, Germany, hauled away what appeared to be a heap of abandoned building materials they had found on a city street. When the head of sanitation later read in the newspaper about an exhibition of public sculpture in progress, he realized that the heap removed by his men, and subsequently incinerated, was intended to be a work of art. "I didn't recognize it as art," he said, as reported in the London *Guardian*. Thirty of the city's sanitation workers were subsequently sent to "modern art" classes to learn to avoid such mistakes in the future.[1]

In Allentown, Pennsylvania, a rundown building was slated for demolition as part of the city's redevelopment program. When the head of that program was asked what he planned to do with the art on the side of the building, he replied, in effect, What art? Although he had often walked by it, he had never noticed a work of art there. After being informed of its existence, he remarked: "It just looks like a metal grid. I thought it was some kind of condensation pipes." According to authorities consulted in the matter, however—individuals ranging from the director of the Smithsonian Institution's "Save

Arts Education Policy Review, May/June 2006, 31–38. This is a revised version of a talk given at the annual meeting of the National Art Education Association in Boston, Massachusetts, on March 4, 2005; it was originally published, without endnotes, in *Aristos,* August 2005.

Outdoor Sculpture!" program to a professor of sculpture at Temple University—the piece (an arrangement of thirty-five galvanized steel bars) is not only a work of art but an *important* one, by "one of the top public sculpture artists" of the time, as one expert put it.[2]

Numerous incidents of this kind have been reported in recent years. In more than one case, a work in a gallery of "contemporary art"—by a highly esteemed member of the artworld—was removed by the cleaning staff, who mistook it for trash.[3]

The question is, How have we reached the point in the civilized world where a purported work of art can't be distinguished from a pile of rubbish or a grid of condensation pipes? The answer to that question lies in the basic assumption of nearly everyone in today's artworld, from philosophers of art to critics, would-be artists, and teachers of art. In their view, art cannot be defined. Virtually anything is accepted as art if a reputed artist presents it as such. And many would-be artists eager to make a name for themselves on the "cutting edge" keep "pushing the envelope" of what is accepted, to borrow two of the clichés employed by critics nowadays. (The only contemporary artists categorically excluded from serious consideration in today's artworld are painters and sculptors working in a traditional style—unless, like John Currin for example, they employ it for the ironic or politically correct themes approved by postmodernist theorists and critics.[4])

Yet ordinary people such as the Frankfurt trash collectors and the city official in Allentown—indeed much of the general public—still adhere to a traditional view of art. Are they simply behind the times and in need of reeducation, as the unfortunate Frankfurt trash collectors were judged to be? Or might the traditional concept of art be worth preserving? And is it perhaps the presumed experts who should re-think their basic premises? Those are some of the questions I aim to shed light on here.

When I refer to a traditional view of art in the present context, I mean what was originally termed *fine art*. In its broad sense, that term included all the mimetic (or "imitative") arts—that is, music and dance, poetry, drama, and fiction, as well as painting and sculpture. In the narrower sense most relevant to the field of art education, however, the term has been used to refer to the purely visual arts of

painting and sculpture. When most ordinary people think of visual art, what generally comes to mind for them are traditional (that is, representational) works of painting and sculpture. They are more likely to think of Rembrandt, van Gogh, or Michelangelo, for example, than of Mondrian, Rothko, or Pollock. And they surely do not think of postmodernist inventions such as "installation art," "performance art," "video art," "conceptual art," and "earth art." But why, one may well ask, do so many people fail to regard these twentieth-century inventions as art?

Some observers might say that it is merely out of resistance to anything new. I disagree. Abstract work, for example, is scarcely new. It has been around for nearly a century. Yet many people, even fairly sophisticated art lovers, still have strong reservations about it, as was well documented more than a decade ago by David Halle's informative sociological study *Inside Culture: Art and Class in the American Home* (Chicago: University of Chicago Press, 1993). In my view, a more logical answer to why so many people do not consider the new inventions to be art is this: they sense that such things differ fundamentally from the sort of work that was originally called art—that is, traditional painting and sculpture. To call them art, as the artworld does, implies that they are similar.

Some members of the public are willing to grant that anti-traditional contemporary work is art, yet they find it meaningless, unintelligible, or simply worthless. The artworld responds that the problem lies not in the work itself but in the public's ignorance. In order to comprehend and appreciate such work, it is claimed, one must be well versed in art history and theory. Such an argument surely confirms the truth of Tom Wolfe's thesis in *The Painted Word*: works of art have been increasingly displaced in importance in recent decades by theoretical justifications—by the "incessant verbalizing" about art, to quote cultural historian Jacques Barzun.[5]

No theory merits acceptance, however, without a rational assessment of its underlying premises and practical results. Louis Torres and I offered such an assessment of both modernist and postmodernist theory and practice in Part II of *What Art Is: The Esthetic Theory of Ayn Rand* (Chicago: Open Court, 2000). What follows here is a summary of key points of that discussion, as well

as an outline of basic principles of the alternative view presented
in the book. Let me emphasize that while this alternative view is
based most directly on Ayn Rand's esthetic theory, it is compat-
ible with ideas about the essential nature of art held by thinkers
ranging from Aristotle to Zen philosophers to members of African
tribal cultures—as we documented throughout the book. It may
therefore be regarded as a universal theory of art, transcending
cultural diversity.

The three views that I outline here—modernist, postmodernist,
and Rand's alternative—differ radically in the answers they give to
four key questions regarding the nature of art:

1. What is the relationship between art and life?

2. What is the role of subject matter and content versus form
 and style in a work of visual art?

3. What part does emotion play in the creation of, and response
 to, a work of art?

4. What is the nature of the artist's role in the creative process?

The most important of these questions, closely connected to the
other three, is, *What is the relationship between art and life—between
works of art and reality itself?*

For most of human existence, in every known culture since the
dawn of mankind, a meaningful relationship between art and life
was clearly discernible. Since time immemorial, humans have created
images, whether in two- or three-dimensional form, representing the
animal kingdom, their fellow men or themselves, the world they
inhabit, and the divine realm conceived in their imagination. Such
painted and sculptured forms resembled, in some measure, things in
the real world, and were intelligible in terms of human knowledge of
such things.

Consider, for example, the prehistoric image of *Two Reindeer*
from the Font-de-Gaume cave in France.[6] A male deer is represented
as if nuzzling the head of a female depicted lying on her side, perhaps
wounded, ill, or about to give birth. What was the meaning or pur-

pose of such an image? It has often been suggested that prehistoric cave paintings were intended solely for magic efficacy, to ensure success in the hunt or that some other physical need would be met. The subtle rendering of tender feeling apparent here goes far beyond the perfunctory, schematic character of representations employed in modern-day cultures for purposes of ritual magic, however. Voodoo figures, for example, are typically crudely fashioned. Although we can never know for certain what purpose motivated the prehistoric man who painted the Font-de-Gaume image, we may reasonably infer from the qualities embodied in it that he felt some empathy for the fellow creatures on whom he depended for sustenance. In taking the considerable trouble to create this visual representation, he was probably satisfying another sort of need—not a physical but a purely psychological one—the need to objectify his thoughts and feelings in concrete form. As the writer Robert Payne suggested in *The World of Art*, it is likely that prehistoric artists filled the walls of their caves with the images of such animals "because their minds were filled with them."[7]

As indicated by the Images of Exemplary Works of Art accompanying my article "Rescuing Art from Visual Culture Studies," the long tradition of representational painting and sculpture has encompassed a wide range of styles and an infinite variety of subject matter, yet certain subjects have recurred from era to era and culture to culture—no doubt because they represent things that have always been of human interest. Such images provide a context in which to assess modernism's radical break with the past.[8]

The Modernist View

In the early years of the twentieth century, in a dramatic departure from millennia of art-making, modernists such as Kandinsky, Malevich, and Mondrian entirely abandoned representation, not only of living things but of recognizable objects in general. Even more remarkable than that salient fact of art history are the premises and intentions that moved them to do so.[9]

The relationship between art and life. The pioneers of abstract painting believed that works of art pertain to a realm completely detached

from, and superior to, life. Reacting against cultural materialism, these first abstract painters sought to reflect what they imagined to be a higher plane of reality, by creating work in which no recognizable objects at all were represented, only abstract forms. Through mere shapes, colors, and lines, they attempted to represent a realm of pure spirit, untainted by material reality. But they were profoundly mistaken—even deluded—in thinking that such a goal was attainable, much less desirable, given the nature of human perception and cognition. For one thing, it is impossible to guess the modernists' lofty intention just by looking at their work. We know it only from their extensive theoretical writing, and from that of like-minded critics. To the ordinary viewer, one of Mondrian's typical grid-like *Compositions*, for example, conveys no meaning, exalted or banal. It simply looks like an interesting pattern, and, as such, has inspired design motifs for fabrics and various decorative products, from floor covering to high-fashion clothing. Nonetheless, Mondrian insisted that only through the "annihilation" of objective reality could art express the higher consciousness toward which he believed humanity was evolving.[10]

Modernists who were not mystically inspired also severed the objective connection between art and life. The influential British critic Clive Bell, for instance, argued that art possesses "an intense and peculiar significance of its own . . . unrelated to the significance of life." In his view, "To appreciate a work of art we need bring with us nothing from life, no knowledge of its ideas and affairs, no familiarity with its emotions."[11]

At the same time, modernists held that the understanding and appreciation of art involves a special aesthetic faculty, or sensibility, that is not possessed by all people and that is quite distinct from our everyday faculties of perception. Influenced by occult philosophy, the first abstract painters actually believed that they possessed a more highly evolved form of consciousness—which was, they claimed, "beyond reason," and which conferred (in the view of Malevich and other Russian Cubo-Futurists) not merely clairvoyance but even the ability to see through solid objects. If you did not understand one of Malevich's Suprematist paintings, therefore, it was simply a sign that your consciousness had not yet evolved to this higher plane.[12]

Later in the century, the pre-eminent modernist critic Clement Greenberg ignored such metaphysical claims. But his approach was equally divorced from any meaningful connection to life experience. Explaining different responses to art as simply a matter of intuitive judgments by "people with good eyes" versus "[people with] bad eyes," he saw no relationship at all between aesthetic judgment and the exercise of one's visual faculty in real life. If you could not see why Jackson Pollock's drip paintings (such as *Cathedral* or *Number 1, 1948*, both of which were praised by Greenberg) should justify the superlatives the critic heaped upon the painter—including the claim that he was "one of the major painters of our time"—you could be sure that you would be counted among the "philistines," the ultimate term of cultural opprobrium employed by Greenberg and other modernists.[13] No doubt you would be similarly labeled if you failed to discern in what respect the series of abstract *Elegies to the Spanish Republic* by Pollock's fellow Abstract Expressionist Robert Motherwell constitutes a "majestic commemoration of human suffering" that is expressive of "the inexorable cycle of life and death" (to quote the Guggenheim Museum's website). Motherwell, by the way, painted some two hundred variations on that theme.[14]

Form / style versus subject matter / content. On the second theoretical question, regarding the relationship between form and style, on one hand, and subject matter or content, on the other, I have already noted that the modernists deliberately abandoned recognizable subject matter in favor of abstract forms. In Mondrian's emphatic terms, all subject matter "*must be banished* from art," because the representation of physical objects "is fatal to pure art."[15] Although neither he nor the other early abstract painters aimed to abandon meaning in their work, their occult premises led them sadly astray. By abandoning the representation of recognizable objects, they rendered their work incomprehensible to the poor viewer who had not yet evolved "beyond reason."

Later modernists, such as Clement Greenberg and his critical disciples, ignored the spiritual aims of the artists who had invented abstract painting, however, tending instead to discuss it in purely formalist terms. According to Greenberg, both subject matter and content had become "something to be avoided like a plague" in

this "advanced art," as he pretentiously dubbed it.[16] As a result, the artistic breakthroughs he acclaimed in abstract painting generally consisted of the emergence of various signature styles—from the drips of Jackson Pollock to the "zips" (or stripes) of another Abstract Expressionist, Barnett Newman.

The role of emotion. What about the modernist answer to the third key question of art theory, regarding the role of emotion in art? For modernists, emotion was of prime importance in art, but they viewed it as a direct, unmediated response, divorced from ideas and values related to life. Malevich, for example, wrote: "[A] blissful sense of liberating non-objectivity drew me forth into the 'desert' [of black squares on a white background], where nothing is real except feeling . . . and so feeling became the substance of my life."[17]

Similarly, a half century later, Robert Motherwell declared: "The emergence of abstract art is one sign that there are still men able to assert feeling in the world. Men who know how to respect and follow their inner feelings, no matter how irrational or absurd they may first appear. . . . Abstract art is an attempt to close the void that modern men feel."[18] Yet, without the benefit of such an explanation, no viewer could guess the feelings that Motherwell attempted to embody in one of his Spanish elegies, for example. And even with his explanation, it seems unlikely that anyone would actually experience such feelings.

The role of the artist. As for the modernist view of the artist's creative role, it was equally ineffable. The artist was seen as an inspired visionary, a genius whose intentions, however unfathomable to ordinary mortals, are nonetheless worthy of the struggle to comprehend them. Greenberg praised works such as Barnett Newman's *Vir Heroicus Sublimis* not only for their simplicity (they surely have that) but for their "transcendent" capacity—a claim that represented a lapse from Greenberg's customary formalist emphasis. Newman's pretentious Latin title for the painting means "heroic sublime man." Without benefit of the title, however, who would have any idea what this work is intended to mean? To the museum guard who spent much of his working life in the presence of it, in fact, Newman's painting looked like nothing more than "a blank wall with stripes."[19] Most ordinary people would agree. For such viewers, Michelangelo's

David or his *Moses* would be far more likely to qualify as a transcendent image suggesting heroic sublime man.

Postmodernist Reaction

Postmodernism in the arts began as an extreme reaction against modernism—in particular, against the dominance of Abstract Expressionism in the artworld. On virtually every point of theory and practice, therefore, postmodernists adopted a diametrically opposite approach. The primary impetus for the bizarre forms they invented was their wish to challenge the status of modernist work, not an earnest desire to create something of value in itself.

The relationship between art and life. On the key question of the relationship between art and life, as I observed earlier, modernists held art to be a supreme value in its own right, without objective reference to human life. Postmodernists therefore began by treating art as if it had no distinctive nature or value at all. In its most extreme form, this attitude was expressed in the explicit aim of blurring the very distinction between art and life.

The prominent postmodernist Robert Rauschenberg declared, for example, that painting "relates to both art and life" and that he tries to work "in the gap between the two."[20] What on earth does that mean? And should something purportedly in the *gap* between art and life (such as his "mixed media" piece, *Bed* (which is neither painting nor sculpture, consisting instead of an old quilt, sheet, and pillow affixed to a frame, with paint slathered over them), therefore be considered as something quite different from *art*?

Another major early postmodernist, Allan Kaprow, even wrote essays on the blurring of art and life.[21] Kaprow was the inventor of "Happenings"—kookily staged events involving spectators in a series of arbitrary and incoherent actions, which were the precursors for such postmodernist genres as "installation art" and "performance art." He advocated creating work "as open and fluid as . . . everyday experience." Tellingly, he admitted that he was "not so sure" whether such work was "art or something not quite art."[22] Of course, it was *not* art. Nonetheless, it was soon fully accepted as such by the arts

establishment, which now treats its successors on a par with traditional painting and sculpture.

Form/style versus subject matter/content. The postmodernists' blurring of the distinction between art and life has inevitably affected their attitude toward the relationship between subject matter and content, on one hand, and form and style, on the other. Recall that modernist theory and practice greatly inflated the significance of formal properties and style, at the expense of discernible subject matter. Not surprisingly, the postmodernist reaction was to dismiss formal properties and style as having no value at all. Occasionally, their work actually makes ironic reference to this idea. Rauschenberg's slathering of paint on *Bed*, for example, was an irreverent parody of much Abstract Expressionist painting.

Typically, however, postmodernist work is deliberately impersonal and mechanical in execution, removing all traces of the artist's hand or personal style. Postmodernists tend to appropriate existing images (photographs, advertisements, or previous art works) or use everyday objects, simply arranging them in assemblages or installations (as in Tracey Emin's *My Bed*[23]). Such work contains recognizable things, but the very banality of such things can make the viewer wonder just what the point is. Seeing one of Duane Hanson's hyperrealistic "sculptures," for example—figures cast directly from a live model, adorned with real clothing and props—does not significantly differ from looking at a real person when one catches sight of it at a distance in the sort of busy public space in which his work is often exhibited (such as an airport passenger terminal). Because Hanson did not transform the subject matter in any distinctive way through his handling of the material, the work does not suggest anything particular about his view of reality. It offers no insight. Unlike a true work of sculpture, it is not a representation of reality, filtered through his imagination and sensibility. It is so literal as to be, for all intents and purposes, tantamount to a mere *presentation.*

Consider another example, Joseph Kosuth's *One and Three Chairs*, which consists of a nondescript folding chair, a life-size photograph of such a chair, and an enlarged dictionary entry on the word *chair*. Not long ago, a retired art teacher lamented to me that she had no

idea what to make of this work of so-called conceptual art, which she had just seen on a visit to New York's Museum of Modern Art. What, she wondered, was such a work doing in an art museum? The *Oxford Dictionary of Art* (1988) defines *conceptual art* as "various forms of art in which the idea for a work is considered more important than the finished product, if any." But such an invention turns the very nature of *visual* art on its head, ruling out the artist's role in the meaningful shaping of visual form.

The role of emotion. What about the role of emotion in post-modernist work? In contrast with the modernists, who viewed art as a direct expression of emotion, postmodernists are typically detached from emotion and even reject it outright. Andy Warhol once explained that the reason why he didn't create paintings was because he did not "love roses or bottles or anything like that enough to want to sit down and paint them lovingly and patiently"—a revealing confession indeed. Equally revealing is what John Cage—the avant-garde "composer" who inspired many postmodernists in the visual arts—had to say on the subject: "Emotions do not interest me," he declared. "Emotions have long been known to be dangerous. You must free yourself of your likes and dislikes." The dysfunctional implications of such extreme emotional detachment, I should note, are analyzed by psychologist Louis Sass in his illuminating study *Madness and Modernism.*[24]

The artist's role. Since postmodernists seek to blur the very dis-tinction between art and life, thereby denying the value of works of art as such, it is not surprising that they minimize the artist's role in the creative process. Meaningful intention is downplayed or utterly belied. In its place, chance and accident are fully accepted as legiti-mate factors in the creative process. Cage, for example (notorious for his practice of composing "music" by rolling dice), actually stated: "[M]y purpose is to remove purpose." That attitude was echoed by Rauschenberg, his frequent collaborator. When a curator speculated about a purposeful intention in one of his canvases, Rauschenberg is said to have remarked: "You mean I had a direction? It's a damned good thing I didn't know that before I did the painting. When I know what I'm doing, I don't do it."[25]

The sketchbooks of another leading postmodernist, Jasper Johns, are full of such pointless notes as "Put a lot of paint & a wooden

ball or other object on a board. Push to the other end of the board. Use this in a painting." And "Take a canvas. / Put a mark on it. / Put another mark on it." Notwithstanding the mindlessness of such an approach to the creation of art, the head of the prestigious Wilden-stein art gallery in New York—a gallery famed for its handling of Old Master paintings—recently referred to Johns as today's "greatest living artist." Surely a sign of just how precipitously the artworld has declined from any meaningful standard![26]

Andy Warhol, the preeminent purveyor of "Pop art," further typifies the postmodernists' dismissive attitude toward the artist's creative role. Some theorists (most notably, the philosopher-critic Arthur Danto) have attempted to read serious philosophic or sociopolitical intent into banal pieces such as Warhol's *Brillo Boxes* or his *Green Coca Cola Bottles*, whereas others praise Pop art, in general, as "simple, direct, and immediately comprehensible." War-hol's own words, however, indicate that the emotional emptiness of his blandly mechanical and repetitive work—much of which was, in fact, mechanically produced by assistants in his studio (aptly dubbed "The Factory" by him)—was neither a quasi-philosophic reflection on the nature of art nor an ironic comment on, or cri-tique of, consumerism but merely a direct reflection of his own disturbed psychology. "Everything is nothing," he once wrote. "The reason I'm painting this way," he told an interviewer, "is that I want to be a machine."[27]

In recent decades, postmodernists have attempted to assume a more meaningful role for themselves as "artists," by referring to social and political issues in their work (this sociopolitical focus has endeared them to advocates of Visual Culture Studies in art education). Yet they continue to work in anti-art genres such as "installation" and "conceptual art"—which, as I indicated above, had been invented in the 1960s with the express intention of *subverting* art. They choose these genres not because they consider them to be the most effective means to convey whatever ideas they may have but because they lack the talent and skill to paint or sculpt. Damien Hirst, one of the postmodernist artworld's superstars, for example, confided in a televised interview that he would really like to be able to paint—that is, to "represent the three-dimensional world on a two-dimensional

surface"—but had "tried it and . . . couldn't do it." When faced with the void of a blank canvas, he further explained, "[he doesn't] know what the hell to do."[28] An entire generation of would-be artists like him have graduated from art schools here and abroad with no real art instruction, and they fill museums and galleries with their videos, photography, and installation pieces.

Typical of this vein of postmodernism is an installation by a Rhode Island high school student, who won a silver key for the piece in the state's Scholastic Art competition, provoking a furor when a local citizen objected to the work. The piece is a diorama-like "assemblage" that simply juxtaposes quotes from Adolf Hitler with statements by President George W. Bush, Nazi swastikas with American flags, and sand-colored toy soldiers (representing Americans) with olive-drab figures (representing Nazis). It is evident that the student did nothing to shape the material; and any other arrangement of appropriated images and texts might have just as easily conveyed his crude political intent—which was "to point out certain similarities between the U.S.-led war in Iraq and the German blitzkrieg," as he told the *Providence Journal*. As in all "conceptual art," no skill was involved—only a simple-minded (and historically ill-informed) idea. To the citizen who complained about it, it is merely a bit of offensive political propaganda. To the teachers who awarded it a silver key, however, it qualifies as art.[29]

A Sane Alternative

The view of art articulated by Ayn Rand and analyzed in detail in *What Art Is* presents a sane alternative to both modernism and postmodernism. What follows below is a cursory summary of that view.

The relationship between art and life. On the crucial question of the connection between art and life, Rand's theory holds (in sharp contrast with both modernism and postmodernism) that painting and sculpture, like the other major art forms, serve an important psychological function—one that is bound up with our life as conscious beings. Through carefully wrought images informed by the artist's knowledge, experience, and feelings, they embody values, and suggest a view of life, in perceptually and emotionally compelling form. In

so doing, they serve to make us more aware of what we think and how we feel about the world and our life in it, as well as about the alternative worlds we imagine. They bring those ideas and values more fully to consciousness. The means employed to accomplish this is the selective re-creation of visible reality.

Form/style versus subject matter/content. Since the purpose of each work of art is to embody meaning (through the eyes of the artist), form and style are important—not so much in themselves, but because they affect the work's ultimate significance. Meaning, or content, is the product of subject matter, form, and style. Although the subject matter of Picasso's *Weeping Woman* and Rubens's drawing *Young Woman (Study for the Head of St. Apollonia)*, for example, or Picasso's *First Steps* and Cecilia Beaux's *Ernesta (Child with Nurse)*,[30] is similar, the stylistic disparity of these images yields vastly different content and suggests much about the values and sensibility of each artist. And each work will no doubt elicit very different responses on the part of a viewer, according to his own values and sense of life.

The role of emotion. I have already hinted at the role of emotion in this alternative view of art. Contrary to *postmodernist* theory, emotion has always been deemed a crucial factor in both the creation of art and the response to it. But equally contrary to *modernist* notions, it cannot be expressed directly in abstract form. It must be suggested through objective forms. Centuries ago Chinese poets and sages wisely spoke, for example, of the need to "embed feelings in an object."[31]

Every genuine work of art represents something the artist cared enough about to have gone to the considerable trouble of representing it. Whether a direct interpretation of observed nature, or an imaginary re-creation of reality, every true work of art reflects what its maker regarded as worth remembering or reflecting upon. Each viewer responds emotionally to what is represented according to his own values and life view.

The artist's role. Andy Warhol's comment that he did not love anything enough "to want to sit down and paint [it] lovingly and patiently" reveals a profound truth about the nature of the artist's role, and the part that emotion plays in it. Ironically, it is Warhol's tacit admission that he was really not an artist, despite his fair talent

as an illustrator early in his career. Now contrast Warhol's remarks with those of Vincent van Gogh, from a letter to his brother Theo about a painting he was just finishing, *The Potato Eaters*. About this work, depicting a group of rough peasants seated at their simple dinner table in a dimly lit room, he wrote:

> I have tried to emphasize that those people, eating their potatoes in the lamplight, have dug the earth with those very hands they put in the dish, and so it speaks of *manual labor*, and how they have honestly earned their food. / I have wanted to give the impression of a way of life quite different from [ours]. [emphasis in original]

And later he added:

> Painting peasant life is a serious thing, and I should reproach myself if I did not try to make pictures which will rouse serious thoughts in those who think seriously about art and life.

He further explained that although the entire painting would be completed in a relatively short time and largely from memory, "it [had] taken a whole winter of painting studies of heads and hands."[32]

Van Gogh's letters are full of such passages describing the impression things he has seen have made on him and his struggle to master technique in order to give them satisfactory expression. And his comments are worlds apart from the inane notes I quoted earlier from Jasper Johns's sketchbooks: "Take a canvas. / Put a mark on it. / Put another mark on it." Jasper Johns is not an artist. Vincent van Gogh was. His account of the creative process is expressive of something universal in human nature, when that nature has not been thrown off course by psychopathology or by foolish theories of art. Centuries of Chinese commentators have similarly emphasized that the art of painting is the product not only of technique but of deep thought and feeling as well. In the words of one Chinese poet, Po Chü-i:

> Painting is not only skill, though likeness cannot be rendered without skill. . . . [T]o express an idea or to represent an object properly, it must be turned over and over again in the mind, until it unites with the soul.[33]

The greatest artists, therefore, have not only developed keen powers of observation, they have also possessed great sensitivity, and have so

honed their skill at visual representation that they are able to embody their values and suggest a sense of life in their work. It is because of their capacity to think and feel intensely, and to create images that give expression to their thoughts and feelings, that their work is of value to others. Their subject matter may at times appear quite ordinary, but their treatment of the subject never is. In works such as Vermeer's *View of Delft*, Thomas Eakins's painting of a *Baby at Play*, a kitchen still life by Chardin, or a twelfth-century Chinese painting of a kitten, even ordinary things gain a heightened reality that endows them with enhanced value and significance.[34]

Implications for Art Education

Since I originally prepared these remarks for an audience of art teachers, let me add a word about some implications that the alternative view of art I have outlined would have for the classroom, the studio, and the museum. To begin with, I would echo Jacques Barzun in urging teachers and others to use common sense (as well as urge young people to use theirs) on the question of what constitutes a work of art.[35] If artworld professionals such as the head of the Wildenstein gallery cannot recognize that what Jasper Johns and other postmodernists do has no relationship to what the Old Masters did, then they are the real philistines and there is no reason to follow their example. The time is long overdue to declare that the artworld emperors have no clothes. This admonition also requires reconsidering the status of abstract art. If by the term *fine art*—as contrasted with *decorative art*—we mean work that conveys meaning through visual form, abstract work (however serious or sincere the intention of some of its makers) belongs, at best, in the latter category and, at worst, in neither.

Moreover, I would advise against attempting to teach students or museum visitors how to comprehend work that is, by any objective standard, incomprehensible. In the art classroom, I would banish collage and installation projects, photography, and video, and would focus instead on instruction and practice in drawing and on the study and appreciation of high-quality works of painting and sculpture from all periods and cultures, including our own.

Finally, I would suggest that in teaching about a work of art, instructors begin by eliciting students' emotional response to the work before proceeding to the issue of meaning and how it is conveyed. For if all one does is intellectualize about art, one has not really gotten it, and might just as well be otherwise engaged.

The Undefining of Art and Its Consequences

What has become of Western visual art during the past hundred years? And what role have the ideas of influential critics played in the evident breakdown?

A quick answer to the first of those questions was offered by the inaugural exhibition of the Whitney Museum of American Art's costly new building in New York, which opened to great fanfare in 2015. The exhibition aimed to trace the course of American art from the beginning of the twentieth century to the present. It was entitled *America Is Hard to See*— after a line by the American poet Robert Frost. America was indeed "hard to see" in any significant sense from the "contemporary art" shown in one of the exhibition's galleries. It featured an abstract canvas, installations of vacuum cleaners and TV sets, and a bit of graffiti art.

In sharp contrast, the exhibition's upper floors displayed relatively traditional works that represented something instantly graspable and potentially moving about significant aspects of our nation's experience—from Grant Wood's celebration of our agricultural heartland to a powerfully graphic image by Paul Cadmus dealing with racism and a lovely woodcut evocation of the American landscape by the Japanese-American artist Chiura Obata. All of these works, I should note, were created before 1940.

On proceeding to later years, however, the unlucky visitor who was not an artworld insider was probably adrift on unknown waters.

Based on a talk given at the Wackers Academie, Amsterdam, July 10, 2018.

What sense could be made of Jackson Pollock's Abstract Expressionist drip painting *Number 27, 1950*, for example? And why, one might well wonder, should a piece as incoherent and carelessly made as Robert Rauschenberg's "combine" *Satellite* merit our attention at all—much less be considered *art*? Finally, what was one to make of Robert Gober's startling facsimile of a disembodied leg, seemingly projecting through the gallery wall, with a candle stuck into it? Unlike traditional art, such pieces defy ordinary understanding. They require explanation by elite artworld insiders—explanation readily supplied by the museum's ubiquitous audioguides and docents.

How did we get to the point where people of normal intelligence cannot begin to understand the art of our own time without expert help? Why is the art of the past more accessible to us than the "contemporary art" displayed with so much ado in our museums? Does the problem lie in the public's ignorance, as artworld insiders would have us believe? Or does it lie instead in the bizarre nature of the avant-garde work they promote?

In *Who Says That's Art?* I argue that the problem lies in the kinds of work favored by today's art experts. And the sad truth is that critics on both sides of the political divide have contributed equally to this breakdown, because neither side has a clear sense of what art is. Both sides are quite "clueless" regarding the basic nature and function of art. What is remarkable is how readily the cultural establishment has swallowed the critical nonsense they have purveyed.

Clement Greenberg and "Abstract Art"

Let me begin with the influential modernist critic Clement Greenberg—who died in 1994, at the age of 85. According to Hilton Kramer, the founding co-editor of the neoconservative journal *The New Criterion*, Greenberg was "the greatest art critic of his time." It was Greenberg, of course, who almost single-handedly propelled abstract art to the zenith of American culture in the mid twentieth century. In 1939, he had declared that in the truly "advanced art" of his day "subject matter or content [was] something to be avoided like a plague."[1] By "no other means" than abstraction, he insisted, was it possible to create art "of a high order."[2]

So if you share my doubts about the value of work such as Jackson Pollock's drip painting, it behooves us to re-assess Greenberg's reputation.

One of Greenberg's many admirers claims that his criticism was imbued with "art-historical wisdom."[3] On close examination, however, it is in fact riddled with misrepresentations and nonsense. Greenberg not only insisted that truly modern artists must abandon subject matter and concern themselves merely with formal values such as shape and color; he also claimed that the pioneers of abstract art—such as Mondrian and Kandinsky—shared that purely formalist outlook, being preoccupied only with "the invention and arrangement of spaces, surfaces, shapes, colors, etc."[4] That claim was patently false, however. As documented in *Who Says That's Art?*, and in more detail in *What Art Is,* Mondrian and his fellow pioneers of abstract painting expressly aimed to represent deeply spiritual values in their work.[5] Yet they constantly feared that in the absence of recognizable subject matter, viewers would fail to understand their paintings and would see them as merely "decorative," not meaningful. Judging from such latter-day appropriations of their work as a bathroom design emulating Mondrian's abstract work and a Kandinsky-inspired scarf, their fears were fully justified.

In that light, it is astonishing to consider the way a major Mondrian exhibition in The Hague in 2017 was promoted. His characteristic grid patterns were displayed throughout the city in a purely decorative manner that might well have dismayed him. Still worse, when a leading authority on his work was interviewed on American TV, no mention at all was made of Mondrian's well-documented *intent*[6]—which was to represent a realm of pure spirit, entirely detached from the material world.

Even more disturbing, when I recently questioned (in an online art education discussion forum) whether abstract work truly qualifies as "fine art,"[7] a professor of art education stubbornly insisted that it does, and even argued that it is "advanced" art. In addition, she cited Hitler's well-known hatred of "abstract art" as if it proved her point. Further, she mistakenly attempted to draw an analogy with the Swiss psychologist Jean Piaget's theory of cognitive development, in which abstract thinking is the most advanced stage.[8] There is a world of

difference between abstract *thinking* (based on observing similarities and differences between actual entities in reality) and so-called abstract (that is, nonobjective) *art*, which deliberately attempts to eliminate all reference to reality.

To return to Clement Greenberg, one of his outrageously false claims was that

> no hard-and-fast line separates [abstract art] from representational art. . . . The old masters stand or fall, their pictures succeed or fail, on the same ultimate basis as do those of Mondrian or any other abstract artist.[9]

For Greenberg, in short, representation was simply one of painting's "expendable conventions."[10] Really? What would Michelangelo or Rembrandt—or even Van Gogh or Seurat—have thought of such a claim?

Yet in the modernist dogma according to Greenberg, truly "advanced" painters had to abandon *imagery* and concern themselves instead with the essential "flatness" of paintings, since "flatness alone was unique and exclusive to pictorial art."[11] (That absurd dictum was fittingly derided by the recently deceased American journalist Tom Wolfe in his aptly titled book *The Painted Word*.) Note that, despite the absence of imagery, Greenberg nonetheless referred to abstract work as "pictorial art." Never mind that *pictures*, properly speaking, *depict* something. In other words, they are *images*.

In spite of such nonsense, Greenberg continues to serve as a beacon of artistic truth to many right-wing intellectuals. Nor are they troubled that Greenberg's seminal essay on abstract art, entitled "Avant-Garde and Kitsch," was first published in the leftist journal *Partisan Review*, or that he had served as art critic for another leftist periodical, *The Nation*. Nor do they note that he eventually dismissed that hugely influential essay as "full of simple-minded Bolshevism."[12]

What do American conservatives mainly admire Greenberg for? Terry Teachout—the first arts critic to win a $250,000 prize from the conservative Lynde and Harry Bradley Foundation—has praised Greenberg for his "prescient advocacy" of Jackson Pollock and other abstract painters, and for his "commitment to 'quality' as the essential criterion for the evaluation of art."[13] It's therefore worth quoting a bit

of Greenberg's writing on Pollock. In 1949, he published an influential review in *The Nation* of a show of Pollock abstracts, declaring as follows:

> [With this show] Pollock . . . continued his astounding progress. . . . One large picture, *Number One*, . . . quieted any doubts this reviewer may have felt . . . as to the justness of the superlatives with which he has praised Pollock's art in the past. I do not know of any other painting by an American that I could safely put next to this huge baroque scrawl. . . . Beneath the apparent monotony of its surface composition it reveals a sumptuous variety of design and incident, and as a whole it is as well contained in its canvas as anything by a Quattrocento master. . . . There were no other things [in the show] . . . that came off quite as conclusively . . . , but the general quality that emerged seemed more than enough to justify the claim that Pollock is one of the major painters of our time.[14]

Note that Greenberg utterly failed to justify his assertion regarding the "quality" of Pollock's work. Should we not expect to find more than "a huge baroque scrawl" and "a sumptuous variety of design and incident" in the work of someone judged to be "one of the major painters of our time"? Moreover, Greenberg's feeble analogy with work by "a Quattrocento master" reveals his distorted sense of art history. To put his comparison in perspective, consider an example by one of my favorite Quattrocento masters, Piero della Francesca—in whose honor my weblog is named *For Piero's Sake*. Surely the value of his work consists in more than merely being "well contained in its canvas."

Conservative critics who ignore Greenberg's critical and art-historical idiocies, while touting what Hilton Kramer called the "high purposes and moral grandeur" of abstract art,[15] appear to be equally unaware that the Greenbergian pied piper ultimately disowned his prior assertions about the superiority of abstract work. In a late-life interview, this critic who had probably done more than anyone else to inflate the value of abstract painting confided to an interviewer that he had in fact always preferred "figurative art"![16] Further, as if responding to Tom Wolfe, Greenberg declared that his emphasis on flatness had been merely descriptive—that he had never intended it to dictate the course of all future painting. Most significantly,

he avowed a "prejudice . . . towards realistic art," and he protested as "hearsay" the idea that he was "for abstract art."[17] Indeed, three decades earlier, in a lecture first published posthumously in 2004, he had stated:

> If it were up to me, the major painting of our time would go back to the Corot of the late 1830s and early 1840s—that is, to a species of photographic naturalism.[18]

Arthur Danto and Postmodernism

Greenberg's influential counterpart on the left was Arthur Danto. Unlike Greenberg, he was an academic—a longtime professor of philosophy at Columbia University. Like Greenberg, however, he too served as art critic for the leftist periodical *The Nation*—in his case, for a much longer period, from 1984 to 2009.

In 1964, Danto had had an epiphany. On visiting a New York art gallery displaying the first of Andy Warhol's *Brillo Box* pieces, Danto had asked himself a question that has occurred to many of us. Why should something virtually indiscernible from ordinary product cartons in a supermarket stockroom be considered *art*? Danto's groundbreaking answer was, Because it was in an art gallery.

Implicit in its being in an art gallery, of course, was the premise that it had been made by an *artist*—a key assumption that Danto didn't bother to examine, however. Instead, what he argued (in the essay in which he coined the term *Artworld*, as one word instead of the customary two) was this:

> What in the end makes the difference between a[n actual] Brillo box and a work of art [simulating] a Brillo Box is a certain theory of art. It is the theory that takes it up into the world of art. . . . [W]ithout the theory, one is unlikely to see it as art, and in order to see it as part of the Artworld, one must have mastered a good deal of artistic theory as well as a considerable amount of the history of recent New York painting. It could not have been art fifty years ago.[19]

The Artworld "theory" Danto referred to was, in fact, no theory at all, because by that time, philosophers had generally despaired of even defining art (much less offering a coherent theory), which they

regarded as an impossible task.[20] A major factor in that seeming impossibility was the very ascendancy of abstract art, which seemed to refute ancient ideas about the essentially mimetic nature of art. The "history of recent New York painting" that Danto referred to was most notably marked by Abstract Expressionism, of course. That was the Artworld juggernaut against which "Pop artists" like Warhol were notoriously reacting.

Danto's appreciation of Warhol did not end with his 1964 essay entitled "The Artworld." As late as 1994, he wrote a tribute for the inaugural catalogue of the Andy Warhol Museum in Pittsburgh, in which he declared that

> Warhol possessed a philosophical intelligence of an intoxicatingly high order. He could not touch anything without at the same time touching the very boundaries of thought, at the very least thought about art. . . .
>
> [It] was among Warhol's chief contributions to the history of art that he brought artistic practice to a level of philosophical self-consciousness never before attained. . . . [He] violated every condition thought necessary to something['s] being an artwork, but in so doing he disclosed the essence of art.[21]

A "philosophical intelligence of an intoxicatingly high order"? Was Danto joking? Had he never sampled one of Warhol's many zombie-like conversations taped or transcribed over the years? They exemplified what the American clinical psychologist Louis Sass has characterized as Warhol's "nearly catatonic demeanor." In a monumental study entitled *Madness and Modernism*, Sass astutely observes that Warhol seemed "infinitely empty—as if [his] inner self had been rendered contentless."[22] Such an affect is common among schizoid individuals but is surely not characteristic of genuine artists.

Astonishingly, Danto ignored the many signs of Warhol's profoundly disordered personality. Nor did he heed Warhol's confession that he worked in a mechanical way because he "want[ed] to be a machine."[23] Tellingly, he even called his studio *The Factory*. Such clues ought to have discouraged Danto from regarding Warhol as a deep thinker, much less hanging an entire philosophy of art upon him. Yet they didn't, and all too many of Danto's fellow philosophers—as well

as the vast majority of critics—swallowed whole his theory of "art" based on Warhol's inane *Brillo Boxes*.

That "institutional theory" now rules the artworld. But it sheds no light at all on the nature of art. All it says, in effect, is that art is anything put forth by a purported artist in the artworld. Who qualifies as an "artist"? Anyone regarded as such by the artworld. That is circular reasoning to make your head spin!

Significantly, Danto, like Greenberg, ultimately confessed to a decided preference for realist painting such as *The Tempest* by the Venetian Renaissance master Giorgione.[24]

So much for Danto and Greenberg, the most influential American critics of the twentieth century—whose influence has regrettably been felt worldwide.

A Far Wiser Critic—John Canaday

While Greenberg and Danto were equally clueless regarding the essential nature of art, a now largely forgotten critic possessed what they crucially lacked. He was John Canaday, who served as art critic for the *New York Times* in the heyday of Abstract Expressionism.

Canaday aptly held that works of art are "the tangible expression of the intangible values that men live by."[25] That phrase is worth remembering: "the tangible expression of the intangible values that men live by."

Canaday's observations on Abstract Expressionism offered a healthy antidote to Greenbergian formalist esthetics. Objecting to the fact that the "New York School" of painting was being touted at home and abroad as quintessentially "American" painting, Canaday wrote that it was merely

> New York painting, not American painting. And even as New York painting, there is plenty of question as to whether it gives any order or meaning, as art should do, to the energy it expresses, or whether it has created only explosive fragments.[26]

In Canaday's view, that expression of energy was "no more complete and authentic than are fireworks as an expression of what the Fourth of July means."

> Fireworks are wonderful to look at but . . . I would not want the sky filled with them all night, year after year. Similarly, I enjoy looking at abstract expressionist painting, but there is a limit to how much of it one can take, and I am tired of hearing that its skyrockets are cosmic manifestations.[27]

Further noting that "the things that make [New York] exciting also make it monotonous if they are not tied to something deeper than surface movement and color," Canaday concluded:

> A fine place for a visit, but I wouldn't want to live there without the sustenance of those inner human values that are universal—even to New Yorkers—yet are non-existent in the painting of the New York School.[28]

For such writing, Canaday was viciously attacked by Hilton Kramer, who succeeded him as chief art critic at the *Times*. Canaday, Kramer charged, was among the "notoriously philistine" and "benighted" critics who had resisted "modernist innovation and intellectual seriousness."[29] To the contrary, I would argue that it was Kramer who was benighted. Canaday had offered a far more thoughtful argument against Abstract Expressionism than either Greenberg or Kramer ever gave for their enthusiastic embrace of it.

Kramer was equally benighted on the subject of realist painting. His absurd claim that what such painting most lacked was a "persuasive theory"[30] has outlived him in infamy—thanks again to Tom Wolfe's *Painted Word*. Most lamentably, Kramer's bias utterly blinded him to the values in the work of the American painter Andrew Wyeth—which he dismissed as "sentimental mush"—"an escape into a never-never land of pastoral nostalgia."[31]

In sharp contrast, Canaday had argued that in work such as the portrait *Christina Olson*, Wyeth's "meticulous rendering of quiet subjects is deceptive, concealing as it does—or revealing as it does, for those who know how to see a picture—the most acute perceptions of personality, [and] of the life in inanimate objects as ordinary as a weathered door."[32]

Remarkably, that portrait was created at nearly the same time as Jackson Pollock's signature drip paintings. Unjustly, it is far less critically acclaimed. Its subject is the reclusive, severely disabled

Maine neighbor who inspired Wyeth's more famous work *Christina's World*. In the portrait, her frail, subtly misshapen figure is dwarfed by the weatherbeaten door she leans against. Yet this homely woman seems almost regal in her upright bearing and quiet repose—an effect enhanced by the bold triangle of shadow Wyeth projected behind her. It is an intensely realized portrait, capable of eliciting empathy and respect rather than pity—conveying a sense of this solitary woman's inner life and, by extension, that of any human being.

To dismiss Wyeth's work as "sentimentalizing," as Hilton Kramer did,[33] verges on total blindness. It is the ultimate indictment of a clueless critic.

Marcel Duchamp's Baleful Influence

No account of the false ideas that have led to the current break-down of visual art would be complete, of course, without mention of the Franco-American artworld charlatan Marcel Duchamp and the mindless critics and curators who take him seriously. His readymades were the ultimate nail in the coffin of Western art.

That truth became glaringly evident to me a few years ago, at a press preview for an exhibition of "sound art" at New York's Museum of Modern Art. The show included pieces ranging from "visualizations of . . . inaudible sound" to an "exploration of how sound ricochets within a gallery" and field recordings of sounds made by echo-locating bats. In remarks at the press preview, the museum's director, Glenn Lowry, observed that much of the work was "almost scientific" in effect, some of it "very scientific." Nonetheless, he was very "excited" to present *Soundings* because, he explained, it was the museum's "mission to follow artists wherever they're going." When I asked if he might ever consider that where purported artists were going was no longer art, he replied that we could no longer ask that question, because Duchamp had forever settled it. "If an artist does it, it's art," Lowry concluded.

That, in a nutshell, is the view held throughout the global art establishment. Never mind that Duchamp had clearly stated on more than one occasion that he had not intended the readymades as art, that they were for him merely a "distraction." And even if had intended them as art, why should anyone necessarily accept them

as such? Only because purported artworld experts have completely surrendered the power of independent analysis and judgment.

So, too, have journalists who cover the arts. In February 2018, the Art Institute of Chicago, one of America's premier museums, announced that it had purchased a Duchamp *Bottle Rack*, for a sum reported to be no less than twelve million dollars. It was not even Duchamp's first such readymade, which had long since been put out with the trash—clearly indicating how little he valued it. It was instead one he had much later purchased from a hardware store and signed for his artworld pal Robert Rauschenberg. Nonetheless, the *Chicago Tribune* touted Duchamp's mundane item of household hardware as a "modern masterpiece."[34] The last time I looked, a *masterpiece* was defined as "a work done with extraordinary skill; especially, a supreme intellectual or artistic achievement." Like the artworld they write about, most journalists today have little regard for the proper meaning of the terms they use.

To add insult to injury, the Art Institute not only spent an astronomical sum on this piece of ordinary hardware but was also threatening to raise its admission price—making it harder for ordinary people to see the genuine masterpieces in its collection, such as Seurat's captivating *Sunday Afternoon on the Island of Grande Jatte*.

Defining—vs. Undefining—Art

The question remains, *How should art be defined?* When John Canaday referred to it as "the tangible expression of the intangible values men live by," he of course did not mean *tangible* in the literal sense of being "discernible to the faculty of touch" but in the metaphorical sense of being "clearly perceptible."

A compelling answer to the crucial question of why we *need* such expressions was offered by novelist-philosopher Ayn Rand. In her view, humans create art because of a fundamental psychological need, both cognitive and emotional, to give concrete external form to our inmost ideas and feelings about life and the world around us. She understood that without external embodiment, such mental abstractions remain vaguely unreal, detached from our emotional life. Through the arts' sensory immediacy, we reconnect our thoughts

and feelings about things that matter to us, and are thus made more fully conscious of them.

Rand also understood that genuine artists create work that reflects what they regard as important, things they care about, existentially. And how they shape that work is influenced not only by their cultural context but by their unique individuality. Moreover, how each person responds emotionally to a given work depends on whether the values embodied in its imagery comport with his own deeply held values.

That, I would argue, is the theory that Hilton Kramer notoriously argued realist painting lacked. Moreover, unlike the theory behind modernism's rejection of representation, it is grounded in the way the human mind actually works. Based on that theory, I offered the following definition:

> *Visual art is imagery that skillfully represents real or imagined people, places, and things in a form expressive of the maker's temperament, deeply held values, and view of life.*

Might some other phrasing better express the essential criteria? Perhaps. Formulating a genus-differentia definition is challenging. Mine is but one attempt. The important thing to bear in mind is the sort of objects the definition refers to. As emphasized in both *What Art Is* and *Who Says That's Art?*, those objects are primarily the *fine arts* of painting, sculpture, and drawing, as distinguished from the *decorative arts*. The fine arts serve the purely psychological function of embodying meaning in an emotionally compelling way, while the decorative arts enhance objects that have a physical function. Though rejected by today's artworld, with lamentable consequences, such a distinction has a long history. It is explicit in both ancient and eighteenth-century European discussions of art. It is also clearly implicit in non-Western cultures, as Louis Torres and I have further pointed out in *What Art Is*.

Also rejected by today's artworld—with equally lamentable consequences—is the idea that skill is essential to the visual arts. According to the absurd notion of "conceptual art" now pervasive in the art establishment, a would-be artist's *idea* is considered more important than the finished product, if there is one. It is precisely in

the creation of a finished product that skill is involved, of course. And skill is a defining attribute of *every* kind of *art*, broadly speaking—from the art of cooking to the art of warfare.

Among the most dismaying consequences of the modernist and postmodernist undefining of art is its degrading influence on art education—not only on the academic level but in K–12 art teaching as well. I've already noted, for example, that a professor of art education—whose job is to train future teachers—maintains that abstract art is "advanced." Tell that to the countless artworld outsiders who, with good reason, find such work objectively meaningless.

Let me cite just two striking examples of how the undefining of art has influenced K–12 art teachers. In an online discussion in 2018, one earnest teacher posted a photograph of a quilt she had made, as evidence that she manages to pursue her own artistic creativity in spite of a full-time teaching job.[35] While it was surely an attractive, carefully crafted bit of *decorative art*, the teacher intended it as much more. As she explained, it had been inspired by the recent horrific school shooting in Parkland, Florida, and was meant to document all the school shootings in the U.S. since 1998—the white squares marking the year, the black representing the shooters, the red the deaths, and the yellow the injuries. The photo of her quilt elicited enthusiastic praise from several members of the discussion group. In a different vein, I commented that while it was colorful and well-crafted, no one could guess, without its maker telling us, that it was about school shootings. As I further explained, "It is a work of *decorative art* aspiring to the 'conceptual' content of *fine art*—a telling example of the unfortunate blurring of the functional distinction between the two categories." Not one teacher voiced agreement with me. Instead, I was censured by the aforementioned professor of art education for hurting the quilt-maker's feelings.

On a different art education discussion thread—devoted to the question "Who defines what is art and what we teach?"—another earnest young teacher noted that in addition to showing her students modern work such as Goya's *Third of May* and Picasso's *Guernica*, she also presents "more conceptual, contemporary work such as Doris Salcedo's *1,550 Chairs Stacked Between Two City Buildings.*" When I expressed doubt that students could guess its intended meaning from

the piece itself (a common failing of "conceptual art")—in this case "the history of migration and displacement in Istanbul"—the teacher assured me that her students got it, without any background information. Moreover, she asserted that they were more moved by it than by the other works she had shown. I remain skeptical. In any case, there is surely no skill in such an installation, and therefore no *art*, properly speaking. Nonetheless, the teacher reported, quite remarkably, that she used this work to illustrate the principles of design in her Introduction to Design class! I have yet to see how a chaotic pile of chairs could effectively illustrate the concept of *design*—that is, "the purposeful or inventive arrangement of parts or details"—in any but the loosest sense. But such is the anti-logic that now governs the artworld and its offshoots in the classroom.

Thanks to the undefining of art, postmodernist pseudo art such as these "conceptual" pieces—and the confused thinking behind them—have an absolute stranglehold on the global artworld. What is needed to end its grip is a revolution in thinking, beginning with a reasoned definition of art that is grounded in a fact-based analysis of art history, as well as in a grasp of the fundamental principles of cognition. I have offered such a definition.

The Art of Critical Spinning

The Art of Looking (Basic Books, 2018) by art critic Lance Esplund—a frequent contributor to the *Wall Street Journal*, among other prestigious publications—is yet another of countless attempts to reconcile the public to the bizarre inventions of the avant-garde.[1] A more fitting title would be "The Art of Critical Spinning."

Subtitled *How to Read Modern and Contemporary Art*, the book begins: "The landscape of art has changed dramatically during the past one hundred years." Indeed it has. As Esplund then recounts, we've seen things ranging from Kazimir Malevich's *Black Square* and Marcel Duchamp's urinal dubbed *Fountain* to Jackson Pollock's "drip" paintings, Andy Warhol's *Campbell's Soup Cans*, Piero Manzoni's *Artist's Shit*, and Chris Burden's performance piece *Shoot*. "Is it any wonder," he asks, "that the art-viewing public is bewildered, even intimidated?" How about "disgusted—even totally alienated," I would ask.

Yet Esplund sees nothing wrong with such inventions. He treats them all as if they were continuous with traditional painting and sculpture of the past. His aim is to make contemporary art "more approachable, by illuminating the similarities between recent and past art." Like other defenders of the avant-garde, however, he thereby ignores or discounts the explicitly disjunctive intentions of the most radical of its inventors—from the abstract pioneers to the early postmodernists—who knew very well that they were breaking with the past, not continuing it. More on that below.

For Piero's Sake, June 4, 2019.

Esplund defines *contemporary art* as "any art being created by living or recently deceased artists— . . . whatever the mode and materials and subjects." Yet like most other critics he says nothing about traditional contemporary work such as that in "Contemporary Art Worth Knowing" (above, pages 97–100). Only two of the sixteen works illustrated in his book—Edouard Manet's *Déjeuner sur l'herbe* and *The Cat with a Mirror I* by Balthus—are representational paintings. And both are aggressively "modern" in their markedly transgressive content.

Despite the chaotic diversity of works he accepts as art, Esplund nonetheless aims to demonstrate what he sees as the "continuum of art's language." It leads him to draw some very dubious connections.

What Is the Language of Art?

For millennia prior to the invention of "abstract (nonobjective) art," the universal language of art consisted of *imagery*. Contrary to a widely held view in response to the advent of nonobjective work, the "elements of art" discussed by Esplund—line, color, shape, texture, etc.—do not constitute the equivalent of a "language." Properly speaking, they are analogous merely to the letters or syllables of a language. It is not through such elements in themselves but through the *images* they constitute—images representing recognizable objects, albeit often in a highly stylized rather than realistic manner—that art most powerfully conveys its meaning. And it is through our experience of objects in the real world that we understand it. In the absence of imagery, art is merely "decorative."[2]

Moreover, unlike spoken or written language, the visual language of art—that is, *imagery*—is not an arbitrary system of symbols but a natural byproduct of how we grasp reality. The abstract pioneers attempted to invent a *new* visual language without any reference to objects in the real world. But they failed, as they themselves in effect admitted.[3] As they feared, their paintings were unintelligible to the public, who perceived them as merely "decorative," and could not discern the deep metaphysical meaning they were meant to convey.[4]

In his effort to accommodate every invention of the avant-garde, Esplund ignores such facts. Instead, he claims that the language of art "continually evolves and reinvents itself" and that this "complex lan-

guage . . . often has nothing to do with the appearance of the world outside of art." Moreover, he perversely insists that "the elements and language of art remain basically unchanged" in objects as diametrically different as Piet Mondrian's abstract painting *Composition with Blue* and Damien Hirst's postmodernist piece consisting of a real shark in a tank of formaldehyde.

Astonishingly, Esplund refers to the latter—as well as to the Great Pyramid of Giza—as a work of "sculpture"! Were his editors at Basic Books (a widely respected publisher) asleep at the helm? Was no one troubled by so promiscuous a use of that key term?

Falling into the Duchamp Trap

What, we should ask, requires us to regard a pickled shark and other postmodernist oddities as *art*, in Esplund's view? Marcel Duchamp's *readymades*, of course. And exactly what is a readymade? Duchamp is often quoted as having defined it as "an ordinary object elevated to the dignity of a work of art by the mere choice of an artist."[5] The only source for that quote (in French) is the *Dictionnaire abrégé du Surréalisme* by André Breton and Paul Éluard, however, and the attribution to Duchamp has been questioned.[6] In other, more reliable sources, Duchamp unequivocally declared that he never intended the readymades as art; they were just a "distraction" for him.[7]

Nonetheless, Esplund offers the standard account of Duchamp's *Fountain* as his "most famous and influential" work—although Duchamp's two chief biographers treat it as little more than a practical joke. To his credit, Esplund correctly notes that the readymades were "not fully embraced until after the mid-twentieth century." Yet he doesn't pause to consider why.[8] He merely asserts that, after Duchamp, "anything—anything whatsoever, as long as it came from an artist—could be designated as art." As he later reiterates: "art is whatever an artist says it is."

Never mind that Duchamp didn't intend the readymades as art. Even if he had, why are we obliged to accede to his or anyone else's claim that they are art? Isn't an *artist* properly defined as someone who creates *art*? And doesn't that definition also imply that works

of art differ from ordinary objects? Why should we grant purported artists infallibility on this crucial cultural question?

Such questions go unasked by Esplund. And as he observes early in his book, the "anti-aesthetic" assumptions of postmodernism—based on the shaky foundation of Duchamp's readymades—have become the artworld's "reigning ideology."

A Fundamental Disconnect

Esplund often says the right things about art in general, making points that I would tend to agree with. For example, he believes that the best artists "have something to say, and the creative means to say it well." He also holds that the purpose of art is to "heighten . . . experience," for viewers as well as for the artist. "The more deeply one engages with art," he further observes, "the more deeply one engages with life and with what it means to be human." Moreover, he notes that artists expect each viewer to engage with a work in relation to his own life experience, to personal memories and desires—I would say "values"—that the work awakens. In addition, he emphasizes (much as I have done in *Who Says That's Art?*) that the experience of art can be enhanced by viewing and discussing it with other people. His ultimate goal is "to help you learn to have faith in your own eyes and heart and gut, and to feel confident reading [I would say *experiencing*] works of art on your own."

So far so good. The problem arises when one attempts to reconcile such principles with the anti-traditional works Esplund focuses on. For example, he rhapsodizes for nearly four pages on Mondrian's "extremely spare" *Composition with Blue*—expatiating on the "pushing and pulling" (ideas he borrows from the abstract painter Hans Hofmann and returns to throughout the book) and "tensions" of its minimalist forms and lines. Such a formalist analysis may interest him as a former painter, but how many viewers would have their engagement with life heightened by Mondrian's abstract design? More remarkably, Esplund says nothing about what Mondrian was actually trying "to say" in such work—which was inspired by his desire, grounded in dubious tenets of Theosophy, to escape from the material world into a realm of pure spirit. How many viewers would guess that from the work itself?

Furthermore, what does Hirst's pickled shark (which Esplund has the temerity to compare to "an Assyrian sculpture of a deity-king") tell us about "what it means to be human"?

When Esplund discusses traditional art, he can offer illuminating insights, as in a passage about metaphor in art, likening the figure of *Eve* by the sculptor Gislebertus (in the wondrous Romanesque relief from the twelfth-century cathedral of Autun) to a serpent. The two identities, he aptly observes, "are bridged, fused, and a new being is born—neither Eve nor serpent, but somehow a joining of the two, as she sinuously undulates, as if swimming horizontally across the rectangle—as if passing before us like a dream."

But the value of such insights is undercut when Esplund attempts to apply them to modernist and postmodernist work. If, as he claims, Alberto Giacometti's abstract sculpture *Reclining Woman Who Dreams* (1929) "explored . . . metaphoric territory" similar to that of Gislebertus's *Eve*, for example, it is not at all evident in the finished work, even with the aid of the title.

That is but one example of Esplund's failure to recognize how a normal person not besotted by artworld sophistry is likely to respond to radically unconventional contemporary work. A more troubling instance is his extended discussion of *The Cat with a Mirror I* by the Polish-French painter Balthus. Though he devotes nearly ten pages to that work, he fails to adequately deal with the feature that is likely to be most salient to an ordinary viewer: her pose with legs spread far apart placing her naked pubic area nearly at the center of the picture. Apart from his rather tame allusion to the fact that "she appears to be opening herself to us," Esplund ignores that most viewers trusting their gut (as he urges us to do) would probably—and quite reasonably—be repelled by the image as redolent of child pornography.

The publisher of Basic Books touts this as a "wise and wonderful" book.[9] I beg to differ.

Why Discarding the Concept of "Fine Art" Has Been a Grave Error

Since its publication in 1951–1952, Paul Oskar Kristeller's essay "The Modern System of the Arts" has assumed canonical status in thought about art. It purported to show that the concept of *fine art* (Fr. *beaux arts*)—colloquially, "Art with a capital A"—originated in eighteenth-century Europe. Only then and there, Kristeller argued, did the group he termed the "irreducible nucleus of the modern system of the arts"—that is, painting, sculpture, architecture, music, and poetry—solidify as an arena of human undertaking "clearly separated . . . from the crafts, the sciences, and other human activities."[1] With few exceptions, subsequent scholars and others concerned with the arts—particularly those inclined toward postmodernist critiques of Western culture—have accepted Kristeller's account whole cloth.[2] Taking it as having demonstrated that the modern concept of art was an arbitrary

Aristos, April 2017. An earlier version of this paper was rejected by the *British Journal of Aesthetics* (*BJA*), albeit with some favorable comments. It was then revised and submitted to the *Journal of Aesthetics and Art Criticism* (*JAAC*) for inclusion in a special 75th anniversary issue entitled *Where do we come from? What are we? Where are we going?*—a theme for which it was particularly apt. The *JAAC* (published by the American Society for Aesthetics) also rejected it despite some favorable observations by its referees. Since the paper challenges reigning assumptions of both the artworld and most academic philosophers of art, Louis Torres and I published it in *Aristos* (along with my responses to both journals' objections, in the same issue). The only changes made from the *JAAC* version are in the manner of citation.

invention of eighteenth-century European culture with little or no relevance to other times and places, they have used it to deconstruct the institution of art in modern culture. The net effect of the resulting avalanche of commentary has been to dramatically discredit a once-useful category, and to question related ideas such as that of creative "genius," also said to be an eighteenth-century invention.

The study that has most fully developed that line of argument is Larry Shiner's *The Invention of Art* (2001), explicitly inspired by Kristeller's "showing that the category of fine art did not exist before the eighteenth century."[3] Reviewing it for the *Journal of Aesthetics and Art Criticism*, Mitch Avila began by declaring that Shiner "has cleared the path toward more productive ways of conceptualizing the tasks of aesthetics," and ended by celebrating his driving "one more nail in the coffin for those theories of art that would pretend to tell us all what is and is not art."[4]

In this paper I argue quite the opposite. I suggest that by ignoring fundamental errors and oversights in Kristeller's essay, Shiner and other philosophers have been engaged in building an intellectual house of cards. In the process, they have abandoned what was originally the central task of aesthetics as a philosophic discipline: that is, explicating the nature and function of the major arts. The result has been a de facto legitimizing of today's unmoored artworld—"the fractured world of modern and postmodern Western and global art and anti-art," to quote David Clowney.[5] While ostensibly aiming to create a more democratic culture liberated from the artist as "genius," such scholars have in effect given license to every would-be artist to create anything at all in the name of art—increasingly alienating the general public from what was formerly a rich sphere of cultural expression.

Whereas "artists" originally were, by definition, people who create art, "art" is now defined as anything made by a purported artist. The "institutional theory" codifying that premise is fully operative in the global art establishment. As Shiner himself observed in the opening sentence of his book, "Today you can call virtually anything 'art' and get away with it." Anti-traditional forms such as "installation" and "performance," and "transgressive" works of painting and sculpture are regarded as the only contemporary art that counts, while

talented artists pursuing a more traditional approach to art-making are ignored.

In the following argument, I first consider key points overlooked or misconstrued by Kristeller and subsequent scholars. I then show how correcting those points might help to advance a theory of "fine art" consistent with human needs and capacities. I further argue that such a theory is, as Clowney has urged, "cross-culturally and trans-historically applicable." Moreover, it fundamentally challenges the now-prevailing view that art is boundlessly open-ended.

Mistaken Inclusion of Architecture among the "Fine Arts"

Kristeller's main project was to define the "modern system" of classifying the arts and trace its genesis. His pivotal mistake was his unquestioning acceptance of fine art's "irreducible nucleus" as "painting, sculpture, *architecture*, music, and poetry." In that con-nection, he correctly cites the influence exerted by Denis Diderot's great *Encyclopédie* "and especially its famous introduction" by Jean le Rond d'Alembert—which "codified the system of the fine arts . . . and through its prestige and authority gave it the widest possible currency all over Europe."[6]

Yet Kristeller had previously noted (p. 199) that the "decisive step" toward classifying the fine arts had been taken by the Abbé Charles Batteux in his "famous and influential treatise, *Les Beaux-Arts réduits à un même principe* (1746)." And he then claimed, misleadingly, that "Diderot and the other authors of the *Encyclopédie* . . . followed Batteux's system." That claim is all the more surprising as it directly follows a largely accurate account of Batteux's classification scheme. As summarized by Kristeller, Batteux's "clear division of the arts"

> separates the fine arts which have pleasure for their end from the mechanical arts, and lists the fine arts as follows: music, poetry, painting, sculpture and the dance. He adds a third group which combines pleasure and usefulness and puts eloquence and archi-tecture in this category.

Two pages later, Kristeller correctly observes that while depending on Batteux "in certain phrases and in the principle of imitation,"

D'Alembert—"against Batteux and the classical tradition"—includes architecture among the imitative arts, "thus removing the last irregularity which had separated Batteux's system from the modern scheme of the fine arts."

By implication throughout, Kristeller accepts the "modern scheme" bequeathed by D'Alembert, never questioning its validity. Astonishingly, moreover, he fails to examine why D'Alembert took the unprecedented step of including architecture among the "imitative arts," much less why he abandoned Batteux's eminently logical classification scheme. Even more remarkably, subsequent scholars have glossed over the fundamental contradictions in D'Alembert's system.

To begin with, one of the distinguishing characteristics of the "fine" or "imitative" arts had always been that they serve only to give pleasure (a purely psychological function)—in contrast with the utilitarian "mechanical arts," which serve man's physical needs. D'Alembert completely ignored architecture's practical function, however. While that basic contradiction is often remarked on by scholars, it has rarely led them to question the treatment of architecture as "(fine) art." An introductory esthetics text by philosopher Gordon Graham, for example, notes that the "undisputed [physical] usefulness of architecture" raises the question of "whether it is properly called an art at all"—yet he proceeds to discuss it as "art."[7]

So, too, the *Oxford Dictionary of Art* (3rd ed., 2004) uncritically observes that the term *fine arts*, which "came into use in the 18th century to describe the . . . non-utilitarian arts," is usually taken to include architecture "even though [it] is obviously a 'useful' art." The second edition of the *Dictionary* (1997) had even cited Batteux's tripartite classification—with architecture included among the arts that "combined beauty [*sic*] and utility."[8] Why was Batteux's sensible classification scheme superseded by one so glaringly illogical? According to the *Dictionary's* cryptically inadequate explanation: "Soon after, in Diderot's *Encyclopédie*, the philosopher D'Alembert (1717–1783) listed the fine arts as painting, sculpture, architecture, poetry, and music. This list established itself."

D'Alembert's treatment of architecture as an "imitative art" was equally unprecedented, defying common sense as well as tradition. Fundamental similarities between the imitative (mimetic) arts of

poetry, painting, sculpture, music, and dance had long been observed and analyzed by philosophers, poets, and visual artists. But architecture had been nearly universally omitted from this group.[9] Moreover, the flimsy justification D'Alembert offered for including it so attenuated the concept of imitation as to render it largely meaningless.

D'Alembert began by acknowledging that the imitation of nature is "less striking and more restricted [in Architecture] than in Painting or Sculpture," since the latter "express all the parts of [Nature] . . . without restriction" (a proposition that incidentally exaggerates the mimetic range of sculpture). He then argued that architecture "is confined to imitating the *symmetrical arrangement* that Nature observes . . . in each individual thing."[10] Thus his conception reduces to the abstract, impersonal property of symmetry the mimetic aspect that is so powerfully expressive of vital meaning in the other arts. Further, as noted above, he ignored architecture's practical function—in contrast with the nonutilitarian nature of the imitative arts—and focused instead on their shared attribute of imaginative invention. Tellingly, when D'Alembert compared the various art forms, however, he omitted architecture—as do other theorists who nominally include architecture among the fine arts—no doubt for the simple reason that it is fundamentally incommensurable with them.[11]

Nonetheless, D'Alembert's classification of the fine arts took hold. Architecture is generally included alongside painting and sculpture in art history texts, and is frequently cited in theories of art. Contrary to D'Alembert, however, such accounts tend to emphasize architecture's abstract nature, comparing it to what is characterized (misleadingly) as the abstract character of music and (with more justification) to abstract sculpture.[12] They thus ignore D'Alembert's claim that architecture is an imitative art—although that claim constituted one of his two main criteria for classifying it as a fine art, the other being imaginative invention.

A notable exception to such flawed reasoning can be found in the work of art historian Moshe Barasch (1920–2004). Pointedly omitting architecture from his insightful survey *Theories of Art*, he chose instead to focus on the "image-producing arts, that is, primarily painting and sculpture." As he argued, those arts have "a strong common basis" in their representation of nature through imagery,

whereas the problems architecture deals with "constitute a realm of thought not easily merged with those of painting and sculpture."[13]

In sum, it was by historical prestige, not by superior argument, that D'Alembert's classification, not Batteux's more logical one, became the basis for Kristeller's "irreducible nucleus of the modern system of the arts." As acknowledged by Kristeller and others, that system owed its ascendancy to the intellectual clout of the *Encyclopédie*. Ironically, however, Diderot's entry on "Art" for that monumental project did not discuss the "fine" arts at all. It dealt instead with the "liberal"— and, more especially, the "mechanical"—arts. Clear indication that the *Encyclopédie*'s focus was on scientific, mathematical, and practical pursuits, not on the humanities and fine arts. In contrast, as James O. Young shows in his new translation and Introduction to Batteux's treatise, that work is informed by considerable scholarship and reflection on the arts.[14]

Like Kristeller, other eminent scholars have tended to blur the fundamental differences between Batteux's classification scheme and D'Alembert's muddled revision of it. Wladyslaw Tatarkiewicz, for example, mistakenly claims that "Batteux included architecture . . . among the imitative arts."[15] So, too, the recent debate regarding Kristeller's "modern system" tends to ignore D'Alembert's key influence on that system.

Surprisingly, even Young succumbs to that error. He argues that the "ancients had a category essentially indistinguishable from that adopted by Batteux *and subsequent thinkers*" yet notes that "neither Plato nor Aristotle states that architecture counts as an art." Nonetheless, he refers to Kristeller's "modern system"—which includes architecture in its "irreducible nucleus," and downplays the ancients' central idea of the arts' mimetic nature—as if it were the same as Batteux's.[16]

In critiquing Kristeller's "modern system," James I. Porter also seems to minimize D'Alembert's role. He begins by citing Batteux as his "chief exhibit" and "best single witness" and only much later points out that Kristeller's "nucleus of five fine arts . . . differs markedly from Batteux's." Although a footnote cites Kristeller on D'Alembert's inclusion of architecture, Porter surprisingly muses "one has to wonder where and how Kristeller arrives at his nucleus"—as if ignorant

of its source in D'Alembert. Yet he later notes that "D'Alembert added to Batteux's list not only architecture, but also *engraving*."[17] That second addition is far less consequential than the inclusion of architecture, however, since engraving is essentially akin to painting as a mode of two-dimensional representation.

Minimizing the Relevance of Antiquity's "Imitative (Mimetic) Arts"

On the relationship between the "fine" and "imitative" arts, Kristeller observes (p. 171):

> If we want to find in classical philosophy a link between poetry, music and the fine arts, it is provided primarily by the concept of imitation (mimesis). . . . Plato and Aristotle . . . clearly . . . considered poetry, music, the dance, painting, and sculpture as different forms of imitation.

Yet Kristeller gives short shrift to the ancient concept of "mimetic art," in part because it "excludes architecture" (171–72)! He also faults the ancient writers and thinkers for their inability or unwillingness "to detach the aesthetic quality of . . . works of art from their intellectual, moral, religious and practical function or content," as well as for their failure "to use . . . aesthetic qualit[ies] as a standard for grouping the fine arts together or for making them the subject of a comprehensive philosophical interpretation" (174). As I will argue, that alleged failure (as well as the omission of architecture) should be seen as a virtue.

Subsequently observing that "some [sixteenth-century] authors also notice and stress the analogies between poetry, painting, sculpture and music as forms of imitation" (180), Kristeller nonetheless argues that "hardly anyone among them is trying to establish the 'imitative arts' as a separate class." In sharp contrast, Batteux makes clear, in the Preface to his treatise, that his system of the "fine arts" is deeply indebted to the ancient category of the "imitative arts."[18] And Kristeller acknowledges (200) that "the 'imitative' arts were the only authentic ancient precedent for the 'fine arts.'"

At several points, Kristeller indicates that imitation is insufficient as a defining criterion. Even in antiquity, he claims (albeit mislead-

ingly, as indicated below), it was "anything but a laudatory category, at least for Plato" (172). Later theorists (such as Johann Adolf Schlegel and Moses Mendelssohn), he further observes, argued that a better principle should be found (213, 217). Significantly, Peter Kivy correctly maintains that even for Batteux imitation was merely "the first step in an Aristotelian genus/difference definition"—his genus being "representation" through imitation. Ignoring that principle, Kivy had previously referred to architecture as a "totally-in-the-ballpark" member of the fine arts, however.[19]

The scholar who has probably shed the greatest light on thought about the "imitative arts" in antiquity and their relevance in the present day is Stephen Halliwell. At the outset of his magisterial study *The Aesthetics of Mimesis*, he maintains that mimesis "gave antiquity something much closer to a unified conception of 'art' (more specifically, of the mimetic or representational arts as a class) than Kristeller was prepared to admit."[20] Commenting on that in a response to Porter, Shiner admits that he "found Halliwell's analysis of Plato and Aristotle . . . sufficiently persuasive to think that 'mimetic arts' was 'closer' to a unified concept of art than either Kristeller or I portrayed it."[21]

To begin with, Halliwell cautions against the "perils of equating [the Greek concept of] *mimesis* with [mere] imitation."[22] Tellingly, he introduces antiquity's broader view of mimesis by citing (3–4) a late-eighteenth-century counterpart in the thought of Goethe. Halliwell interprets Goethe as holding that the best art "must make contact with something more than the surfaces of nature, but must nonetheless do so by working *through* the representation of natural phenomena." For Goethe, the imitation of nature in art involved "striving to penetrate 'into the depths of things.'" That last idea finds a striking counterpart in ancient Chinese thought. In the words of one commentator, "Painting is an art [whose great practitioners] all started from representing outward likeness but arrived at expressing the meaning, feelings, and innate character of things."[23]

Halliwell even discerns (131–32) evidence of such a broader view in Plato—for whom

> the beauty of a mimetic work (visual or otherwise . . .) depends not on straightforward, one-to-one correspondence to a (putative) model but on a complex relationship in which a certain kind of

purposiveness ("what . . . [an image] wants/intends/means") . . . must be taken into account. . . .

. . . [B]eauty of form is a matter not just of appearances but of appearances that embody and convey ethical value. . . . [I]n the visual arts (and elsewhere) form is not neutrally depictional but communicative of feeling and value.

Halliwell also illuminates (202–206) Aristotle's view of the "pleasure" involved in the arts. In contrast with the English term (which tends to connote a superficial experience), its Greek referent, *hedone*, had far more serious connotations. For Aristotle, the pleasure derived from art was a highly meaningful experience, in which emotion is aroused by the understanding of a work's content and an appreciation of its relevance to life. More on this below. Suffice it to say now that in downplaying the ancient group of "imitative arts," Kristeller committed a major oversight.

What Should the "Modern System of the Arts" Be?

Kristeller's "irreducible nucleus" of the "modern system of the arts" was correct in one sense. Diderot's classification scheme *was* the one that had taken hold in Western culture. But a more astute analysis might have led Kristeller to question its authority, rather than simply accept it at face value. Ideally, he would have recognized the logical superiority of Batteux's scheme, with its deep roots in prior thought.

A proper system of classification would identify the major mimetic arts (Batteux's group: music, poetry, painting, sculpture and dance) as a special category, distinct from the "decorative" (or "applied") arts, crafts, and design. The latter category—encompassing the attractive design, ornamenting, and crafting of objects whose primary function is physical or practical—would include architecture, as Batteux had argued. In contrast, the major mimetic arts have an exclusively psychological function.

The confused inclusion of architecture among the "fine arts" aside, a distinction between "fine" and "decorative" art similar to the one I've just described was of course largely accepted in Western culture prior to the onslaught of postmodernist critiques. Shiner and other postmodernists applaud blurring or ignoring the distinction,

however. For example, Shiner welcomes the fact that "women's needlework has been rescued from the dungeon of 'domestic art' to enter the main floor of our museums." Further, he uncritically notes that Judy Chicago's *Dinner Party* "celebrated the low-ranked crafts of ceramics and embroidery."[24] While aiming to celebrate women's achievements and experiences, however, *The Dinner Party* in fact conveys very little about the individuals it purports to commemorate through crafts such as needlework. The ultimate test is to ask, Which gives a fuller sense of women's contributions to civilization—*The Dinner Party*'s place settings (however exquisitely crafted) or works of "fine art" such as Artemesia Gentileschi's painting *Judith Slaying Holofernes* or Mary Cassatt's *The Child's Bath*?[25]

Much like Shiner, Clowney applauds "the recent rise of 'fine crafts,' such as fine art furniture, wood turning, and 'fiber arts' within the world of art."[26] From another perspective, it can be argued that the conceptual breakdown he and others advocate has served to legitimize artworld absurdities such as Michael Beitz's furniture "sculptures"—in which useful items such as sofas and tables are distorted out of any functional shape, in order to explore "relationships." Useless as furniture, they also fail as art.[27]

Such muddled theory and practice is at least partly due to inadequate understanding of the role of mimesis in the major arts. While Young, for example, makes a strong case for Batteux's grouping of the *imitative* "fine arts," and extensively documents its precedence in antiquity, he admits that he has little to say about "what makes the fine arts fine (what they have in common)" or "the related question of what makes them valuable."[28] Let me try to fill that gap here.

As suggested by Halliwell's analysis, cited above, neither Plato nor Aristotle viewed mimesis/imitation in the arts as an end in itself. It served instead as a powerful means of representing ideas and values relevant to human life. Batteux was therefore mistaken in claiming that "the imitation of nature should be the common *goal* of the arts."[29] Moreover, as Halliwell observes (9–10), antiquity's broader view can be discerned in other eighteenth-century thinkers—not only Goethe, but also Alexander Baumgarten and Immanuel Kant. For Baumgarten, Halliwell rightly argues, *aesthetics* denoted "'the science of perception,' the sphere of immediate and particular sensory

cognition, as opposed to the general, abstract forms of conceptual or intellectual cognition." It did not refer to the "autonomous and 'disinterested' realm of experience" that later dominated eighteenth-century thought about aesthetics.

Nor did Kant conceive of art as a "disinterested" realm divorced from vital concerns. In sections 44–54 of the *Critique of Judgement*, dealing with the "fine arts" per se, Kant stipulates that works of art present "aesthetical Ideas." He explains:

> [B]y an aesthetical Idea I understand that representation of the Imagination which . . . cannot be completely compassed and made intelligible by language. . . . [I]t is the counterpart (pendant) of a *rational Idea*. . . .
>
> The Imagination (as a productive faculty of cognition) is very powerful in creating another nature, as it were, out of the material that actual nature gives it. . . . [A]nd by it we remould experience, always indeed in accordance with analogical laws. . . .
>
> Such representations of the Imagination we may call *Ideas*, partly because they at least strive after something which lies beyond the bounds of experience, and so seek to approximate to a presentation of concepts of Reason (intellectual Ideas), thus giving to the latter the appearance of objective reality.[30]

In other words, the arts present perceptual embodiments of important ideas—not only ideas about existential phenomena, such as death, envy, love, and fame, but also conceptions of other-worldly things, such as heaven and hell. In all cases, as Kant clearly implies, the products of the artist's imagination are mimetic—resembling the appearance of nature, or "objective reality." As he further indicates, a work of art does not merely copy nature, for it embodies concepts more fully than any single instance in nature.

All of those thinkers were of course writing long before the invention of "abstract art." Still less could they have envisioned the endless proliferation of new "art" forms concocted since the mid twentieth century, none of which could be accommodated by their view. What is needed now, therefore, is an answer to the question, Why are the arts *necessarily* mimetic?

The most compelling answer I know of to that crucial question was offered by philosopher-novelist Ayn Rand in four essays she published in Objectivist periodicals between 1965 and 1971. They later

appeared (along with essays on literature and contemporary culture) in a volume she entitled *The Romantic Manifesto*.[31] That work was recently recommended on a reading list prepared for the American Society for Aesthetics by Simon Fokt (2015).[32] As he notes, Rand's theory has had little attention from analytic philosophers.[33] Apparently unknown to him, an in-depth study of it was published nearly two decades ago by Louis Torres and me, however, and was recently expanded upon by me with respect to the visual arts. As summarized in the latter work, Rand held that

> humans create art because of a deep psychological need, both cognitive and emotional, to give concrete external form to our inmost ideas and feelings about life and the world around us. As she understood (and is increasingly confirmed by neuroscience), emotions are directly tied to sensory perceptual experience, whereas ideas and values are mental abstractions from that experience. Without external embodiment, such abstractions remain vaguely unreal, detached from our emotional life. Through the arts' sensory immediacy, we reconnect our thoughts and feelings about things that matter to us, and we are thus made more fully conscious of them. As Rand succinctly put it, "Art brings man's concepts [about such things] to the perceptual level of his consciousness and allows him to grasp them directly, as if they were percepts."[34]

Without knowing it, Rand gave clear expression to the view adumbrated by Baumgarten and Kant. The greater clarity of her view was no doubt due to the increased understanding of thought and emotion provided by the cognitive revolution that had begun in the 1950s. While Baumgarten had recognized that emotion plays a key role in the arts, Rand understood *why*. It is owing to the hard-wired connection between direct perception and emotion. Moreover, Rand correctly stressed that emotions are based on *values*.

As neuroscientist Antonio Damasio has since emphasized, every perceptual experience we have is accompanied by a corresponding emotional coloration—an implicit evaluation of good or bad, painful or pleasurable, according to the circumstances—which is stored in the brain for future reference.[35] Each new object we encounter is automatically compared to those stored cognitive and emotional memories of past experience, providing an instantaneous evaluation

based on past knowledge and experience. In Rand's theory, art is not mere "cheesecake" for the mind. It is instead a cultural adaptation of great significance. Since human action is largely voluntary, not governed by instinct, individuals and societies must constantly make choices that affect both present and future well-being. In so doing, we need to remain mindful, amid the myriad demands and distractions of daily life, of what we believe and value, not just at the moment but in the long term.

One of Rand's essays was entitled "Art and Cognition." In its crucial emphasis on values and emotion, her account differs significantly from other cognitive theories of art. In *Art and Knowledge*, for instance, James O. Young argues that the "most basic criterion of aesthetic value" is the knowledge provided by a work of art, and the cognitive value of an artwork "will be proportional to the value of the knowledge it makes available."[36] According to Rand, we do not turn to art for mere information or knowledge in the abstract. Art serves instead to concretize value-laden beliefs about the world and our place in it—by means of perceptual representations that grab our attention and engage our emotions. A similar view was expressed by Moshe Barasch when he argued that the chief purpose of medieval Christian art, for example, was not to convey new information about the life of Christ or the saints but rather to "intensify" believers' "absorption" in the meaning of those lives.[37]

To summarize Rand's view, the major art forms serve an important psychological function, profoundly linked to our life as conscious beings. They make us more aware of what we think and how we feel about the world and our life in it, as well as about the alternative worlds we might imagine. For the individual and, by extension, for society, they bring those ideas and values more fully to mind. Mimetic representation is not in itself the *goal* of art. It is the indispensable *means* by which art performs its psychological function. Avant-garde inventions such as "abstract art" ignore this principle at their peril.[38]

Recent findings in neuroscience offer support for Rand's theory. As I have argued elsewhere, the discovery of the "mirror neuron system," in particular, sheds light on the power of mimetic art.[39] First discovered in the early 1990s in the macaque monkey through electrodes inserted into the skull, the mirror neuron system comprises a

network of neurons in the area of the brain that controls movement. Remarkably, they are not only activated when the monkey is about to execute a goal-related action such as grasping an object but also discharge when the monkey observes another individual (monkey or human) executing a similar act.[40]

Studies using noninvasive techniques have provided abundant indirect evidence that humans possess a similar system, with an even wider range of responses. It is involved in the processing of both emotions and actions. Most important for the arts, mirror neurons are not only activated by observing actual instances of emotional expression and action in others; they are also triggered by seeing *images* of such phenomena.[41]

Advocates of "abstract art" have long resisted the idea that visual art requires imagery to convey meaning, however. Highly telling in this regard is a series of experiments performed by neuroscientist Semir Zeki. They show that "much larger parts of the brain are activated" by colored *images* than by colors in an abstract context. Imagery not only engages more of the brain's visual processing center, it also involves "regions of the brain traditionally associated with higher cognitive functions"—in particular, with the hippocampus, which manages both emotion and long-term memory.[42] This is not surprising. As cognitive scientist Robert Solso suggested, when we look at art, we experience it in terms of our past knowledge, searching for something that "coincides with our view of the world."[43] Abstract work provides very little that one can connect with.

Why Such a Theory Has Universal Relevance

In addition to claiming that "Art as we have generally understood it is a European invention barely two hundred years old," Shiner maintains that there are "profound differences between basic assumptions about the arts" in the traditional cultures of China, Japan, India, and Africa, on one hand, and the "mainstream assumptions of Europe and the Americas," on the other.[44] As I've argued in *Who Says That's Art?*, however, his claims are true only if one regards as "mainstream" the dubious theory and practices of the avant-garde. If one takes as "mainstream" the more traditional views held by many art lovers,

evidence abounds to refute such claims, beginning with the examples cited above from classical antiquity and ancient Chinese thought.

Perhaps most crucial is the now-controversial distinction between the major ("fine") arts and the minor or "decorative" arts and crafts. In *What Art Is*, Torres and I maintain that such a distinction is clearly implicit in Ellen Dissanayake's studies of traditional societies, though she missed seeing it. As we note, when she argues that art in preliterate societies served to "express and reinforce the values and beliefs of the society" in emotionally compelling ways, the arts she cites are poetry, music, dance, and painting.[45] So, too, Robert L. Anderson's cross-cultural survey in his book *Calliope's Sisters* reveals a clear *functional* distinction between those major arts and the "decorative" arts associated with utilitarian objects. As revealed by his case studies, though not recognized by him, a culture's core values generally find embodiment in the major arts that the eighteenth century dubbed "fine."[46]

A prime instance cited by Torres and me of the high status universally granted to works of art that perceptibly embody the primary values of the society are the private devotional sculptures known as "spirit figures" in the West African culture of the Baule people. They depict the "spirit" husband or wife believed to have been left in the other world before birth, and represent a Baule ideal of physical beauty and social perfection. As emphasized by Susan Vogel, these small wooden sculptures are much more highly valued than utilitarian objects whose ornamental figures serve primarily to afford aesthetic pleasure and social prestige. She observes:

> Baule artists and householders have created a profusion of useful objects decorated with exceptional care and skill. . . . In Baule life these objects, far more elaborate than the ordinary ones, are amusing, delightful to behold, and, as I was often told, "will make people talk about you," but they are devoid of spiritual power, and Baule people finally consider them trivial.[47]

The spirit figures clearly qualify as works of ("fine") *art* according to the principles outlined here, although there is no comparable term in the Baule language. Vogel further maintains that her findings on Baule art and culture are broadly applicable to other African societies.[48] Finally, when Dissanayake observes that the world's great civilizations

presumably needed "aesthetic manifestations of their worldview, not simply the worldview itself," her examples are Egyptian sculpture, Hindu temple facades (which have rich sculptural components), and Chinese landscape painting.[49] It is telling that she omits mention of such practices as body decoration, basket weaving, or ritual displays of food in that context, though they are included in her broad designation of art. Considered in that light, Dissanayake's characterization of the arts as "time-tested means for making sense of human existence"[50] seems applicable mainly to Batteux's "fine art" forms.

Philosophers Should Be Willing to Say That Not Everything Is Art

One of Fokt's reasons for recommending study of Ayn Rand's theory is especially apt here. In his view, it can foster "discussion on the status of the avant-garde and most abstract art forms." Some students, he adds, "likely share the sentiment that many such works are not art." As do many ordinary art lovers and museumgoers, I would add.

At the conclusion of his influential essay, Kristeller observes that "the traditional system of the fine arts [was beginning] to show signs of disintegration." Recapping his claim that while the "various arts are certainly as old as human civilization" how we group them is "comparatively recent," he adds that "new techniques may lead to modes of artistic expression for which the aestheticians of the eighteenth and nineteenth century had no place in their systems"—as exemplified by motion pictures. True, but the art of film can be categorized as essentially akin to fiction and drama. It was not a radically unprecedented new form.[51]

Moreover, as I've argued here, the primary groups of major ("fine") and lesser ("decorative") arts are far less "arbitrary and subject to change" than Kristeller claims. In addition, his failure to recognize the universal significance of the major mimetic arts led him into yet another error. He adds: "The tendency among some contemporary philosophers to consider Art and the aesthetic realm as a pervasive aspect of human experience rather than as the specific domain of the conventional fine arts, also . . . weaken[s] the latter

notion in its traditional form." In that connection, he cites John Dewey's *Art as Experience*.

From his mid-twentieth-century perspective, Kristeller could not see just how far such ideas would go toward undermining the traditional fine arts. But he hoped that "an understanding of the historical origins and limitations of the modern system . . . might help to free us from certain conventional preconceptions." From our twenty-first-century perspective, in contrast, we can see all too clearly how far the breakdown of the traditional fine arts has gone toward "freeing" the artworld from ideas that were not merely "conventional" but were based on actual functional differences. However unwittingly, Dewey greatly contributed to that breakdown, by inspiring Allan Kaprow's misguided "blurring of art and life" in the "Happenings" of the 1950s.[52] Those, in turn, gave rise to the "installation art" and "performance art" that dominate today's artworld. Blurring the boundary between art and life in effect obliterates *art*. Since art has always been *about* life, it implies and requires a distinction between the two. Kaprow himself seemed to recognize this when he wrote: "I am not so sure whether what we do now is art or something not quite art. If I call it art, it is because I wish to avoid the endless arguments some other name would bring forth."[53]

The inventor of "concept art," Henry Flynt, actually calls himself an "anti-art activist."[54] In the essay introducing his work, he even suggested that it might be best to regard his "activity as an independent, new activity, irrelevant to art."[55] Philosophers of art have largely ignored such revealing statements by leading avant-garde figures whose inventions began as expressly anti-art gestures yet have been wholly assimilated into the contemporary "art" establishment. As Shiner documents in the final part of his book, artworld assimilation has encompassed virtually everything—from photography and architecture to Marcel Duchamp's urinal, John Cage's *4'33"*, and beyond.

A decade ago, Denis Dutton aptly charged that his fellow aestheticians had erred in "endless analysis" to accommodate the most outrageous "hard cases"[56]—even including work *avowed by its maker to be non-art or anti-art*, I would add. Ironically, Dutton later succumbed to the same tendency, however, joining the chorus of those for whom Duchamp's readymades had become "the central hurdle

over which any attempt to define art must leap."[57] While pointing out that Duchamp's readymades indisputably flouted several of his proposed "universal criteria of art," he nonetheless concluded that *Fountain* was an important work of "conceptual art," even "a work of genius."[58] No matter that Dutton himself quoted Duchamp as saying that he never intended the readymades as "art."[59]

As Dutton rightly lamented, "[t]oo many disputes in art theory tiresomely rehash the artistic status of amusing modernist provocations, such as Andy Warhol's signed soup cans."[60] Most lamentably, in my view, philosopher and critic Arthur Danto hung his influential institutional theory on Warhol's vacuous *Brillo Boxes*.[61] No less eminent a philosopher than the late Peter Kivy regards that theory as "arguably the most powerful philosophy of art to be produced in the second half of the twentieth century."[62] I beg to differ. As Danto himself acknowledged, it was based on "the eviscerated work the artworld now enfranchises."[63] But why should philosophers necessarily give credence to whatever "the artworld now enfranchises"—however "eviscerated"?[64] Shouldn't they be the intellectual gatekeepers of culture?

Held to that role, who would regard Warhol as a genuine artist, much less as one "possess[ing] a philosophical intelligence of an intoxicatingly high order" (to quote Danto[65])—worth basing a radically new theory of art upon? Would it not be more prudent to surmise that the unprecedented banality of his work was in fact due to the total anomie and emotional deadness he confessed to and displayed? As he once explained, he employed a mechanical approach to creating paintings because he didn't "love roses or bottles or anything like that enough to want to sit down and paint them lovingly and patiently."[66] And he repeatedly asserted "everything is nothing."[67]

In the astute view of clinical psychologist Louis Sass, Warhol's "nearly catatonic demeanor" suggested that he was "infinitely empty—as if the inner self had been rendered contentless."[68] Has such vacuousness ever been associated with genuine art or artists? Should it not prompt a fundamental reassessment of the influential theory based on Warhol's "indiscernible" facsimiles of supermarket cartons? More broadly, isn't it time for philosophers to recognize that not everything enfranchised by the artworld merits our attention as "art"?

Notes

In the following, URLs have been omitted for articles online in Aristos *and other publications that can be easily found by googling the title in quotation marks. Two books are cited simply by their main titles: Louis Torres and Michelle Marder Kamhi,* What Art Is: The Esthetic Theory of Ayn Rand *(Chicago: Open Court, 2000) and my* Who Says That's Art? A Commonsense View of the Visual Arts *(New York: Pro Arte Books, 2014).*

Valentin Who?—A Neglected French Master

1. Remarkably, a quick perusal of H. W. Janson's *History of Art* (3rd ed., 1986) yields nary a mention of Valentin. Perhaps more surprising, *A History of Art* by Germain Bazin (London: Thames and Hudson, 1959)—then chief curator of the Louvre, which holds the most extensive collection of Valentin's work—merely lists him among numerous "foreigners (in Rome) who were to spread Caravaggio's style all over Europe."

2. An infrared image of Valentin's unfinished *Abraham Sacrificing Isaac* clearly reveals that he sketched the outline of his figures in broad brushstrokes on the canvas and then altered the composition on the canvas as he rearranged his studio models into a more satisfactory grouping.

Understanding and Appreciating Art

1. Barbara Branden, *The Passion of Ayn Rand* (Garden City, N.Y.: Doubleday), 242–43, 386–87.

2. Ayn Rand, "The Psycho-Epistemology of Art," in *The Romantic Manifesto: A Philosophy of Literature*, 2nd rev. ed. (New York: Signet, 1975), 20.

3. In my talk, as in *Who Says That's Art?*, I mistakenly inferred that the Christ child's pointing to the book alluded to his later sacrifice. The Met's web page on the work explains instead that the key to the work's theological meaning is the Latin inscription on the bench: "Taken from the Book of Ecclesiasticus, dedicated to and extolling wisdom, it [means], 'From the beginning, and before the world, was I created (24:14).' Although by the thirteenth century the Church applied this text, which refers to Wisdom as a feminine entity, to discuss[ions of] Mary, it was Christ as God incarnate who was seen as the personification of divine Wisdom on earth and Mary [as] the vessel, or throne, that bore him."

4. Ayn Rand, "Introduction to [Victor Hugo's] *Ninety-Three*," in *Romantic Manifesto*, 153.

5. Rand, "Art and Cognition," in *Romantic Manifesto*, 48.

6. Rand, "Art and Sense of Life," in *Romantic Manifesto*, 40.

7. Rand, "Art and Cognition," 49.

8. Linda Nochlin, "*La Grande Jatte*: An Anti-Utopian Allegory," in *The Politics of Vision: Essays on Nineteenth-Century Art and Society* (New York: Harper & Row, 1989), 170–93.

9. Rand refers to the "malevolent universe" premise in relation to literature, in "What Is Romanticism?," *Romantic Manifesto*, 109.

10. Richard Meryman, *Andrew Wyeth: A Secret Life* (New York: HarperCollins, 1996), esp. 20–21.

Two Exhibitions Worth Praising

1. The Morgan's film *An Illuminated Haggadah for the 21st Century* conveys Barbara Wolff's mastery of the extraordinarily painstaking technique involved in manuscript illumination. (Quite a contrast to Andy Warhol, who "didn't love [any things] enough to want to sit down and paint them lovingly and patiently"!) See also *Over Her Shoulder: Illuminating Psalm 104*, on http://www.artofbarbarawolff.com.

2. See *The Rose Haggadah*, the online exhibition of the entire manuscript on the Morgan's website, https://www.themorgan.org.

3. The slideshow "America Today, by Thomas Hart Benton" on the Met's website provides an overview of all the panels, with numerous closeups, https://tinyurl.com/y2hydfh4. See also "Thomas Hart Benton's *America Today* Mural" on the Met's Heilbrunn Timeline of Art History.

4. Paul Theroux, "The Story Behind Thomas Hart Benton's Incredible Masterwork," *Smithsonian*, December 2014—an appreciative and informed account of Benton's creative trajectory.

5. *MetCollects—Episode 9 / 2014: Thomas Hart Benton's Mural America Today Comes to the Met*—an 8-minute video on the Met's website (under Met Media)—recounts the checkered history and reputation of the work, which is now being seen by Met curators "with fresh eyes." For evidence of the lingering critical bias favoring "advanced art" over Benton's forthright brand of boldly stylized realism, see Holland Cotter, "America's Portraitist" (review of *Thomas Hart Benton* by Justin Wolff), *New York Times, Sunday Book Review*, June 29, 2012.

Picasso's Sculpture: Much Ado about Very Little

1. *Picasso Sculpture*, Museum of Modern Art, New York, September 14, 2015–February 7, 2016.

2. Roberta Smith, "Picasso, Completely Himself in 3 Dimensions," *New York Times*, September 10, 2015.

3. Jason Farago, "Picasso Sculpture Review—a Dumbfounding Triumph," *The Guardian*, September 11, 2015.

4. "[Carl] Jung's 1932 Article on Picasso," http://web.org.uk/picasso/jung_article.html.

5. Wilhelm Worringer, *Abstraction and Empathy: A Contribution to the Psychology of Style* (1907 dissertation originally published as a book in German in 1908), trans. by Michael Bullock, 3rd ed. (New York: International Universities Press, 1953).

What's Wrong with Today's Protest Art?

1. Scott has said that his flag was inspired by one used (without the words "by police") by the National Association for the Advancement of Colored People (NAACP) in the 1920s and '30s, when the lynching of blacks by white mobs was a major problem in the south—a substantially different situation from the 2015 case of a man shot by a police officer when he evaded arrest following a traffic stop (although deeply troubling aspects of that case led to the officer's conviction). And the NAACP surely didn't regard its flag as art.

2. In a strange twist, Ai's *Han Dynasty Urn* piece inspired a copycat gesture in which one of his purportedly costly vases was destroyed. See

"Artist Smashes $1 Million Ai Weiwei Vase in Protest," *Portland Press Herald*, February 18, 2014.

3. See "Museum Miseducation: Perpetuating the Duchamp Myth," above, 207–209.

The Apotheosis of Andy Warhol

1. For more evidence of the Met's apotheosis of Warhol, see "Warhol's Factory at the Met" (a "College Group at the Met" event), October 24, 2012, https://tinyurl.com/y3qv5g7y. On Warhol's glorification elsewhere, see *The Andy Monument*, Union Square, New York City, May 30, 2011–September 4, 2012; Contemporary Arts Museum Houston, October 8, 2012–April 30, 2013, https://camh.org/event/rob-pruitt-andy-monument.

2. On Arthur Danto's theory of art inspired by Warhol's *Brillo Boxes*, see Sarah Boxer, "Non-Art for Non-Art's Sake," *New York Times*, August 6, 2000. Regarding the Mapplethorpe obscenity case, see *The Robert Mapplethorpe Obscenity Trial (1990): Selected Links and Bibliography*, by Cynthia L. Ernst, https://tinyurl.com/nlslyel; and "Art and the Law," in *What Art Is*, 296–97.

3. Warhol's "engagement with portrait making" is examined in "EXHIBITION: Non-Portraits," in Notes & Comments, *Aristos*, June 2008 (scroll down to this brief review of *Warhol's Jews: Ten Portraits Reconsidered* at the Jewish Museum).

Fake Art—the Rauschenberg Phenomenon

1. Philosopher and cultural critic Roger Scruton has aptly excoriated such "fake art" in several articles, but this sense of the term has, regrettably, not yet gained wide currency.

2. For insights like this, Dickerman has won numerous awards—most notably for her *Inventing Abstraction* catalogue. For my own views on that exhibition and her catalogue essay, see "Has the Artworld Been Kidding Itself about Abstract Art?," above, 129–32.

3. On critics' attempts to read meaning into this work (despite Rauschenberg's repeated denials of coherent intention), see *Who Says That's Art?*, 131–33.

4. Though Rauschenberg is only mentioned in passing in clinical psychologist Louis Sass's illuminating study *Madness and Modernism:*

Insanity in the Light of Modern Art, Literature, and Thought (New York: Basic Books, 1992), his Combines and other work surely exhibit many of the characteristics Sass associates with schizoid personality disorders, as do his often kooky statements about his work.

5. See Holland Cotter, "Robert Rauschenberg: It Takes a Village to Raise a Genius," *New York Times*, May 18, 2017.

Old and New Art—Continuity vs. Rupture

1. Regarding the Morgan Library's break with tradition, see "Cy Twombly in Mr. Morgan's House?," above, 78–79; and "Folded Paper and Other Modern 'Drawings'," above, 80–82. On the Metropolitan, see "The Apotheosis of Andy Warhol," above, 86–88; "Met Rooftop Folly: Cornelia Parker's *PsychoBarn*," *For Piero's Sake*, April 26, 2016; and Louis Torres, "An Urgent Letter to *Aristos* Readers," *Aristos*, December 2013.

2. Unlike Damien Hirst—who once lamented never having learned to represent the three-dimensional world on a two-dimensional surface— these artists have mastered that foundational skill. For more on Classical Realism, see Louis Torres, "The New Dawn of Painting," *Aristos*, March 1986; my "R.H. Ives Gammell," above, 36–40; Louis Torres, "The Legacy of Richard Lack," *Aristos*, December 2006; and Jacob Collins, "Reflections on 'Classical Realism'," *Aristos*, November 2007.

3. My article was entitled "Anti-Art Is Not Art," *What Art Is* Online, June 2002.

Contemporary Art Worth Knowing

1. Milène Fernàndez, "Self-Portraits: Meeting the Artist Eye-to-Eye," *Epoch Times*, April 23, 2017.

2. Katsu Nakajima's statement regarding *Stream of the Shadow*: https://tinyurl.com/yyp2379a. As Joseph McGurl reports, his *Transfiguration* is indeed a "synthesis of several landscapes . . . seen and painted over the years": https://tinyurl.com/y4tc2lwl.

3. For more about the 2017 ARC Salon, both pro and con, see Milène Fernàndez, "A One of a Kind Art Salon Champions Realism," *Epoch Times*, May 18, 2017.

Dismaying Exhibition of De Waal Installations at the Frick

1. De Waal's creative process can be viewed in a BBC video entitled *What Do Artists Do All Day?*. In referring to De Waal as an "artist," the BBC apes the artworld's promiscuous terminology—which is not missed by viewers, one of whom comments: "He churns out pots and calls it Art, is that it?"

2. The piece titled *an alchemy* is so inconspicuously placed in the Frick Library that on noticing my searching for it a guard stepped forward to point it out to me, a service I saw him perform for other visitiors as well.

3. De Waal stresses the importance of the vitrines as an integral part of each work.

Commemorating Andrew Wyeth

1. Wyeth has long been a thorn in the side of the modernist and postmodernist artworld for his essentially traditional brand of realism. Following his first one-man show in New York in 1937 (which sold out in two days), his father reported that dealers had commented: "at last a man who has the guts to present nature honestly, powerfully and beautifully" and "a much-needed spirit in a New York sick with unmeaningful, unsightly and unsalable moderns." Early in his career, Wyeth actually found admirers among prominent modernists—from Alfred Barr (the Museum of Modern Art director who purchased *Christina's World*) to, most astonishingly, painter-critic Elaine de Kooning. But by the late 1950s, dealers, collectors, exhibitors, and critics alike were nearly universally united in promoting abstraction and Abstract Expressionism. And the few who were inclined to dissent, based on their personal response to Wyeth's work, were too cowardly to defy such a juggernaut. A trenchant summary of the lamentable history of anti-Wyeth bias is provided by Richard Meryman in *Andrew Wyeth: A Secret Life* (New York: HarperCollins, 1996), 391–99.

2. In light of that profound contrast, Andrew's son Jamie's admiration for Warhol is astonishing and more than a little ironic.

3. See Patricia Junker, Audrey Lewis, et al., *Andrew Wyeth: In Retrospect* (New Haven: Yale University Press, 2017), the catalogue of the 2017 centenary retrospective.

4. Thomas Hoving, ed., *Andrew Wyeth: Autobiography* (Old Saybrook, Conn.: Konecky & Konecky, 1995), 33. This volume offers an illuminating

account of Wyeth's life through his art and what he says about it. It is based on a major retrospective that originated in Japan and was shown in 1995 at the Nelson-Atkins Museum of Art in Kansas City, which sponsored it.

5. Snowden was an inveterate alcoholic, and the catalogue notes the disturbing fact that Wyeth in effect abetted his destructive habit by providing money to enable it—adding that it was "characteristic of his nonjudgmental acceptance of all his regular models, black or white."

6. Purchased by the Museum of Modern Art in 1949 for a mere $1,800, *Christina's World* is surely one of the most popular works in the museum. Yet as of this date (2017), it has been relegated to a corridor. Perhaps because it differs so greatly from most of the works displayed in the galleries nearby— with the exception of those by Charles Sheeler and Edward Hopper. The latter, much admired by Wyeth, was a staunch (and more outspoken) ally in the defense of realism against notorious artworld bias. Louis Torres notes that the museum's description of the painting mistakenly characterizes it as an example of "magic realism." In addition, it reports that Christina had been "crippled by polio." She is likely to have suffered instead from a congenital degenerative disorder known as Charcot-Marie-Tooth disease.

Kandinsky and His Progeny

1. Hilton Kramer, "Idiotic Curators Present Wretched [Bruce] Nauman Show" (review of Museum of Modern Art retrospective), *New York Observer*, March 13, 1995.

2. Hilton Kramer, "Kandinsky & the Birth of Abstraction," *The New Criterion*, March 1995, 3.

3. Wassily Kandinsky, *Concerning the Spiritual in Art* (originally published in German in 1911), trans. with Introduction by M.T.H. Sadler (New York: Dover, 1977), 60.

4. Kandinsky, 21.

5. Edward Hower, "The Spirited Story of the Psychic and the Colonel," *Smithsonian Magazine*, May 1995.

6. Kramer, "Kandinsky & the Birth of Abstraction," 4.

Hilton Kramer's Misreading of Abstract Art

1. Hilton Kramer, "Does Abstract Art Have a Future?," *The New Criterion*, December 2002, 10.

2. Ibid., 11.

3. Ibid., 12.

4. Ibid.

5. "Minimalism," *Encyclopedia of Aesthetics*, ed. by Michael Kelly (New York: Oxford University Press, 1998), 238.

6. Frank Stella, in "Questions to Stella and Judd" (text of a February 1964 WBAI interview by Bruce Glaser), ed. by Lucy R. Lippard, *ARTnews*, September 1966, 59.

7. Clement Greenberg, "Recentness of Sculpture," reprinted from the exhibition catalogue *American Sculpture of the Sixties* (Los Angeles County Museum of Art, 1967), in *Minimal Art: A Critical Anthology*, ed. by Gregory Battcock (Berkeley: University of California Press, 1995), 181.

8. Kramer, "Does Abstract Art Have a Future?," 12.

9. Donald Judd, in "Questions to Stella and Judd," 60.

10. Ibid.

11. Lionel Trilling, as quoted by Hilton Kramer from "Aggression and Utopia: A Note on William Morris's *News from Nowhere*," *Psychoanalytic Quarterly*, April 1973, 214–25.

12. Kramer, "Does Abstract Art Have a Future?," 12.

13. Ibid.

14. Frank Stella, as quoted by Hilton Kramer from *Working Space (The Charles Eliot Norton Lectures)* (Cambridge, Mass.: Harvard University Press, 1986), 161.

Has the Artworld Been Kidding Itself about Abstract Art?

1. Wilhelm Worringer, *Abstraction and Empathy: A Contribution to the Psychology of Style* (first published in German in 1908), trans. by Michael Bullock with Introduction by Hilton Kramer (Chicago: Ivan R. Dee, 1997), 17. Cited by Leah Dickerman in "Inventing Abstraction," *Inventing Abstraction, 1910–1925: How a Radical Idea Changed Modern Art* (New York: Museum of Modern Art, 2013), 23.

2. The occultist beliefs that inspired early abstract painters are discussed in "The Myth of 'Abstract Art,'" in *What Art Is*, 133–79. See also "Art and Theosophy" an anonymous but generally informative article

(notwithstanding any errors of detail) on http://www.katinkahesselink.net, one of many websites devoted to Theosophical beliefs.

3. Dickerman, 32.

4. Ibid., 32–34.

5. Ibid., 28.

6. Ibid., 34. The phrase is Dickerman's, not Duchamp's. It is in reference to his seeking to "[remove] the retinal aspect" from his work *The Large Glass*—as discussed by him in Pierre Cabanne, *Dialogues with Marcel Duchamp*, trans. by Ron Padgett (New York: Viking, 1971), 43. Remarkably, Dickerman ignores the absurdity of attempting to remove the "retinal aspect" from *visual* art.

7. Glenn Lowry, remarks at press preview for *Inventing Abstraction*, Museum of Modern Art, New York, December 18, 2012.

Abstract Art Is an Absurd Inversion of American Values

1. See *What Art Is*, 154–55, citing the 1950 "Statement on Modern Art" signed by directors of major modern art museums, reprinted in Clifford Ross, ed., *Abstract Expressionism: Creators and Critics* (New York: Abrams, 1991), 230–33.

2. On the work of Schapiro and Greenberg, see *What Art Is*, 146–51.

3. Ibid., 136–37, citing, in particular, the 1918 manifesto of De Stijl (the influential modernist journal co-founded by Mondrian), quoted in Harry Holtzman and Martin S. James, eds., *The New Art—The New Life: The Collected Writings of Piet Mondrian* (Boston: G. K. Hall, 1986), 24.

4. Piet Mondrian, "Purely Abstract Art" (1926), in Holtzman and James, 199.

5. Mondrian, "Pure Abstract Art" (1929), in Holtzman and James, 225.

6. Wassily Kandinsky, *Concerning the Spiritual in Art* (1911), trans. from the German with Introduction by M.T.H. Sadler (New York: Dover, 1977), 11.

7. On the abstract pioneers' claim of extraordinary psychic powers, see, for example, Charlotte Douglas, "Malevich and Art Theory," in *Malevich: Artist and Theoretician*, ed. by Evgeniya Petrova et al., trans. from the Russian by Sharon McKee (Paris: Flammarion, 1991), 58–59.

Jousting with Mark Rothko's Son

1. See, for example, "Barking Up the Wrong Trees in Art Education," above, 237–40.

2. Contrary to my suggestion that knowledge of Rothko's troubled personality probably contributes to a viewer's emotional response to his work, Kobayashi reported that her first contact with Rothko's work was at the 1978 Guggenheim Museum retrospective, when she knew very little about his biography. What moved her, she said, was the sense that he could "touch feeling without forms" and that he understood the "condition that we all live in"—the "pain" as well as the "happiness." Such an account—from a fellow abstract painter who shares the same premises—does not prompt me to alter my general view, however, that emotional responses to Rothko's work are mainly self-generated, rather than evoked by visual attributes of the paintings themselves.

3. Transcribed from audio recording of remarks made at the NYC Junto, June 2, 2016.

4. Oliver Sacks, *The Man Who Mistook His Wife for a Hat—and Other Clinical Tales* (New York: HarperPerennial, 1990), 8–22.

Where's the *Art* in Today's Art Education?

1. *What Art Is*, 11–12.

2. Teachers wishing to gain a clearer appreciation of some of the key humanistic values at the core of American culture would do well to read "Did Western Civilization Survive the 20th Century?" (2000), by historian Alan Kors, on https://phillysoc.org.

3. Pat Villeneuve, "Back to the Future: [Re][De]Fining Art Education," *Art Education*, May 2002, 4.

4. Kerry Freedman and Patricia Stuhr, "Visual Culture: Broadening the Domain of Art Education" (unpublished paper for the Council for Policy Studies in Education, 2001), cited in Ohio State University TETAC (Transforming Education Through the Arts Challenge) Mentors, "Integrated Curriculum: Possibilities for the Arts," *Art Education*, May 2002, 22.

5. Villeneuve, ibid.

6. John Stinespring, "Moving from the Postmodern Trap," paper presented at the annual convention of the National Art Education Association, Miami Beach, Florida, March 2002.

7. Freedman and Stuhr, "Visual Culture," quoted by Ohio State University TETAC Mentors (see above, note 7), emphasis mine.

8. Anna Wagner-Ott, "Analysis of Gender Identity through Doll and Action Figure Politics in Art Education," *Studies in Art Education*, Spring 2002, 246–63, quoting (259) Paul Duncum, "A Case for an Art Education of Everyday Aesthetic Experiences," *Studies in Art Education*, Summer 1999, 299.

9. Duncum, ibid., 295, cited in Wagner-Ott, 258.

10. Paul Duncum, "Clarifying Visual Culture Art Education," *Art Education*, May 2002, 8.

11. Christine Ballengee-Morris and Patricia Stuhr, "Multicultural Art and Visual Cultural Education in a Changing World," *Art Education*, July 2001, 1–8.

12. I am reminded of the caution sounded three decades ago by philosopher of education Mary Anne Raywid—whom Torres and I cited in *What Art Is* (474, note 101). Raywid, then the president of the John Dewey Society, warned that the anti-individualism implicit in the multiculturalist emphasis on ethnicity was threatening the very fabric of American society. In her view, cultural separatism and particularism should be replaced with "universalism"—that is, "the tendency . . . to stress the similarity and brotherhood of peoples, and to promulgate a common core of beliefs and common standards to which all can aspire and against which all can be judged." See "Pluralism as a Basis for Educational Policy: Some Second Thoughts," in *Educational Policy: Highlights of the Lyndon B Johnson Memorial Symposium on Educational Policy* (at Glassboro State College, 1973), ed. by Janice F. Weaver (Danville, Ill.: Interstate Press, 1975), 81–99.

13. Ballengee-Morris and Stuhr, 6–7.

Rescuing Art from Visual Culture Studies

1. Perhaps the most telling evidence of the bankruptcy of cultural theory in literary studies is the revisionist view put forth in the latest book by Terry Eagleton, one of the foremost proponents of such a theoretical emphasis. Although he protests that it is "not as though the whole project was a ghastly mistake on which some merciful soul has now blown the whistle," he insists—against the tendencies of contemporary cultural theory—on a renewed concern with such values as truth, virtue, objectivity, and standards of morality (*After Theory* [New York: Basic Books, 2003], 1 *et passim*). Later, Eagleton said "The

postmodern prejudice against norms, unities and consensuses is a politically catastrophic one." Cultural theorists, he maintained, can no longer "afford simply to keep recounting the same narratives of class, race, and gender" (quoted in Dinitia Smith, "Cultural Theorists, Start Your Epitaphs," *New York Times*, January 3, 2004).

2. "Where's the *Art* in Today's Art Education?," above, 143–51.

3. To quote the prospectus of an academic program in VCS at the University of Wisconsin-Madison: "Anything visible is a potential object of study for Visual Culture, and the worthiness of any visual object or practice as an object of study depends not on its inherent qualities, as in the work of art, but on its place within the context of the whole of culture" ("New Academic Paradigms," *University of Wisconsin-Madison Visual Culture Cluster*, https://tinyurl.com/yy9o6oxp). In effect, then, works of art such as the *Nike of Samothrace* and Michelangelo's *David* are to be treated on a par with artifacts such as Mattel's Barbie and Ken dolls.

4. For an analysis of the nature of art (in the sense of the "fine arts"), and why both abstract (nonobjective) painting and sculpture and the decorative arts should be excluded from this category, *What Art Is*, especially chapter 8, "The Myth of 'Abstract Art.'" Although K–12 art education has traditionally concerned itself as much with the crafts and design as with painting and sculpture, teachers should be mindful of the important distinctions between these categories and their respective functions.

5. Terry Barrett, "Interpreting Visual Culture," *Art Education*, March 2003, 6.

6. In this respect, *Cut and Paste* falls entirely within the spurious postmodernist category of "conceptual art," defined in the *Oxford Dictionary of Art*, ed. Ian Chilvers and Harold Osborne (New York: Oxford University Press, 1988), as "various forms of art in which the idea for a work is considered more important than the finished product, if any." Not surprisingly, Michael Ray Charles began as a student of advertising design and illustration, the features of which remain prominent in his work.

7. Barrett, "Interpreting Visual Culture," 8.

8. National Standards for Arts Education, "Summary Statement: Education Reform, Standards, and the Arts," http://www.ed.gov/pubs/ArtsStandards.html.

9. Sometime after writing this, I was able to locate the painting—*Ernesta*, by Cecilia Beaux, in the museum's collection—in which the figure of the nursemaid is actually cut off below the waist.

10. See note 8.

11. See the discussion of Oliver Sacks's work in *What Art Is*, 123–27.

12. In any discussion of this kind, it is of course important to recognize that although the boundaries between categories of things in reality may not always be clear-cut, identifying prototypical characteristics for each category is nonetheless valid and useful. Despite any disagreement that might exist over whether a particular shade of aquamarine is more blue or more green, for example, we do not hesitate to teach children to recognize the colors blue and green.

13. Unlike virtually all of today's art historians and critics, I do not regard photography as an art form, although it shares certain features with painting. See "Photography: An Invented 'Art,'" *What Art Is*, 180–88; also "Ansel Adams—a Great Modern 'Artist'?," *What Art Is* Online, March 2002, and "Yousuf Karsh—Portrait Photographer par Excellence," *What Art Is* Online, November 2002.

14. On postmodernism in the visual arts, see *What Art Is* Online, http://www.aristos.org/whatart/ch14.htm, and *What Art Is*, 262–82.

15. For an image of Sophie's drawing, see "A Wild Day at Half Moon Bay," http://www.aristos.org/images/wildday.jpg.

16. See Louis Torres, "Thomas Eakins: Painting Pure Thought," *Aristos*, August 2003.

17. Erwin Panofsky, "Iconography and Iconology: An Introduction to the Study of Renaissance Art" (1939), reprinted in *Meaning in the Visual Arts* (Garden City, N.Y.: Doubleday, 1955), 26–54.

18. National Standards for Art Education (see above, note 8).

19. See "Images of Exemplary Works of Art," *Aristos*, January 2004.

20. Wendell Castle's work is discussed in *What Art Is*, 211–12.

Why Teach Art?

1. Gaye Green, "In Their Own Words: Critical Thinking in Artists' Diaries and Interviews," *Art Education*, July 2006, 53.

2. For an informative overview of cognitivist theories in relation to pedagogy, see P. E. Doolittle, "Constructivism and Online Education," *1999 Online Conference on Teaching Online in Higher Education*, https://tinyurl.com/y3vo7kfl.

3. Suzi Gablik, *The Reenchantment of Art* (New York: Thames and Hudson, 1991), 100–102.

4. René Magritte, http://www.magritte.com, emphasis added.

5. *What Art Is*, 143–44.

6. The stated intentions of prominent postmodernists are analyzed in relation to cognitive principles in "Postmodernism in the Visual Arts," *What Art Is*, 262–82, and "Modernism, Postmodernism, or Neither?," above, 263–79.

7. Jasper Johns, quoted in "Art: His Heart Belongs to DADA," *Time*, May 4, 1959, 58.

8. Johns, quoted in Kirk Varnedoe, ed., *Jasper Johns: Writings, Sketchbook Notes, Interviews*, comp. Christel Hollevoet (New York: Museum of Modern Art, 1996), 82, from Selden Rodman, *The Insiders: Rejection and Rediscovery of Man in the Arts of Our Time* (Baton Rouge: Louisiana State University Press, 1960), 36.

9. Johns, quoted in Donald Key, "Johns Adds Plaster Casts to Focus Target Paintings," *Milwaukee Journal*, June 9, 1960.

10. Leo Steinberg, "Jasper Johns: The First Seven Years of His Art," in *Other Criteria: Confrontations with Twentieth-Century Art* (New York: Oxford University Press, 1972), 35, 37, 32.

11. Linda Nochlin, "Seurat's *La Grande Jatte:* An Anti-Utopian Allegory," in *The Politics of Vision: Essays on Nineteenth-Century Art and Society* (New York: Harper & Row, 1989), 170–93.

12. Nochlin, 171, emphasis in original.

13. Mary Matthews Gedo, "*The Grande Jatte* as the Icon of a New Religion: A Psycho-Iconographic Interpretation" (1989), *Art Institute of Chicago Museum Studies* 14 (2): 223–24. Both John Rewald and Albert Boime shed considerable light on Seurat's general interests and concerns as an artist, and on the motivation behind *La Grande Jatte* in particular. See Rewald, "Artists' Quarrels (including letters by Pissarro, Signac, Seurat, and Hayet, 1887–1890)," in Norma Broude, ed., *Seurat in Perspective* (Englewood Cliffs, N.J.: Prentice Hall, 1978), 103–7; and "Seurat's Theories," in *Seurat: A Biography* (New York: Abrams, 1990), 159–66. Contrary to Nochlin's Marxist-inspired anti-utopian thesis, Boime persuasively argues that Seurat's work was instead inspired by utopian socialist views harking back to Saint-Simon. "Seurat and Piero della Francesca," in Broude, *Seurat in Perspective*, 265–71.

14. By an odd coincidence, just before this article was first published, Louis Torres and I received an e-mail message from a high school student, asking us what we thought of Seurat's *Grande Jatte* scene. When asked what he thought of it, he replied: "It's a beautiful Sunday afternoon. . . . [P]eople are having a great time with friends, the weather is perfect, the water is perfect, the clothing and people are perfect, it just seems like something taken out of a dream." As the sources cited in the preceding note indicate, such an impression is probably truer to Seurat's intent than Nochlin's politicizing interpretation.

15. Daniel Serig, "A Conceptual Structure of Visual Metaphor," *Studies in Art Education*, Spring 2006, 229–47.

16. On the crucial question of what qualifies as art, and of how that question relates to cognition, see *What Art Is* and "Art and Cognition: Mimesis vs. the Avant-Garde," above, 253-62.

17. John Wilmerding, "Introduction," in *Andrew Wyeth: Memory & Magic*, ed. by Anne Knutson et al. (New York: Rizzoli, 2005), 15.

18. Richard Meryman, *Andrew Wyeth: A Secret Life* (New York: HarperCollins, 1996), 293–95.

The Hijacking of Art Education

1. Sol Stern, "Pedagogy of the Oppressor," *City Journal*, Spring 2009.

2. White House Briefing on Art, Community, Social Justice, National Recovery, Washington, D.C., May 12, 2009; report published online by State Voices, https://tinyurl.com/y6xqntmf.

3. Ernesto Che Guevara, "A Note in the Margin," in *The Motorcycle Diaries* (New York: Ocean Press, 2003), 165.

4. Daniel James, *Ché Guevara: A Biography* (New York: Cooper Square Press, 2001), esp. 113–14; and Douglas Young, "The Real Che Guevara," *Samizdata.net.*

5. James Janega, "Bill Ayers: 'What could I possibly add?,'" *Chicago Tribune*, October 15, 2008, https://tinyurl.com/y5l22clq.

6. Quoted from the description of Ayers's session in the convention program. As it turned out, the session was canceled. Perhaps this article, first published before the convention began, contributed to its cancellation.

7. Sol Stern, "The Bomber as School Reformer," *City Journal*, October 6, 2008.

8. "Bill Ayers: Life in bubble will explode in America's face," Interview with *RT* (*Russia Today*), *YouTube*, December 16, 2009.

9. Bill Ayers, Speech at the World Education Forum, Centro Internacional Miranda, Caracas, Venezuela, November 7, 2006, https://billayers.org/2006/11/07/world-education-forum.

10. Mariano Castillo, "U.S. Report: Chavez Moving to Silence Media Critics," CNN.com, August 18, 2009; and Abraham H. Foxman, "Chávez's Anti-Semitism," *Washington Post*, February 5, 2008.

11. For a list of the signers and their academic affiliations, see https://tinyurl.com/y4e3m78v.

12. Therese Quinn, "Out of Cite, Out of Mind: Social Justice and Art Education," *Journal of Social Theory in Art Education*, 2006, 282–301.

13. Kamhi, "Anti-Art Is Not Art," *What Art Is* Online, June 2002; Kamhi and Louis Torres, "What about the *Other* Face of Contemporary Art?," *Art Education*, March 2008, reprinted in *Aristos*, June 2008; and Thomas McEvilley, *The Triumph of Anti-Art* (Kingston, N.Y.: McPherson, 2005).

14. "Defining Characteristics of a Discipline-Based Art Education Program," from "Discipline-Based Art Education: Becoming Students of Art," *Journal of Aesthetic Education*, Summer 1987, 135.

15. Gregory Sholette, "Some Call It Art," published on his website.

16. *What Art Is*, esp. 284–86 and 294–97.

17. For my objections to that and other aspects of the NET proposal, see "What Hope Is There for Art Education?," *Aristos*, July 2009.

18. Kamhi, "The Future of Education in the Visual Arts," comments submitted for a U. S. Department of Education meeting on January 20, 2010, regarding the reauthorization of the Elementary and Secondary Education Act, https://www.aristos.org/editors/kamhi-ESEA.pdf.

19. Dennis Fehr, personal email communication, February 11, 2010.

20. Dennis Fehr, talk given at a Symposium on "The Future of Arts Education," sponsored by the University Council for Art Education, Metropolitan Museum of Art, September 25, 2009.

21. Erika Tyner Allen, "The Kennedy-Nixon Presidential Debates, 1960," The Museum of Broadcast Communications, https://tinyurl.com/y54eraja.

22. See, for example, Mark Curnutte, "For Some Black Students, Failing Is Safer," *Cincinnati Enquirer*, May 28, 1998; and John H. McWhorter, "What's Holding Blacks Back?," *City Journal*, Winter 2001.

23. Deborah A. Kuster, "Critical Theory in Art Education: Some Comparisons," National Art Education Association, *Translations (From Theory to Practice)*, Summer 2008.

24. See "What Hope Is There for Art Education?," *Aristos*, July 2009.

The Great Divide in Art Education

1. "The Political Assault on Art Education," *Wall Street Journal*, June 25, 2010.

2. Amy Isackson, "State-of-the-Art Shoes Aid Migrants," *BBC News*, November 17, 2005.

3. I eschew Jagodzinski's affectation of dispensing with initial capitals in his name.

4. Jan Jagodzinski, "A Mondofesto for the 21st Century," https://sites.ualberta.ca/~jj3/mondofesto.html. In Jagodzinski's usage, "designer capitalism" means something very different from its original sense. As coined by the sociologist David Stark after the collapse of the Soviet Union in 1989, it referred to the externally imposed "recipes, formulas, blueprints and therapies for how to get from Communism to capitalism" (Columbia University, Fathom Archive, "Transitions in Postsocialist Eastern Europe" [interview with David Stark], accessed October 20, 2010).

5. On Matthew Barney's work, see comments by Louis Torres in Letters from the Editors, *Aristos*, May 2003.

6. See, for example, "Old and New Art—Continuity vs. Rupture" above, 93–96.

7. The website from which this was taken is no longer online.

8. In "Modernism, Postmodernism, or Neither?" above, 263–79, I urged that collage be banned from the art classroom. What I had in mind were collages that are either wholly abstract or are merely assemblages of pre-existing images appropriated from various sources. I would certainly not ban the creation of original imagery through collage, which has been successfully employed by children's book illustrators such as Eric Carle, Leo Lionni, and Jack Ezra Keats, and by Olshansky in the classroom—though I would not emphasize such a technique in the upper grades.

9. The image from *My New Life*, by fourth-grader Ruslan Sharpe, is online at https://www.aristos.org/images/imagebyRussianboy.pdf.

10. View the page from *Iraq to Syria to America*, by fourth-grader Saif Zuhair, at https://www.aristos.org/images/imagebyIraqiboy.pdf.

11. Letter from Ronnie Seiden-Moss to Irving Seidenberg, who then taught at Herbert H. Lehman High School (New York City), December 14, 1977. See also Sylvia Corwin's comments in the "Forum on Social Justice Art Education," *Aristos*, November 2010.

12. See the brief account of this approach in *What Art Is*, 312–15.

13. Lauren Stetz, "Teaching a Visual Culture Art Education: Because It's a Jungle Out There" (paper for course AVT 605, Issues and Research in Art Education, at George Mason University, November 25, 2007), 3.

14. Kerry Freedman, "Rethinking Creativity: A Definition to Support Contemporary Practice," *Art Education*, March 2010, 8–14.

15. On distinguishing between art and other forms of "visual culture," see "Rescuing Art from Visual Culture Studies," above, 152–64.

16. On Duchamp's lack of interest in politics, see Pierre Cabanne, *Dialogues with Marcel Duchamp*, trans. by Ron Padgett (New York: Viking Press, 1971), 103.

17. A refreshing exception to the recent trend of higher-ed predominance is the July 2010 issue of *Art Education*, devoted to the work and thoughts of practicing art teachers.

Understanding Contemporary Art

1. Examples of self-mutilation as "performance art" range from pieces such as *Shoot* (1971) and *Transfixed* (1974) by the American postmodernist Chris Burden to the French "carnal artist" Orlan's ongoing surgical manipulations of her own anatomy. Animal cruelty as "art" became a topic of heated controversy when the public learned of *Shot Dog Film* (1977), an early work by Tom Otterness, a postmodernist who has received major public art commissions in recent years. "Environmental artist" Christo Yavacheff's 1991 *Umbrellas* project killed a woman when one of the huge umbrellas came loose from its mooring and crushed her. In 2010, ceramic dust raised by visitors trampling on an interactive piece by political activist and "installation artist" Ai Weiwei prompted London's Tate Gallery to bar such interaction out of fears that the dust would endanger the public (see Mark Brown, "Tate stops visitors trampling on *Sunflower Seeds*," *The Guardian*, October 15, 2010). More recently, an art school student triggered

a terror alert in central London after leaving a bomb-like backpack, fitted with trailing wires, on a college campus (see "What was she thinking? . . . ," *Mail Online,* 12 July 2012. These are but a few of many disturbing examples that could be cited.

2. Laura Lopez et al., "The Individual Video Experience (iVE): The iPod as an Educational Tool in the Museum," *Art Education*, January 2008, 13–18.

3. Ironically, that observation is attributed to the "installation artist" Robert Irwin, from a lecture he gave entitled "On the Nature of Abstraction" at Rice University, March 23, 2000, quoted by Cynthia Freeland, *But is it Art? An Introduction to Art Theory* (New York: Oxford University Press, 2001), 206.

4. The ideas behind the invention of "abstract art" are discussed more fully, with citation of the original sources, in "The Myth of 'Abstract Art'," *What Art Is*, 134–46 and the corresponding notes.

5. Piet Mondrian, letter to the architect J. J. P. Oud (1925), quoted in Harry Holtzman and Martin S. James, eds., *The New Art—The New Life: The Collected Writings of Piet Mondrian* (Boston: G. K. Hall, 1986), 198, emphasis in original; and "Purely Abstract Art" (1926), ibid., 200.

6. Mondrian, "Neo-Plasticism" (1923), in Holtzman and James, 176–77; "Purely Abstract Art" (1926), ibid., 198–201; and "Art without Subject Matter" (1938), ibid., 303.

7. Kazimir Malevich, *The Non-Objective World* (1927), trans. by Howard Dearstyne (Chicago: Paul Theolbold, 1959), 76.

8. Wassily Kandinsky, *Concerning the Spiritual in Art* (1911), trans. by M.T.H. Sadler (New York: Dover, 1977), 2.

9. Clive Bell, "The Aesthetic Hypothesis" (1912), in *Art*, rev. ed. (New York: Capricorn, 1958), 27.

10. See Semir Zeki and Ludovica Marini, "Three Cortical Stages of Colour Processing in the Human Brain," *Brain: A Journal of Neurology*, vol. 121 (1998), 1676, 1678 and 1681.

11. Robert Rauschenberg, quoted by Grace Glueck, "Rauschenberg at 65, With All Due Immodesty," *New York Times*, December 16, 1990.

12. Rauschenberg, quoted by Calvin Tomkins, *Off the Wall: Robert Rauschenberg and the Art World of Our Time* (New York: Penguin, 1981), 183.

13. Marcel Duchamp, in Pierre Cabanne, *Dialogues with Marcel Duchamp*, trans. by Ron Padgett (New York: Viking, 1971), 47.

14. Thomas McEvilley, *The Triumph of Anti-Art: Conceptual and Performance Art in the Formation of Post-Modernism* (Kingston, N.Y.: McPherson, 2005).

15. Allan Kaprow, "Happenings in the New York Scene" (1961), in *Essays on the Blurring of Art and Life* (Berkeley: University of California Press, 1993), 21.

16. Henry Flynt, "Concept Art" (1961), in Richard Kostelanetz, ed., *Esthetics Contemporary*, rev. ed. (Buffalo, N.Y.: Prometheus, 1989), 431, emphasis added.

17. "A Conversation with Damien Hirst," *Charlie Rose Show*, February 20, 2002.

18. Holly Meyers, "Performance Artist Dawn Kasper 'Always Swirling,'" *Los Angeles Times*, May 16, 2010.

19. Carmen Winant, "What to See (and Not to See) at the 2012 Whitney Biennial," *WNYC.org*, March 1, 2012.

20. Janine Antoni's talk at the 2010 *Thinking Like an Artist* Guggenheim conference can be viewed in its entirety on YouTube.

How Not to Teach Art History

1. The lesson plan provided by *Scholastic* implicitly lauds Basquiat as a street artist who "gained recognition in the art world through collaborations with established artists such as Andy Warhol. His solo work, which explores ideas of inequality, race, and politics, brought him success and wealth." As noted above, Basquiat's exploration of ideas is not at all clear, as even his defenders have admitted. On Warhol's inflated reputation as an "established artist," see "The Apotheosis of Andy Warhol," above, 86-88.

2. Readers who would like to know more about the meaning of this great work should consult Erwin Panofsky, *Early Netherlandish Painting: Its Origins and Character* (Cambridge, Mass.: Harvard University Press, 1964), 201–203. The National Gallery web page on the work asserts that the painting is not intended as a "record" of the couple's wedding, but Panofsky (a highly esteemed art historian) cites compelling iconographic evidence that the work aimed to memorialize the couple's marriage vows. See also H.W. Janson, *History of Art*, 3rd ed., revised and expanded by Anthony F. Janson (New York: Abrams, 1986), 377–78.

3. Unfortunately, it is not clear from the magazine's account if the painting was done in connection with an art class at the student's school or as an independent, extracurricular project.

The Truth about Pop Art

1. Louis A. Sass, *Madness and Modernism: Insanity in the Light of Modern Art, Literature, and Thought* (New York: Basic Books, 1992), 344–45.

2. Roy Lichtenstein, quoted by Robin Cembalest in "Inside the Shrine with the Straight-Talking Artist," *New York Times*, August, 24, 1998.

3. It is worth contrasting Hanson Wu's self-portrait with the very different one by Grace Lin, another *Scholastic Art* award winner—who was inspired by traditional art, not Pop. See the closing paragraphs of "How Not to Teach Art History," above, 232.

4. For more on this point, see *What Art Is*, 265–70; and *Who Says That's Art?*, 70–79.

5. For further reading: "The Apotheosis of Andy Warhol," above, 86–88; "EXHIBITION: Non-Portraits," brief review of *Warhol's Jews: Ten Portraits Reconsidered* at the Jewish Museum in New York, *Aristos*, Notes & Comments, June 2008; and "Portraiture or Not?—the Work of Chuck Close," *Aristos*, February 2012.

Barking Up the Wrong Trees in Art Education

1. Sarah Ackermann, "Spin Me Round and Round: The Dizzying Work of Alex Garant," *Art Education*, January 2016. See also "Alex Garant's 'Queen of Double Eyes' Will Break Your Brain," by Andres Jauregui, which aptly appeared in the "Weird News" section of the *Huffington Post*, August 17, 2015.

2. Mary Hoefferle, "Michael Beitz: Objects of Communication," *Art Education*, May 2014.

Art Education or Miseducation?
From Koons to Herring

1. A notable exception was a featured session on "How to Read Chinese Paintings," by Maxwell K. Hearn, Chairman of the Department of Asian Art, Metropolitan Museum of Art. I saw nothing comparable about Western art on the program.

2. On this point, see "Museum Miseducation: Perpetuating the Duchamp Myth," above, 207–209.

3. See, for example, "Vermeer's *Milkmaid*: More than Meets the Eye?," *Aristos*, December 2009.

4. Perhaps the most glaring instance of Koons's reduction of high art to banality is his *Antiquity* series—notwithstanding the efforts of one academic, Joachim Pissarro, to take it seriously ("Jeff Koons's *Antiquity* Series—a Reflection on Acceptance"). Though Pissarro, a former Museum of Modern Art curator, is now the Bershad Professor of Art History and Director of the Hunter College Galleries, teachers should be wary of his scholarship. See "Museum Miseducation."

5. I'm happy to report that at least one other conference attendee was as troubled as I by Koons's presentation. At a session devoted to "Culturally Sensitive Art Education in a Global World," Enid Zimmerman (Professor Emeritus and Coordinator of Gifted and Talented Education, Indiana University, School of Education) expressed, in passing, her strong disapproval of the Koons talk. Yet Kim Defibaugh, the current NAEA president, uncritically observes that Koons "takes everyday objects like balloons, basketballs, and vacuum cleaners and presents them in ways that challenge the viewer to consider them fine art" ("From the President," *NAEA News*, June/July 2017, 3). How such a practice can be reconciled with the "quality visual arts education" NAEA advocates is anybody's guess.

6. Jethro Gillespie, "Oliver Herring's TASK in the Classroom: A Case for Process, Play, and Possibility," *Art Education*, January 2016, 31–37.

7. As I've reported in "Understanding Contemporary Art," above 214–28, and elsewhere, Allan Kaprow, the inventor of the "Happening," himself recognized that it was "not quite art"—an understatement if there ever was one. Regrettably, that recognition did not impede his participation as a featured speaker in the landmark 1965 Penn State Seminar for Research and Curriculum Development in Art Education—a sure indication that the concept of art has been eroding for decades.

8. See "The Hijacking of Art Education," above, 179–93; and "A Forum on Social Justice Art Education," *Aristos*, November 2010.

9. Entitled "Building Relationships through Art Dialogue: A Whole School Initiative at an Urban Middle School," the session described a schoolwide initiative involving all faculty, staff, and students, and as many caregivers as possible, in visits to the Virginia Museum of Fine Arts, combined with facilitated small-group discussions about the works seen there.

10. Sara Wilson McKay, "Shared Head Space: Cultivating Dialogue through Art," *NAEA News*, February/March 2017.

11. The talk, entitled "What's Wrong with Contemporary Art?," was presented by Jane Deeth, an Australian "arts writer, curator and educator."

12. Anna M. Kindler, Professor of Education, University of British Columbia, quoted in my blog post "Lively NAEA Debate on *Who Says That's Art?,*" *For Piero's Sake*, March 12, 2017.

Art and Cognition
Mimesis vs. the Avant Garde

1. Joseph A. Goguen, "What Is Art?," Introduction to *Art and the Brain*, Part 2, *Journal of Consciousness Studies*, special issue, August–September 2000.

2. Cynthia Freeland, "Teaching Cognitive Science and the Arts," Part I, *Newsletter of the American Society for Aesthetics*, Spring 2001, 1–3.

3. See my reflections on Efland's book in "Why Teach Art?," above, 165–78.

4. Alexander Baumgarten, *Meditationes philosophicae de nonnullis ad poema pertinentibus* (1734), trans. by Karl Aschenbrenner and William B. Holther as *Reflections on Poetry* (Berkeley: University of California Press, 1954).

5. Immanuel Kant, *Critique of Judgement* [1790], trans. by J. H. Bernard (2nd ed. rev., 1914), §49, in Theodore M. Greene, ed., *Kant: Selections* (New York: Scribner's, 1957), 426, italics in original.

6. Ayn Rand, "The Psycho-Epistemology of Art," in *The Romantic Manifesto: A Philosophy of Literature*, 2nd rev. ed. (New York: Signet, 1975), 20.

7. Cynthia Freeland, *But is it art? An Introduction to Art Theory* (New York: Oxford University Press, 2001).

8. On this point, see "The Myth of 'Abstract Art,'" in *What Art Is*, 133–79.

9. Erwin Panofsky, "Iconography and Iconology: An Introduction to the Study of Renaissance Art" (1939), reprinted in *Meaning in the Visual Arts: Papers in and on Art History* (Garden City, N.Y.: Doubleday, 1955), 27. Panofsky's observations on "natural" versus "conventional," or symbolic, meanings are applicable to all art, not just to the Western Renaissance.

10. Stephen Halliwell, *The Aesthetics of Mimesis: Ancient Texts and Modern Problems* (Princeton, N.J.: Princeton University Press, 2002), Introduction.

11. Robert Farris Thompson, "Yoruba Artistic Criticism," in Warren L. d'Azevedo, ed., *The Traditional Artist in African Societies* (Bloomington, Ind.: Indiana University Press, 1973).

12. Merlin Donald, *Origins of the Modern Mind: Three Stages in the Evolution of Culture and Cognition* (Cambridge, Mass.: Harvard University Press, 1991), 199. See also his *A Mind So Rare: The Evolution of Human Consciousness* (New York: Norton, 2001).

13. Oliver Sacks, *An Anthropologist on Mars* (New York: Vintage, 1995), 240.

Modernism, Postmodernism, or Neither?

1. Ben Aris, "Back to School for Binmen Who Thought Modern Art Was a Load of Old Rubbish," *Guardian*, January 13, 2005.

2. Scott Kraus, "Allentown Art in Need of Appreciation, New Home," *Morning Call*, January 29, 2005.

3. See, for example, "In the Eye of the Beholder," *Waste Age*, December 1, 2001, https://tinyurl.com/y2y7h4l5; and "Cleaner Bins Rubbish Bag Artwork," *BBC News*, August 27, 2004.

4. On the neglect of "traditional" artists, see Kamhi and Torres, "The Other Face of 'Contemporary Art,'" *Aristos*, January 2006, as well as the letters from Michael Ome Untiedt and Currie McCullough in the same issue.

5. Tom Wolfe, *The Painted Word* (New York: Bantam Books, 1976); and Jacques Barzun, *The Use and Abuse of Art* (A. W. Mellon Lectures in the Fine Arts, 1973, Bollingen Series, XXXY [Princeton, N.J.: Princeton University Press, 1974]), 18. On *The Painted Word*, see Louis Torres, "Tom Wolfe's Epiphany," *Aristos*, January 2006.

6. *Two Reindeer* from Font-de-Gaume is included in the list of images cited in note 8.

7. Robert Payne, *The World of Art* (Garden City, N.Y.: Doubleday, 1972), 22.

8. "Rescuing Art from Visual Culture Studies," above, 152–64; and "Images of Exemplary Works of Art," *Aristos*, January 2004.

9. For a more detailed overview of the ideas presented here and the sources they are based on, see "The Myth of 'Abstract Art,'" in *What Art Is*, esp. 134–46 and the relevant notes.

10. Piet Mondrian, in Harry Holtzman and Martin S. James, eds., *The New Art—The New Life: The Collected Writings of Piet Mondrian* (Boston: G. K. Hall, 1986): see "Neo-Plasticism" (1923), 176–77; "Pure Abstract Art" (1929), 223–25; and "Art without Subject Matter" (1938), 303.

11. Clive Bell, "The Aesthetic Hypothesis" (1912), in *Art* (New York: Capricorn, 1958), 28 and 27.

12. The assumption by the early practitioners of abstract painting and sculpture that they possessed a more evolved form of consciousness than their fellow mortals pervades their writing; see, for example, Mondrian, letter to H. P. Bremmer (January 29, 1914), quoted in Holtzman and James, 14, and in Carel Blotkamp, *Mondrian: The Art of Destruction*, trans. by Barbara Potter Fasting (New York: Abrams, 1995), 81; Mondrian, "Pure Abstract Art" (1929), in Holtzman and James, 224; and Charlotte Douglas, in Kazimir Malevich, *Malevich: Artist and Theoretician*, trans. by Sharon McKee (Paris: Flammarion, 1991), 58–59.

13. On Clement Greenberg's views, see *What Art Is*, 149–51 and the corresponding notes; Peter Fuller's interview with him in *Modern Painters*, Winter 1991, esp. 20–22; and his reviews of Jackson Pollock's *Cathedral and Number One*, 1948, originally published in *The Nation*, January 24, 1948, and February 19, 1949, respectively, reprinted in John O'Brian, ed., *Clement Greenberg: The Collected Essays and Criticism*, vol. 2 (Chicago: Chicago University Press, 1986), 200–202 and 285–86.

14. Guggenheim Museum website page on Robert Motherwell's *Elegy to the Spanish Republic No. 110*.

15. Mondrian, letter to the architect J. J. P. Oud (1925), quoted in Holtzman and James, 198, emphasis in original; and "Purely Abstract Art," 200.

16. Clement Greenberg, "Avant-Garde and Kitsch" (1939), in O'Brian, *Collected Essays*, vol. 1 (1986), 5–22. Regarding this widely influential early essay, Greenberg declared in 1991: "[It] embarrasses me now: it's so crude and the writing is so bad, and it's so full of simple-minded Bolshevism. . . . I can't stand [it] today" (interview in *Modern Painters*, 19). But that does not discourage his admirers from continuing to cite it as a groundbreaking contribution to criticism.

17. Kazimir Malevich, *The Non-Objective World*, trans. by Howard Dearstyne (Chicago: Paul Theobold, 1959), 68.

18. Robert Motherwell, "What Abstract Art Means to Me" (talk given at a Museum of Modern Art symposium, 1951), reprinted in Stephanie

Terenzio, ed., *The Collected Writings of Robert Motherwell* (New York: Oxford University Press, 1992), 85.

19. Alec Sologob, quoted in John Tierney, "Defender, Critic, Watcher: All in One at the Modern," *New York Times*, November 20, 1991.

20. Robert Rauschenberg, "Untitled Statement," in Dorothy C. Miller, ed., *Sixteen Americans*, exhibition catalogue (New York: Museum of Modern Art, 1959), 58, quoted in Lisa Phillips, *The American Century: Art and Culture 1950–2000*, Whitney Museum of Modern Art exhibition catalogue (New York: Norton, 1999), 83. On Rauschenberg and his fellow postmodernists, see "Postmodernism in the Visual Arts," *What Art Is*, 262–82.

21. Allan Kaprow, *Essays on the Blurring of Art and Life* (Berkeley: University of California Press, 1993).

22. Kaprow, "Happenings in the New York Scene" (1961), in *Essays*, 21.

23. Tracey Emin's installation *My Bed* was shortlisted for Britain's Turner Prize in 1999.

24. Andy Warhol, interview with G. R. Swenson, in John Russell and Suzi Gablik, eds., *Pop Art Redefined* (New York: Praeger, 1969), 119; John Cage, quoted in Joseph H. Mazo, "John Cage Quietly Speaks His Piece," *Bergen Sunday Record*, March 13, 1983, excerpted in Richard Kostelanetz, "Cagean Esthetics," in *Esthetics Contemporary* (Buffalo, N.Y.: Prometheus Books), 293; and Louis Sass, *Madness and Modernism: Insanity in the Light of Modern Art, Literature, and Thought* (New York: Basic Books, 1992).

25. John Cage, interview with Roger Reynolds, *Generation*, January 1962, excerpted in Kostelanetz, "Cagean Esthetics," 296; Rauschenberg, quoted in Grace Glueck, "Rauschenberg at 65, with All Due Immodesty," *New York Times,* December 16, 1990.

26. Jasper Johns, "Sketchbook Notes" (1965), in Russell and Gablik, 84–85; and Guy Wildenstein, quoted in "Inside Art" item: "Putting Jasper Johns on the Page," *New York Times*, January 28, 2005.

27. Arthur C. Danto, "The Artworld," *Journal of Philosophy* 61 (1964): 571–84, and *The Transfiguration of the Commonplace: A Philosophy of Art* (Cambridge, Mass.: Harvard University Press, 1981); Russell and Gablik, 9; and Warhol interview cited above, note 24.

28. Damien Hirst, interview, *The Charlie Rose Show*, PBS, February 20, 2002.

29. Mark Reynolds, "Youth Defends Prize-Winning Bush/Hitler Art," *Providence Journal,* February 8, 2005.

30. Picasso, *Weeping Woman*, Tate Collection; Rubens, *Study for the Head of St. Apollonia*, Uffizi Gallery; Picasso, *First Steps*, Yale University Art Gallery; and Cecilia Beaux, *Ernesta (Child with Nurse)*, Metropolitan Museum of Art.

31. Li Zehou, *The Path of Beauty: A Study of Chinese Aesthetics* (New York: Oxford University Press, 1994), 54.

32. Vincent van Gogh, letter to Theo van Gogh, ca. April 30, 1885; *Head of a Woman* (1885) and *Study of Three Hands, two holding forks* (1885)—all of which can be viewed on the website of the Van Gogh Museum, Amsterdam.

33. The poet Po Chü-i, quoted in Osvald Sirén, *The Chinese on the Art of Painting: Translations and Comments* (New York: Schocken Books, 1963), 29.

34. "Images of Exemplary Works of Art" cited in note 8 includes most of the works cited here; for Thomas Eakins, *Baby at Play*, see the National Gallery of Art, Washington, D.C.

35. Jacques Barzun, "Occupational Disease: Verbal Inflation," talk given at National Art Education Association convention, Houston, 1978, reprinted in *Begin Here: The Forgotten Conditions of Teaching and Learning* (Chicago: University of Chicago Press, 1991), 110. Judging from the NAEA brochure "Ten Lessons the Arts Teach," however, the organization has not much heeded Barzun's admonition to avoid verbal inflation.

The Undefining of Art and Its Consequences

1. Clement Greenberg, "Avant-Garde and Kitsch," in *Clement Greenberg: The Collected Essays and Criticism*, 4 vols., ed. by John O'Brian (Chicago: Chicago University Press, 1986–1993), vol. 1, 8.

2. Ibid., 10.

3. Tim Hilton, "Clement Greenberg," *The New Criterion*, September 2000, 16.

4. Greenberg, "Avant-Garde and Kitsch," 9.

5. *What Art Is*, 135–41, and *Who Says That's Art?*, 52–57.

6. "The Art of Piet Mondrian," *CBS News*, October 1, 2017.

7. My post "RE: Balancing TEACHING art with MAKING art" was in response to a teacher's posting of an image of an abstract quilt design by her as an example of her art-making (Cynthia Gaub, National Art

Education Association [NAEA] Open Forum online discussion, March 28, 2018). It appeared on the NAEA Open Forum, March 31, 2018.

8. Susanne Floyd Gunter (Associate Professor of Art Education, Converse College, Spartanburg, South Carolina), "Who defines what is art and what we teach?," NAEA Open Forum, April 21, 2018, and subsequent posts.

9. Clement Greenberg, "The Case for Abstract Art," in *Collected Essays*, vol. 4, 82–83.

10. Clement Greenberg, "'American Type' Painting," in Clifford Ross, ed., *Abstract Expressionism: Creators and Critics* (New York: Abrams, 1991), 235.

11. Clement Greenberg, "Modernist Painting," in *Collected Essays,* vol. 4, 87.

12. Clement Greenberg, Interview with Peter Fuller, *Modern Painters*, Winter 1991, 19.

13. Terry Teachout, "What Clement Greenberg Knew," *Commentary*, July–August 2006.

14. Clement Greenberg, "Review of Exhibitions of Adolph Gottlieb, Jackson Pollock, and Joseph Albers," *The Nation*, February 19, 1949; reprinted in *Collected Essays*, vol. 2, 285–86.

15. Hilton Kramer, *The Revenge of the Philistines: 1972–1984* (New York: Free Press, 1985), 11.

16. Clement Greenberg, quoted by Deborah Solomon, "Catching Up with the High Priest of Criticism," *New York Times*, June 23, 1991.

17. Greenberg, Interview with Peter Fuller, 20, 22.

18. Clement Greenberg, "Pop Art" (a lecture probably dating from the early 1960s), first published by James Meyer in "Pop Art: Clement Greenberg," *ArtForum*, October 2004.

19. Arthur Danto, "The Artworld," *Journal of Philosophy*, October 15, 1964, 571–84; reprinted in *Aesthetics: A Critical Anthology*, ed. by George Dickie, Richard Sclafani, and Ronald Roblin, 2nd ed. (New York: St. Martin's, 1977), 180.

20. A key essay symptomatic of that trend was Morris Weitz, "The Role of Theory in Aesthetics," *Journal of Aesthetics and Art Criticism*, September 1956, 27–35.

21. Arthur Danto, "The Philosopher as Andy Warhol," reprinted from *The Andy Warhol Museum* (Pittsburgh: Andy Warhol Museum, 1994) in his

Philosophizing Art: Selected Essays (Berkeley: University of California Press, 2001), 62–63.

22. Louis A. Sass, *Madness and Modernism: Insanity in the Light of Modern Art, Literature, and Thought* (New York: Basic Books, 1992), 106.

23. Andy Warhol, Interview with Gene Swenson, from "What Is Pop Art: Interviews with Eight Painters (Part 1)," *Art News*, November 1963; reprinted in *Pop Art Redefined*, ed. by John Russell and Suzi Gablik (New York: Praeger, 1969), 117.

24. Arthur Danto, Reply in *Danto and His Critics*, ed. by Mark Rollins (Cambridge, Mass.: Blackwell, 1993), 198.

25. John Canaday, "The Collector: Origin and Examples of the Species" (*New York Times*, August 6, 1961), reprinted in *Embattled Critic: Views on Modern Art* (New York: Farrar, Straus, 1962), 181.

26. John Canaday, "New York, U.SA: The City and 'The New York School'," *New York Times*, May 22, 1960, in Embattled Critic, 28.

27. Ibid.

28. Ibid., 29.

29. Hilton Kramer, "Reflections on the Changing Times," *City Journal*, Summer 1998.

30. Hilton Kramer, "Realism: 'The Painting Is Fiction Enough'," *New York Times*, April 28, 1974.

31. Hilton Kramer, "Shame! Brooklyn Museum Exhibits Wyeth's Dreary Pictures of Helga," *New York Observer*, August 7, 1989.

32. John Canaday, *Mainstreams of Modern Art* (New York: Simon and Schuster, 1959), 542.

33. Hilton Kramer, "Mammoth Wyeth Exhibition at Met," *New York Times*, October 16, 1976.

34. Steve Johnson, "Art Institute Wins Global Competition for Modern Masterpiece—a Multimillion Dollar Bottle Rack," *Chicago Tribune*, February 13, 2018.

35. See above, note 7.

The Art of Critical Spinning

1. Another such book is *Seeing Slowly: Looking at Modern Art*, by art dealer Michael Findlay (New York: Prestel, 2017).

2. Some abstract designs, such as the *mandala* in Indian culture, do carry *symbolic* meaning. I maintain that their psychological impact is far weaker than that of imagery, however, and they therefore belong in another category than "fine art."

3. See "Has the Artworld Been Kidding Itself about Abstract Art?," above, 129–32.

4. The abstract pioneers' intent, as well as their recognition of failure, is discussed in "The Myth of 'Abstract Art,'" *What Art Is*, 134–46.

5. See the Museum of Modern Art's gloss on the readymade *In Advance of the Broken Arm*, for example.

6. Hector Obalk attributes the definition to Breton, as affirmed by André Gervais, in "The Unfindable Readymade," *Tout-Fait: The Marcel Duchamp Studies Online Journal*, May 1, 2000.

7. Marcel Duchamp, in Pierre Cabanne, *Dialogues with Marcel Duchamp*, trans. by Ron Padgett (New York: Viking Press, 1971), 47.

8. The reason is that it suited the anti-art aims of postmodernists reacting against the artworld ascendancy of Abstract Expressionism.

9. Lara Heimert, on *Twitter*, https://tinyurl.com/y3x3q4un.

Why Discarding the Concept of "Fine Art" Has Been a Grave Error

1. Paul Oskar Kristeller, "The Modern System of the Arts" (first published in 1951–1952), reprinted in *Renaissance Thought and the Arts: Collected Essays*, expanded ed. (Princeton, N.J.: Princeton University Press, 1990), 164–65.

2. See, for example, David Clowney, "A Third System of the Arts? An Exploration of Some Ideas from Larry Shiner's *The Invention of Art: A Cultural History*," *Contemporary Aesthetics*, vol. 6 (2008). Notable exceptions have been Stephen Halliwell, James I. Porter, Peter Kivy, and James O. Young—all cited below. Kristeller's shortcomings were first explored by Louis Torres and me in *What Art Is*, 193, 326n6, 420n18, 421n22.

3. Larry Shiner, *The Invention of Art: A Cultural History* (Chicago: University of Chicago Press, 2001), 10.

4. Mitch Avila, Review of *Larry Shiner, The Invention of Art: A Cultural History*, *JAAC*, Fall 2003, 401–403.

5. David Clowney, "Definitions of Art and Fine Art's Historical Origins," *JAAC*, Summer 2011, 316.

6. Kristeller, 165, emphasis added; and 202.

7. Gordon Graham, *Philosophy of the Arts: An Introduction to Aesthetics* (New York: Routledge, 1997), 131.

8. Batteux's designation of this category referred to "pleasure"—not "beauty."

9. In response to James I. Porter's "Is Art Modern? Kristeller's 'Modern System of the Arts' Reconsidered," *BJA*, January 2009, 1–24, Larry Shiner argues (in "Continuity and Discontinuity in the Concept of Art," p. 160 of the same issue) that no fewer than ten other eighteenth-century classifications of fine art list "the same 'nucleus' of five arts" (including architecture) as D'Alembert. Nearly all of them were later than D'Alembert's *Preliminary Discourse*, however, and were therefore probably influenced by it.

10. Jean le Rond d'Alembert, *Preliminary Discourse to the Encyclopedia of Diderot* (1751), trans. by Richard N. Schwab, excerpted in *Aesthetics*, ed. by Susan L. Feagin and Patrick Maynard (New York: Oxford University Press, 1997), 105, emphasis added.

11. For D'Alembert's comparison of the fine arts, omitting architecture, see his *Preliminary Discourse in Denis Diderot's Encyclopedia (Selections)*, trans. by Stephen J. Gendzier (New York: Harper Torchbooks, 1967), 16.

12. For example, under the rubric "Non-imitative character of architecture," the comprehensive article on the "Fine Arts" by Sidney Colvin in the classic 11th edition of the *Encyclopedia Britannica* (1910) compares architecture to music. On the imitative nature of music, see *What Art Is*, 87–90; on architecture and abstract sculpture, 198–99.

13. Moshe Barasch, *Theories of Art: From Plato to Winckelmann* (New York: New York University Press, 1985), xi—xii.

14. Charles Batteux, *The Fine Arts Reduced to a Single Principle* (originally published in French in 1746), trans. with introduction and notes by James O. Young (New York: Oxford University Press, 2015).

15. Wladyslaw Tatarkiewicz, *A History of Six Ideas: An Essay in Aesthetics* (Dordrecht: Kluwer, 1980), 276.

16. James O. Young, "The Ancient and Modern System of the Arts," *BJA*, January 2015, 1, emphasis added; and 1–3, 11.

17. Porter, "Is Art Modern?," 2, 9, 14. Also of interest is Porter's "Reply to Shiner" in the same issue of the *BJA*, 171–78.

18. Batteux (see note 14), lxxvii—lxxix.

19. Peter Kivy, "What Really Happened in the Eighteenth Century: The 'Modern System' Re-examined (Again)," *BJA*, January 2012, 69 and 64.

20. Stephen Halliwell, *The Aesthetics of Mimesis: Ancient Texts and Modern Problems* (Princeton, N.J.: Princeton University Press, 2002), 7.

21. Shiner, "Continuity and Discontinuity," 168.

22. Halliwell, 6, footnote, and ff.

23. Lien An, quoted in Osvald Sirén, *The Chinese on the Art of Painting: Translations and Comments* (New York: Schocken Books, 1963; first published in 1936), 152.

24. Shiner, *Invention of Art*, 7, 294.

25. For my further analysis of *The Dinner Party*, see *Who Says That's Art?*, 93–95.

26. Clowney, "Definitions of Art," 315.

27. On Michael Beitz's work, see "Barking Up the Wrong Trees in Art Education," above, 239–40.

28. Young, "Ancient and Modern System," 3. Somewhat confusingly Young refers here to Kristeller's grouping, rather than to Batteux's, as if the two were synonymous.

29. Batteux, lxxix, emphasis added.

30. Immanuel Kant, *Critique of Judgement* (originally published in 1790), trans. by J. H. Bernard, excerpted in *Kant: Selections*, ed. by Theodore Meyer Greene (New York: Scribner's, 1957), 426.

31. Ayn Rand, *The Romantic Manifesto: A Philosophy of Literature*, rev. ed. (New York: Signet, 1975).

32. Simon Fokt, "Ayn Rand, *The Romantic Manifesto* (Signet, 1962 [*sic*])," in *What Is Art? A Reading List* (American Society for Aesthetics, Curriculum Diversification Grant Project, 2015), 16. The correct publication date of the first Signet edition was 1971. The 1962 edition was from Bantam Books. The revised second edition published by Signet in 1975 included the essay "Art and Cognition."

33. See Kamhi and Torres, "Critical Neglect of Ayn Rand's Theory of Art," *Journal of Ayn Rand Studies*, Fall 2000, 1–46; and *Who Says That's Art?*, Preface. *What Art Is* was favorably reviewed by *Choice* magazine (Association of College & Research Libraries) and *The Art Book* (Association of Art Historians, U.K.), but was overlooked by academic journals devoted to aesthetics.

34. *Who Says That's Art?*, 163, quoting Rand, *Romantic Manifesto*, 20.

35. Antonio Damasio, *Descartes' Error: Emotion, Reason, and the Human Brain* (New York: Putnam's, 1994), 136–37.

36. James O. Young, *Art and Knowledge* (New York: Routledge, 2001), 126.

37. Barasch, *Theories of Art*, 65.

38. On the misguided intentions and ultimate failure of "abstract art," see "The Myth of 'Abstract Art,'" *What Art Is*, 133–79; and "What's Wrong with 'Abstract Art'?," *Who Says That's Art?*, 50–68.

39. *Who Says That's Art?*, 160–62.

40. Vittorio Gallese, "Mirror Neurons and Art." In *Art and the Senses*, ed. by Francesca Bacci and David Melcher (New York: Oxford University Press, 2011), 441–49.

41. Gallese, 444.

42. Semir Zeki and Ludovica Marini, "Three cortical stages of colour processing in the human brain," *Brain* 121: 1676–81.

43. Robert Solso, *The Psychology of Art and the Evolution of the Conscious Brain* (Cambridge, Mass.: MIT Press, 2003), 27.

44. Shiner, *Invention of Art*, 14–15.

45. Ellen Dissanayake, *What Is Art For?* (Seattle, Wash.: University of Washington Press, 1988), 152–53.

46. Robert L. Anderson, *Calliope's Sisters: A Comparative Study of Philosophies of Art* (Upper Saddle River, N.J.: Pearson Prentice Hall, 2004). See the discussion of Anderson's study in *Who Says That's Art?*, 28–29. See also Warren L. d'Azevedo, ed., *The Traditional Artist in African Societies* (Bloomington, Ind.: Indiana University Press, 1973), esp. Robert Farris Thompson, "Yoruba Artistic Criticism"; William Bascom, "A Yoruba Master Carver"; James Fernandez, "The Exposition and Imposition of Order: Artistic Expression in Fang Culture"; and d'Azevedo, "Sources of Gola Artistry."

47. Susan Mullin Vogel, *Baule: African Art / Western Eyes* (New Haven, Conn.: Yale University Press, 1997), 270.

48. Vogel, 17 and 291.

49. Dissanayake, *What Is Art For?* 34.

50. Ellen Dissanayake, *Homo Aestheticus: Where Art Comes From and Why* (New York: Free Press, 1992), 139.

51. On the art of film in relation to Rand's theory, see *What Art Is*, 74–75, 253–57; and *Who Says That's Art?*, 114–17.

52. John Dewey had advocated "restor[ing] continuity between the refined and intensified forms of experience that are works of art and . . . everyday events, doings, and sufferings." *Art as Experience* (New York: Capricorn, 1958 [originally published in 1934]), 3. Did he mean what Kaprow took him to mean? Or did he mainly intend to counter Clive Bell's notoriously false claim that the significance of (fine) art is "unrelated to the significance of life"? My guess is the latter.

53. Allan Kaprow, "Happenings in the New York Scene" (1961), in *Essays on the Blurring of Art and Life* (Oakland, Calif.: University of California Press, 1993), 21. On Kaprow's influence, see *What Art Is*, 274–78.

54. "About Henry Flynt," on http://www.henryflynt.org.

55. Henry Flynt, "Concept Art" (1961), in *Esthetics Contemporary*, ed. by Richard Kostelanetz (Buffalo, N.Y.: Prometheus Books, 1989), 431. On the spurious category of "conceptual art," see *What Art Is*, 270–73; and *Who Says That's Art?*, 89–92.

56. Denis Dutton, "A Naturalist Definition of Art," *JAAC*, Summer 2006, 367–68.

57. Steven Goldsmith, "The Readymades of Marcel Duchamp: The Ambiguities of an Aesthetic Revolution," *JAAC*, Winter 1983, 197.

58. Denis Dutton, *The Art Instinct: Beauty, Pleasure, and Human Evolution* (New York: Bloomsbury 2009), 196–200; and "Has Conceptual Art Jumped the Shark Tank?" *New York Times*, October 16, 2009.

59. Dutton, *Art Instinct*, 200–201. Dutton doesn't cite the source of the Duchamp quote. It was Pierre Cabanne, *Dialogues with Marcel Duchamp*, trans. by Ron Padgett (New York: Viking, 1971), 47. On Dutton and Duchamp, see *Who Says That's Art?*, 147–48; on the readymades, ibid., 80–83.

60. Dutton, *Art Instinct*, 4.

61. Arthur C. Danto, "The Artworld," *Journal of Philosophy* 61 (1964): 571–84.

62. Kivy, "What Really Happened," 66.

63. Arthur Danto, "The Transfiguration of the Commonplace," *JAAC*, Winter 1974, 140.

64. Regarding the artworld's enfranchisement of Warhol, see "The Apotheosis of Andy Warhol," above, 86–88.

65. Arthur Danto, "The Philosopher as Andy Warhol" (1994), in *Philosophizing Art: Selected Essays* (Oakland, Calif.: University of California Press, 2001), 62–63.

66. Andy Warhol, Interview with G. R. Swenson, *Art News*, November 1963, reprinted in *Pop Art Redefined*, ed. by John Russell and Suzi Gablik (New York: Praeger, 1969), 119.

67. *The Philosophy of Andy Warhol: From A to B and Back Again* (New York: Harcourt Brace, 1975), passim.

68. Louis Sass, *Madness and Modernism: Insanity in the Light of Modern Art, Literature, and Thought* (New York: Basic Books, 1992), 106.

Index